Art and Life in Aestheticis

Art and Life in Aestheticism

De-Humanizing and Re-Humanizing Art, the Artist, and the Artistic Receptor

Edited by

Kelly Comfort

palgrave
macmillan

First published 2008 by
PALGRAVE MACMILLAN
Houndmills, Basingstoke, Hampshire RG21 6XS and
175 Fifth Avenue, New York, N.Y. 10010
Companies and representatives throughout the world

PALGRAVE MACMILLAN is the global academic imprint of the Palgrave
Macmillan division of St. Martin's Press, LLC and of Palgrave Macmillan Ltd.
Macmillan® is a registered trademark in the United States, United Kingdom and
other countries. Palgrave is a registered trademark in the European Union and
other countries.

ISBN 978-1-349-36204-2 ISBN 978-0-230-58349-8 (eBook)
DOI 10.1007/978-0-230-58349-8

A catalogue record for this book is available from the British Library.

A catalog record for this book is available from the Library of Congress.

10 9 8 7 6 5 4 3 2 1
17 16 15 14 13 12 11 10 09 08

Transferred to Digital Printing 2012

Contents

Illustrations

Acknowledgments

First and foremost, I want to thank my husband for his constant support and encouragement, for knowing when to provide perspective, distance, and distraction, and, most importantly, for the strength of his love. I am grateful to my mom and dad, who provide the perfect balance of the aesthetic and the human, of art and life. I also thank my brother for always trying to keep me on track.

I wish to express my gratitude to Gail Finney, Liz Constable, and Ana Peluffo for guiding me through my dissertation research on the relationship between art for art's sake and "art for capital's sake" in European and Latin American literature, and for assisting me at various stages throughout this project. Their support is always with me.

I owe my introduction to aestheticism to an inspiring class I took with Eric Downing during my undergraduate years at UNC. I appreciate his continued guidance and support over the past decade.

The cover art for this volume, Stephen Alcorn's *The Portrait of Dorian Gray*, seems to me to so perfectly capture the de-humanizing and re-humanizing extremes of aestheticism that I would like to acknowledge my debt to Stephen for granting me permission to use his work. You can see more at www.alcorngallery.com.

To the participants in the seminar I chaired on "Aestheticism: Dehumanizing or Rehumanizing Art, the Artist, or the Artistic Receptor?" at the 2006 American Comparative Literature Association's Conference in Princeton, I wish to express my appreciation for the diversity and richness of their ideas as well as the provocative nature of our discussions. The inception of this volume's topic came in response to the 2006 ACLA Conference theme: "The Human and Its Other."

I am grateful for the permission to use Dante Gabriel Rosetti's *Regina Cordium* (© Glasgow Art and Gallery Museum), *Lady Lilith* (© Delaware Art Museum, Samuel and Mary R. Bancroft Memorial, 1935), *Sibylla Palmifera* (© Walker Art Gallery, National Museums Liverpool), and *Proserpina* (© Birmingham Museums & Art Gallery, presented by the Public Picture Gallery Fund, 1927).

The comments and suggestions of Palgrave's anonymous external reader proved invaluable to the successful completion of this volume, and I am

very grateful for his/her comprehensive feedback. I am also very appreciative of Palgrave's editors for their diligent efforts and helpful guidance.

Finally, I wish to thank the contributors to this volume—for their insightful approaches to the topic, for their shared and passionate interest in aestheticism, and for their patience and diligence throughout the entire process.

Notes on Contributors

Robert Archambeau is Associate Professor at Lake Forest College. A poet and critic, he has taught at the University of Notre Dame and Lund University, Sweden, and was for six years the editor of the international poetry journal *Samizdat*. His work on aesthetics grows out of his concern with avant-garde poetry and literary theory. His books include *Word Play Place: Essays on the Poetry of John Matthias* (Ohio University Press), the poetry collection *Home and Variations* (Salt Modern Poets), and *Laureates and Heretics* (University of Notre Dame Press). He is currently at work on a study of poetry and aestheticism from the late nineteenth century to the early twenty-first century.

Kael Ashbaugh is a Ph.D. candidate in the Program in Comparative Literature at Rutgers University. At present he is writing his dissertation on the aesthetics of playfulness in twentieth-century Latin American fiction. He has studied Nietzsche and aesthetics with Walter Sokel. His enthusiasm for the particular topic of Nietzsche's aestheticism can be traced to a course he took on the philosophy of beauty with the Princeton philosopher and scholar of Nietzsche Alexander Nehamas. Recently, he has presented a paper on "Becoming Fictions: The Aesthetic Humanizing of Being in Nietzsche and Cabrera Infante" at the 2006 ACLA Conference. He is also an exhibited artist, working in the media of painting and printmaking.

Gene H. Bell-Villada is Professor of Romance Languages at Williams College. His *Art for Art's Sake and Literary Life: How Politics and Markets Helped Shape the Ideology and Culture of Aestheticism, 1790–1990* was a finalist for the 1997 National Book Critics Circle Award, and has since been translated into Serbian and Chinese. Bell-Villada's books on Borges and García Márquez are used regularly in high school and college classrooms, and have gone through multiple printings. The author of two books of fiction (one of which, *The Carlos Chadwick Mystery*, originally took its cue from Nabokov's *Pale Fire*), Bell-Villada recently published a memoir, *Overseas American: Growing Up Gringo in the Tropics* (University Press of Mississippi).

Ben De Bruyn is a research assistant at the Flemish Fund for Scientific Research (FWO) in connection with the Catholic University of Leuven, Belgium. He is currently pursuing a Ph.D. on the reception theory of Wolfgang Iser and its theoretical and literary sources. Apart from several presentations on related issues, he has recently published an article in *Image & Narrative* on Hans Belting's attempt to extrapolate Iser's "literary anthropology" to the visual arts. Forthcoming projects include an article on the relationship between Iser's "implied reader" and Wayne C. Booth's "implied author." His research

interests include literary and cultural theory, modernist fiction and poetry, and the history of criticism.

Kelly Comfort is Assistant Professor in the School of Modern Languages at Georgia Tech. Her research on transnational aestheticism has led to publications and presentations on Wilde, Nietzsche, Wedekind, Schnitzler, Huysmans, Darío, Silva, and Martí. Her current book project explores the relationship between "art for art's sake" and "art for capital's sake" in European aestheticism and Latin American *modernismo*. She is also coediting, with Vanessa Pérez, a volume entitled *Voces caribeñas: Literature of Exile and (Im)migration from the Islands to the Diasporas*.

Andrew Eastham is a visiting lecturer at King's College London, specializing in Victorian aestheticism, modernism, and contemporary literature. He has recently published articles on Samuel Beckett, Henry James, and Alan Hollinghurst. He is currently working on two monographs, "Aestheticism and Theatricality: From Pater to Elliot" and a further work on "Literary Modernity and the Concept of Irony," which extends ideas already suggested in his article "Inoperative Ironies: Jamesian Aestheticism and Postmodern Culture in Hollinghurst's *The Line of Beauty*" (*Textual Practice* 20.3, September 2006).

Paul Fox is Associate Professor of Literature at Zayed University in the United Arab Emirates. He has published various articles on the subjects of decadence and late Victorian aesthetics. His most recent research explores the influence of formal aesthetics on Victorian and Edwardian detective fiction. He is presently working on a manuscript entitled *The Untimely Art: Literary Decadence and the Aesthetic Moment*.

Sarah Garland teaches American Literature and Culture at the University of East Anglia, England. Her recent research explores the ways in which twentieth-century British and American avant-garde texts address their readers, focusing particularly on the function of style in works by Samuel Beckett, Vladimir Nabokov, William Burroughs, and Henry Miller. She has also written on the return of baroque aesthetics in late twentieth-century fiction, film, and theory. She is currently working on a book-length study provisionally titled *Strong Words: Rhetoric and Excess in Twentieth-Century American Writing*.

Yvonne Ivory is Assistant Professor of German at the University of South Carolina, Columbia. She is currently completing a book project on the interplay between discourses of aesthetics and sexuality—specifically of Renaissance revivalism and homosexuality—in fin-de-siècle Europe. She has worked extensively on Oscar Wilde and his reception in the German-speaking world, and her article on Wilde's fascination with the Renaissance is forthcoming in *Victorian Literature and Culture*.

Ileana Marin is Associate Professor at Ovidius University of Constanta, Romania, and is currently attending the Textual Studies Program at the University of Washington in Seattle. Her work on Pre-Raphaelites includes *Beata Beatrix* (Marco Lugli), *Pictura prerafaelita sub semnul narativulvui* (Meridiane), and *Poezia si proza prerafaelitilor* (Ex Ponto). Her interest in cultural icons brought her two important research fellowships: a Fulbright Grant in 2004 and an ESSE senior scholarship in 2005.

Margueritte Murphy is Associate Professor and Chair of the English Department at Bentley College. She is author of *A Tradition of Subversion: The Prose Poem in English from Wilde to Ashbery* and coeditor (with Samir Dayal) of *Global Babel: Questions of Discourse and Communication in a Time of Globalization* (forthcoming), she has also published essays in edited collections and journals, including *Mosaic, Studies in the History and Philosophy of Science, American Poetry, Contemporary Literature, Victorian Literature and Culture*, and *Studies in Romanticism* (forthcoming). Margueritte is currently working on a study of nineteenth-century French political economy, aesthetics, and the art criticism and poetry of Baudelaire. Her current research interests include nineteenth-century consumer aesthetics, the Industrial Expositions of the July Monarchy, and everyday economic discourse in nineteenth-century France. Some of her recent presentations related to this book project include "Pure Art, Pure Desire: Changing Definitions of *l'art pour l'art*" from Kant to Gautier," "Measures of Desire: Equilibrium, Beauty, and Utility in Nineteenth-Century Aesthetics and Political Economy," and "Nostalgic for the New: Commodity Aesthetics in the Industrial Expositions of Paris, 1834–1844."

Daniel M. Shea is Assistant Professor of English at Mount Saint Mary College. His work includes the forthcoming *James Joyce and the Mythology of Modernism* and publications in *English Language Notes* and the *James Joyce Quarterly*. His research examines the political implications of the aesthetic question in the works of the modernist era, and he is presently at work on a comparative study of aestheticized politics within Walter Benjamin's theory of history and Joyce's *Ulysses*.

Charles B. Sumner is completing his dissertation, entitled Negative Hope and Anglo-American Modernism, at the University of California, Berkeley. His dissertation examines literary works that critique modern social administration by reproducing its alienating affects in the reader. In keeping with the interests of his dissertation, Charles has recently published an article that examines Wyndham Lewis's opposition to mass culture, and has given numerous conference papers that examine how modernist artworks draw a link between philosophical aesthetics and pressing sociopolitical issues.

Introduction: Reflections on the Relationship between Art and Life in Aestheticism

Kelly Comfort

> *What is behind this disgust at seeing art mixed up with life?*
> *Could it be disgust for the human sphere as such, for reality, for*
> *life?*
> *Or is it rather the opposite: respect for life and unwillingness*
> *to confuse it with art, so inferior a thing is art?*
> *But what do we mean calling art an inferior function—*
> *divine art, glory of civilization, fine fleur of culture, and so forth?*
> *As we were saying, these questions are impertinent; let us dismiss*
> *them.*
>
> —José Ortega y Gasset, *The Dehumanization of Art*

The questions that underpin this study are the same ones that José Ortega y Gasset, in his 1925 essay *The Dehumanization of Art* (*La deshumanización del arte*), deems impertinent and dismisses. The contributors to this volume strive to answer the queries Ortega y Gasset posed, but refrained from exploring: "What is behind this disgust at seeing art mixed up with life? Could it be disgust for the human sphere as such, for reality, for life? Or is it rather the opposite: respect for life and unwillingness to confuse it with art, so inferior a thing is art?" (29). The subject of how art and literature both determine and are determined by the human is at the forefront of aestheticism, although it is rarely examined in these terms. To the contrary, aestheticism is commonly seen as an attempt to separate art from life (i.e. the social, economic, scientific, pragmatic, political, national, etc.), as many authors, artists, aesthetes, and dandies have consciously elevated art to a position of supreme importance and to an autonomous sphere of its own. Yet the question as to whether art for art's sake actually seeks to de-humanize or re-humanize art, the artist, and the artistic receptor has not received comprehensive critical attention,[1] despite the coexistence of life-evading and life-sustaining attitudes present in the major literary, artistic, and philosophical works of aestheticism. *Art and Life in Aestheticism: De-Humanizing and Re-Humanizing Art, the Artist, and the Artistic Receptor* addresses the tenuous

1

and changing relationship between the aesthetic and the human in aestheticism over the last two centuries—from its origins in the early nineteenth century with figures such as Gautier and Baudelaire through to the "new aestheticism" of today[2]—in an effort to ascertain the position of art for art's sake regarding the role or place of the human.

I shall first clarify the titular terms that define this study so as to: establish what is meant by aestheticism throughout the volume; explain why an examination of aestheticism as de-humanizing or re-humanizing should involve a consideration of art, the artist, and the artistic receptor; and point out the multiple ways of approaching the concepts of de-humanization and re-humanization—both by tracing some of the key ideas on the subject from practitioners and theorists of aestheticism over the past two centuries and by outlining the varying viewpoints expressed throughout this volume.

Aestheticism—the term is linked to art for art's sake and its French equivalent *l'art pour l'art*; associated with the idea of pure art; related to the notion of autonomous art. To make sense of these multiple definitions it is helpful to follow the approach suggested by R.V. Johnson, who treats aestheticism in three different applications: (1) "as a view of art," which he calls art for art's sake; (2) "as a practical tendency in literature and the arts (and in literary and art criticism)" in which the artist does not feel "called upon to speak either for or to his age at all"; and (3) "as a view of life," which he terms "contemplative aestheticism—the idea of treating experience, 'in the spirit of art', as material for aesthetic enjoyment" (12).

Beginning with the first classification of art for art's sake as a view of art, it is important to note that the most defining characteristic is the tendency to attach an unusually high value to the form of the artwork as opposed to its subject matter. Style is what matters; it alone determines the quality of a work of art. The particular stylistic proclivities that came to be recognized as distinctly aestheticist include the use of sketches (instead of drawings), suggestion (rather than statement), sensual imagery, symbol, synesthesia, musicality, mandarin prose, aphorisms, fragments, non-linear narratives, catalogs, lists, etc. Moreover, the downplaying of the work's content led authors and artists to distance their subject matter from "real" and "everyday" life, and instead to conjure distant and exotic realms, to fashion fantastic and unreal spaces, and to take on forbidden and taboo themes.

The second categorization of aestheticism as the tendency toward artistic autonomy is best characterized by the call for complete artistic freedom—freedom from morality, from didacticism, from convention, and, as the previous paragraph suggests, from the responsibility of realistically representing reality. As Robert C. Olson accurately explains, aestheticism served as an alternative "to prevailing utilitarianism and moralism," since the aestheticist artist was protesting "against literature's being used to teach lessons, against art as political, religious, or social propaganda" (60). In contrast to the commonly accepted and long-standing view that literature (or any other art form)

is meant both to instruct and to hold a mirror up to reality, aestheticism embraces the idea that literature should lack all extraliterary purposes—be they moral or social, since its sole objectives are to be beautiful and to give pleasure. Art for art's sake consciously avoids the alternative of art for some other sake. Nevertheless, the defense of the aesthetic as an autonomous sphere without relations or obligations to the domains of utility, morality, politics, religion, etc., does not necessarily preclude the possibility that aestheticist works of art and literature critique the societal status quo and undermine its norms of gender, sexuality, or class, to name only its most salient targets. Many recent studies examine the way in which aestheticist texts: contribute to "the dissemination of dissident views" (Denisoff 2); have the "power to interrupt ideologies of sexual normativity" (Ohi xi); offer "potentially resistive implications in the arena of sexual politics (Felski 102); operate "as a central mode of engaging in and interpreting philosophy, history, and politics" (Loesberg 4); cause "moral, theological, and sexual shock" (Shrimpton 6). As this volume aims to demonstrate, aestheticism's ability to engage with, contribute to, interrupt, resist, interpret, and shock warrants further, comprehensive attention, especially in relation to its simultaneous call for autonomy and independence.

Finally, by examining aestheticism of the third kind, as a view of life instead of a view of art, we learn much about the artist's tenuous relationship with society. What Johnson calls "contemplative aestheticism"—the act of treating life in the spirit of art—is a position adopted by many nineteenth-century aesthetes and dandies (and then revisited in a variety of ways by supporters of twentieth-century movements such as formalism, camp, and deconstruction). What emerges *in art* as the self-contained and self-sufficient artwork manifests itself *in life* in the figure of the solipsistic aesthete or dandy who creates himself in a similarly conceived form of artistic expression and chooses an equally unique and independent existence. Dandies and aesthetes elevated art "to a position of supreme—or even exclusive—importance in the conduct of life" and willingly subsumed all aspects of life into the sole criterion of artistic beauty and pleasure (Johnson 12). By consecrating life to the cultivation of art, beauty, and taste above all else, the aesthete's slogan is not so much "art for art's sake" as it is "life for art's sake" or "life for the sake of beauty." Because those who adopted aestheticism as a view of life insisted on placing the aesthetic at the forefront of life, art was promoted as a quasi-religion, as an alternative to the materialist ethic of industrial–capitalist society that undermined the place of art and the artist in the changing marketplace.[3] Whereas I previously outlined the dominant artistic "styles" common in aestheticism, it is here worth mentioning the prevailing life "styles" common to the aesthete: elitism (and a critique of bourgeois culture and philistinism); orientalism (and a distaste for the common and ordinary); and, quite often, homosexuality (and a rejection of mainstream "tastes" and orientations).

Art, the artist, and the artistic receptor—these terms reflect three ways of approaching an analysis of aestheticism. The term art is used in its most expansive definition, as an all-encompassing word for any object of aesthetic production—from painting to poetry; from music to sculpture; from prose to interior design. In this regard, contributors to this volume refer to art in the same way that theorists and practitioners of art for art's sake were apt to do, since the term is not limited to one particular artistic medium. By artist we refer to the person who gives the art object its particular qualities and characteristics. The artist is the creator or producer of art. Yet in aestheticism the term artist needs to be expanded to include those aesthetes and dandies who turn their lives into works of art as well as those artistic or impressionistic critics[4] whose appreciation of art often led to the creation of new art. Nonetheless, such figures as the aesthete, dandy, and artistic or impressionistic critic should also be considered artistic receptors insofar as they represent the highly specialized and markedly attuned viewers, readers, or listeners; they are those most moved by art. More generally, however, the term artistic receptor refers to any person who receives art and who, not having created the work of art, studies, judges, and measures its effects.

De-humanization—the term can be understood as the process of eliminating the human from art's subject matter; the method of isolating art in its own autonomous sphere; the desire to free art from human utility or usefulness;[5] the act of rejecting a universal, communal, or collective experience of art; the practice of privileging repetition and emulation over improvisation and originality in artistic production or reception; the reification and self-alienation that occur as a given social fact under the capitalist mode of production. As these multiple definitions suggest, there are a variety of ways of conceiving of the term de-humanization. The fact that the contributors to this volume are not all working from a single definition does not constitute a problem or a cause for worry; rather, the diverse meanings employed throughout this study serve to demonstrate just how provocative and complex a subject we are dealing with. Because aestheticism emphasizes the formal aspects of art, promotes stylistic innovation, and demands freedom of artistic expression, it is commonly interpreted as an attempt to isolate the aesthetic from the human, to divorce art from life. As such, aestheticism has been a target of critique by those critics who find fault with its de-humanizing tendencies and see it as an amoral, asocial, and apolitical artistic tradition, as "the *inhuman* deification of 'Art'" (Coomaraswamy 42, emphasis added).

Re-humanization—this term refers to the process of reengaging with the human through the creation of, exposure to, or appreciation of art; the act of affirming a unique, subjective experience of art that promotes individual humanity; the desire to make life meaningful and livable through the sublimation of the external world into the artistic mind or the aesthetic personality; the generative practice of aesthetic reception that breathes life into art

and leads to the creation of new art; the method of reassigning meaning and reconstructing identity as a result of certain subversive and liberating readerly and writerly processes; the ability to undermine reification, commodification, consumption, and self-alienation through exposure to and engagement with specific types of art. These diverse definitions of the term re-humanization likewise reflect the complexity of the problem of determining aestheticism's position regarding the relationship between the aesthetic and the human. Whereas the phrase art for art's sake is indeed provocative for its de-humanizing potential, so too are the alternatives of "art for some other sake"—art for money's sake, art for fame's sake, art for the nation's sake, art for the sake of politics, etc. If aestheticism is a form of "pure art," then its advocates insist that art for some other sake—art with an agenda—makes art "impure" (Guérard 178). Nicholas Shrimpton explains that art for art's sake "is not a mark of triviality," since for both artists and critics "it is the guarantee of their professional and intellectual integrity" (15). Seen in this light, the long-standing tension between art and life that fuels the aestheticist doctrine as well as the general privileging of art over life comes to constitute a critique of life. It is possible, in this way, to locate an important and undeniable social function in aestheticism: aestheticist works condemn the dominant social values that make such a redefinition of art and literature necessary in the first place. Consequently, some practitioners and theorists of art for art's sake locate a re-humanizing potential in the (perhaps already de-humanized) works of the aestheticist tradition.

To better understand these dichotomous positions regarding aestheticism, let us return to the Spanish essayist Ortega y Gasset so as to examine his praise of art's de-humanizing characteristics. Ortega y Gasset highlights what are to him the most laudable features of modernist art—the de-humanization of art, the deformation of reality, the avoidance of living forms, and the triumph over human matter (14). Art undergoes a process of purification in the modern period, Ortega y Gasset argues, as it experiences "a progressive elimination of the human, all too human, elements" that were common in romantic, realist, and naturalistic production (12). This "purified" or "pure" art shares much with aestheticist works of art and literature, which also aim to expel life from the sphere of art. To distinguish this modernist art from other types of artistic production, those lamentable types that are "not art but an extract from life" (12), Ortega y Gasset constructs the following metaphor of a garden seen through a window:

> Looking at the garden we adjust our eyes in such a way that the ray of vision travels through the pane without delay and rests on the shrubs and flowers. Since we are focusing on the garden and our ray of vision is directed toward it, we do not see the window but look clear through it. The purer the glass, the less we see it. But we can also deliberately disregard

the garden and, withdrawing the ray of vision, detain it at the window. We then lose sight of the garden; what we still behold is a confused mass of color which appears pasted to the pane.

(10)

Ortega y Gasset first introduces the possibility of looking at the garden. In this instance, the function of the windowpane (the artistic form) is simply to remain transparent so that the reality of the garden (the content of the art object) may be observed. He continues by establishing a second method of viewing that maintains that we detain the garden at the window. This method requires a foregrounding technique that makes the window—the formal features of the artwork—appear, while intentionally disregarding the real-life garden behind it. Rather than promoting an art form that strives to make itself a transparent object through which one may catch a glimpse of reality, the Spanish philosopher promotes an overtly aestheticized and proudly de-humanized art form. He insists that "to see the garden and to see the windowpane are two *incompatible* operations which exclude one another because they require different adjustments" (10, emphasis added). Based on this understanding, art has two possible and mutually exclusive roles: either to represent content or to represent form; either to reveal the garden or to reveal the masses of confused colors on the windowpane. As Ortega y Gasset remarks, "life is one thing, art is another ... let us keep the two apart" (31). He notes a second incompatibility when he states that "preoccupation with the human content of the work is in principle *incompatible* with aesthetic enjoyment proper" (9–10, emphasis added). Focusing on reality precludes the receptor's enjoyment of art, and thus Ortega y Gasset prefers art that represents art as opposed to reality. In this regard, he defends the notion of art for art's sake even if he refrains from using aestheticism's most-touted slogan.

What is equally interesting, however, is the fact that for Ortega y Gasset the new modernist art—this "art for artists and not for the masses"—has a re-humanizing potential (12). Pure art divides the public into two classes— "those who understand it and those who do not" (6). These two classes correspond to what Ortega y Gasset calls "two different varieties of the human species" (6), i.e., the vulgar masses of society and the discerning minority— "a special class of men" (8), a "gifted minority" (6), the "illustrious", (7) and the "elite," who possess "an organ of comprehension denied to the other" (6). For those who appreciate and understand this new art "of a privileged aristocracy of finer senses" (6), it can trigger a "fundamental revision of man's attitude towards life" (42) by redeeming him, "saving him from the seriousness of life and restoring him to an unexpected boyishness" (50). Thus, even though Ortega y Gasset refrains from using the term re-humanization in his essay, one could convincingly argue that his praise of the de-humanization of art rests on art's ability to re-humanize the artistic receptor, who gains a new perspective through exposure to this particular type of artistic production.

Thus, in answer to his questions—"Why this desire to dehumanize? Why this disgust at living forms?"—Ortega y Gasset seems to respond: because such de-humanization has the potential to re-humanize, because the new art redefines what it means to be human (42).

Over three decades before the publication of Ortega y Gasset's landmark essay on the de-humanization of art, Oscar Wilde was already celebrating art's distance from the human in two of his most famous literary–philosophical dialogues: "The Decay of Lying" (1889) and "The Critic as Artist" (1890). In the former text, Wilde famously notes that "whenever we have returned to Life and Nature, our work has always become vulgar, common, and uninteresting" (303). Because "life is terribly deficient," Wilde explains in the latter work, the critical and cultured spirits "grow less and less interested in actual life, and [...] seek to gain their impressions almost entirely from" art (375). Rejecting mimetic art, he promotes the de-humanization of art insofar as life and nature are removed from the possible sources of art. Wilde clearly anticipates Ortega y Gasset's affirmation that "an object of art is artistic only in so far as it is not real" (10).

Yet Wilde too addresses the re-humanizing role of art for art's sake. He argues in "The Critic as Artist" that the de-humanized artwork can cultivate "a beauty-sense" (394), an "artistic temperament" (400), and a "creative instinct" (396) in the receptor as it prepares humans for the experience of "new desires and appetites" (400), a "larger vision and ... nobler moods" (400). In this regard, Wilde echoes the sentiments of Walter Pater, who in *The Renaissance* rejects the concept of universal beauty and insists that beauty is relative, that the fundamental step in aesthetic criticism becomes, in a significant twist to the famous Arnoldian dictum, knowing "one's impression as it really is" (71). One should strive to answer the questions: "What is this song or picture, this engaging personality presented in life or in a book, to *me*? What effect does it really produce on me?" (71). Pater insists that art affects life, that the aesthetic influences the human, since for him the aesthetic critic seeks to know how his "nature" is "modified" by the "presence" or "influence" of the art object, which brings about "a special, a unique, impression of pleasure" (72). Just as Ortega y Gasset notes that only a select few could be re-humanized by modernist art, because only they were capable of understanding it, so too does Pater argue that the aesthetic critic must possess "a certain kind of temperament, the power of being deeply moved by the presence of beautiful objects" (72) in order to experience "the elevation and adorning of our spirits" that art affords (91). It is "the love of things of the intellect and the imagination for their own sake" that leads to "new subjects" of poetry and "new forms" of art, and, more importantly, to "new experiences" for both the artist and the artistic receptor (Pater 76–77).

In addition to these theoretical considerations of the relationship between the aesthetic and the human, there are numerous examples in literature of artist protagonists who promote a de-humanized art form, on the one hand,

and a re-humanizing form of creation or reception, on the other hand. The most notable literary personage in this regard is Duke Jean des Esseintes, the hero of J.-K. Huysmans's *Against Nature* (*A Rebours,* 1884). Tempted by the idea "of hiding away far from human society" (23), des Esseintes decides to remove himself from "the tidal wave of Parisian life" (24) in order to fashion for himself a fresh existence in the peaceful silence of his new residence at Fontenay-aux-Roses. He is the dandy-aesthete who, like the aestheticist artwork, is removed from the sphere of life and intentionally or self-consciously de-humanized. Upon extracting himself physically from the society he loathes, des Esseintes strives to sever himself—intellectually, spiritually, aesthetically—from the age of late nineteenth-century industrial capitalism. Simply put, Huysmans's protagonist longs "to escape from the horrible realities of life [...] in the misty upper regions of art" (115). In trying to escape from life, des Esseintes surrounds himself with art, believing as he did that "anyone who dreams of the ideal, prefers illusion to reality, and calls for veils to clothe the naked truth" (29). According to des Esseintes, the time has surely come for artifice to take nature's place given that nature merely "supplies the raw materials," while it is man who "rears, shapes, paints, and carves [it] afterwards to suit his fancy" (102). In addition to his preference for the artistic over the real, des Esseintes also privileges the mental over the material, believing wholeheartedly that "the imagination could provide a more-than-adequate substitute for the vulgar reality of actual experience" (35). Owing to his contemplative power, he continually fashions something new out of his otherwise limited surroundings, while still managing to avoid contact with the external realm of life.

It is important to recognize, however, that des Esseintes's cloistered existence on the outskirts of human life is designed solely "for his own personal pleasure" (28). It is in this de-humanized setting that des Esseintes embarks on a re-humanizing mission: to become that singular individual who alone "was capable of appreciating the delicacy of a phrase, the subtlety of a painting, the quintessence of an idea, [... and] whose soul was sensitive enough to understand Mallarmé and love Verlaine" (213). In all that he does, he aspires "towards an ideal, towards an unknown universe, towards a distant beatitude" and lives for the sake of art and aesthetic pleasure (89). As a result, he both epitomizes and anticipates the re-humanized receptor or the artistic critic praised by Pater, Wilde, and Ortega y Gasset.

Just a few years after the publication of Huysmans's influential novel, a group of authors on the other side of the Atlantic embraced many tenets of aestheticism as they voiced a communal critique of the burgeoning capitalist marketplace as being responsible for the de-humanization of art and the artist figure. According to many of the leading figures of Latin American *modernismo,*[6] authors such as Manuel Gutiérrez Nájera from Mexico, Rubén Darío from Nicaragua, José Asunción Silva from Colombia, and Julián del Casal from Cuba, the act of introducing art into the public sphere and selling

it in the capitalist marketplace has the tendency to de-humanize the artist figure, whereas maintaining art in the private sphere and preventing its existence as a commodity has the potential to re-humanize the artist figure, or at least to conserve the artist's humanity. The dichotomous relationship between the de-humanized and (re-)humanized artist and between what I term "art for money's sake" and the notion of "art for art's sake"[7] is best characterized by the Cuban poet Julián del Casal, who asserts in 1890 that "modern artists" can be divided into "two large groups":

> The first is made up of those who cultivate their faculties, as the farmers do their fields, in order to speculate on their products, always selling them to the highest bidder. These are the false artists, courtiers to the masses, a breed of hypocritical merchants, whom Posterity—the new Jesus—will expel from the temple of Art with lashings. The second is composed of those who deliver their productions to the public, not in order to obtain their applause, but rather their money, so as to be able to take refuge from the miseries of existence and to preserve a bit of the wild independence that they need to live and create. Far from conforming to majority tastes, these artists try instead to make the public itself adapt to their own taste.
>
> (148)[8]

By contrasting the so-called false artists of the former category with what we might term the "true artists" of the latter group, we find interesting parallels to the notions of the de-humanized and re-humanized artist figure. This distinction is underscored throughout numerous fictional works of the Latin American *modernismo* period, most notably in Rubén Darío's short stories from the collection *Azul* (*Blue*, 1888) and in José Asunción Silva's novel *De sobremesa* (*After-Dinner Conversation*, written in 1896, published posthumously in 1925).

An entirely different set of dichotomous possibilities for aestheticism's dehumanizing or re-humanizing role is considered by Peter Bürger and Theodor Adorno in their ongoing philosophical debates on the relationship between art for art's sake and the avant-garde. It is Bürger who, in *Theory of the Avant-Garde* (*Theorie der Avantgarde*, 1974), assigns aestheticism a de-humanizing function.[9] He insists that in aestheticism art altogether detaches itself from the praxis of life in order to develop itself as purely aesthetic. Art for art's sake's "break with society," "progressive detachment [...] from real life contexts," and "correlative crystallization of a distinctive sphere of experience, i.e., the aesthetic" come to constitute the center of aestheticist works of art and literature (Bürger 33, 23). As a result of art's desire "to be nothing other than art" and to make art "the content of art," aestheticism loses its ability to make a social impact, since "social ineffectuality" and the functionlessness of the aestheticist artwork stand revealed as its essence

(Bürger 27, 49). Aestheticism interests Bürger, however, on account of its role as "the logically necessary precondition of the historical avant-garde movements" that protest and position themselves against nineteenth-century aestheticism and its call for the autonomy of art (96). Thus, the avant-garde, in contrast to aestheticism, inaugurates the reintegration of art into the praxis of life and the beginning of the self-criticism of art in bourgeois society (96). For these reasons, the avant-gardist works, in Bürger's estimation, have the ability to re-humanize the artistic receptor, whereas aestheticist works by contrast can only de-humanize given that they remain "unassociated with the praxis of men."

In contrast to Bürger, however, Adorno praises aestheticism as a socially significant art form in its own right. Adorno celebrates art for art's sake for its "opposition to society" and its position as "autonomous art" (*Aesthetic Theory* 225). Additionally, he hails aestheticism's ability to criticize society "merely by existing," since for him what "is social in art is its immanent movement against society" (*Aesthetic Theory* 225, 227). In response to what he saw as the "united front" from Brecht to the Youth Movement that existed against *l'art pour l'art*, Adorno writes in a letter dated March 18, 1936 to his colleague and friend Walter Benjamin that aestheticism is "in need of a defense" and deserves "a rescue" ("Letters" 122). He finally offers this defense of art for art's sake in his posthumously published *Aesthetic Theory* (*Ästhetische Theorie*, 1970), when he states that "Art's asociality is the determinate negation of a determinate society" (225). Here we see Adorno assign to aestheticism an important function: that of negating the social status quo and imagining alternative possibilities—not just for art, but for life as well. Because the aestheticist work of art "posit[s] something spiritual as being independent from the conditions of its material production," claims Adorno, it "keeps itself alive through its social force of resistance; unless it reifies itself, art becomes a commodity" (*Aesthetic Theory* 226). Another way he explains his position is by noting:

> Insofar as a social function can be predicated for artworks, it is their functionlessness. Through their difference from a bewitched reality, they embody negatively a position in which what is would find its rightful place, its own. Their enchantment is disenchantment. Their social essence requires a double reflection on their being-for-themselves and on their relations to society.
>
> (Adorno, *Aesthetic Theory* 227)

It should not come as a surprise to learn that Bürger rejects Adorno's praise of aestheticism's break with society and critiques the latter's "repeated attempts to vindicate it" (Bürger 34). For Bürger, art for art's sake cannot engage in the "double reflection" that Adorno assigns to it, that is, it cannot reflect on its being-for-itself without precluding all reflection on the relation

of aesthetics to society. For Adorno, however, the tension between art and life in aestheticism does not preclude the ability of *l'art pour l'art* to critique life, and thereby to have significant import and a viable social function—what many contributors to this volume label a re-humanizing function.

One convincing attempt to solve the Bürger–Adorno debate over aestheticism's social ineffectuality versus its social function comes from Jeffrey D. Todd in "Stefan George and Two Types of Aestheticism." According to Todd, aestheticism's "central tenet is that art occupies its own autonomous realm independent of other spheres of life" (127). Given the autonomy structure inherent in aestheticism, two types are conceivable: a "weak" and a "strong" aestheticism. According to Todd, "weak" aestheticism

is characterized by a reciprocal separation between spheres [...]. If an autonomous art conceives of the separation between spheres as reciprocal, that is to say, if it understands itself as being just as unable to encroach upon the domain of, say, morals as morals are to determine the content of art, its possibilities will be circumscribed by those boundaries, and consequently rather limited. In this case, the freedom from determination from other spheres won through autonomy exacts a rather high price: the separation of art from life.

(127)

By contrast, "strong" aestheticism is the term Todd designates to encompass another attitude according to which "art, while maintaining the autonomy of its own sphere, oversteps the boundaries of the other spheres, trespasses on their terrain, and proceeds to determine their content. Here art is less well behaved, less self-effacing, less observant of the boundaries between itself and the other domains" (127–128). Todd's distinction relates well to the focus of this investigation insofar as the question as to whether aestheticism de-humanizes or re-humanizes, whether it evades or sustains life, can be said to derive from the distinction between "weak" and "strong" aestheticisms.[10]

Whereas Todd offers one way to solve the critical task posed by this volume's examination of aestheticism as de-humanizing or re-humanizing, each of the twelve chapters included in this book present an additional and distinctive way of addressing the topic. Together they constitute a truly comparative endeavor in their treatment of key figures in the genealogy of aestheticism over the past two centuries and across three major linguistic traditions: from the German: Nietzsche, George, Benjamin, Adorno, and Iser; from the French: Gautier, Baudelaire, Huysmans, the surrealists, and Barthes; from the English: Rossetti, Pater, Wilde, Joyce, the American avant-gardists, and Sontag. Additional consideration of such figures as Kierkegaard (Denmark), Ortega y Gasset (Spain), and Nabokov (Russia and abroad) helps to complete the volume's transnational and comparative focus. Arranged

chronologically and divided into four sections on (I) the seminal works of nineteenth-century aestheticism, (II) turn-of-the-century aestheticism, (III) the aestheticist strand of twentieth-century literature, and (IV) aestheticism in twentieth-century theory, this volume presents a variety of perspectives on the topic of international aestheticism, from the old to the new. Moreover, by intertwining essays of three types—those that contend that aestheticism involves a process of de-humanization; those that privilege its re-humanizing efforts; and those that locate a combination of both tendencies—this volume invites readers to make sense of what appear to be mutually exclusive analyses of the subject. Through this unique approach, the editor and contributors hope to initiate new directions in aestheticism studies.

Six of the twelve contributors reject the notion that aestheticism re-humanizes art, the artist, or the artistic receptor, and point out the ways in which art for art's sake involves (at least primarily) a process of - de-humanization. In "Rossetti's Aesthetically Saturated Readings: Art's De-Humanizing Power," Ileana Marin analyzes the way in which Dante Gabriel Rossetti made reality conform to an aesthetically ideal image. She selects a series of sonnets and their corresponding paintings to show how such aesthetically oversaturated readings of the myth of beauty and love de-humanize Rossetti's world. The process of de-humanization is subtly illustrated by visual and communicational inaccessibility. Nonetheless, intricate intertextual connections, identified between Rossetti's sonnets, paintings, and other literary works, spark a process of re-humanization only at the emotional level as mythical stories embellish the private incidents of the artist and the artistic receptor, and transport them to the territory of artificial construct. In his chapter "Aesthetic Vamipirism: Pater, Wilde, and the Concept of Irony," Andrew Eastham argues that Pater's and Wilde's attempts to develop an aesthetic humanism from German idealist sources is haunted by the figure of the vampire, which is consistently associated with the concept of irony. Drawing on the treatment of the ironic condition of aesthetic subjectivity in Hegel and Kierkegaard, Eastham's essay suggests that the trope of the vampire is used by aesthetic critics to figure a de-humanizing process: the aesthetic personality aspires to imitate the ideal detachment of the autonomous artwork, but in doing so becomes undead. Although the idealist discourses of aestheticism prescribe a dialectical process—the "return of art to life"—both Pater and Wilde, Eastham argues, demonstrate how the vampiric condition of the aesthetic personality stalls this process in the ironic attempt to step outside of history. In her essay on "The De-Humanization of the Artistic Receptor: The George Circle's Rejection of Paterian Aestheticism," Yvonne Ivory focuses less on the relationship between art and life, and more on the link between the artist and society. She highlights the de-humaniza-tion of the artistic receptor that was typical of the circle around the German aesthete Stefan George. While George makes grand gestures toward the concept of individual aesthetic autonomy, Ivory notes, his keenness on the

prophet/disciple model of aesthetic education reifies and thus de-humanizes the aesthetic experience of those around him. Ivory argues that this is precisely the mode of aesthetic reception criticized by Pater in his famous—and, she argues, re-humanizing—"Conclusion." She thus points to a notion of de-humanizing aestheticism that is based not on the usual principle that *l'art pour l'art* separates life from art, but rather on the principle that emulation or reification in the realm of artistic reception empties aesthetic experience of its human element. Daniel M. Shea explains, in "From 'God of the Creation' to 'Hangman God': Joyce's Reassessment of Aestheticism," that although Joyce early sympathized with the aims of *l'art pour l'art*, the limitations of aestheticism as a mode capable of depicting Ireland quickly led to an outright rejection of its de-humanizing effects made clear by the Great War. Shea's essay argues that the shift in controlling theological metaphors, from the "God of the Creation" in *A Portrait of the Artist as a Young Man* to the "hangman god" of *Ulysses*, is Joyce's recognition that this supposed autonomy of art participates in hegemonic political discourses, what Walter Benjamin referred to as the "aestheticization of politics." The aesthete Buck Mulligan's impotent parodic presence and, more ominously, his subservient relationship to the Englishman Haines serve to highlight the fact that the problems created by imperialism and bourgeois economics are ignored in favor of an aesthetic concerned with the contemplation of beauty. Aestheticism de-humanizes art, Shea concludes, due to its unwillingness to portray life as experienced in colonized Ireland, symbolized in the "hangman god," the "lord of things as they are." In "On the Cold War, American Aestheticism, the Nabokov Problem—and Me," Gene H. Bell-Villada locates a resurgence of aestheticism in the United States during the Cold-War period, which was characterized by a wholesale purge of the American left in entertainment and education, a staunch rejection of Soviet-style socialist–realist and "social" conceptions of art, and the triumph of New Criticism's antihistorical formalism. This post-war aestheticist "turn" in the United States is both embodied and embraced by Nabokov, the stylistic perfectionist whose art assumes no critical function and for whom issues of morality are replaced by the exclusive concern with form. Bell-Villada insists that the Russian émigré's most famous novel, *Lolita*, stands for de-humanization at its utmost, in Ortega y Gasset's sense of the word, since to deal with the book in terms of pedophilia, child molestation, or statutory rape would be to violate the novel's implicit aestheticist universe. It is in the interviews and the prefaces, moreover, that Nabokov states his aestheticist and de-humanizing position ever more baldly as he critiques numerous authors and theorists for whom "human interest" is even of the slightest concern, and insists repeatedly that a work of art should have "no importance whatever for society" (33). Bell-Villada nonetheless admits to being a lapsed Nabokovophile, and comments on the powerful—dare I say re-humanizing—effect Nabokov's prose style made on him during his days

as a student. Yet, the presence of what he terms "the other Nabokov," namely the Nabokov of the prefaces and especially of the interviews in *Strong Opinions*, led to his disillusionment. Simply put, Nabokov the public figure cannot re-humanize the reader in the same way as Nabokov the artist might perhaps be able to do. Finally, Charles Sumner begins his chapter— "Beauty Be Damned: Or Why Adorno Valorizes Carrion, Stench, and Putrefaction"—by rejecting any critical potential central to the notion of aestheticism. For him, art for art's sake, both of Kantian disinterestedness and fin de siècle decadence, has no bearing on the question of humanity, namely because the aestheticist artwork is completely abstracted from, and thus cannot mediate, the instrumental mechanism of enlightenment humanism. Mere abstraction may signal protest, but it cannot facilitate critique, Sumner insists. Instead, by analyzing Adorno's theory of the relationship between art and society, Sumner argues for the moral value of ugliness as an aesthetic category. Specifically, he focuses on Adorno's belief that the motifs of carrion, stench, and putrefaction, when mediated by formal dissonance, can enliven critical consciousness and thereby prepare the possibility for changes in reality. This process, he contends, is a form of re-humanization in which art plays a definite role. Thus, in contrast to aestheticism's de-humanization, there are other, distinct ways for art and literature to serve re-humanizing roles.

The remaining six chapters in this book assert either that aestheticism involves the combination of de-humanizing and re-humanizing aims, of life-evading and life-sustaining strategies, or that art for art's sake adopts a re-humanizing agenda. These essays challenge widespread and persistent interpretations of art for art's sake as having little or nothing to do with life and contest the apparent severance between the aesthetic and the human in aestheticism, which has so long been considered to constitute one of its central characteristics. In "The Critic as Cosmopolite: Baudelaire's International Sensibility and the Transformation of Viewer Subjectivity," Margueritte Murphy considers Charles Baudelaire's aesthetic of the "bizarre" as an answer to de-humanizing academic or neoclassical notions of ideal beauty. Baudelaire proposes this aesthetic in his first essay on the Universal Exposition of 1855, an event which gave him rich, visual evidence of the relativity of beauty through exposure to art and artifacts from around the world. Murphy argues that the "bizarre" for Baudelaire does not represent a distancing from common experience, but rather becomes a means for the spectator to perceive varied beauties and to undergo a fuller sensorial and imaginative experience. In Baudelaire's "cosmopolitan" aesthetic, the object transforms the subject or spectator by conjuring ideas and provoking daydreaming in an utterly subjective process, and yet this process is the means to understanding more profoundly foreign art and its social and cultural context. Murphy thus concludes that Baudelaire's efforts to forge a new aesthetic, one that combines sensual *and* spiritual art, have the goal of

re-humanizing the aesthetic receptor. Paul Fox, in "Dickens À La Carte: Aesthetic Victualism and the Invigoration of the Artist in Huysmans's *Against Nature*," examines the particularity of the aesthete and his artistic task: to be impressed by the world in a vitalistic manner and through his own personality. In examining the appetites of Joris-Karl Huysmans's archdecadent des Esseintes, Fox demonstrates that, for the aesthete, every experience was to be inflected by, and refined to accommodate, the artist's personal tastes. The project of des Esseintes, Fox maintains, is not an either/or situation where one's options are reduced to living in the world, or as a lonely solipsist. For des Esseintes, life is one of the two necessary ingredients for aesthetic experience, the other being his own artistic temperament. Kael Ashbaugh's study on "Art for the Body's Sake: Nietzsche's Physical Aestheticism" focuses on the transvaluation of the value of art that occurs in Nietzsche's physical aestheticism. At first glance, Nietzsche's aes-theticism, Ashbaugh admits, seems to de-humanize art in order to establish a primal, physical element of human experience. Ashbaugh shows, however, that by progressively revaluing the human in physical terms and reclaiming the sensuousness of art, Nietzsche's transvaluation re-humanizes art for the body. He subverts a metaphysical approach to art for art's sake, and refuses to treat art as an out-of-body experience; on the contrary, Nietzsche ties art more closely to the physical world and gives aesthetic experience a bodily dimension. This promotion of art for the body's sake serves to undermine the common misconception that the primacy of art in aestheticism is at the expense of life. Robert Archambeau argues in "The Aesthetic Anxiety: Avant-Garde Poetics, Autonomous Aesthetics, and the Idea of Politics" that several generations of avant-garde poets have tried, with imperfect success, to re-humanize aestheticism. Noting that many of the aesthetes and decadents of the 1890s were haunted by the sense that art for art's sake was inherently limited, Archambeau demonstrates how these anxieties continued to res-onate throughout the twentieth century. Both the surrealists of the 1920s and the Language Poets of the 1970s wished to maintain the freedoms of an autonomous aesthetic while seeking the kind of social and political utility traditionally associated with heteronomous art (art in the service of institu-tions or movements other than art itself). Both groups' projects for the re-humanization of an autonomous aesthetic founder on their inherent contradictions, Archambeau concludes. In "'This temptation to be undone ...' Sontag, Barthes, and the Uses of Style," Sarah Garland points to what I would term an initial de-humanizing stage in the thought of Sontag and Barthes insofar as an instance of "aesthetic dissolution" causes the reader or writer of a text to have the experience of value being emptied out, content voided, consciousness undone, and nature undermined. Yet this leads to an important disassociation of the human with the natural, and allows Sontag and Barthes to promote a second stage of re-humanization in which meaning is reassigned and identity recomposed. In this way, "aesthetic dissolution"

is subversive and liberating. It allows one to shift power and value away from the already legitimate, to remove inherent and natural authority, to de-center the self, and, ultimately for Sontag and Barthes, to assert a queer subject position in a defiant display of self-construction and a vital act of self-definition. These contemporary representatives of aestheticism call for the re-humanization of life (or of the readerly and writerly self) through art, and they do so by connecting the human to construction, creation, and change, as opposed to linking it to the assigned, natural, and fixed. For Garland, Sontag and Barthes locate in the reading and writing processes a path toward an active, constructivist approach to life. Lastly, Ben De Bruyn discusses the varying conceptions of the "aesthetic existence" espoused by Kierkegaard, Pater, and Iser. In his chapter "Art for Heart's Sake: The Aesthetic Existences of Kierkegaard, Pater, and Iser," De Bruyn demonstrates how each author renounces the "aesthetic existence" as de-humanizing, yet returns to it in his articulation of a re-humanizing alternative, since the properly ethical and human life is also conceived in artistic terms. Each in his own way, then, Kierkegaard, Pater, and Iser do not propagate an uncommitted "art for art's sake," but rather an "art for heart's sake" insofar as they aim to re-humanize their audience by defending one conception of the artistic life (seen as re-humanizing), but also by rejecting another conception of it (seen as de-humanizing).

Art and Life in Aestheticism: De-Humanizing and Re-Humanizing Art, the Artist, and the Artistic Receptor addresses the question of the relationship in aestheticism between the aesthetic and the human realms, between art and life, over the past two hundred years. The chronological and transnational scope permits a varied and significant reexamination of the concept of aestheticism that considers the potential social import of literary and artistic creations that purportedly exists for their own sake. Drawing on and expanding the concept of de-humanization put forth by Ortega y Gasset, this volume seeks to determine whether or not de-humanization leads to re-humanization, to a reconsidered and deepened relationship between the aesthetic sphere and the world at large, or more modestly, between the artistic receptor and his or her human existence. The challenge posed by this volume, then, is to search for a corresponding process of re-humanization to match, counter, or accompany aestheticism's de-humanizing impulse. Although not all contributors agree that such re-humanization occurs, the collected essays in this book share the common mission of rethinking and reformulating the underpinnings of the aestheticism movement.

Notes

1. According to Nicholas Shrimpton, most of the recent considerations of aestheticism employ one of three methodological approaches: "cultural materialist, gender-based and deconstructive criticisms" (7). Indeed, the overwhelming majority of studies on

aestheticism published in this millennium have focused on how issues of gender and sexuality intersect with art for art's sake, e.g. *Women Poets and Urban Aestheticism: Passengers of Modernity* (Perejo Vadillo, 2005), *Aestheticism and Sexual Parody, 1840–1940* (Denisoff, 2001), and *Forgotten Female Aesthetes: Literary Cultures in Late-Victorian England* (Schaffer, 2000). Going back to the 1990s, we discover two important studies of the history of art for art's sake. Leon Chai's *Aestheticism: The Religion of Art in Post-Romantic Literature* (1990) and Gene H. Bell-Villada's *Art for Art's Sake and Literary Life: How Politics and Markets Helped Shape the Ideology and Culture of Aestheticism, 1790–1990* (1996) mark a significant revival of scholarly interest in the movement and inaugurate new directions in aestheticism studies. Chai locates a central desire in art for art's sake to "redefine the relation of art to life, to impart to life itself the form of a work of art and thereby raise it to a higher level of existence" (ix). Bell-Villada asserts that "there are concrete social, economic, political, and cultural reasons for the emergence, growth, diffusion, and triumph of *l'art pour l'art* over the past two centuries" (11). The former book looks at art's influence on life, whereas the latter text explores life's impact on art. Chai explains why aestheticism is central to our understanding of the modern condition, whereas Bell-Villada elucidates why the modern condition is central to our understanding of aestheticism. By contrast, the present volume combines both lines of investigation in a study that takes up these varying possibilities and puts them in dialogue with each other.

2. Mapping out the genealogy of aestheticism over the past two centuries is a challenging and formidable task, one that many of this volume's contributors take up in the initial pages of their essays. To avoid duplication of those efforts as well as the tedious task of tracing aestheticism's every twist and turn, I would like instead to refer to Bell-Villada's lengthy sketch of the movement's dizzying evolution, which he traces backwards from Oscar Wilde to Kant and Shaftesbury:

> [Wilde's] aphorisms are actually a distillation and ideed a simplification of some arguments learned from his high Oxford mentors, John Ruskin and Walter Pater, while his general vision is an outlook consciously akin to that of French Romantic and Symbolist poets such as Gautier and Baudelaire. Baudelaire for his part had learned a few lessons from Poe, who had misread Coleridge, whereas Gautier early on had set forth a much-simplified if memorable version of a theory taught by some Parisian professors, notably Victor Cousin.
>
> Meanwhile, Cousin's lectures take their initial cue from the weighty treatises of a remote, recondite thinker named Immanuel Kant; and Kant's magisterial aesthetic arguments in the *Critique of Judgment*, in turn, stem ultimately from the rapt institutionalism of the Third Earl of Shaftesbury.
>
> (1–2)

For an assessment of the movement's post-Wildean evolution, it is helpful to consider the stages of "intermediate" and "new" aestheticism discussed by Shrimpton. Intermediate aestheticism refers to "the critical formalism practised and recommended by British and American 'New Critics' in the mid-twentieth century," which—given the emphasis on the text as an autotelic artifact, complete within itself, valued for its formal and technical properties, and written for its own sake— would be "sternly repudiated by the linguistic and ideological turn of the 1970s and 80s" (Shrimpton 2). "New Aestheticism" refers to the resurgence in the 1990s of concepts associated with the creed of art for art's sake in modern critical practices such as deconstruction (Shrimpton 8). In *Aestheticism and Deconstruction: Pater,*

Derrida, and De Man, Jonathan Loesberg locates a common goal of "reformism and resistance to institutional structures of power" in the aestheticism of Pater and the deconstruction of Derrida and de Man (9).

3. See Bell-Villada for an examination of various aspects of the relationship between art for art's sake and the nineteenth-century marketplace. To sum up briefly his position, Bell-Villada contends that *"l'art pour l'art* was the position adopted by certain authors whose specific mode of discourse and personal rhythms of production conflicted with demands of the newly industrialized literary market" (50). The economic motive of producing as much as could be sold—so as to satisfy the reading demands of the growing middle classes and also to pay for the technical machinery that made increased production possible in the first place—meant that art forms that could not sell to mass audiences lost their privileged place in a cultural sphere determined by market rules of output and genre. The carefully and slowly crafted verse of many aestheticist practitioners simply lacked function in the mass print culture of the bourgeois marketplace.

4. The notion of the artistic or impressionistic critic is most notably established first by Pater and subsequently by Wilde. In "The Critic as Artist," Wilde builds on Pater's concept when his protagonist, Gilbert, explains that for the highest critic, "the work of art is simply a suggestion for a new work of his own, that need not necessarily bear any obvious resemblance to the thing it criticizes" (388). The artist's creation, Gilbert insists, "may be merely of value in so far as it gives to the critic a suggestion for some new mood of thought and feeling which he can realize with equal, or perhaps greater, distinction of form, and, through the use of a fresh medium of expression, make differently beautiful and more perfect" (388). Wilde's mouthpiece thus celebrates being further removed from the real: criticism treats neither Life nor Nature, nor an imitation thereof, but rather an artistic creation already detached from the social realm and isolated in the aesthetic sphere. The end product becomes art based on art—not life, and it is thus more creative than (the original) creation.

5. Amanda K. Coomaraswamy begins her article "Art for Art's Sake" with the following statement: "Some have answered the question 'What is the use of art?' by saying that art is for art's sake, and it is rather odd that those who thus maintain that art has no *human use* should have emphasized the *value* of art" (39, emphasis added). With these introductory remarks, Coomaraswamy locates a certain oddity inherent in aestheticism: if art for art's sake maintains that art has no "human use," we must wonder whether its problem is primarily with the notion of the human or with the concept of use? If art still has "value," what kind of value is it, since it is clearly not use-value, and, one would assume, even less exchange-value?

6. Although this is not the place to elaborate on the numerous connections between Latin American *modernismo* and nineteenth-century European aestheticism, it is worth mentioning Bell-Villada's accurate claim that *modernismo* "represents the arrival and implanting of the theory of Art for Art's Sake in Latin American literary life," since "[v]irtually all *modernista* adepts [...] consciously advocated a 'pure' verse in which beauty was the sole relevant factor, to the exclusion of all moral, civic, or social content" (107). Beginning as early as 1882 with the publication of José Martí's *Ismaelillo* and extending until approximately 1920 when the avant-garde period replaces it, Latin American *modernismo* can be characterized by the following "articles of faith":

(a) a preoccupation with the marginalized status of the writer and his or her fall from legislator to "non producer" [...]; (b) disdain for the acquisitiveness of the

philistine classes and all that was admired by bourgeois values [...]; (c) art as a new source of faith; (d) language as incantatory, orphic, and the means to transgressing, transcending, and creating a "double" of the universe; (e) formal refinement and innovation; (f) an aspiration toward beauty [...]; (g) a cultivation of the vague and suggestive over the concrete [...]; and (h) the awareness of Latin America as a presence emerging from exotic "Other" to exploited source of resources and victim of the foreign policies and cultural hegemony of colonial aggressors.

(Washbourne 8–9)

Although *l'art pour l'art* is not explicitly mentioned in this extensive outline of Latin American *modernismo's* dominant features, the intersections between these literary and artistic movements are most obvious with regard to letters c, d, e, f, and g above, which correspond to the sacralization of art, the power of language, the emphasis on form, the quest for beauty, and the non-representational status of art, respectively. What is distinctive or exaggerated in the Latin American context has to do with letters a, b, and h in Washbourne's detailed list. The marginalized status of the writer and the critique of bourgeois values become exacerbated as a result of the ways in which an expanding market economy fueled by powerful Western European nations exploits a budding yet peripheral Spanish American continent in the latter part of the nineteenth century. Thus, while the leading figures of Latin American *modernismo* share an emphasis on form, style, poetic innovation, the musicality of language, and the renovation and expansion of the linguistic and content material constituting their art—an emphasis likewise shared by practitioners of aestheticism on the other side of the Atlantic—they also share a continual and communal lamentation regarding the precarious situation of the Latin American artist at the turn of the nineteenth century.

7. I use the phrase "art for money's sake" to refer to art, or literature, that either (1) designates money-making is the highest, most transcendent aim or (2) accommodates itself to the changes brought about by the emergence of the Latin American literary marketplace (in contrast to "art for art's sake," which can be said to work against or in spite of such changes). My current book project explores the tension between art for art's sake and art for money's sake in turn-of-the-century European and Latin American literature.

8. I thank Gene H. Bell-Villada for his assistance with the translation of this passage.

9. Although Adorno's views on aestheticism predate those of Bürger, I find it useful to discuss Bürger's ideas about aestheticism's de-humanization before addressing Adorno's assessment of art for art's sake's re-humanization so as to continue a structural pattern and organization that contrasts one initial notion of de-humanization with a subsequent concept of re-humanization.

10. A similar distinction is made by Julia Prewitt Brown, who notes how Wilde's theory of reception "becomes entangled with the 'main contradiction' of aestheticism— that is, the paradoxical separation yet interdependence of art and life" (72). The difference between Brown and Todd is that the latter goes a step further by undoing this "contradiction." According to Todd's categorization, "weak" aestheticism involves "separation" and "strong" aestheticism involves not so much the "interdependence of art and life," but rather the supremacy of art over life. This idea is echoed by Aatos Ojala, who, in her *Aestheticism and Oscar Wilde*, makes an important distinction between aestheticism as that which "remains only an

intellectual attitude, revealing itself only in the sphere of art but not in that of life" and an aesthetic movement which goes even further by claiming "the hegemony of art over life" (13–14).

Works Cited

Adorno, Theodor. *Aesthetic Theory*. Trans. Robert Hullot-Kentor. Eds. Gretel Adorno and Rolf Tiedemann. *Theory and History of Literature 88*. Minneapolis: University of Minnesota Press, 1997.

———. "Letters to Walter Benjamin." *Aesthetics and Politics*. Trans. Ronald Taylor. Norfolk: Lowe and Brydone, 1977. 100–141.

Bell-Villada, Gene H. *Art for Art's Sake and Literary Life: How Politics and Markets Helped Shape the Ideology and Culture of Aestheticism, 1790–1990*. Lincoln: University of Nebraska Press, 1996.

Brown, Julia Prewitt. *Cosmopolitan Criticism: Oscar Wilde's Philosophy of Art*. Charlottesville, VA: University of Virginia Press, 1997.

Bürger, Peter. *Theory of the Avant-Garde*. Trans. Michael Shaw. *Theory and History of Literature 4*. Minneapolis: University of Minnesota Press, 1984.

Casal, Julián del. *Crónicas habaneras*. Las Villas, Universidad Central de Las Villas, 1963.

Chai, Leon. *Aestheticism: The Religion of Art in Post-Romantic Literature*. New York: Columbia University Press, 1990.

Coomaraswamy, Amanda K. "Art for Art's Sake." *Catholic Art Quarterly*. 20 (1957): 39–43.

Denisoff, Dennis. *Aestheticism and Sexual Parody, 1840–1940*. Cambridge: Cambridge University Press, 2001.

Felski, Rita. *The Gender of Modernity*. Cambridge, MA: Harvard University Press, 1995.

Guérard, Albert. "Art for Art's Sake." *Southwest Review*. 28 (1953): 173–84.

Huysmans, J.-K. *Against Nature*. Trans. Robert Baldick. New York: Penguin, 1959.

Johnson, R. V. *Aestheticism*. London: Methuen, 1969.

Loesberg, Jonathan. *Aestheticism and Deconstruction: Pater, Derrida, and De Man*. Princeton: Princeton University Press, 1991.

Nabokov, Vladimir. *Strong Opinions*. New York: McGraw-Hill, 1973.

Ohi, Kevin. *Innocence and Rapture: The Erotic Child in Pater, Wilde, James, and Nabokov*. New York: Palgrave Macmillan; 2005.

Ojala, Aatos. *Aestheticism and Oscar Wilde*. Folcroft, PA: Folcroft Library, 1971.

Olson, Robert C. "A Defense of Art for Art's Sake." *Lamar Journal of the Humanities*. 4:1 (1978) 59–64.

Ortega y Gasset, José. *The Dehumanization of Art and Other Essays on Art, Culture,and Literature*. Trans. Helene Weyl. Princeton, NJ: Princeton University Press, 1968.

Pater, Walter. *Walter Pater: Three Major Texts (The Renaissance, Appreciations, and Imaginary Portraits)*. Ed. William E. Buckler. New York: New York University Press, 1986.

Perejo Vadillo, Ana. *Women Poets and Urban Aestheticism: Passengers of Modernity*. Basingstoke, England: Palgrave Macmillan, 2005.

Schaffer, Talia, and Psomiades, Kathy Alexis. "Introduction." *Women and British Aestheticism*. Ed. Talia Schaffer and Kathy Alexis Psomiades. Charlottesville: University Press of Virginia, 1999. 1–22.

Shrimpton, Nicholas. "The Old Aestheticism and the New." *Literature Compass*. 2:1 (2005): 1–16.

Todd, Jeffrey D. "Stefan George and Two Types of Aestheticism." *A Companion to the Works of Stefan George*. Ed. Jens Rieckmann. Rochester, NY: Camden House, 2005. 127–143.

Washbourne, Kelly. "An Art Both Nervous and New." Introduction. *After-Dinner Conversation: The Diary of a Decadent.* By José Asunción Silva. Ed. and trans. Washbourne. Austin: University of Texas Press, 2005. 1–48.

Wilde, Oscar. "The Critic as Artist." *The Artist as Critic: Critical Writings of Oscar Wilde.* Ed. Richard Ellmann. Chicago: University of Chicago Press, 1982. 341–408.

———. "The Decay of Lying." *The Artist as Critic: Critical Writings of Oscar Wilde.* Ed. Richard Ellmann. Chicago: University of Chicago Press, 1982. 290–320.

Part I Reevaluating the Seminal Works of Nineteenth-Century Aestheticism

1

The Critic as Cosmopolite: Baudelaire's International Sensibility and the Transformation of Viewer Subjectivity

Margueritte Murphy

In a note to the Garnier edition of *Aesthetic Curiosities, Romantic Art* (*Curiosités esthétiques L'Art romantique*), the editor, Henri Lemaitre, describes the section of Charles Baudelaire's *Universal Exposition – 1855 – Fine Arts* (*Exposition universelle – 1855 – Beaux-arts*), in which Baudelaire outlines his new aesthetic of "the strange" (*l'insolite*), as "one of the most important of all modern aesthetic literature, because it ushers in that great revolution that will replace, with an aesthetic of the *strange*, the neoclassical aesthetic of *ideal beauty*" (212). Baudelaire's interest in replacing the neoclassical ideal of beauty, an "absolute" ideal in his words, with a "relative" one predates this essay, appearing as early as 1846 in "On the Heroism of Modern Life" ("De l'Héroïsme de la vie moderne") of his famous *Salon*. But the appearance of this formulation of a new aesthetic owes something to the occasion for writing: his coverage of the Universal Exposition of 1855, the first international exposition in France. It was also the first whose official rationale included the measurement and stimulation of "progress" in the fine arts through a system of display categories and awards adapted from expositions of products of industry. France, by devoting an entire hall to the fine arts, would mount a "universal" exposition of art, parallel to the industrial exposition, an improvement on Great Britain's Crystal Palace of 1851, in French eyes (Mainardi 42). Works from twenty-eight countries were exhibited, and so the challenge to the many critics who covered the fine arts exhibition was to find a critical framework that would offer a single vantage point. The officially sanctioned approach was the eclecticism of Victor Cousin, both as an overarching approach to art generally and as the distinctive feature of French art.[1] The eclectic critic strove to appreciate the best qualities of competing schools, hitherto considered irreconcilable, and so France's aesthetic wars, between the camps of Ingres and Delacroix, for instance, were turned into evidence of the wealth and breadth of French creativity. Hence, as Théophile Gautier argued in *The Universal Monitor* (*Le Moniteur Universel*), the official government newspaper, French art was "universal" by being "eclectic," and thus superior to the art of other nations (Mainardi 69–70).

Baudelaire, in his *Salon of 1846*, vehemently criticized both the eclectic and the nationalistic in art.[2] And so his review of the Universal Exposition takes a different course from that of mainstream criticism as he theorizes "universal" beauty. Stimulated by exposure to art and artifacts from around the world, Baudelaire interprets the "universal" as the "cosmopolitan"[3] and thereby expands and refines his notion of relative beauty. In a way, he is able to counter the presumption of universality in the neoclassical Platonist aesthetic[4] with a redefinition of the universal as cosmopolitan. How he articulates this new aesthetic not only sets his coverage apart from the run-of-the-mill nationalism and ethnic stereotyping of other critics, but also looks forward to the redefinition of beauty that is key to the aesthetic of modernity of *The Painter of Modern Life* (*Le peintre de la vie moderne*). Further, this turn is evidence of Baudelaire's desire to articulate and advocate for an aesthetic, and even an aestheticism, that was fully human, that is, one that engages fully the human sensorium—through "[t]he exercise of the five senses" (*Salon de 1846* in *Complete Works* [*Œuvres complètes*] 2: 415)—and that encompassed cultural experience far beyond France's borders.

Baudelaire begins his review[5] by acknowledging that what is essentially the program of the Universal Exposition—the comparison of nations and their products—generates "surprise" and "revelations" for the critic: "There can be few occupations so interesting, so attractive, so full of surprises and revelations for a critic, a dreamer whose mind is given to generalization as well as to the study of details—or, to put it even better, to the idea of an universal order and hierarchy—as a comparison of the nations and their respective products" (121).[6]

Although Baudelaire's subject is the fine arts, he uses "products" (*produits*) here ambiguously: they could be works of art or the products of industry or both. Indeed, his repeated use of the word "products" in this essay signifies the degree to which he is reacting to the entire exposition of art and industry. Later he refers to "the various workrooms of our artistic factory," suggesting an equivalence between the studio and the factory (123–4). But "products" also suggests fruits of the earth, the results of natural processes (a meaning already overdetermined in the discourse of political economy in modeling industrial production on the historically more prestigious agricultural production). Official decrees ordering the exposition, while at times referring to "works of art" (*les œuvres d'art*), also include this tripartite classification, "the products of agriculture, industry, and art" (*Rapports*, xi). Thus the idiom of the entire exposition, of art and industry, inflects this art criticism with an emphasis on the similarities between art and industry rather than the distinctions, which contrasts what a strong advocate of *l'art pour l'art* would insist upon.[7] Since the products of industry on display included objects representing the applied arts—metalwork, porcelain, furniture, and other luxury goods—Baudelaire's use of this broader category may be motivated by his interest in objects that did not fit in the category of "fine arts."

His enthusiastic language of "surprises" and "revelations" also gives a sense of his experience as a spectator and of what he values in the viewing experience, the "shock" that will become part of his modern aesthetic.[8] That he speaks of a critic who is a "dreamer," specifically one prone to dream of a universal order and harmony, would seem to prepare the way for a grand utopian scheme, yet this passage is a setup for a disavowal of any such aim, citing his own failures at creating enduring systems in the past and the inevitability of some surprise or unexpected disruption to the system: "But always some spontaneous, unexpected product of universal vitality would come to give the lie to my childish and superannuated wisdom—that lamentable child of Utopia! It was no good shifting or stretching my criterion—it always lagged behind universal man, and never stopped chasing after multiform and multi-coloured Beauty as it moved in the infinite spirals of life" (123). Thus Baudelaire will not stipulate the hierarchy of this universal order.[9] He also resists the common analytic ploy of using differences among nations to erect a more earth-bound hierarchy intended to "assert the supremacy of any one nation over another" (121). As we will see, behind such resistance is the questioning of common notions of the "civilized" and the "barbarous." His stress on "vitality" is also key, since the assault on the neoclassical ideal stems in part from his sense that it neglects the full sensorial experience that art provides and the "life" of art as a living organism.

Indeed, in this essay, he takes direct aim at contemporary neoclassicists and the inadequacy of the aesthetic of absolute beauty to account for the beauties on display:

Let him [the reader] imagine a modern Winckelmann (we are full of them; the nation overflows with them; they are the idols of the lazy). What would *he* say, if faced with a product of China—something weird, strange, distorted in form, intense in color and sometimes delicate to the point of evanescence? And yet such a thing is a specimen of universal beauty; but in order for it to be understood, it is necessary for the critic, for the spectator, to work a transformation in himself which partakes of the nature of a mystery—it is necessary for him, by means of a phenomenon of the will acting upon the imagination, to learn of himself to participate in the surroundings which have given birth to this singular flowering. Few men have the divine grace of cosmopolitanism in its entirety; but all can acquire it in different degrees. The best endowed in this respect are those solitary wanderers who have lived for years in the heart of forests, in the midst of illimitable prairies, with no other companion but their gun—contemplating, dissecting, writing. No scholastic veil, no university paradox, no academic utopia has intervened between them and the complex truth. They know the admirable, eternal and inevitable relationship between form and function. Such people do not criticize; they contemplate, they study.

(121–2)

Of the thirty art critics who covered the Universal Exposition, only Baudelaire and Gautier mentioned Chinese art, and Gautier distinguished between the Greek "ideal beauty" and Chinese "ideal ugliness,"[10] making Baudelaire the only critic to discern beauty in the Chinese works. The Chinese object is, moreover, a "specimen of universal beauty" in Baudelaire's eyes, and as he emphasizes elsewhere in the essay, such beauty is not uniform, but "multiform" (123). For Baudelaire the truly cosmopolitan critic would see freshly—"contemplate," "study"—and avoid judging works according to preexisting academic systems that blind the critic to their "complex truth," including the functionality of the object's form. In other words, in a move away from a doctrine of formal autonomy, Baudelaire represents the relationship between form and function as part of the object's aesthetic impact, a perception of the embeddedness of the object within its original cultural context and the contribution of that embedding to the object's beauty.

Before discussing in detail the transformative critical process that Baudelaire here theorizes, I will turn briefly to Gautier's longer article on Chinese art, for the difference between Gautier's appraisal of this collection and Baudelaire's emerging cosmopolitan aesthetic is instructive. Although Baudelaire in a later essay will praise his wit as "cosmopolitan,"[11] Gautier's approach to the Chinese collection falls short of what Baudelaire calls for here in a "cosmopolitan" critic. The difference between their approaches to the Chinese collection helps us see what is novel about Baudelaire's "bizarre" or "*insolite*"—how these terms anchor a cosmopolitan criticism that diverges even in its basic assumptions about the nature of the aesthetic experience from that practiced by the older poet and critic whom Baudelaire so admired.

Gautier's article first appeared in *L'Artiste*, entitled "Chinese Art" ("L'Art chinois"), in the October 7, 1855, issue, and was reprinted in Gautier's 1857 collection of his reviews of the Universal Exposition of 1855, *The Fine Arts in Europe* (*Les Beaux-Arts en Europe*), published by Michel Lévy Frères as "The Chinese Collection" ("Collection chinoise"). This minor change of title may well be significant, for Gautier's tone is derisive when he speaks of Chinese art while he greatly admires Chinese objects—the porcelain, furniture, and other luxury goods that are ordinarily found on the "industrial" side of the exposition. He begins his article with the usual tired stereotypes of the Chinese as an ancient but "immobile" people who "have invented everything and perfected nothing; they understood the compass, gunpowder, printing, gas, long before the rest of the world had any idea of these precious discoveries" (130). Such a remark owes something to the general temper of exposition coverage, since the exposition is meant to measure and compare "progress," and so the relevance of technology and inventions that were not exploited, symptoms, perhaps, of the immobility that he deems a national trait. In describing the Chinese "genius," Gautier

employs some of the same vocabulary as Baudelaire, but the inflection is entirely different:

> They have a bizarre, eccentric and patient genius, unlike that of any other people, and which instead of opening like a flower, writhes like a mandrake root. Lacking interest in serious beauty, they excel in curiosities; while they have nothing to send to museums, they can fill all the bric-a-brac shops with baroque and deformed creations of the most whimsical sort. You have no doubt seen this dwarf of the River of Pearls enclosed in a porcelain vase so that his growth is curiously stunted; this is the most apt image of the Chinese genius.
>
> (131)

Thus, for Gautier, the "bizarre" implies deformity, stunted growth, and the production of shop goods, not art. He contrasts their aesthetic vision directly with that of classical Greece: "Other nations, beginning with the Greeks, who attained it, seek ideal beauty; the Chinese seek ideal ugliness; they think that art should be as distant as possible from nature, that it is useless to represent, since the original and the copy do the same thing" (131–2). Gautier's move here is revealing: ideal beauty is ultimately representational, legitimized by the doctrine of mimesis, and thus a more "natural" flowering, while the Chinese pursue an antimimetic aesthetic, symptomatic of a "deformed" genius that produces "curiosities." This aspect of Gautier's aesthetic philosophy seems more classical than romantic, but more important to our investigation of the "bizarre" are his underlying assumptions. He assumes here a close relationship between nature and beauty and the universal recognition of this relationship. For him Chinese art and artifacts reflect a particular "genius" but not a different way of viewing nature. Rather, it is a "genius" that subverts or distorts the relationship between art and nature and thus produces deformed and stunted products. He mocks Chinese painting in terms of both composition—"to put in the same frame objects that perspective separates"—and use of color—"A sky-blue tiger, an apple-green lion, are much more singular than if they were simply painted in their natural hues." He concludes that "the ugly is infinite and its monstrous combinations offer to fancy unlimited possibilities" (132). Of course, in retrospect, we discern here the features of modernist painting that emerged later in the century, influenced by the art of Japan and other "exotic" cultures: the nonnaturalistic, arbitrary use of color, the telescoping of objects within the picture plane, and the crucial antirepresentational turn.

Gautier's tone changes when he describes Chinese luxury goods, "the truly serious part of the collection composed of the most rare and precious objects in enamel, bronze, porcelain, lacquerware, of cabinets, and furniture of all sorts" (136). The materials, the work, and the provenance—imperial palaces—all add value to these objects. He explicitly contrasts Chinese

antimimetic painting with the art of ornament, where whimsy is to be applauded: "for pure arabesque, for whimsical ornamentation in bronze, porcelain, wood, lacquer and hard stones, the Chinese are inimitable masters, and one can only admire the thousand products of their inexhaustibly fertile imagination" (137). His use even of the word "arabesque" is telling, for he adopts Orientalist lenses fashioned by Western perspectives on the Islamic world to stimulate interest in these objects and the world he suggests they intimate. For example, the beauty of Chinese characters and their use in ornamentation remind him of the Alhambra (133), and he imagines apartments for Chinese women "as closed to Europeans as the harems of the pashas of Asia" (134). Indeed, the general idea of mystery, of a hidden world, and of this exposition as the exposure of what is normally veiled or forbidden to Western eyes is a leitmotif throughout the review, which begins with the visitor passing by the faux-Chinese "guard," "two bronzes by Jules Cordier, a mandarin and his wife, perfect types of the Middle Empire that grimace with a jovial gravity on their pedestals" (130), and ends, not surprisingly, with the assertion that this "wonderful collection ... takes you across the Great Wall of China for a few moments" (142).

In contrast with Gautier's presentation of this exhibit as a sneak peek into the world of imperial China, Baudelaire theorizes that for any understanding of the object, itself a specimen of "universal beauty," a more profound change in the spectator is required: a "transformation" dependent on the imagination—that is, the imagining of the locale that produced this art or artifact. Thus Baudelaire invokes a cosmopolitanism rooted in a local (foreign) imaginary. Further, the Chinese object is a "product" of a "strange efflorescence," tropes which suggest a natural process. But, in contrast with Gautier's mimetic ideal, Baudelaire's view of the relationship between art and nature emphasizes analogous harmonic systems rather than representation, and thus redefines the aesthetic worth of these productions within a different ontology, a different sense of the interconnection between art and nature and of natural processes *tout court*. Understanding Chinese art is just one window to understanding "universal beauty," which, he implies, is not fully knowable because of its infinite potential configurations or "*correspondances*" among sensorial instantiations.

Since the *Salon of 1846*, Baudelaire has intimated that the viewing of art may change the alert and receptive spectator. In this 1855 essay, the transformation is so radical that he sketches a solitary traveler in nature, rather than the typical cosmopolite, as the subject best suited for such a transformation, in line with his valuing naiveté and freshness.[12] But he goes on to imagine a voyage to a foreign country by "a man of the world, an intelligent being" with the capacity to feel a sympathy that will "create in him a whole new world of ideas, which would form an integral part of himself and would accompany him, in the form of memories, to the day of his death" (122). Baudelaire emphasizes a process of surprise, of a subject disconcerted by difference, who

gradually is "penetrated" by "several thousands of ideas and sensations" that will "enrich his earthly dictionary" and so change his aesthetic allegiances as to cause him to "do like the converted Sicambrian and burn what he had formerly adored—and adore what he had formerly burnt" (122). In contrast, "[t]he crazy doctrinaire of Beauty" will not only be blind to these beauties and the cultures they evoke, but is blind to nature and finally blocked from all sensual experience:

> Locked up within the blinding fortress of his system, he would blaspheme both life and nature; and under the influence of his fanaticism, be it Greek, Italian or Parisian, he would prohibit that insolent race from enjoying, from dreaming or from thinking in any other ways but his very own. O ink-smudged science, bastard taste, more barbarous than the barbarians themselves! you that have forgotten the color of the sky, the movement and the smell of animality! you whose wizened fingers, paralysed by the pen, can no longer run with agility up and down the immense keyboard of the universal *correspondences!*
>
> (123)

Thus Baudelaire posits in the object the capacity to elicit its own original environment under the gaze of the receptive and imaginative spectator. If we take the hypothetical Chinese "product" as an example, he notes its tortuous form, the intensity of its color, and its almost ethereal delicacy, evidence for the cosmopolitan critic of "the admirable, eternal and inevitable relationship between form and function," without, of course, saying what that function might be. Thus a formal appreciation of the object is insufficient; the apprehension of function is needed in order to imagine the culture that produced it. In other words, this visionary eye sees form, color, and near inutility, and imagines the object's making and use. The aesthetic experience of the object—appreciation of its formal qualities—has the power to evoke not only a foreign world but also functionality within that world, the object's use value, as it were, a different register of value from that of exchange, relevant to Gautier's references to the shop-worthiness of the Chinese collection and to the commercial subtext of the Universal Exposition as a whole.[13] He also imagines the object as a specimen of universal beauty, but not as a model or ideal type; rather, it is an instantiation of harmonies, analogous with those in the natural world, something quite different from Gautier's ideal beauty.[14]

In this brief essay, Baudelaire, as Lemaitre remarks, develops his new aesthetic that will eventually replace the dominant aesthetic of the time: "*The beautiful is always bizarre*" (2: 578; my translation).[15] This "bizarrerie" itself "depend[s] upon the environment, the climate, the manners, the race, the religion and the temperament of the artist" (124); thus the bizarre is not simply the exotic, in other words, the effect of foreignness, but depends on

its own cultural context for its effect. That is, as there are many diverse beauties, so there are many bizarreries, and they are bizarre through their relationship with their own context. It is a cosmopolitanism that would be firmly non-Eurocentric, by recognizing that the bizarre itself is locally meaningful, not the effect of distance from the local culture. Further, the bizarre brings to the foreground the ideational or cognitive in the aesthetic by playing the same role as taste or seasoning in food, which reveals an "idea" to the tongue. This is in part a defense of his methodology—or argument for lack thereof—for throwing over the tired language of salon reviews and approaches to beauty which stifle the imagination. His authority is Balzac, who responded to a painting of a winter scene by wondering about the lives of those depicted; so Baudelaire concludes: "You will often find me appraising a picture exclusively for the sum of ideas or of dreams that it suggests to my mind," and generalizes that "[p]ainting is an evocation, a magical operation" (125). Thus the sine qua non of his alternative aesthetic lies in the object's capacity to conjure ideas, provoke daydreaming, in an utterly subjective process, and yet this process is the means to a more profound understanding of the foreign. Only through such transformation of the subject can an authentic cosmopolitanism emerge. The object, too, is individual: "This dash of strangeness, which constitutes and defines individuality (without which there can be no Beauty), plays in art the role of taste and of seasoning in cooking (may the exactness of this comparison excuse its triviality!), since, setting aside their utility or the quantity of nutritive substance which they contain, the only way in which dishes differ from one another is in the *idea* which they reveal to the palate" (124–5). Thus the aesthetic is reliant on individualism in the object which is also an ethos for the "idea" of the bizarre, the individual, the different, which sets off the transformative process. Here he implies that the rest of the aesthetic effect, that which does not partake of the bizarre, is blandly utilitarian, the nutrition found in the dish, to use his analogy, so ordinary as to have lost its capacity to please or to *mean*.

It is striking how enthusiastic he is about "this fine exhibition, so varied in its elements, so disturbing in its variety, and so baffling for the pedagogues" (125), and how it has worked as the impetus for his aesthetic of the bizarre. The contrast between this enthusiasm and his dismay before the banality of the Salon of 1859 is equally striking. Is Baudelaire so seduced by the beauty of the objects on display at the Universal Exposition that he is drawn into its official rhetoric? His repeated use of "products" for the art objects on display suggests as much, as I mention earlier. His awareness, however, of the rhetoric surrounding the exposition becomes obvious when he turns to the notion of "progress." Since the first industrial exposition in 1798, the display and measurement of "progress" has been a central aim of the government in launching these shows and has been part of the official rhetoric in both documents of authorization and publicity. We find

such a rationale in the official documents associated with the Universal Exposition, for instance, in the decree from Napoleon the Third that calls for the fine arts portion of the exposition, "[g]iven that one of the most effective means of contributing to progress in the arts is a Universal Exposition, which, by establishing a competition among all the artists of the world and by displaying so many diverse works, should be a powerful incentive for emulation and should offer a source of fruitful comparisons" (*Rapports*, i). The institutional apparatus also encourages the measurement of progress explicitly in the awarding of prizes.

But Baudelaire's argument is not so much with any implied equivalence between industry and art. Rather he takes issue with the broader conception of history behind the contemporary notion of progress, for which technological innovation and industrial production serve as bellwethers. Baudelaire admits that progress can occur—specifically, in questions of morality, in the careers of individual artists from year to year, in the price and quality of goods. But he objects to the belief in the inevitability of progress, seeing this as both a constraint on liberty and a delusion. He critiques the idea of progress in the arts among individuals, arguing that the greatest artists rarely had important predecessors: "Every efflorescence is spontaneous, individual" (127). Further, in the individual careers of the greatest living French painters Ingres and Delacroix, Baudelaire discerns no "progress" as such.

The same holds for nations: contemporary excellence does not guarantee future greatness. As evidence, he cites the discrepancy between contemporary Italian, German, and Spanish art and that of Leonardo, Raphael, Michelangelo; Dürer; and Zurbaran and Velásquez, respectively. This remark about the mistaken expectations of the public, viewing contemporary art from these countries for the first time, was made frequently by critics covering the fine arts at the Universal Exposition. More startling is Baudelaire's contention that the expectation that progress is inevitable is itself a sign of decadence because those who assume as much "will fall into the driveling slumber of decrepitude upon the pillow of their destiny. Such an infatuation is the symptom of an already too obvious decadence" (126). In other words, this assumption induces inertia, indolence, stagnation, and ultimately decay, and thus serves as, and produces, a sign of decadence. This charge echoes his derision of the "modern Winckelmanns" as "idols of the lazy," another instance of the acceptance of the commonplace and of intellectual complacency. Physical or material progress as signified by new technologies should not be confused with "the spiritual order," and so Baudelaire decries the loss of responsibility, or moral duty, and concomitant loss of freedom and free will that the assumption of the inevitability of progress entails, and the misguided thinking of the average man "so Americanized by zoocratic and industrial philosophers" who would confuse the physical and moral, the natural and supernatural (126).[16]

In effect, Baudelaire's critique of progress is a critique of the epistemolog-ical basis of such belief, which he characterizes as information gleaned from the daily newspaper: "Take any good Frenchman who reads *his* newspaper each day in *his* taproom, and ask him what he understands by 'progress'. He will answer that it is steam, electricity and gas—miracles unknown to the Romans—whose discovery bears full witness to our superiority over the ancients" (126). The exposition itself, offering exposure to diverse cultures, serves as an antidote by discrediting the idea of inevitable progress, taking, for instance, "decline" in Italian and Spanish art as cases in point. In other words, the Romans' lack of technological sophistication from the vantage point of the nineteenth century, from the point of view of the reader of daily news, is countered by the inferior state of Italian art in comparison with their Renaissance forerunners. Further, in Baudelaire's view, the expo-sition offers the spectacle of diverse beauties, no matter what the level of "civilization" of the country of their origin; thus art represents knowledge of a different order from that of technology that leads to different conclu-sions about cultural superiority among nations.

Indeed Baudelaire's aesthetic of the bizarre is a challenge to the idea of lev-els of civilization, to the ideology of civilization as a marker of progress. Ironically, in his view, the exposition as a cultural cosmopolis undercuts the rhetoric of progress that the display of technological innovation would support. Here the knowledge of art—visual and remembered—trumps journal-istic commonplaces about "progress," and so Baudelaire promotes an aestheticism in that art reveals the fuller truth about the state of current culture and the ontology of history itself, an aesthetic approach to social and cultural critique. But clearly it is not the aestheticism that considers art as ultimately self-referential, existing in a sphere apart from politics, history, and "life," but one that gives art epistemological priority over everyday dis-course and that sees in art critical categories for understanding social and historical trends. Of course, for Baudelaire, art is a complex vehicle of social truth, for, at its most bizarre, art has "ideas" that are best apprehended imag-inatively rather than delivered didactically. Patricia Mainardi argues con-vincingly that the official policy of eclecticism and the use of the retrospective in the 1855 Beaux-Arts exhibition took politics out of art by reducing differences among schools to differences of style, not politics, and by shifting emphasis onto individual careers rather than schools and tradi-tions with their political affiliations. Baudelaire, however, would retain for art a role in assessing the state of current society by dint of art's own level of aesthetic accomplishment. Furthermore, art, specifically its "bizarre" beauty, serves as an entrée into understanding its social and cultural con-text, as in the case of the Chinese objects.

Cosmopolitanism has recently come under attack as the cultural adjunct to and discursive cover for globalization that well-meaning leftist academics have not sufficiently interrogated. Timothy Brennan, for instance, asserts

that "an attempt to imagine the relations between emergent financial interests and scholarly models is widely lacking in scholarship itself," while research "finesses" its embeddedness in a social system beholden to corporate interests (661). For Brennan, the cosmopolitan is "*local* while denying its local character" (660), by which he means American: based on an American model of pluralism with American aspirations of global management. He also accuses academia of forgetting and thus unconsciously abetting the repeating of the history of cosmopolitanism. We might look at the Universal Exposition and its coverage as a case in point. The aim of engendering interest in the cosmopolitan was openly commercial: not only was the Universal Exposition meant to promote industrial competition and desire for the commodities on display, but, in a departure from protocol in earlier industrial expositions, prices were attached and some objects were literally for sale.[17] Further, the relationship between the financial interests that would promote French goods and the official school of aesthetics, eclecticism, that helped define French superiority in art as universal was strong in the sense that both were aspects of a single governmental campaign. How might we judge Baudelaire's concept in this light? Should we then be suspicious of Baudelaire's promotion of the "bizarre" as aesthetic value? Undoubtedly his admiration, indeed, desire, for such objects was whetted by the exposition, but the image of the cosmopolite that he sketches is radically different from the more conventional type of the, frankly, touristic shopper. He limns a transformation of subjectivity, as I described above, that would come to understand the "bizarre" or "strange" (*insolite*) as an idea within its own context. Granted, this desire to universalize an aesthetic that for him serves as an escape from the burden of neoclassicism is unwittingly local for a Parisian in the capital of the nineteenth century, and his imagining the effect of this aesthetic as a transformation of subjectivity belies a reliance on and obsession with a form of subjectivity particular to the West. But, in the context of contemporary discourse, when measured against the notion of the bizarre as deformed, ugly, and alien, his aesthetic implies an ethos of cosmopolitanism that seeks to understand foreign cultures through self-transformation that other inflections of the word at the time lacked. For all that Baudelaire, by valuing foreign goods, was complicit with the capitalist system—which is basically what Brennan charges intellectuals today with—he also critiqued the major ideology of that system: the assumption and value of progress, with technology and increased productivity as its indicators. Further, he questioned the meaning of the apparent superiority of French art over that of other nations, seeing no sign there of a greater degree of "civilization," but simply a phase in the life of a nation.

In sum, a transformative cosmopolitanism, such as Baudelaire envisions, should be distinguished from a cosmopolitanism that is a guise for an assumption of French or European superiority in art and industry by way of contrast with the products of other cultures and the imposition of Western

aesthetic norms. (Indeed, the arrangement of the Beaux-Arts exhibition, with the central placement and preponderance of French art, is enough to undercut any fair notions of the exposition as a truly cosmopolitan event.)[18] We might go further: Baudelaire's cosmopolitanism escapes the rationale for the official cosmopolitanism—a contest among nations that is nonmilitary, which nonetheless reinforces the ideology of the national. Sheldon Pollock has described the "coercive cosmopolitanism" of the Roman Republic and Empire and its Latin language and literature where participation in the cosmopolis is militarily "compelled by the state" (596) in contradistinction to the "voluntaristic cosmopolitanism" of the spread of Sanskrit as a literary culture through "the circulation of traders, literati, religious professionals, and freelance adventurers" (603). In nineteenth-century France, we see a sort of replay and ultimate failure of the first kind in Napoleon's military conquests and imposition of the Napoleonic code, replaced by the "peaceful" competition of trade. While Baudelaire's solitary traveler conjures the romance of earlier traders and adventurers, the "voluntaristic cosmopolitanism" of Pollock's Sanskrit culture, Baudelaire emphasizes the influence of the foreign on the French, not the hegemony of any single culture, language, or literature. This difference from the official "cosmopolitan" aim of promoting French superiority in a commercial and cultural arena in the shadow of military defeat forty years earlier, through an exposition overseen by Prince Napoleon Bonaparte, ordered by another Emperor Napoleon, is important.[19]

For Baudelaire, the cosmopolitan offered a solution to the debate over ideal beauty at the heart of aestheticism: here was evidence that beauty is relative, not absolute, a visual refutation of the academic or neoclassical ideal. Jacques Rancière, in his critique of theories of aesthetic modernism, outlines a "distribution of the sensible" (*le partage du sensible*) that confers a privileged role on literary language since romanticism: he contends that the romantic age did not deem language autotelic, but "actually plunged language into the materiality of the traits by which the historical and social world becomes visible to itself, be it in the form of the silent language of things or the coded language of images" (36). Rancière's larger concern is to describe how what he calls the "aesthetic regime" made fact-based and fiction-based logics or discourses interdependent, indeed, giving priority to fiction as producing the means of writing and comprehending history. For Baudelaire, imagination, modeled on Balzac's fiction-making, is a means of anthropological investigation. Further, his ongoing interrogation of existing aesthetic systems and his own fashioning of a new aesthetic are instances of such a striving after materiality through language, with contact with the visual arts and art objects as model, and a resistance against an aesthetic that moves beauty away from the human sensorium. In *Universal Exposition – 1855 – Fine Arts*, Baudelaire is especially interested in how, in Rancière's words, the "silent language of things or the coded language of images"

makes imaginable the traits of other, non-European historical and social worlds, and the transformation of the subject-spectator that accompanies this imagining.

The "coded language of images" and the idea of relative beauty are topics that Baudelaire takes up again in *The Painter of Modern Life*, his fullest articulation of the aesthetic of modernity. In it he famously writes:

> Beauty is composed of an eternal, invariable element, the amount of which is excessively difficult to determine, and a relative, circumstantial element, which will be, if you like, in turn or all at once, the era, fashion, morals, passions. Without this second element, which is the amusing, titillating, enticing covering of the divine cake, the first element would be indigestible, impossible to appreciate, unadapted and unsuited to human nature.
>
> (2: 685)

Thus the "relative, circumstantial element" in this model of beauty plays a similar role to the "bizarre" in the previous one: it is the "aperitif" that makes the unchanging, eternal, and frankly nonhuman in beauty digestible, like the "seasoning" offered by the bizarre. But in *The Painter of Modern Life*, Baudelaire famously chooses fashion as his central example of this relative and circumstantial aspect of beauty. In the passage quoted above, fashion is on a par with the era, its morals and passions; again, analogous to the "bizarre," this aspect of beauty reveals the culture to itself. But this is not just Baudelaire the cynic, the contrarian who would insist that the conventionally unbeautiful is beautiful for the sake of paradox, or that fashion is art simply to gall the academic critics. If we take seriously his idea of the "bizarre" as essential to beauty, then we should expect to find a similar notion in his analysis of the beauty of modern life in Paris. The "bizarre" is the element within a culture that is arresting to that culture as well as to others, and here fashion fits the bill. In other words, the couturier's dream is finally not so different from the shock and beauty of cosmopolitan discovery, and similarly functions as a distillation of cultural meaning.

It is ironic that the "bizarre" in later decades would become associated with decadence since Baudelaire attempts to forestall such an association by making a case for the real decadence of its opposite: the decadence of the commonplace, of Everyman of the Second Empire, the complacent reader of newspapers who has forfeited his free will in the very expectation of inexorable technological progress, the complacent viewer of art whose judgment relies on moribund models of beauty. There is, however, some etymological support for Baudelaire's aesthetic of the bizarre in Emile Littré's *Dictionnaire de la langue française* of 1863. Littré proposes two possible origins for the word: from the Basque for "beard," since "bizarre" seems to have come to French from Spanish and first meant "valiant, brave," and from the Arabic "bāshāret"—"beauty, elegance, whence valiant, chivalrous, then the sense of

anger, fiery, extravagant" (352)—a reminder from one of Baudelaire's con-
temporaries of the cosmopolitan roots of the French language and nation.
In conclusion, in his essay on the Universal Exposition of 1855,
Baudelaire redefines the "cosmopolitan," the "universal," and the "bizarre,"
urging an openness to the beauties of foreign or unfamiliar art and outlin-
ing a complex transformation of the spectator/critic that would make possi-
ble the full apprehension of such art as examples of "universal beauty."
"Universal beauty" takes on multiple forms, yet is locally meaningful. The
cosmopolitan spectator/critic, through a willed leap of the imagination,
comes to an appreciation of the art and understanding of the other culture
through contemplation and study rather than through preformed academic
knowledge or categories. The "bizarre" conveys the new as image and idea.
It does not rely upon a distance from the realm of life but a relationship with
the work's original context, in other words, a relationship with the particu-
lars of life.[20] Baudelaire would invest the bizarre with the role of revivifying
the aesthetic experience, making it more piquant, less mediated by aca-
demic criticism, and a means of transporting the spectator into the world of
the object. Rejecting a mimetic naturalism as foundational to "universal
beauty," Baudelaire instead envisions a cosmopolitan aesthetic that
embraces a broader sense of what defines the human.

Notes

1. Cousin's philosophical eclecticism strove to take only the "true" from past
 schools of thought in a "spirit of conciliation" (2: 13). Extended to the realm of
 art and specifically to the organization of the Universal Exposition, eclecticism
 meant that instead of competing schools and aesthetic norms, the careers of the
 greatest artists, such as Ingres and Delacroix, were spotlighted and equally
 revered, according to Mainardi's analysis.
2. Timothy Raser remarks that Baudelaire's criticism of "a nameless *professeur-juré*"
 undoubtedly refers to Victor Cousin (337).
3. "Cosmopolitan" can have different meanings. For instance, Natalia Majluf, in
 discussing Latin American artists residing in and/or trained in Paris or other
 Western art centers, calls them "marginal cosmopolitans," as "participants in a
 world culture" who have been marginalized by a "discourse of authenticity"
 imposed on what were deemed "exotic" cultures (869–70). She also discusses the
 anxiety of French critics covering the Universal Exposition over the homogene-
 ity bred of technological "progress" and "universalism." This resulted in an
 understanding of "cosmopolitan" as sameness or lack of national difference, of
 which they were critical (873–5). Her essay is wonderfully illustrative of the mis-
 readings of art by Peruvian and Mexican artists, especially Francisco Laso's *The
 Inhabitant of the Cordillera of Peru*, given the penchant of critics to look for a
 national difference in the mold of travelers' "picturesque". But her brief mention
 of Baudelaire's criticism does not take into account his sense of the cosmopolitan
 as one who values difference in art to the point of transformation of viewer sub-
 jectivity and aesthetic understanding. Her analysis of a "double standard of
 value" is astute: that Latin American painters would be judged according to their

"authenticity," an emphasis on the collectivity, content over form, and the expression of an unchanging national "core," while the emerging modernism valued individual expression, form over content, and newness. But she ignores Baudelaire's more radical delineation of the "cosmopolitan" as an aesthetic which would open the door to non-European aesthetic norms that modernism would, to some degree, embrace.

4. Michel Brix argues that Baudelaire comes out of a second romantic tradition, following Stendhal, in opposing the Platonist idea of a single, absolute Beauty inextricably tied to the Good and the True, articulating instead the notion of relative beauties and of an aesthetic based on sense experience as expressive of feelings and the moral. Using passages from Baudelaire's criticism and correspondence, he demonstrates how for Baudelaire the sense of the beautiful arises from feelings within the subjective viewer, and has symbolic value in correspondences between a moral and material world that are volatile and transitory rather than fixed and eternal.

5. Baudelaire published three essays on the Universal Exposition, later collected in *Curiosités esthétiques*. The first and third appeared in *Le Pays* of May 26 and June 3, 1855; the second, critical of the art of Ingres, was rejected by *Le Pays* and appeared instead in *Le Portefeuille* of August 12, 1855 (Claude Pichois, notes, 2: 1366).

6. All translations of Baudelaire's *Exposition universelle – 1855 – Beaux-arts* are taken from Jonathan Mayne's *The Mirror of Art* unless otherwise noted. All other translations are my own.

7. My argument about Baudelaire's use of the official discourse of the exposition is different from that of Raser, who argues that "Baudelaire's account of the Exposition, deliberately provocative as it is, still shares the main lines of its argument with Second Empire ideology." Raser points to his "condemnation of doctrinal beauty, his opposition of art and progress, his elevation of tradition at the expense of novelty" as elements of his argument drawn from the government's rhetoric. I emphasize instead his interest in the aesthetics of the "product," but dispute any shared doctrine of beauty, shared attitude toward art and progress, or neglect by Baudelaire of the value of novelty implied by the very encounter with the "bizarre." But certainly Raser is correct in arguing that Baudelaire's criticism is ideological. See Raser, especially 341.

8. See Walter Benjamin's famous analysis of "shock" in "On Some Motifs in Baudelaire."

9. As Pichois notes, "analogie universelle" is a Fourierist expression, and "harmonie" belongs to several mystical doctrines, but Baudelaire here has incorporated these terms into his own "supple" system (2: 1368, n. 3).

10. The Chinese museum in the Palais des Beaux-Arts consisted of a collection brought back by Montigni, former consul at Shanghai and Ning-Po, according to Pichois who cites an article by Yoshio Abé in *Le Monde*, November 28, 1968 (2: 1368, n. 2).

11. "[H]is wit is a cosmopolitan mirror of beauty." "[S]on esprit est un miroir cosmopolite de beauté" ("Théophile Gautier [I]," 2: 108). The context is important: Baudelaire wants to stress romantic aspects of Gautier's sensibility for all that he defends classical beauty.

12. Jenine Abboushi Dallal helpfully points out the influence of Emerson and Thoreau in this "New World pioneer analogy" (263, n. 53).

13. Here I disagree with Dallal who notes that the evanescence of the object "facilitates the detachment of Chinese art from its cultural context and specificity" (244), when the thrust of Baudelaire's description of that encounter is to use it to imagine the object's context. Nonetheless she sees this discussion of the object and its apprehension as evidence that Baudelaire "defines the aesthetic in terms of cultural renunciation," like Gautier in the preface of *Mademoiselle de Maupin*,

which may indeed be an important aspect of Baudelaire's cosmopolitanism. See Dallal 244–5.

14. Debarati Sanyal emphasizes the colonialist agenda of the Universal Exposition, and thereby reads this transformation of the viewer as "a profound physiological and spiritual penetration that resists the assumed conversion and convertibility of a conquered nation 'penetrated' by the colonial presence" (123). While agreeing with her general sense of Baudelaire as a critic of Western cultural hegemony, her focus on the colonial seems misplaced when the hypothetical object is Chinese, the product of another empire. I also situate this transformation within the larger trajectory of Baudelaire's inquiry into the aesthetic, and, in this context, the "reversal of visual power in the exhibition of foreign merchandise" (123) represents a new stage in Baudelaire's theorization of the ideal of imaginative receptivity for the cosmopolitan critic rather than the experience of the common viewer (see Sanyal 120–3).

15. Ascribing a positive value to the bizarre or strange is not unique to Baudelaire, of course. For instance, Charles Perrier in his coverage of the 1855 Exposition writes in defense of exaggeration in Delacroix's art, "in terms of art, the strange (*l'étrange*) is often more perfect than the perfect" (75).

16. Sanyal points out that such "vitriolic denunciations of progress are usually read within a Catholic or de Maistrean framework of original sin and providentialism," yet "Baudelaire's anti-progressivist stance consistently dislocates the Western civilizing mission to assert the value, dignity, and energy of pre-industrial peoples and nations against the apparent supremacy of Western nations and their modes of production" (121). Her point underscores the consistency between Baudelaire's description of the ideal cosmopolitan critic as a wanderer in the wilderness and this denunciation of the ideology of Progress, all part of his critique of Franco-centricity at the Universal Exposition.

17. Prince Napoléon speaks of the display of pricing: "this principle is important" in assessing merit (*Le Travail universel*, xxvi).

18. As Raser notes, "[T]he official catalogue lists 10,691 exhibits from France, Algeria, and French colonies; the rest of the world contributed 10,148" (344, n. 5).

19. Despite the official rationale that the Universal Exposition would replace war with peaceful competition, France and England were at war with Russia (the Crimean War of 1853–6). This paradox is explicitly acknowledged in government documents, for instance, in the editor's introduction to *Le Travail universel*.

20. I thank Kelly Comfort for making me aware of this consequence of my reading, which relates to the focus of this volume as a whole.

Works Cited

Arnoux, J.-J., ed. *Le Travail universel: Revue complète des Œuvres de l'art et de l'industrie, exposées à Paris en 1855*. Paris: Bureaux de la Patrie, 1856.

Baudelaire, Charles. *Œuvres complètes*. ed. Claude Pichois. 2 vols. Paris: Pléiade-Gallimard, 1975.

———. *The Mirror of Art: Critical Studies*. Trans. Jonathan Mayne. New York: Phaidon, 1955.

Benjamin, Walter. *Illuminations*. Trans. Harry Zohn. New York: Schocken, 1968.

Brennan, Timothy. "Cosmo-Theory." *The South Atlantic Quarterly* 100.3 (2001): 659–91.

Brix, Michel. "Modern Beauty versus Platonist Beauty." Trans. Tony Campbell. *Baudelaire and the Poetics of Modernity.* ed. Patricia A. Ward and James S. Patty. Nashville: Vanderbilt UP, 2001. 1–14.

Cousin, Victor. *Cours de l'histoire de la philosophie moderne.* 5 vols. Paris: Ladrange Didier, 1846.

Dallal, Jenine Abboushi. "French Cultural Imperialism and the Aesthetics of Extinction." *The Yale Journal of Criticism* 13.2 (2000): 229–65.

Gautier, Théophile. *Les Beaux-Arts en Europe.* Paris: Michel Lévy Frères, 1857.

Lemaitre, Henri, ed. *Curiosités esthétiques L'Art romantique et autres Œuvres critiques.* By Charles Baudelaire. Paris: Garnier Frères, 1962.

Littré, Émile. *Dictionnaire de la langue française.* Vol. 1. 4 vols. Paris: L. Hachette, 1863.

Mainardi, Patricia. *Art and Politics of the Second Empire: The Universal Expositions of 1855 and 1867.* New Haven and London: Yale UP, 1987.

Majluf, Natalia. "'Ce n'est pas Le Pérou,' or, the Failure of Authenticity: Marginal Cosmopolitans at the Paris Universal Exhibition of 1855." *Critical Inquiry* 23.4 (1997): 868–93.

Perrier, Charles. "Exposition Universelle des Beaux-Arts [4]." *L'Artiste* 15.6 (1855): 71–5.

Pollock, Sheldon. "Cosmopolitan and Vernacular in History." *Public Culture* 12.3 (2000): 591–625.

Rancière, Jacques. *The Politics of Aesthetics: The Distribution of the Sensible.* Le Partage du sensible: Esthétique et politique. 2000. Trans. Gabriel Rockhill. London, New York: Continuum, 2004.

Rapports du Jury Mixte Internationale publiés sous la direction de S.A.I. Le Prince Napoléon. Paris: Imprimerie Impériale, 1856.

Raser, Timothy. "The Politics of Art Criticism: Baudelaire's *Exposition Universelle.*" *Nineteenth-Century French Studies* 26.3&4 (1998): 336–45.

Sanyal, Debarati. *The Violence of Modernity: Baudelaire, Irony, and the Politics of Form.* Baltimore: The Johns Hopkins UP, 2006.

2

Rossetti's Aesthetically Saturated Readings: Art's De-Humanizing Power

Ileana Marin

Dante Gabriel Rossetti is considered an artist of "double talent"[1] because he frequently alternated painting with writing poetry, in many cases combining the two media. Throughout his corpus, there is a constant going back and forth between these two artistic media with no other justification than his consistent effort to express beauty exhaustively. Paintings inspire poems and vice versa, as if the writing table was abandoned for the palette, and the palette set down in the midst of composing a theme in favor of sitting again at the table to record the quintessence of visual representation. Rossetti constructed a completely artificial environment for his art, one opposed to the Victorian materialistic world of his contemporaries. Aware of the discrepancies between his artistic universe and Victorian reality, he tried to isolate his art as much as possible. As such, he anticipates or intersects with aestheticism in two important ways: by disregarding the goal of art as a receptor-centered activity and by ignoring the major source of most artistic inspiration, namely the reality outside the artistic phenomenon. Embedded in his literary and pictorial works are his readings of other artifacts, either alluding to or making explicit references to what he considered the greatest artistic achievements, and sometimes to his own artworks. In doing this, Rossetti multiplies art's meaning by recontextualizing visual icons and/or poetic syntagmas. This intricate aesthetic system is both a world in itself and its own interpretative consciousness.

In this chapter, I trace three "aesthetically saturated readings": (1) *Venus Verticordia* and its sonnet with the same title; (2) *Lady Lilith* and its sonnet Body's Beauty, together with *Sibylla Palmifera* and its sonnet Soul's Beauty; and (3) *Proserpine* and the two sonnets of the same title, one in Italian, one in English.[2] I use the term "aesthetically saturated reading" to refer to the various inter- and intra-artistic mutations of the myth of beauty and love that appear between Rossetti's *Sonnets for Pictures* cycle and his corresponding paintings. As my analysis will show, owing to the construction of aesthetic spaces outside public reception, the multiple levels of inaccessibility that result from the dialogic relationships between poetry and painting, and

the intertextual and intermedial network of artistic media, Rossetti's art intersects with art for art's sake and its process of de-humanization.

Aesthetic space outside public reception

Rossetti was well aware that only those few people already familiar with his movement's aesthetics—the members of the Pre-Raphaelite group—could really perceive and understand the complexity of his intertexts and iconographical exchanges. This interpretive difficulty was exacerbated, and to a large extent caused by Rossetti's refusal to exhibit his works publicly, preferring instead to show them only to the intimate circle of his friends and patrons. Rossetti may have been attempting to prevent the contact of neophytes with his sophisticated art, or, as Holman Hunt speculates, he may have done this because he "could not stand the effect of rancorous criticism ... [and so] resolved never again to exhibit in public" (Hunt 204). Rossetti, in his turn, referred to his "non-exhibition needs" in a letter to William Graham:

Pardon this long-standing mood of reticence but the position of an Artist at my age, and who has preserved hitherto one rule of non-exhibition needs the greatest circumspection as to any step in the other direction. I consider that much depends for me on the privilege of retaining control over the public production of my picture.

(Doughty 1634–35)

Rossetti's confession that "much depends" on the ability to retaining "control" over "public production" can be explained by the threat of outsiders who might have adulterated his art by relating it to reality. They might have judged it according to other aesthetic programs or artistically extraneous criteria. This attitude recalls Oscar Wilde's definition of the authentic artist vis-à-vis the public in *The Soul of Man under Socialism*. Wilde seems to have had Rossetti in mind when he delineates the artist's conflict with public taste:

The fact is, the public make use of the classics of a country as a means of checking the progress of Art. They degrade the classics into authorities. They use them as bludgeon for preventing the free expression of Beauty in new forms. They are always asking a writer why he does not write like somebody else, or a painter why he does not paint like somebody else, quite oblivious of the fact that if either of them did anything of the kind he would cease to be an artist. [...] The true artist is a man who believes absolutely in himself, because he is absolutely himself.

(1031)

Both Wilde and Rossetti view the public as unable to judge when novel art is also genuine. Recognizing preexisting and valued patterns is much easier

than discovering and enjoying new artistic formulas. Although Rossetti did accept the invitation to exhibit on certain occasions,[3] he consciously limited both public access to his artworks and the intersection between art and life that results from direct reception of art.

In addition to Rossetti's general reluctance to present his work in the public sphere, the difficulty of mapping out the significance of the poetic and pictorial works comes from the fact that they (text and painting) were seldom displayed together, except those—*Venus Verticordia*, *Lady Lilith*, and *Sibylla Palmifera*—which had the sonnet inscribed on the paintings' frames. The Victorian spectator and reader had only limited access to the image of the paintings as well as to the sonnets for these paintings, since public opportunities to connect the two media were really scarce, and the rift between most picture-sonnets and their pictorial counterparts remained unbridgeable for the majority of Rossetti's receptors. Writing a sonnet for one of his paintings did not necessarily mean that he would send it to the owner of the painting. If he did, sometimes he would send the poem months after the buyer had purchased the painting. For instance, the oil painting *Venus Verticordia* was sent to J. Mitchell of Bradford in January 1868, and the sonnet in September of the same year. Other sonnets for pictures were published in the *Athenaeum*, Rossetti's most favorable magazine, either as individual pieces or as fragments quoted in Stephen's articles dedicated to Rossetti's work. *Astarte Syriaca*, initially inscribed as a six-line poem on the original frame of the painting delivered to Clarence E. Fry sometime before February 1877, was integrated into a later sonnet and published in the *Athenaeum* in its complete form with fourteen lines in April 1877. It was mainly through the ekphrastic articles of F.G. Stephens or through the occasional publication of Rossetti's sonnets for pictures that the public learnt about his new artworks. As a result of these multiple obstacles to accessibility, then, a set of legitimate questions arises: For whom did he create the aesthetic space of his works since he did not need the public's response? Is this attitude a sign of the aestheticist movement's poetics? Is his confession an aesthetic engagement whose purpose is "art for art's sake"?

Aesthetic network—Aestheticism avant la lettre

Inaccessibility is also a subjacent theme of Rossetti's work itself. His portraits of women are rendered by and within his decorative style that seems to shelter them, allegorically making them inaccessible. The viewer cannot find a way to get closer to these women as real people, a difficulty enhanced by the characteristic indecipherable attitude Rossetti has given them. When accompanied by sonnets, these portraits gain a complexity otherwise inconceivable. The images are enigmas, and the sonnets only open up further possibilities of meaning. Given the hermetic quality inherent to the sonnet form, no precise meaning is possible.

Even though the sonnets are not simple commentaries of the paintings, however, they do orient the gaze of the viewers (if they are also readers of the sonnets when the sonnet and painting appear together) on visually nonrepresentable aspects such as: acoustic images and repetitive moves ("Thy voice and hand shake still" from Soul's Beauty); potential sequences of events impossible to project otherwise ("And still she sits, young while the earth is old, / And, subtly of herself contemplative, / Draws men to watch the bright web she can weave, / Till heart and body and life are in its hold" from Body's Beauty); inner voices of the character ("'Behold, he is at peace,' saith she; / 'Alas! the apple for his lips, – the dart / That follows its brief sweetness to his heart, – / The wandering of his feet perpetually'" from Venus Verticordia); or physical reactions which a viewer might not have deduced from looking at the image ("Afar those skies from this Tartarean grey / That chills me: and afar, how far away, / The nights that shall from the days that were" from Proserpine).

The choice of sonnet as the most suitable poetic form to complement the visual expression is also significant. Due to the fixed combinations of rhymes, internal rhythms, and a symmetrical sonorous structure, the sonnet is able to create unexpected associations, to communicate unutterable emotions, or irrational and inexpressible fears. Form and content cannot be separated any longer; they both participate in the signifying process. The sonnets enrich mythical imagery with their musicality. Rossetti's artistic syncretism is contemporary with aesthetic theories that present the unity between form and content as the goal of the arts and that consider musicality the supreme artistic feature. Pater addresses a related topic in his study "Et Ego in Arcadia Fui" from *The Renaissance Studies in Art and Poetry* where he expresses his admiration for the perfect fusion of form and matter in the classical sculpture *Venus of Melos*, which "is in no sense a symbol, a suggestion, of anything beyond its own victorious fairness. The mind begins and ends with the finite image, yet loses no part of the spiritual motive. That motive is not lightly and loosely attached to the sensuous form, as its meaning to an allegory, but *saturates* and is identical with it" (Pater 205–6, emphasis added). In "School of Giorgione," Pater further clarifies his concept of the ideal combination of matter and form, identifying music as the ultimate art because its form and matter are indistinct: "For while in all other kinds of art it is possible to distinguish the matter from the form, and the understanding can always make this distinction, yet it is the constant effort of art to obliterate it. [...] All art constantly aspires towards the condition of music" (206). Oscar Wilde reconsiders the same ideas in both "The Critic as Artist" and "De Profundis" in which he seems to borrow Rossetti's poetic vocabulary to define incompatible, but still complementary, realms such as spirit and matter, heaven and earth, soul and body:

What the artist is always looking for is the mode of existence in which soul and body are one and indivisible: in which the outward is expressive

of the inward: in which form reveals. [...] Music, in which all subject is absorbed in expression and cannot be separated from it [...] Truth in art is the unity of a thing with itself: the outward rendered expressive of the inward: the soul made incarnate: the body instinct with spirit.

(1031)

Perhaps the closest theoretical approach to Rossetti's artistic practice is Wilde's comparative analysis of arts. According to Wilde, literature has a great advantage over the other arts, since it is able to suggest musicality, create visual images, and express abstract ideas simply because words, the matter of literature, offer multiple possibilities of expression.

From a semiotic point of view, Rossetti's *Sonnets for Pictures* cycle entangles the relationship between form (signifier) and content or concept (signified). Paintings are primary signs whose pictorial strategies can be defined as signifiers and whose mythical stories, as they are embedded into sonnets, as signifieds. Nevertheless, their significances become the signifiers of the sonnets which wrap the former pictorial signifiers into poetic form. Thus, paintings and sonnets, or primary and secondary artistic signs in semiotic terms, form an aesthetic signifying system, a personal *ars combinatoria*, from which a new mythology is born. There are no completely independent pieces outside this network and, especially, there is no piece, connected with the *Sonnets for Pictures*, without a double function in terms of signification. Literary or pictorial, Rossetti's works stand for themselves, propose their own meaning, are self-reflexive, and, at the same time, enrich their meaning by their dialogic relationship (sonnets and paintings), and by appropriating key symbols, emblematic of other artists' work. They may be found in the poetry of Dante Alighieri, Guido Cavalcanti, and Charles Algernon Swinburne, and in the painting of Sandro Botticelli, Raphael Sanzio, and Michelangelo Buonarroti. Self-reflexivity and interconnectability put them inside a self-sufficient artistic world with no intended connections with the world outside. To use the dichotomous terms so often applied to aestheticism: art refers to art and continually distances itself from life.

Art as a dialogic process

The gap between art and life is also put into evidence by the process of versioning. By versioning, I do not refer to the preliminary sketches through which artists generally look for compositional solutions or chromatic or spatial arrangements, but rather to the extended process of versioning that continues, in the case of Rossetti's work, after the compositions were finished. Once Rossetti considered that he reached a certain degree of artistry, he painted and repainted the same work several times. The most famous example is *Proserpine*, which was painted seven times according to William Holman Hunt.[4] In this case, differences between final versions are imperceptible.

However, there are works on the same topic, which are progressively different from the first to the last version. Modifications draw attention to Rossetti's quest for the perfect aesthetic choice and to his continuously changing perspective. Such works with several "final" versions, but no ultimate version, recall the artistic status of performative arts.[5]

Moreover, Rossetti's habit of making several versions of his poems and artworks indicates the tendency to consummate the possibilities of a single subject to the very last detail. Each new version is another reading of the myth, not necessarily better than previous ones, but closer to Rossetti's ideal image. For each subject and its versions, he used models interchangeably, preserved significant details, and repeated postures, which together form a sort of reservoir of icons and intertexts waiting for new revisitations, either by a new *mise-en-image* or by a new *mise-en-texte* or both. This intertextual and intermedial network in itself forms a perfect aesthetic body, a textual/ pictorial corpus that avoids representation, figuration, or depiction as a consequence of Rossetti's focus on the paradigmatic element of myths, which lead to the loss of their narrative fabric and to the alteration of the initial spiritual significance.

Three aesthetically saturated readings

I shall now trace three aesthetically saturated readings (*Venus Verticordia* and its sonnet with the same title, *Lady Lilith* and its sonnet Body's Beauty in comparison with *Sibylla Palmifera* and its sonnet Soul's Beauty, and *Proserpine* and the two sonnets of the same title, one in Italian, one in English) in order to reveal the mechanisms of de-humanization as they have taken place in the process of creation and to analyze their aesthetic consequences in Rossetti's art. From this perspective, Rossetti's art represents a coherent aesthetic experiment, programmatically conducted to reconcile the irreconcilable aspects of life and art, matter and spirit, reality and dream into a mystic synthesis.

Venus Verticordia: Another *Regina Cordium*

The long history of Rossetti's *Venus Verticordia* begins in 1860 when he painted his first *Regina Cordium*, with Elizabeth Siddal as the model. The small panel (25.4×20.3 cm), painted in oil with applied gold leaf, portrays the head and bare shoulders of a woman behind a wooden barrier.[6] Turned toward the viewer slightly, her left shoulder seems to push up against the barrier, and her right hand, holding a pansy, reaches just above the barrier to rest on it. The pansy's face is clearly visible, echoing the broad, bare face of the woman, and both are oriented to the left and slightly upward. Her eyes are directed in the opposite direction, down and to the right, just past the viewer's gaze, in a pose that is meditative. As if she were doomed to pine

for the world from which she has been totally separated, her body is crushed between the barrier, which pushes her back, and the lattice pattern of stylized hearts and "kisses" (as Alastair Grieve calls the pattern) in the background behind her, which pushes her forward. Her extremely small and unremittingly enclosed space acts as a visual metaphor of the heart's struggle for love that keeps her prisoner in the box-like chest. The woman, iconographically identifiable by her necklace with its heart medallion as Regina Cordium, a connection confirmed by the inscription on the front of the wood barrier, is sentenced to waste her desire alone with no chance to escape and forced to meditate upon her immutable fate.

A more elaborate *Regina Cordium* is the 1866 version. The model, again with only head and shoulders showing above the wood barrier spanning the lower foreground, is Alice Wilding, who holds an iris in her right hand and rests both her hands on the barrier that here is covered by an embroidered tablecloth, emblem of Victorian domestic life. She seems to be less controlled by the space in which she is squeezed, partly because she is looking directly out at the viewer as if confronting him or her; partly because of the color contrasts which make her look more powerful. The three realistically painted roses in front of the barrier suggest that there is another world outside the domestic realm. The fresh blooming roses, icons for the mythical Venus, belong to the world in which women, no longer captive inside their household space, respond to the challenges of love. Yet the roses are also symbols of all things transitory, including passing love.

The gold and green lattice in the background emphasizes the red of the shawl and the red hair of the woman. The composition transforms Venus's characteristic icons into superfluous ornaments: the golden heart and arrow pendant, the medallion decorated with a blindfolded Cupid, the red color of passion, and the roses. Thus, the passion of love has become only an effigy of it.

While Rossetti did not write a sonnet for *Regina Cordium*, the Venus Verticordia sonnet matches it, with references actualized in the other painting, such as the heart-shaped medallion and the blindfolded Cupid in the miniature on the wall. Venus Verticordia embodies, as its Latin name suggests, momentary, passionate transformations. Allusions and ambiguous cross-references deceive both the viewer of the painting and the reader of the sonnet, which I include here in its entirety:

> She hath the apple in her hand for thee,
> Yet almost in her heart would hold it back;
> She muses, with her eyes upon the track
> Of that which in thy spirit they can see.
> Haply, "Behold, he is at peace," saith she;
> "Alas! the apple for his lips, – the dart
> That follows its brief sweetness to his heart, –
> The wandering of his feet perpetually!"

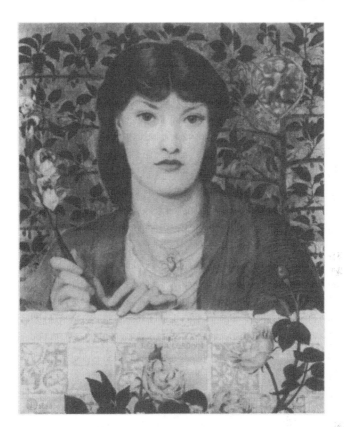

Figure 2.1 *Regina Cordium*, 1866, oil on canvas, 23½ × 19½ inches, © Glasgow Art and Gallery Museum

> A little space her glance is still and coy;
> But if she gives the fruit that works her spell,
> Those eyes shall flame as for her Phrygian boy.
> Then shall her bird's strained throat the woe foretell,
> And her far seas moan as a single shell,
> And through her dark grove strike the light of Troy.
>
> <div align="right">(Rossetti 360)</div>

The apple identifies Venus, but also Eve, as in the Body's Beauty sonnet: "the gift of Eve / That, ere the snake's, her sweet tongue could deceive." The apple is also the Siren's offer of temptation in Rossetti's short story *The Orchard Pit*, a piece of personal mythology:

> In the largest tree, within the fork whence the limbs divide, a fair, golden-haired woman stands and sings, with one arm stretched along a branch of the tree, and with the other holding forth a bright red apple, as if to

some one coming down the slope. Below her feet the trees grow more and more tangled, and stretch from both sides across the deep pit below: and the pit is full of the bodies of men. They lie in heaps beneath the screen of boughs, with her apples bitten in their hands. [...] She stands over them in the glen, and sings for ever, and offers her apple still.

(427)

The foliage surrounds and isolates both the siren in the short story and Venus Verticordia in the painting as an insuperable barrier. They both enchant men by offering them the apple, yet with an ambiguous gesture which may very well mean "do not dare": "Yet almost in her heart would hold it back." This line, revealing Venus's intention, recalls Proserpine who tries to refrain after the first bite from the pomegranate, the fruit of love. She is the victim of Venus, but the aura behind her head shows her spiritual power which she shares with other characters in Rossetti's paintings, such as *Sibylla Palmifera* and *Astarte Syriaca*. Although represented as physically separated from the rest of the world, women as goddesses transcend their imprisonment precisely by their spiritual powers. The idea of potential liberation through spiritual powers is even more threatening than the lure of physical beauty. Rossetti seems to warn that physical beauty may be kept inaccessible, but spiritual power is always free.

Venus Verticordia, like Lady Lilith, "draws men to watch the bright web she can weave," but, unlike Lady Lilith, she looks directly into the eyes of men: "She muses, with her eyes upon the track / Of that which in thy spirit they can see." Her penetrating gaze overwhelms the viewer, who recognizes *Regina Cordium*'s boldness and calm. The dimensions of the painting (98 × 69.9 cm) increase the impression of fear.[7] The viewer is doubly threatened: first, by the bigger than life-size stature; second, by her almost aggressive posture. Under this circumstance, the floral barrier, which frames the woman, also protects the viewer against her, maintaining the two realms apart and safe. In this case, inaccessibility is no longer a matter of isolating the artistic object or of suggesting the inaccessible beauty; paradoxically, inaccessibility protects the viewer against the aggressive posture of the painted character.

Multiple allusions contribute to the effacing of the narratives instead of fleshing them out. The woman in the painting is too sensual to be Venus, the motherless goddess of absolute beauty, identified by Plato with supreme goodness and ultimate knowledge. She cannot represent "immaterial" beauty as long as she displays her sensual nudity with no allegorical veil to recall the renaissance allegories of beauty. She seems to be an Amazon armed with an arrow, or Diana, the chaste goddess of hunting and war, but there are not enough features to clearly identify her as such. William Michael Rossetti's letter to his brother about the title of the sonnet for the 1870 edition, unexpectedly, provides support for this interpretation of the painting. He tried to convince Dante Gabriel that "Venus Verticordia" would have

been an inappropriate title for his sonnet, and he quoted an acquaintance of theirs, Lemprière: "'Venus was also surnamed *Verticordia* because she would turn the hearts of women to cultivate chastity.' If this is at all correct, it is clear that the Verticordian Venus is, technically, just the contrary sort of Venus from the one you contemplate – she must be a phase of Venus Urania" (Peattie 220–1). Dante Gabriel changed the initial title from *Venus Verticordia* to *Venus*, but this episode is relevant for his process of creating a "double work of art." Obviously, his idea to depict Venus as a both chaste and seducing goddess stemmed from his conviction that sensual and non-sensual match perfectly. He combined mythical aspects from different stories to come up with an ambiguous image and poem.

Multiple icons, excerpted from their original stories, are recontextualized in this painting without following a coherent narrative thread. The pair *Venus Verticordia* becomes an artificial construct, an over-elaborated sign, which cannot stand for any of these significances. The sonnet, in its turn, is a textual trap which apparently leads the reader to the Trojan myth props: "Phrygian boy" or "fires of Troy" (a previous version), or "the light of Troy" (Rossetti 360). While there are items which redundantly appear in the sonnet and in the painting, such as the apple, the dart, and the bird, there are other items which connect the painting with another series of paintings: *Pandora* and *Helen of Troy*.

The painting *Helen of Troy*, whose model was Annie Miller, is another version of the two, combining the pieces of the iconographical inventory: "fires of Troy" are shaped in Helen's medallion, while her posture reconfigures their alluring unattainability. The 1868 *Pandora* and the 1878 *Pandora* may be considered versions of Venus painted from different models. While the 1868 version is chromatically closer to *Venus Verticordia*, the 1878 one is iconographically related to it. *Venus*, *Helen of Troy*, and *Pandora* are mythical hypostases of the same inaccessible ideal beauty. Rossetti experimented with different approaches to catch the irresistible beauty in his pictorial readings of the ancient myths.

Lady Lilith versus *Sibylla Palmifera*

Looking again at Rossetti's paintings and reading again his sonnets for pictures, one can agree with Pater's conclusion that the women's portraits epitomize love and beauty as goals in themselves. These paintings do not belong to the genre of portrait, although the features of a certain model can be easily distinguished from another. Their titles—*Venus Verticordia*, *Lady Lilith*, *Sibylla Palmifera*, *Proserpine*, *Pandora*—indicate the mythical story, on the one hand, and point out the temporary pictorial *persona*, on the other. But the paintings do not re-present Elizabeth Siddal, Jane Morris, Alice Wilding, Annie Miller, or Fanny Cornforth. These women were chosen as models because their features met the artistic requirements already upheld by Rossetti. Paradoxically, since

Rossetti chose the models for their resemblance to his ideal, they therefore had the opportunity to regain their lost spiritual value and original ideal status through the chance of becoming artistic objects.[8] Rossetti de-humanized both the premise and the end of his art. First, his selective gaze cut his models' connections with reality, with their status and their social identity, and transformed them into ideal images, abstractions, or mythical characters. Once they met the aesthetic standards to pose for *Lady Lilith, Sibylla Palmifera, Pandora,* or *Proserpine,* they became sensual supports for these artistic fantasies. Second, the viewers of these paintings continued the process of de-humanization at the level of reception; they were not supposed to look for realistic renditions, but for the way in which fictitious embodiments might reveal concealed meanings of a parallel world. Thus, the historically identifiable women are de-humanized by disguise and mask. Their (e)motionless faces are their masks; their impenetrable cold demeanors which assert nothing hide their real personality; their inaccessibility which blocks any communication and makes them idols. Even their physiognomic difference is just another mutable aspect implied in the process of versioning alongside the repetitive patterns. All these elements, which conjure beauty in terms of mythical representations, saturate the work of art whose theme is beauty as the aesthetic and spiritual stimulant of love.

Lady Lilith is the image of the physical Eros, which declines its active conduct and assumes a contemplative attitude (see Figure 2.2). The oxymoronic fusion between physicality and the awareness of physicality, between body and mind, reveals the narcissistic aspect of Lilith's love. In search of the perfect model for Lilith, Rossetti changed Cornforth with Wilding, as the following story underscores. In one of his letters, Charles Fairfax Murray claimed that Samuel Bancroft[9] wrote to him what Fanny Cornforth had told the latter after a session of posing for Rossetti's *Lady Lilith* while she was living in Rossetti's house: "Gabriel 'scraped the face out' only. Then he sat down before it, put his elbows on his knees and his face between his hands, and cried until the tears ran through his fingers, and said, 'I can't do it over again, <u>and you are not what you were!</u>'" (Elzea 112; emphasis in original).

Murray was suspicious regarding Fanny's presence while Rossetti was destroying her portrait, but whether she did or did not witness the scraping of the canvas is unimportant. Murray had no trouble believing that such an episode could have taken place because in the painting, *Lady Lilith'*s facial features do indeed correspond to those of Alice Wilding, but atop Cornforth's corpulent body.[10]

Imposing artistic criteria on living beings, Rossetti adjusted reality to conform to art's artificiality, "tailoring" women's bodies in order to transform them into representations of an aesthetically ideal image. He beheaded two portraits in order to create a Frankensteinean Lilith. First, he scraped out Cornforth's head, and then painted only Wilding's face on the blank surface. He transgressed the limits of art to this paroxysmal experiment.

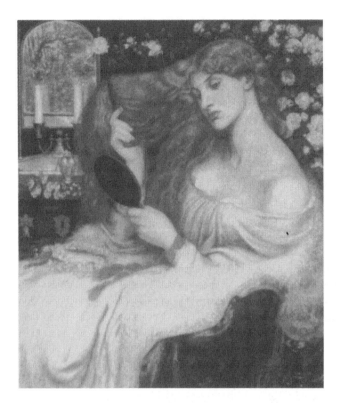

Figure 2.2 Lady Lilith, 1866–8 (altered 1872–3), oil on canvas, 38 × 33½ inches, © Delaware Art Museum, Samuel and Mary R. Bancroft Memorial, 1935

De-humanization, in the sense that *Lady Lilith*'s portrait is the result of a mutilation, is literally part of the process of creation. His choice to paint a more spiritual face on the massive body represents an attempt to reconcile body and soul, flesh and intellect, matter and spirit. Indeed, for Pater, Rossetti's art is "sacramental" precisely because it found a way to eliminate such dichotomies:

> A sustained impressibility towards the mysterious conditions of man's everyday life, towards the very mystery itself in it, gives a singular gravity to all his work: those matters never become trite to him. But throughout, it is the ideal intensity of love – of love based upon a perfect yet peculiar type of physical or material beauty – which is enthroned in the midst of those mysterious powers; Youth and Death, Destiny and Fortune, Fame, Poetic Fame, Memory, Oblivion, and the like.
>
> (235)

The almost unnoticeable disproportion between the head and the body is one of the traces of artistic struggle which finally entrapped his viewer/reader into his multimedia intertextual network. It is the face of Wilding that makes *Lady Lilith* and *Sibylla Palmifera* share the same mysterious aspect. Otherwise, the two sonnets present two completely different instantiations of beauty. Comparing the two allegorical representations of beauty, one may notice that Rossetti challenges the expectations of the Victorian viewer who usually identifies white with virginal purity and red with passion. Rossetti enhances physical beauty using white, and suggesting that beauty itself has nothing enticing or intrinsically seductive. It is the sensuous pose and the multiple reflections that make her embody primordial sensuality. Wilding changes the light fabric of Lilith's gown to a heavy red dress when she poses for *Sibylla Palmifera*. The chromatic contrast between the two paintings is perfect in its details: the scarves, the wreaths of flowers, the poppies and the roses switch white with red and red with golden in order to represent the allegorical hypostases of beauty: corporeal versus spiritual. The sonnet Body's Beauty presents Lilith's as the oldest corrupting beauty which mortals cannot resist. She is a powerful manipulator, able to make men fall in love with her, while she remains unmoved by any human feeling:

> Of Adam's first wife, Lilith, it is told
> (The witch he loved before the gift of Eve,)
> That, ere the snake's, her sweet tongue could deceive,
> And her enchanted hair was the first gold.
> And still she sits, young while the earth is old,
> And, subtly of herself contemplative,
> Draws men to watch the bright web she can weave,
> Till heart and body and life are in its hold.
>
> The rose and poppy are her flower; for where
> Is he not found, O Lilith, whom shed scent
> And soft-shed kisses and soft sleep shall snare?
> Lo! as that youth's eyes burned at thine, so went
> Thy spell through him, and left his straight neck bent
> And round his heart one strangling golden hair.

<div align="right">(Rossetti 216)</div>

The floral symbols, "the rose and poppy," are transposed pictorially as decorations in the bas-relief behind *Sibylla Palmifera* as symbols of love and death, cross-relating the sonnet Body's Beauty with the painting dedicated to Soul's Beauty. The portrait of spiritual beauty reduplicates these symbols in the blindfolded cupid and the skull, and poetically as "love and death, / Terror and mystery, [which] guard her shrine" (Rossetti 215).

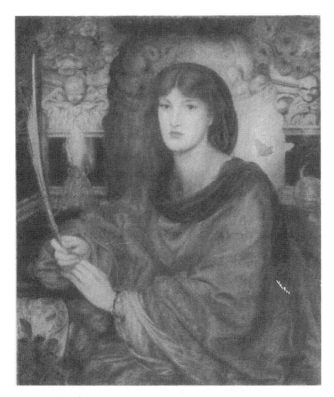

Figure 2.3 Sibylla Palmifera, 1865–70, oil on canvas, 37 × 32½ inches, © Walker Art Gallery, National Museums Liverpool

Revelation emphasizes the ambiguity of beauty, and the vain effort to unveil the meaning beyond the beauty. Beauty is meaningful and meaningless, according to the point of view from which the viewer/reader looks at "her." Thus, Alice Wilding's facial features stand for both the Body's Beauty and the Soul's Beauty; she is the model of *Sibylla Palmifera*, also known as *Venus Palmifera* for which Rossetti wrote the sonnet entitled Soul's Beauty. She is also the model for *Regina Cordium* and for *Venus Verticordia*. At the same time, the aura which surrounds her head in Sibylla Palmifera will very well surround Jane Morris's head in *Pandora, Proserpine*, or *Astarte Syriaca*. These intricate inter/transtextual relationships reshape classic mythology and dress the same models in different attires over and over again to impersonate Rossetti's vision of beauty. Rossetti opposed the mainstream stereotypes of beauty with his own concept of inaccessible, yet terrifying, beauty, which sometimes even was seen as "ugliness" by his contemporaries.

Proserpine

Proserpine, the most complex artwork Rossetti ever created, is intertwined with text both inter- and intra-medially. The sonnet written in Italian that is painted in the right upper corner of the picture is translated into English for the original frame. The different lyrical reverberations of the two texts support this argument. In the process of composing the sonnet, Rossetti deliberately chose the most famous and frequent determinant in Dante Alighieri's *Il Inferno*, "oscuro" ("O lido oscuro"),[11] in order to explicitly reference his poetic paragon, the Italian medieval poet, and to expand the connotations of Proserpine's sufferings in the realm of permanent night, her moral darkness, pain, confusion, and blindness.

He also emended his initial versions to make the sonnet sound more Dantesque. For example, he opted for the oxymoronic syntagma "del rio palazzo" (evil palace) instead of "del mio palazzo" (my palace) simply in order to create the strongest irreconcilable image, according to Dante Alighieri's imagery. Made up of two Dantesque occurrences, each specific to another canto—"rio" occurs in *The Inferno*,[12] and "palazzo" occurs in *The Purgatorio* and *The Paradiso*[13]—the syntagma verbalizes the chromatic contrast between light and dark, the spatial ambiguity between the world above and the world beneath, and the temporal ambiguity between day and night. The choice of the thirteenth-century "rio" is relevant for his determination to make the sonnet in the painting look and sound medieval; he could have used the modern word "reo," which he might have encountered in his Italian readings, in Manzoni or Foscolo. The series of contrasts is reinforced by the three words painted with white on black background: "lungi" twice (at the beginning of both the octet and the sestet) and the name of Proserpina. Another eloquent phrase for the medieval intertext is "omai m'e duro," derived again from *The Inferno* (III, 12).[14] These echoes from Dante Alighieri produce the impression that the sonnet in the painting is an old medieval manuscript.

While the sonnet on the painting, in Italian, suggests the aesthetics of the medieval period, the English translation on the frame is likely related to Rossetti's translations from the *dolce stilnuovo* poets, on the one hand, and to his contemporaries, on the other. Where sonnets by Rossetti's Italian sources convey a semantic paradigm of darkness, in this English sonnet, even though it is a translation of his Italian version, darkness is replaced by coldness. The shift may be explained by the atmosphere conjured by Charles Algernon Swinburne in his poem on the same subject, *The Garden of Proserpine*. Swinburne's "cold immortal hands" compares with Rossetti's "cold cheer" or "Tartarean grey / That chills me."[15] Rossetti gives the character the experience of that cold, as it relates to her presence in cold, unfriendly Hades.

Proserpine is the only sonnet for a picture, which gives voice to the character in the painting. Proserpine's lament enumerates elements of the world (light, flowers, fruit, sweet sounds) that are inaccessible from the world of Hades. Her frustration underlines the fact that inaccessibility is a matter of perspective: Proserpine is inaccessible to anybody outside Hades; all the elements which she misses so much are inaccessible to her. Again, the theme of inaccessibility combines with the theme of isolation. Moreover, the sonnet makes explicit the theme of inaccessibility and the total separation between the two realms: the world outside Hades and Hades. The former world is the most beautiful world, while the irony of the latter world in which Proserpine's beauty is "enthroned" is that it is the unattractive world. She mourns the distance, and the difference:

> Afar away the light that brings cold cheer
> Unto this wall, – one instant and no more
> Admitted at my distant palace-door
> Afar the flowers of Enna from this drear
> Dire fruit, which, tasted once, must thrall me here.
> Afar those skies from this Tartarean grey
> That chills me: and afar, how far away,
> The nights that shall be from the days that were.
>
> Afar from mine own self I seem, and wing
> Strange ways in thought, and listen for a sign:
> And still some heart unto some soul doth pine,
> (Whose sounds mine inner sense in fain to bring,
> Continually together murmuring,) –
> "Woe's me for thee, unhappy Proserpine!"

(Rossetti 317)

The setting of a cold, isolating Hades evoking certain of Swinburne's descriptions is emphasized by the more subtle evocation of Swinburne's rhyme in *The Garden of Proserpine*. Other rhymes also seem to be borrowed from elsewhere, such as the memorable "no more / palace-door" that is comparable to Poe's "chamber door / nothing more" in *The Raven*. In addition to referencing the work of contemporaries, Rossetti also dipped into his own, with such syntagmas as "inner sense is fain to bring ..." or "woe's me" that originate in Rossetti's own earlier translations from Italian sources.[16]

Textual and visual elements overlap and interchange, forcing into the artistic framework the ambiguities from the reality outside. Reality is apt to satisfy artistic standards whenever its events coincide with a mythical story. Thus, Jane Morris, the model for *Proserpine*, who in real life is a captive within a marriage of convenience to William Morris in spite of her love for

Dante Gabriel Rossetti, is a Proserpine from Rossetti's point of view because she must live a life divided between her husband and her lover. Her features dominate the late works of Rossetti: "a tall lean woman in a long dress of some dead purple stuff, guiltless of hoops, ... a long neck without any collar, and in lieu thereof, some dozens strings of outlandish beads", as Henry James described her in 1868 (Cooper 119). By that time, she had totally identified herself with the images for which she posed; she carried their mystery, melancholy, and silences outside the frames of the pictures.

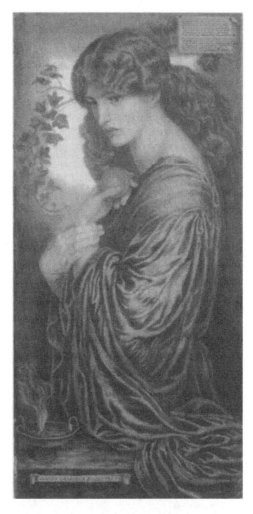

Figure 2.4 Proserpina, 1881–2, oil on canvas, 31 × 15½ inches, © Birmingham Museums & Art Gallery, presented by the Public Picture Gallery Fund, 1927

Taking into account the whole series of "double works of art" dedicated to the myths of love and beauty, it may be considered an artistic construct, which borrowed the features of its model (and the model's personal life of entrapment). The arrangement of her hair connects her with Rossetti's *Pandora*, while her posture with her hands holding the fruit near her breast recalls Helen's position in his *Helen of Troy*. If considered a work in the network, *Proserpine* is obviously an artistic creation with no other connection to reality than the features of the model. The model, however, is theatrically *mise-en-scene* and disguised as a Proserpine whose story is painted in the right upper corner in old Italian. The text itself contributes to effacing Jane Morris's context: she cannot be but Proserpine, the wife of Pluto, the victim of love because of her beauty. The text tells her story to attest her identity. Behind the table on which rests a mundane object, a lamp, Proserpine is allowed to move, maybe to leave the narrow, partially enclosed space, but not for long. The claustrophobic space and the bare wall in the background, on which only a vine of ivy breaks the monotony, give the image of Proserpine's unwelcoming environment. Her status is better than that of *Venus Verticordia* and *Regina Cordium*, who definitely look immobilized, but worse than that of *Lilith* and *Sibylla Palmifera*, who seem to control their space. In this context, she is simply another mythical hypostasis. Moreover, the old Pre-Raphaelite precept "truth to nature" still present in these paintings is a visual trap; everything is so clearly depicted that it annuls denomination, enchanting the viewer's sight in the details of perfectly painted flowers and fruit which build the most appropriate aesthetic context. The excessive insistence on realistic details puts them under a spotlight and makes them equally important with the central characters. The petals of the flowers, the wings of the butterflies, the leaves of the foliage, the unripe cherries of the lattice, are so minutely depicted that they look surrealistic. Reality is betrayed even when it is closely rendered. It is denaturalized in the same way Rossetti's models are de-humanized in his paintings.

The process of de-humanization is subtly illustrated by visual and communicational inaccessibility. Nonetheless, intricate intertextual connections, identified between Rossetti's sonnets and other literary works, spark a process of re-humanization at the emotional level as the reader/viewer gets behind mythical stories which embellish the private incidents of the artist. By attempting to decipher Rossetti's works the reader/viewer puts the parts back together and, thus, gets a glimpse into the sensitive aspects of the human soul. It is the aesthetic pleasure which refills the de-humanized images with the plausibility of life. In the late nineteenth century, when the artist strove for an art that moved away from the simply mimetic or representational, he legitimizes artificiality as a fearful competitor of reality. Art goes over and expands outside the frames of the paintings and beyond the layouts of his pages, competing with history. Art no longer needed reality as a crutch: art was enough for itself.

Notes

1. Maryan Wynn Ainsworth coined the phrases: "double talent" and "double works of art" in *The Double Work of Art*.
2. Digital images of Rossetti's works can be found online at www.rossettiarchive.org. Jerome J. McGann. Institute for Advanced Technology in the Humanities, University of Virginia. December 2007. May 23, 2007.
3. He exhibited *Venus Verticordia, Lady Lilith, Sibylla Palmifera,* and *Beata Beatrix* at the Royal Academy in 1868; he accepted to exhibit *Venus Verticordia* for raising money for the Building Fund for Art Schools in 1870.
4. Holman Hunt mentions seven versions of *Proserpine* in a letter addressed to Ford Madox Brown: "*Proserpina* was begun on seven different canvases, to say nothing of drawings. Three were rejected after being brought well forward; the fourth is now with Parsons, and will shortly come back on my hands; the fifth has twice had the glass smashed and renewed. The sixth has had the frame smashed twice and the glass once. It was nearly spoilt in transferring to a fresh stainer, and is now almost destroyed" (Rossetti *Poems with Illustrations* 69).
5. Three prints from the Delaware Art Museum (Delaware) and the digital image of *Proserpine* from the Tate Gallery (London) are available online at www.rossettiarchive.org. Another version can be seen online at www.victorianweb.org. George P. Landow. Brown University. June 6, 2007. http://www.victorianweb.org/painting/dgr/drawings/5.html. The color version or the black and white reproduction inserted in this article can be found online at www.bmag.org.uk. June 12, 2007. http://www.bmagic.org.uk/objects/1927P7.
6. The digital image of *Regina Cordium* from the Tate Gallery (London), together with another four black and white reproductions can be found online at http://www.rossettiarchive.org/docs/s120.rap.html.
7. *Venus Verticordia,* currently exhibited at Russell-Cotes Art Gallery, Bournemouth, UK, can be seen online at http://www.rossettiarchive.org/docs/s173.rap.html.
8. While Plato bemoaned art's distance from the world of pure forms and defined art as a copy of a copy, Rossetti bemoaned art's proximity to reality. Painting women as pure types, he seems to push reality (the world of imperfect copies) closer to the perfect world of forms.
9. Charles Fairfax Murray, a Pre-Raphaelite artist himself, introduced Samuel Bancroft to the Pre-Raphaelite circle and intermediated the acquisition of several Pre-Raphaelite works for the latter. The episode of scrapping Cornforth's portrait out seems to have circulated among the Pre-Raphaelites.
10. Cornforth's nickname was "Elephant" because of her massive body.
11. Occurrences of "oscuro/a" in *Il Inferno* include: "selva oscura" (I,2), "oscura valle" (XXIX, 65), "oscura costa" (II, 40), "colore oscuro" (III, 10), "Oscura ... era" (IV, 10), "loco e'l piu oscuro" (IX, 29), "d'esser nomato si oscuro" (XXX, 101), which signify both the absence of the physical light and the absence of virtue. For Dante Alighieri's text I used *Dante tutte le opere,* introduced by Italo Borzi, and commented by Giovanni Fallani, Nicola Maggi, and Silvio Zennaro.
12. As an adjective, it appears in "tormento rio" (IX, 112), "presente rio" (XIV, 89); as a noun in: "trapassar lo rio" (III, 124), "per altro rio" (IV, 40), "fuor del rio" (XII, 121).
13. Examples include the following: "de l'eterno palazzo piu s'ascende" (*Il Paradiso,* XXI, 8), "gran palazzo" (*Il Purgatorio,* X, 68), "Currado da Palazzo e'l buon Gherardo" (*Il Purgatorio,* XVI, 124).

14. In Dante Alighieri the line reads "il senso lor m'è duro," and in Longfellow's translation it reads: "Their sense is [...] hard to me!"
15. See other aspects of Swinburne's influence on Rossetti in Alicia Craig Faxon's *Dante Gabriel Rossetti.*
16. See Guido Cavalcanti's "Balatta. He perceives that his highest Love is gone from him" and "Of his Pain from a new Love" or Cino da Pistoria's "To Dante Alighieri. He interprets Dante's Dream" in *The Collected Works of Dante Gabriel Rossetti.*

Works Cited

Ainsworth, Maryan Wynn. *The Double Work of Art.* New Haven: Yale University Art Gallery, 1976.

Cooper, Suzanne Fagence. *Pre-Raphaelite Art in the Victoria and Albert Museum.* London: V&A Publications, 2003.

Dante Alighieri. *Dante tutte le opere.* Roma: Grandi Tascabili Economici Newton, 1993.

Doughty, O. and J.R. Wahl eds. *Letters of Dante Gabriel Rossetti.* Oxford: Clarendon Press, 1965.

Elzea, Rowland. *The Samuel and Mary R. Bancroft, Jr. and Related Pre-Raphaelite Collections.* Wilmington: Delaware Art Museum, 1978.

Faxon, Alicia Craig. *Dante Gabriel Rossetti.* New York: Abbeville Press, 1989.

Fredeman, William E. ed. *The Correspondence of Dante Gabriel Rossetti.* Cambridge: Brewer, 2002.

Hunt, William Holman. *Pre-Raphaelitism and the Pre-Raphaelite Brotherhood.* New York: Macmillan, 1905.

Paris, Leslie ed. *The Pre-Raphaelites.* London: Tate Gallery Publications, 1996.

Pater, Walter. *Dante Gabriel Rossetti.* Edinburgh: R. & R. Clark, 1883.

——. *The Renaissance Studies in Art and Poetry.* Berkeley: University of California Press, 1980.

Peattie, Roger W. ed. *Selected Letters of William Michael Rossetti.* University Park: The Pennsylvania State University Press, 1990.

Rossetti, Dante Gabriel. *Poems.* London: Kelmscott Press, 1894.

——. *Poems with Illustration from His Own Design.* Ed. Elizabeth Luther Cary. New York: G.P. Putman's Sons, 1904.

——. *The Collected Works of Dante Gabriel Rossetti.* London: Elvis and Elvey, 1901.

——. *Doubleworks.* www.rossettiarchive.org. Jerome J. McGann. Institute for Advanced Technology in the Humanities, University of Virginia. December 2007. http://www.rossettiarchive.org/racs/doubleworks.rac.html.

——. *Drawings and Watercolors.* www.victorianweb.org. George P. Landow. The University Scholars Programme, National University of Singapore. December 2006. http://www.victorianweb.org/painting/dgr/drawings/index.html.

Rossetti, William Michael. *Dante Gabriel Rossetti. His Family Letters with a Memoir by William Michael Rossetti.* London: Ellis and Elvey, 1895.

Rossetti, William Michael and Charles Algernon Swinburne. *Notes On The Royal Academy Exhibition, 1868.* London: John Camden Hotten, 1869.

Wilde, Oscar. *The Works of Oscar Wilde.* Ed. G.F. Maine. London: Collins, 1949.

3
Dickens À La Carte: Aesthetic Victualism and the Invigoration of the Artist in Huysmans's *Against Nature*

Paul Fox

> The matter is of little consequence; the manner is every-
> thing. Indeed, the highest skill is shown in taking matter
> apparently commonplace and transmuting it by the high
> alchemy of style into the pure gold of art.
>
> —Arthur Machen, *The Three Imposters;*
> *or, the Transmutations*

For the *fin de siècle* aesthete all of life's experiences were grist for the artistic
mill. Even the most banal of human habits could be refined into an art, and
this refinement was considered by the artist as necessary to making life
livable. The above epigraph from the 1890s writer Arthur Machen reveals that
the style in which one perceives the everyday, the capacity to transform the
trite into art, was the skill that marked the aesthete as a being apart from
others, a latter-day alchemist (105–6). In the quintessentially Decadent text,
Joris-Karl Huysmans's *Against Nature*[1] (1884), the protagonist des Esseintes has
a consuming interest in diet, and artfully redeems the daily round of ingestion
by sublimating it into an aesthetically invigorating end-in-itself. Food and
drink are employed as physiological stimuli, not as part of life's mechanical
needs or desires, but dynamically vital to the principles of an aestheticized
life. Huysmans's hypersensitive aesthete concocts a variety of culinary exper-
iments, always mindful of what is necessary to his most discriminating taste.
Through the media of meat and drink, des Esseintes's rejection of society's
mundane fare is portrayed, his preference for only the choicest of aesthetic
delicacies displayed. In France, and abroad, Huysmans's novel came to be read
as a Decadent Baedeker, the handbook not of an abstract philosophy, but a
guide to how one should live one's life artistically. Food was one of the arts of
life, and in *Against Nature* des Esseintes refines and perfects that art as a vital
stimulant for both his physical and mental existence.

The conceit of *Against Nature* being the aesthetic Baedeker for the *fin de
siècle*, that a novel can chart the avenues and *cul-de-sacs* of the artistic life, is
mirrored in des Esseintes's own conception of the literary, one which is

inflected for him in the particularly stimulating episode of a drinking bout and repast at the beginning of a journey to London. Until the moment of his departure, des Esseintes has lived in self-imposed exile from society, securing himself from what he perceives to be the distasteful Parisian bourgeoisie. But the traveler's meal across a couple of taverns, a meal he believes to be English in every detail, conjures up for des Esseintes a London so perfectly correlated to the descriptions he has read of the metropolis in Dickens that he immediately returns home, convinced that an actual journey across the Channel could in no way match the imagined experience he has had. Literary forms become incarnate through the auspices of smoked haddock and oxtail soup, port wine, and stout. Course by course, waiting for his train to the coast, des Esseintes orders up to mind detail upon Dickensian detail. The dull reality of London, after such a vivid imaginative experience, could only be a disappointment, for the reality of life always is to the Decadent aesthete. The artist's discriminating tastes require, and afford, an imaginative refinement of the quotidian before it is aesthetically palatable. It is in the detailed composition of this episode, as in the specific pattern of the meal itself for des Esseintes, that Huysmans articulates these dynamic tastes, the artist's synesthetic ability to paint his surroundings in accord with his palate.

The details in *Against Nature* were of the utmost importance to Huysmans. His early career as a writer had been dominated by the literary doctrines of Émile Zola, master of the French Naturalist school: the precise and detailed account of everyday life; the profound interest in modern science; and the refusal to shirk the writerly duty of faithfully portraying each aspect of the everyday world, no matter how banal, perverse, and grotesque such detail might seem. But Huysmans believed by the time he was writing *Against Nature* that "Naturalism was becoming exhausted from endlessly working over the same ground," that it "refused [...] to recognize exceptions; it therefore confined itself to the portrayal of existence as it is commonly experienced" ("Preface" 185, 183). He considered this Naturalistic rendition of life, one which leveled existence to the lowest common denominator, to have intruded too far into the domain of art, to have sapped the transformative energies of literature. *Against Nature* was written primarily to revitalize the decrepitude that Huysmans believed to be literarily prevalent among his contemporaries. Rather than a scientific rendering of existence, mechanical in its grubby determinism, des Esseintes was characterized as embodying a life entirely removed from physical and chemical necessity, a life that was aesthetically vitalistic. The critic Charles Bernheimer states that *Against Nature* was intended as a "kind of counter-discourse to Naturalism" (71), and Huysmans's aesthetic contemporaries certainly recognized, and reveled in, its being so. Even if Zola's reaction to the text had not been "chilly in the extreme" (Baldick 133), the author's choice of title for the novel alone would have suggested this break from the prior literary influences that had marked his work up until the early 1880s.

Despite seeing his novel as marking a rupture with his Naturalist past, Huysmans still researched the details of the text to excessive degree, precisely because his protagonist, unlike those of Naturalism, *was* exceptional, and indulged himself in exceptional pursuits. The bizarre intricacies of des Esseintes's experiments required a painstaking checking of facts: in a letter to the Belgian critic Jules Destrée, he wrote that his book was "a work of precision," that he had "spent more than eight months taking notes" (*Letters* 60). When it came to the specifics of des Esseintes's Dickensian meal, Huysmans was no less scrupulous with his research. He wrote to a friend asking for help with the plural forms of the English nouns "pudding," "stout," "porter," and "porto" (54).

It was not just the author of *Against Nature* who paid attention to all aspects of gastronomic minutiae. As in all areas of his life, des Esseintes displays a detailed knowledge of the aesthetic pleasure that the variety of food and drink can offer the artist. In his gourmand enjoyments he treats himself to an array of experiences, with some stimulating end in view, to suit his every taste. Before his idea of journeying to London, des Esseintes had already experimented with the synesthetic properties of drinks in an episode that acts as a primer for his later experience:

> He went into the dining-room, where a cupboard [...] contained a series of little barrels set side by side on minute stands of sandalwood, each pierced by a silver spigot low down in its belly. He called this collection of casks of liqueur his mouth organ.
>
> A rod linked all the spigots and controlled them with a single action, so that once the apparatus was set up, it only required the touch of a button concealed in the panelling for every tap to be turned on simultaneously and fill the minuscule goblets which stood beneath them. The organ could then be played.
>
> (*Against Nature* 39)

The intricacy and beauty displayed in the construction of the mouth organ is, of course, what one might expect of the refined aestheticism of des Esseintes. The presentation of food and drink should be, after all, of the greatest importance. The mouth organ, beyond being a work of art in itself, functions on several different aesthetic levels. In des Esseintes's imagination, each liqueur corresponds[2] to a particular orchestral instrument: the "honeyed and pungent, whining and sweet" crème de menthe and anisette being flutes; dry curaçao, "penetrating and velvety," a clarinet; palate-overpowering whisky and gin complement with the "strident blasts" of "cornets and trombones." As the drinks correspond to instruments, so they converse with each other in "tonal relationships," Benedictine standing "for the minor key of that major key made up of those cordials which commercial specifications designate by the label of green Chartreuse" (40).[3] Through mixing the

various liqueurs in particular combinations des Esseintes is able "to play himself silent melodies upon his tongue" (40). He will both follow actual pieces of music by tapping those corresponding liqueurs, and also compose his own original scores. The music he creates is based upon his own moods, for each liqueur, and each combination, sounds a different emotion for des Esseintes; vespetro, for example, is a taste "heart-rendingly long-drawn-out, melancholy and caressing" and plays the cello's part (39–40).

The synesthetic medleys that are performed on the palate of des Esseintes are, it is vital to note, aligned to *his* tastes, just as they are to his *sense* of taste. The same experiment would not be successful, in the same manner, for any other who would, by physiological necessity, have to arrange the liquid stimuli according to their own sensory and emotional reactions. The very fact that des Esseintes has the aesthetic ability to respond variously to the stimuli of the liqueurs is central to the scheme's synesthetic success. The tiny cups beneath the organ's spigots define des Esseintes's taste: refined, subtle, and hypersensitive. The bourgeois equivalent to the experiment would have bank clerks swilling pints of stout, the underclasses anaesthetizing themselves in low gin- or absinthe-dens. For Huysmans there must be a vital and dynamic correspondence between the sensitive artist and the sensory stimulus; both are meaningless without the other. Indeed, in the aesthetic scheme, neither exists without the other. It is only in the sublimation of the external world into the mind (or mouth, or through the other senses) of the artist that life becomes meaningful in any vital sense. Consequently, the sensitivity of the aesthete to the multiplicity of experiences the world has to offer is absolutely imperative. Without the refinement of taste, drink is at best a means to inebriation, at worst, a liquid like any other; without fine wines and liqueurs the gourmand is a palate incapable of color; in other words, no gourmand at all. To properly appreciate both food and drink, one's taste must be predisposed to digesting their benefit, refined to the point where it is receptive, and the imagination capable of ordering the welter of sensations the senses accumulate.

The importance of these predispositions is central to a full comprehension of des Esseintes's imaginative journey into Dickensian London and also to the Decadent aesthetic presented in *Against Nature*. Several critics have claimed this aesthetic to be self-thwarting, its experiments consistently doomed to failure. In an episode toward the conclusion of the novel, when des Esseintes's stomach has become so weak that the doctor has prescribed him enemas as his only means of nourishment, the idea occurs to the aesthete that ingesting only anally would free him from worrying about food at all. R.K.R. Thornton has suggested that this episode is Huysmans's comic means of describing des Esseintes's detestation of the world and everything in it, his desperate, but ultimately futile, attempt to escape the exigencies of reality (22–3). But here des Esseintes is not antipathetic to food, rather the normal means of ingestion that nature requires. In his weakened state, sickened by the constant vomiting, he decides on besting nature by "eating" in the most unnatural manner

he can imagine. It is not the world that the aesthete hates, rather his natural obligation to it. To the artist, life and nature collude to thwart his imaginative ambitions, and des Esseintes endeavors to perceive them as he vitally requires. Huysmans's novel would seem to suggest that the aesthete barely regards the daily round of "real" life at all, for it exists outside the artifice of his own mind, and artifice is, of course, inimical to nature. There is no aesthetic sympathy between physical need and artistic vitality.

Nevertheless, other critics, along with Thornton, see des Esseintes's apparent escape from bourgeois society as being fraught with difficulties "and his existence founded upon paradox. Although he escapes into artifice, he continually uses artifice to remind himself of the world" (Thornton 23). George Schoolfield suggests a similar worldly reliance on the part of des Esseintes, and seems almost to view him as aesthetically fortunate in the choices that he makes rather than being of a particular imaginative predisposition; of luckily happening across a particular tavern, during a particular storm, both of which are suggestive of Dickens. Disregarding the idea that the sensitivity of aesthetic choice is portrayed by Huysmans as predicated upon imaginative power, Schoolfield writes of the London episode that it

> is dependent not so much on Des Esseintes's power of imagination as on his choice of the right Parisian milieus (and the right bad weather). [...] Des Esseintes lives forever at second hand: he is a not a creator of art or literature, but reflects on what he has seen or read [...] and re-creates it, or suggests it, in words. He is in essence an arranger, a collector [...] of books, of sensations.
>
> (10)

But des Esseintes is also a critic of life and his ability to arrange his impressions, to give the manifold experiences of tawdry reality an aesthetic order and value, is precisely that which Huysmans portrays as the vital prerequisite of an artful existence. It is essential to the aesthetic revaluation of life and it is what makes life worth living.

Christopher Lloyd is another critic who sees des Esseintes's predicament in terms of a troubled relationship between the artistic imagination and worldly reality, writing that

> for Huysmans and his fictional characters there are only two solutions to the general nastiness of the social world of nineteenth-century France: to turn modern life into material for some aesthetic project [...] or, alternatively, to turn one's back on society and retreat into one's shell.
>
> (71)

These suggestions, however, bearing in mind the synesthetic compositions that des Esseintes has tasted upon his mouth organ, would seem to

misappraise the manner in which aesthetic experience functions for Huysmans. It is true that on occasion, in des Esseintes's weaker physical and emotional moments, he feels the urge to return to society from his self-imposed exile on the outskirts of Paris. But when he is most receptive to aesthetic stimuli, he has no manner of need for the outside world. And the primary reason for this aesthetic stance is that des Esseintes simply does not recognize the "real" world when he is in the realm of his stimulated imagination. All three critics quoted above see an ontological division between the artist and the matter comprising his art. But rather than des Esseintes's imagination requiring him to refer constantly back to the world, it refers him to art itself, or rather to existence aesthetically reformulated by, and impressed upon, the perceptions of the artist.

Aestheticism is a self-reflexive process: liqueurs remind the artist of pieces of music, which in turn suggest further synesthetic possibilities; English foods refer des Esseintes to his own readings of Dickens's novels. The entirety of experience is attuned to the artist's own temperament, his rarefied taste, and his imaginative ability to order that experience. The world is inflected *through* his unique personality, is a part of his own self. The project of des Esseintes is not an either/or situation where one's options are reduced to living in the world or in lonely solipsism. He does not perceive the "real" world, but rather his own immediate, imaginative rendition of it. If there is no perceptive division between life and the artist, if reality does not impose itself upon the consciousness, an object upon the perceiving subject, then discussing an external world and an individual separated from it does not at all address des Esseintes's artistic enterprise. It is only in the retreat into one's own artful personality that existence is ascribed aesthetic value.

Oscar Wilde, a major proponent of the Decadent movement in England, himself greatly influenced by Huysmans's *Against Nature*,[4] wrote that, for the aesthete,

> Technique is really personality. That is the reason why the artist cannot teach it, why the pupil cannot learn it, and why the aesthetic critic can understand it. To the great poet, there is only one method of music—his own. To the painter, there is only one manner of painting—that which he himself employs. The aesthetic critic, and the aesthetic critic alone, can appreciate all forms and modes.
>
> ("Critic" 1150)

One might add that to the gourmand, there is only one manner of dining—upon recipes of his own devising. Des Esseintes responds to his perceptions precisely as this Wildean critic-as-artist. He sees what is for others rough material in finer form, but not in its potential to be such, for that would retain the ontological division between art and life; rather he perceives the world in its immediate aesthetic efficacy, and predicated upon his own being.

Rosalind Williams, in her examination of French consumer society, discusses Huysmans's novel in terms of a precise division between subject and object, the aesthete and the external world. Obviously, a market society requires a consuming subject and objects to be consumed, and Williams presents des Esseintes as "the most memorable consumer in French literature" (127). In her critique of the novel, Williams suggests that des Esseintes has attempted to escape bourgeois mass-consumerism, the tasteless investments of Parisian middle-class society, but at Fontenay remains trapped within the same pervasive consumerist dynamic, his own aesthetic attitude being only a reactive attempt to avoid those bourgeois forces that continue to shape his own perceptions. She writes that des Esseintes

> is unable to evaluate objects independently of their market value [...] his mode of consumption is just as dependent on the mass market, just as devoid of intellectual integrity, as that of the butchers' wives. As soon as an object becomes available to the "common herd" he rejects it, irrespective of its intrinsic merits. [...] The market des Esseintes has tried to flee invades even his hermitage at Fontenay, forcing him to reject amethysts and Rembrandts and a host of other objects.
>
> (137)

But des Esseintes leaves Paris not to escape mass-consumerist society *per se*, but rather its pervasive tastes which can so easily pollute his own. When an object is adulterated by the force of bourgeois prejudice, the artist's consumption of such a reality is the aesthetic equivalent of gorging on rotten meat, a poisoning of his own well-being. It is true that at those moments in the novel when he is physiologically weak des Esseintes finds a consumerist reality forcing itself upon his consciousness, but those moments only underline the fact that during other episodes, such as the journey to London, when his aesthetic imagination works upon life fully, the attitude that divides the world into subject and object is precisely the one the artist seeks to avoid. Des Esseintes rejects only that which has already been corrupted, aesthetically polluted for him by consumerist tastes.

The distinction between the valueless world of consumerism where the individual finds the investments of the external world imposing themselves upon him, and the moment of aesthetic consumption when the division of a perceiving subject from a separate object becomes meaningless *in the act of consumption itself*, is central to Huysmans's novel. At Fontenay, by avoiding the bourgeois prejudices that continue to develop in Paris, des Esseintes is attempting to keep his own perceptions unpolluted. The aesthete does not "invest" in objects as Williams suggests (147). It is his project to remove any such distinction between himself and an objectifying, external world where, outside Fontenay, consumerist investment and insinuation does, indeed, hold sway. Des Esseintes's journey toward London will reveal his engagement

in just such a project, one in which the bourgeois divisions between the world and the individual are ignored in the act of aesthetic consumption. The stimulus behind des Esseintes's desire to travel to England comes from two sources: his having recently read Dickens while ill, "evoking visions of English life that he would mull over for hours" (*Against Nature* 105); and the stormy weather that he observes from the window of his house at Fontenay, on the outskirts of Paris, that "further encouraged these thoughts, by intensifying the memories of his reading, by constantly placing before his eyes the image of a land of mist and mud" (105). In his mind, des Esseintes is already in London. So strong is the power of his imagination, that he presumes the mental image he has created to be the reality, and decides to set off to see the sights. He dresses accordingly, as he is playing a part written for him in his own drama: "observing the gloom of the day, the drab monochrome of his outfit, thinking of the object of his enterprise, he quickly chose a pair [of socks] in dingy green silk" (104). In the same manner in which Huysmans pays attention to the smallest details of his novel, des Esseintes revels in the minute detailing of his attire. Draping himself in an inverness coat, and topping his ensemble with a bowler hat, he feels himself to be well suited to his role, and departs for the Paris station.

In the train he closes his eyes, ignorant of the countryside flashing by outside, and sinks into his own thoughts. Existing in the realm of his imagination, he has no sense of these drear external realities, literally does not perceive them. They conform to his expectations, and that is sufficient. In central Paris he already sees London:

> this dreadful weather was already an instalment of England that he was being paid in Paris; a rain-swept, gigantic, measureless London, stinking of heated metal and soot, smoking everlastingly in the fog, was unfolding now before his gaze [...] All this activity was taking place on the waterfront, and in vast warehouses washed by the dark, scummy waters of an imaginary Thames.
>
> (106)

Against this imagined background, des Esseintes enters the "Bodega," a cellar-tavern frequented by travelers on the Rue de Rivoli.

The room is a grander version of the Fontenay mouth organ, all spigots and casks of wines and liqueurs. And the Bodega affords des Esseintes a similar aesthetic experience to that which his earlier experiment allowed; but this time the drinks are redolent of Dickensian literature, not the fugues and funeral marches of classical composers. Des Esseintes orders a glass of port from an English barman, while around him swarm a host of damp, steaming Britons, sheltering from the rain before their journeys continue. The cellar's clientele are "ungainly, pasty-faced clergymen, dressed from head to

foot in black [...] men with coarse, pork-butcher faces, others with bulldog snouts, apoplectic necks, tomato-like ears, bibulous cheeks" (109). Des Esseintes, in this atmosphere, lets

> His mind drift, picturing, under the crimson tints of the port wine filling the glasses, the Dickensian characters who so enjoyed drinking it [...] seeing here the white hair and fiery complexion of Mr Wickfield, there, the cold, cunning expression and implacable eye of Mr Tulkinghorn, the lugubrious solicitor of *Bleak House*. These characters were actually emerging from his memory and installing themselves, complete with all their exploits, in the Bodega; [...] bottles of wine were being unhurriedly poured by Little Dorrit, by Dora Copperfield, by Tom Pinch's sister.
>
> (110)

In his literary imagination, stimulated by a glass of port, described as perceiving *through its crimson tints*, des Esseintes sees in the tavern the Dickensian characters he knows from their novels.[5] He luxuriates in his immediate environment, "listening to the sepulchral hooting of the tugs travelling down the Thames, behind the Tuileries" (110). The boulevards and gardens of Paris are overcome by the smogs off the London river. This is Dickens inflected by des Esseintes and refracted through the stimulating hue of a glass of ruby-red fortified wine.

The extraordinary stimulus of food and drink to the aesthetic imagination becomes apparent when des Esseintes follows his port with a glass of amontillado. His new tipple inspires his literary mind in an immediately new direction, ousting the Dickensian scene and characters momentarily: "the soothing stories of the English author vanished, and in their place appeared the harsh revulsives, the painful skin irritants of Edgar Allan Poe; the chilling nightmare of the cask of Amontillado, of a man walled up in an underground vault" (110). The horror of this reconstituted cellar is promptly vanquished when des Esseintes notices that the Bodega is emptying of its customers as they depart into the rain looking for restaurants to serve them dinner. Des Esseintes leaves with the same inclination. Outside in the appalling weather, his perception is once more aligned with the vision of a dark, glum London.

The clientele of the tavern at which he arrives is similar to that of the Bodega. Des Esseintes sees "islanders with china-blue eyes, purple faces, and pensive or arrogant expressions [...] only here there were some pairs of unaccompanied women dining on their own, sturdy Englishwomen with boyish faces, oversized teeth, apple-red cheeks, long hands and long feet. They were attacking a beefsteak with unfeigned zest" (111). Des Esseintes observes the customers in the tavern, and is delighted to note, looking at his own clothes, that their "colour and cut [...] did not differ in any obvious way from those of his neighbours, and he knew the satisfaction of not looking out of place

in these surroundings, of being [...] a naturalized Londoner" (112). He proceeds to order "rich, smooth, greasy, and substantial" oxtail soup, followed with smoked haddock; his appetite stirred by "watching others gorge," he proceeds to sirloin and potatoes washed down with two pints of English ale (112); after a sharp blue Stilton, some rhubarb tart and a glass of porter, he nears repletion; with a cigarette and a coffee laced with gin, his meal concludes. Des Esseintes's gustatory surprise is that he has eaten so lavishly, and to such great extent, for the first time in many months. Up until his departure for London, he has been almost incapable of ingesting anything but the weakest of broths. It is not at all startling that he should ask himself whence these new appetites have come.

As aesthetic impressions vitalize the artistic mind receptive to them, in a self-reflexive and absorbed round, so des Esseintes's imaginative conception of himself as a Dickensian Londoner requires certain appetites, appetites that are self-fulfilling in their power to stimulate that imaginative conception. He eats oxtail soup and sups porter because that is what Dickens's Englishmen do, and in doing so adds to the literary picture of himself he has composed. The stimulus of his meal proliferates into des Esseintes's entire environment, while in each course is present the confluence of his impressions: the French tavern becomes English, Paris becomes London incarnate (literally, "in the meat" of the sirloin he wolfs down). It would seem that one's aesthetic reality can be revitalized by nibbling a small piece of blue-veined cheese.

The critic Robert Zeigler, quite probably responding to des Esseintes's London episode, suggests that in *Against Nature* "[m]aterial taken directly from reality is served up raw and therefore proves to be indigestible, requiring that it undergo a second culinary presentation that refines it into art" (139). This critical premise again neglects the unifying power of the aesthete's imaginative perceptions, enforcing the division between the artist and his material. The suggestion is that des Esseintes works to reform the world seen as an object that itself exists to the passive consciousness. But it is quite clear that, for the aesthete, there should be no "raw" reality, perceived as such, involved in the artistry of his active imagination, no series of cognitive steps from life to art, for the time des Esseintes spends in the Bodega and the tavern is entirely, and immediately, inspired by his own literary perspective. The refinement of reality does not occur as a willed and conscious exercise, as if the world were fodder for the artist to snuffle through, and chew over; rather this refinement takes place in the immediacy of the artist's reception of his environment when stimulated aesthetically, through the refraction of his own personality. And in this Dickensian episode food is the chief stimulant for des Esseintes, to such an extent that he eats as he has not eaten for months. His aesthetic appetite has been thoroughly whetted for every course set before him.

The "Englishness" of the scene continues when the bill is brought to des Esseintes's table by a waiter, "an individual dressed in black carrying a napkin

over his arm, a kind of major-domo with a bald, pointed head, a greying, wiry beard, no moustache, and with a pencil behind his ear" (113). In his imaginative state, des Esseintes is surprised at the appearance of this "unexpected John Bull" (113). Knowing that he should be leaving to catch his train, but finding himself languorously incapable of moving from behind his table, he asks, "What was the point of moving when one could travel so splendidly sitting in a chair? Wasn't he in London now, surrounded by London's smells, atmosphere, inhabitants, food, utensils?" (114). He considers further: "Ever since leaving home I've been steeped in English life; I would be insane to risk losing, by an ill-advised journey, these unforgettable impressions" (114). Replete after his meal, and stimulated imaginatively in inverse relation to his physical energies, des Esseintes orders his bags back to Fontenay, returning "feeling as physically exhausted and morally spent as a man who comes home after a long and hazardous journey" (114).

The only irruptions of reality during des Esseintes's aesthetic journey seem to have been the repeated insistencies of his schedule to be punctual for the coastal train. At several points in his Dickensian reveries, he is interrupted by the necessities of time. Food and drink may have effected an aesthetic transformation in spatial terms: Paris becoming London, the Tuileries swept away under the Thames, and customers metamorphosed into characters from novels; but might the same be said of des Esseintes's experience in temporal terms? Is time the one fact that the imagination cannot transfigure, whatsoever the stimulus might be?

There are two very different temporalities operating in the Bodega and the tavern where des Esseintes eats. One is "real" time, and is governed by the watches in waistcoat pockets, by the station schedule sitting on the table, the departure of customers to eat at dinner time, and the persistent sounds of trains departing on their appointed hour. By and large, des Esseintes ignores these interruptions, on occasion actually perceiving them as part of his imagined London, the trains' whistling becoming the honking of barges making their way up the Thames. The experience undergone by des Esseintes during his meal is one of immediate and momentary perceptions, unalloyed by any conscious awareness that each one builds upon the others incrementally through time. Each aesthetic moment contains all of the perceiver's accumulated experiences, not just in spatial terms, but also in the sense that time is imaginatively compressed in the mind of the aesthete. Each course of his meal is relished by des Esseintes as being not only the consummation of his own version of Dickens's London, but also as the only aspect of his experience that is consciously present at any given moment. There is no refinement or art in pondering dessert when ordering one's fish course.

This idea of the aesthetic moment is implicit in Huysmans's novel, based upon the concepts of the immediacy of experience and the self-reflexivity of aesthetic vitality. Imaginative stimuli feed themselves from each moment to

the next, but each moment serves as, and appears to the mind, an end-in-itself. These ideas are seen most clearly articulated by Walter Pater, the chief proponent of the English Aesthetic movement, in the conclusion to his *Studies in the History of the Renaissance* (1873).[6] Pater views the entirety of physical life, the individual's and the world's, as a combination of the same dynamic forces: "Like the elements of which we are composed, the action of these forces extends beyond us: it rusts iron and ripens corn" (150). There is no division between what constitutes man and nature, no exteriority to the aesthetic imagination. Life is "but the concurrence, renewed from moment to moment, of forces parting sooner or later on their way" (150). Aesthetic experience is, for Pater, a vitalistic series of ever-altering impressions perceived only as inflected by personality: "Every one of those impressions is the impression of the individual in his isolation, each mind keeping as a solitary prisoner his dream of a world [...] all that is actual in it being a single moment" (151).

Des Esseintes's aesthetic is precisely that of Pater's. He refines his personality to be hypersensitive to dynamic stimuli, feeding his own imaginative perception of existence. As he consumes his tavern meal, he is the summation of the world that he has created for himself; his present perception is at one with his repast. Spatially, exteriority is subsumed into the aesthetic individual's imagination. Linear time, the pressing concerns and schedules of the world, is made redundant in the aesthete's immediate reception of life from moment to moment. Each new perception is all that is actual; the imagination perceives only each present as it is brought into being. What is ingested by des Esseintes is not only physiologically vital but is aesthetically vitalistic. The dynamism of his impressions invigorates his momentary being, his redeeming of life from itself. The tedium and dross of the everyday world is sloughed by the aesthete; his is the capacity that Pater praises in his novel *Marius the Epicurean*, "the art, namely, of so relieving the ideal or poetic traits, the elements of distinction, in our everyday life [...] that the unadorned remainder of it, the mere drift or *débris* of our days, comes to be as though it were not" (31–2).

Critics have read *Against Nature* as a novel where nothing of any substance really happens, in terms of both time and space. This criticism evidently underestimates the interiority of the novel's structure, the fact that it is the story of the unmediated power of the aesthetic personality and the moment-to-moment artistic finesse of the imagination. The critic David Weir has suggested that the spatial and temporal aesthetic of des Esseintes as being reflected in the structure of *Against Nature* itself. He remarks that as aesthetic activity in the novel is generally spatially restricted to the house at Fontenay, so the novel's temporal dimension is always confined to the present, apart from the "Notice" at the start of the novel, and the conclusion (Weir 95–6).[7] When des Esseintes leaves Fontenay at the beginning of his journey, he tells his staff that he has no idea when he will return, "in a year,

in a month, in a week, perhaps sooner" (*Against Nature* 104). It is as if the author writes the common understanding of time out of des Esseintes's mind, as if the character does not know the signification of the words he uses. When he returns he is as exhausted as if he has been on a long, arduous journey, and this only after one day's travel. But in the imaginative experiences he has undergone, he has traveled far and at length. This is physiologically evident: worn out in mind and body des Esseintes retires to his quiet home.

In the Bodega and the tavern where he dines on Dickens à la carte, des Esseintes enjoys the most aesthetically composed of meals. It is true that the drinks and fare are not exceptionally rare dishes, but they are imaginatively rarified to vitalize the tastes of an exceptional, in that it is a unique, personality. The meal is not exquisitely prepared in the kitchens by a culinary genius, but by the refined personality of des Esseintes himself. Dining is not rushed for the aesthete; he has all the time in the world, for both life and time are transfigured through his own momentary tastes. In the stimulating round of artfully prepared dishes and drinks, Huysmans displays the self-perpetuating vitalism of the aesthete, one in which the gourmand is presented as both necessary to, and the arbitrator of, what is fine, and worthy of his palate.

Notes

1. Published in France as *A Rebours*, a title variously translated into English as "Against the Grain" and "Against Nature." There is no exact translation possible from the French phrase, but "Against Nature" is the most frequent attempt.
2. The synesthetic *correspondances* between the different senses echo Baudelaire's poem of that same name.
3. Des Esseintes registers with seemingly snide disdain the unsubtle and indiscriminate commercial classification of all Chartreuse liqueurs as one amorphous type. This highlights not only his own more refined sense of discrimination, but also his recognition of society's clumsily inadequate sense of taste.
4. The book lent by Lord Henry Wotton to Dorian Gray, which so influences the young man's life and thought, was said to have been *Against Nature*. When Wilde was arrested in 1895 for gross indecency he was reported (inaccurately, as it later transpired) to have been reading Huysmans's novel when the constables arrived.
5. Seeing *through* the port wine captures the concept of both the stimulant-as-means and medium, the capacity to color the entire experience in which des Esseintes finds himself.
6. The title of *Studies in the History of the Renaissance* was changed in the second edition of 1877 to *The Renaissance; Studies in Art and Poetry*, to emphasize the impressionistic and aesthetic, rather than the "factual" and "real" historical aspects of Pater's text. Jan B. Gordon highlights this aestheticization of materialist history when she writes of Pater's alteration of the title that "he recognized that history is redeemed by its transposition to art" (40). This aestheticization of life is, of course, perfectly in keeping with des Esseintes's practice.

7. I have suggested that this analysis might be taken a step further: space and time are confined to des Esseintes's own aesthetic perceptions, and the novel's structure, in its "presentism," mirrors these vitalistic perceptions.

Works Cited

Baldick, Robert. *The Life of J.-K. Huysmans*. Oxford: Clarendon, 1955. Sawtry, Cambridgeshire: Dedalus, 2006.

Bernheimer, Charles. *Decadent Subjects: The Idea of Decadence in Art, Literature, Philosophy, and Culture of the Fin de Siècle in Europe*. ed. T. Jefferson Kline and Naomi Schor. Baltimore, Maryland: Johns Hopkins UP, 2002.

Gordon, Jan B. "'Decadent Spaces': Notes for a Phenomenology of the *Fin de Siècle*." *Decadence and the 1890s*. Stratford-upon-Avon Studies 17. ed. Malcolm Bradbury and David Palmer. London: Edward Arnold, 1979. 31–60.

Huysmans, Joris-Karl. *Against Nature*. Trans. Margaret Mauldon. ed. Nicolas White. Oxford: Oxford UP, 1998.

———. "Preface, 'written twenty years after the novel.'" Appendix. By Huysmans. *Against Nature* 183–97.

———. *The Road from Decadence: From Brothel to Cloister. Selected Letters of J. K. Huysmans*. ed. and trans. Barbara Beaumont. London: Athlone, 1989.

Lloyd, Christopher. *J.-K. Huysmans and the Fin-de-siècle Novel*. University of Durham Ser. 3. Edinburgh: Edinburgh UP, 1990.

Machen, Arthur. *The Three Imposters; or, the Transmutations. The Three Imposters and Other Stories: The Best Weird Tales of Arthur Machen 1*. Canada: Chaosium, 2000. 101–234.

Pater, Walter. *Marius the Epicurean*. ed. Ian Small. Oxford: Oxford UP, 1986.

———. *The Renaissance: Studies in Art and Poetry*. ed. Adam Phillips. Oxford: Oxford UP, 1986.

Schoolfield, George C. *The Baedeker of Decadence: Charting a Literary Fashion, 1884–1927*. New Haven and London: Yale UP, 2003.

Thornton, R.K.R. *The Decadent Dilemma*. London: Edward Arnold, 1983.

Weir, David. *Decadence and the Making of Modernism*. Amherst, Massachusetts: U of Massachusetts P, 1995.

Wilde, Oscar. "The Critic as Artist." *Collin's Complete Works of Oscar Wilde*. Centenary edn, Glasgow: HarperCollins, 1999. 1108–55.

Williams, Rosalind H. *Dream Worlds: Mass Consumption in Late Nineteenth-Century France*. Berkeley and Los Angeles, California: U of California P, 1992.

Ziegler, Robert. *The Mirror of Divinity: The World and Creation in J.-K. Huysmans*. Newark: U of Delaware P, 2004.

Part II Reconsidering Turn-of-the-Century Aestheticism

4

Aesthetic Vampirism: Pater, Wilde, and the Concept of Irony

Andrew Eastham

This chapter considers the criticism and fiction of Pater and Wilde according to the decadent symbol of the vampire, in which aestheticism appears to literally embrace the inhuman. Its central argument is that during the evolution of nineteenth-century aestheticism the vampire came to embody the concept of irony: this was a paradoxical embodiment, since it is the very nature of irony to turn against the embodied figure and the nature of the ironist to perform his own detachment from expressive forms. My second and related argument is that the ironic condition of aesthetic vampirism is related to the status of the art-object in modernity—independent from devotional or instructional purposes, from fixed tradition or home and, for Baudelaire or Wilde, from morality and realist imitation. By insisting on this autonomy, aestheticism risked the identification of art as an aristocratic posture of irony, its detachment manifested as an icy reserve, a refusal to manifest itself in the public sphere comparable to the vampire's refusal of daylight. The autonomy of art was both a freedom and danger, but taken to its extreme, the insistence on aesthetic independence might give birth to the inhuman. Articulating such an anxiety in the wake of modernism Ortega y Gasset described a "dehumanization of art" induced mutually by the idea of the autonomous object and the destructive attitude to traditional art, a tendency which left avant-gardists "doomed to irony" (Ortega y Gasset 46). Writing in 1925, Ortega y Gasset identified a contrary humanist principle prior to modernism: the "works of art that the nineteenth century favoured invariably contain a core of 'lived' reality which furnishes the substance, as it were, of the aesthetic body" (Ortega y Gasset 24). But the process of de-humanization Ortega located in modernism might well be regarded as the development of nineteenth-century aestheticism. Perhaps the most sensational manifestation of this inhuman turn was the aristocratic irony and immorality of Oscar Wilde's fictional dandies, Lord Henry Wotton and Dorian Gray. *The Picture of Dorian Gray* has indeed been frequently identified as a vampire novel in all but name, and one of the primary tropes of the novel, the living portrait, is framed by an engagement with Walter Pater's earlier evocation of the

Mona Lisa as a vampire in his essay on "Leonardo Da Vinci." These literary treatments of the haunted portrait can be regarded as two of the classic texts of aesthetic vampirism, but both authors were clearly troubled by the implications of the vampire figure.

If the vampire represents the body without substance or "lived" reality, detached from historical actuality and sensuous presence, then it betrays some of the primary values espoused by the aesthetic Hellenists that emerged from Victorian Oxford. Pater's essay on "Winckelmann" announced a "more liberal mode of life" based on the revitalization of sensuous experience and the progressive development of spirit (*Renaissance* 146). Pater followed Hegel's model of the development of art through a series of cultural phases, reiterating the Hegelian demand that art should be the sensuous manifestation of spirit. In the first edition of "Winckelmann" (1867), art is "a *Versinnlichen* of the idea—the idea turned into an object of sense," and the embodied beauty of the Greek sculpture constitutes its ideal medium (94). This is clearly difficult to reconcile with the insistence on ironic detachment and critical self-consciousness that characterized later documents of aestheticism, such as Wilde's "The Critic as Artist" (1890). Aestheticism was the site of a conflict between an ideal of sensuous aesthetic embodiment and the striving for irony, cosmopolitan detachment, and abstraction, but this tension was integral to the discourses of German idealist aesthetics on which Pater and Wilde's thought was founded. The problematic status of irony was already apparent in the late eighteenth century, in the conflicting positions of Hegel and the German Romantic ironists. Hegel identified the concept of irony as the final product of aesthetic modernity, which had been epitomized by the highly subjective tendencies of the Romantics, particularly the work of the Schlegel brothers. In the overarching narrative of Hegel's *Aesthetics*, irony is the dangerous supplement that he was forced to contain—a seed planted by Kant and nurtured by Fichtean subjectivism until it finally bloomed as a hothouse flower in the work of Friedrich von Schlegel. Schlegel's mode of Romantic irony effectively combined an aesthetic of impersonality and poetic detachment with an ideal of unconstrained play,[1] but this detachment was interpreted as a flagrant refusal of social and ethical commitments. In what we might take as an early and prototypical critique of aestheticism as a de-humanizing principle, Hegel associated Schlegel's Romantic irony with "living as an artist and forming one's own life artistically" (Hegel I: 65), but in such a way that the ironist always remained detached from his elaborate performances. Irony was a moral danger insofar as this performance of detachment replaced the organic body of the community with an absolute subjectivity, and Hegel rejected the "quiescence and impotence" (Hegel I: 66) of the ironist as a "source of yearning and a *morbid* beautiful soul" (Hegel I: 67).[2]

Only a decade later, Hegel's critique of irony was developed at great length by Kierkegaard in his doctoral study, *The Concept of Irony* (1841), and it is

here that the nineteenth-century relationship between irony and vampirism was cemented. Kierkegaard develops his theory from the example of Socrates, who is credited with the extraordinary achievement of inaugurating the spirit of irony in world history. Socrates stood up for the purely negative principle of absolute subjectivity, and this became both a sublime freedom and a curse. Addicted to the experience of beginnings, the Socratic ironist is always "negatively free and as such suspended, because there is nothing that holds him" (Kierkegaard 262). Living absolutely by moods (Kierkegaard 284), his total subjectivism develops into a wasting disease, and Kierkegaard identifies this disease as vampirism. Socrates is a vampire insofar as he embodies the concept of irony:

> There quietly develops in the individual the disease that is just as ironic as any other wasting disease and allows the individual to feel best when he is closest to disintegration. The ironist is the vampire who has sucked the blood of the lover and while doing so has fanned him cool, lulled him to sleep, and tormented him with troubled dreams.
>
> (Kierkegaard 49)

In spite of the dialectical complexity of Kierkegaard's work in relation to irony and the aesthetic life, his determination of irony as a wasting disease here prefigures the terms of Max Nordau's *Degeneration* (1895)—the famously paranoid critique of aestheticism as a pathological condition of egomania. Yet Kierkegaard's ethical psychology is more subtle: his image of the vampire suggests the anxieties of the limitless freedom experienced by the ironist, translating the negative relationship with the speech act into a general refusal of any temporally limited identity. Since irony gives the illusion of limitless possibilities, it sucks the blood out of the present, and Kierkegaard goes on to diagnose this ironic disintegration according to the subject's relationship with history. One of the vampire ironist's foremost sins is his renunciation of historical actuality, what Hegel would see as the substance of the ethical life,[3] and Kierkegaard determines this suspended position as "the purely negative dialectic that continually remains in itself, never goes out into the qualifications of life or of the idea" (135). As Sylviane Agacinski comments, "for Kierkegaard irony will always be what eludes Hegelian sublation (*Aufhebung*)" (44). As the spirit of irony, the vampire preserves the negative moment in dialectical development, but prevents it from being turned back into a positive movement in the manner of the Hegelian process of sublation. As an immortal and undead subject, it thwarts the humanist discourses that dominated the nineteenth century—the idea of dialectical development and the progressive sense of modernity as the unfolding of the European spirit—substituting them with a sublime aesthetic disengagement.

When this demonic irony found artistic expression in the nineteenth century, it assumed a gothic form, finding its most dangerous face in Baudelaire's

poetry. In *The Flowers of Evil* (1861), irony is not only a rhetorical method but an inhuman force: in the final movement of the volume Baudelaire elucidates a compulsive striving for negation—"The Taste for Nothingness" (153)—a self-torturing consciousness which, in "Heautontimoroumenos" is determined as a "voracious irony."[4] The poet's ironic compulsion establishes a "dissonance in the divine symphony," and Baudelaire imagines this negation in the figure of the vampire: "I am the vampire at my own veins" ("Je suis de mon coeur le vampire") (156). In the next poem of the sequence, "The Irremediable," the negative force is an "ironic, infernal beacon" ("Un phare ironique, infernal"), but Baudelaire embraces this vampiric irony within the same terms that Hegel rejected it, as the ultimate refinement of self-consciousness at work on its own collapse (160). Baudelaire's staging of this figure takes the form of a metaphysical melodrama, where irony is embodied as a Satanic principle, and this has the consequence of precluding the possibility that irony might be reincorporated into the civic realm: in *The Flowers of Evil* irony is a performance of subjectivity at its dangerous limits.

Like Stoker's Count Dracula,[5] Baudelaire's gothic irony subsequently migrated across Europe into the very soils where the Arts and Crafts movement was developing its more earnest ideals of artistic labor as the re-humanizing of an impoverished industrial landscape. If Ruskin and Morris were striving to formulate a democratic ideal of an aesthetic life, then the influence of Baudelaire on figures such as Swinburne and Pater would assist the development of an alternative strand in British aestheticism, where a refined aesthetic subjectivity began to replace the laboring craftsman, and a spectral and haunted gothic replaced Ruskin's civic model of gothic culture.[6] Walter Pater made a subtle but provocative announcement of this transformation in "Aesthetic Poetry" (1868), his review of William Morris's poem "The Earthly Paradise," included in *Appreciations* (213–27). Using Baudelaire's idea of the "artificial paradise" to describe Morris's utopian idylls, Pater determined his poetry as a haunted or spectral form: "Of that transfigured world the new poetry takes possession, and sublimates beyond it another still fainter and more spectral, which is literally an artificial or 'earthly paradise'" (*Appreciations* 213). Pater is hardly faithful to the idea of the "earthly paradise" here, since the "transfigured world" he celebrates is clearly unearthly, "spectral," and de-humanized. He goes on to diagnose this poetic aspiration as an "inversion of home-sickness [...] which no actual form of life satisfies" (213–4). This diagnostic representation of Romanticism contains a distinct echo of Hegel's critique of the Romantic ironist, whose "craving for the solid and substantial" is symptomatic of a contrary drive toward unfettered detachment (66). For Hegel the *"truly* beautiful soul acts and is actual," (67), and Pater's assertion that the spectral poetry demands a renunciation of any "actual form of life" suggests a tacit adherence to the logic of Hegel's critique at the very moment when he appears to support Baudelaire's distant and tortured vision of an artificial paradise.

Pater's evocation of the spectral presence of "Aesthetic Poetry" works as a prelude to the many haunted presences that inhabit his work. The most famous of these is the figure of vampire which emerges in his essay on "Leonardo da Vinci" (1873).[7] Pater famously describes *La Gioconda* as an embodiment of vampirism, exploiting the capacity of the image to suggest the inaccessible inner subjectivity through its opaque and haunted surface. Pater begins the passage with an idealist conception of beauty as the sensuous manifestation of inner soul: "It is a beauty wrought out from within upon the flesh" (*Renaissance* 98), but the idea that the Mona Lisa's spirit is sensuously present in the image is soon undermined by a consistent focus on absence and death. The passage which Yeats translated into poetic form evokes this absence as a principle that has presided throughout history:

> She is older than the rocks among which she sits; like the vampire, she has been dead many times, and learned the secrets of the grave, and has been a diver in deep seas, and keeps their fallen day about her; and trafficked for strange webs with Eastern merchants: and, as Leda, was the mother of Helen of Troy, and, as Saint Anne, the mother of Mary; and all this has been to her but a the sound of lyres and flutes, and lives only in the delicacy with which it has moulded the changing lineaments, and tinged the eyelids and hands.
>
> (*Renaissance* 99)

The Mona Lisa has in one sense lived an absolutely discontinuous existence— "like the vampire," she is repeatedly reanimated as a subterranean hidden presence, or as Leda, Saint Anne, and so many mythical mothers. At the same time she eludes the protean identity of mythical embodiment, experiencing the panoply of different incarnations "but as the sound of lyres and flutes"—her famously elusive gaze suggesting her ultimate disengagement. Immediately before the identification of the Mona Lisa as vampire, Pater has described this disengagement in terms of the historical being of the portrait. The aim of the object is to express the spirit of the successive world-historical epochs; "the animalism of Greece, the lust of Rome, the mysticism of the middle ages," (*Renaissance* 98), but the power of Lady Lisa ultimately derives from her position in excess of this evolutionary telos, since to Lady Lisa the historical phases are merely "moods." It is this excess which establishes her as a paradoxical figure of irony.

In the final section of his evocation of *La Gioconda*, Pater directly engages with this relationship between the figure of the vampire and the conception of history according to which "modern philosophy has conceived the idea of humanity as wrought upon by, and summing up in itself, all modes of thought and life" (*Renaissance* 99). This clearly alludes to the Hegelian conception of a developmental history, which had such a crucial influence on Pater's essay on "Winckelmann" and provided him with a conception of art history as a progressive evolution of spirit toward self-consciousness.

By framing *La Gioconda* in these terms, Pater suggests that the image is the final stage of history and the most complete realization of aesthetic modernity, but the nature of this stage is nevertheless uncertain. For Daniel O'Hara, Pater "discloses the ironic muse of modern literature" precisely in the presentation of Lisa as a summation of historical epochs: "the aesthetic ideal, as Pater sees it, requires the cultivation of an ironic detachment, a studied indifference, to the direct phases of life. This ironic pose is best shown in Pater's contention that one must view all phases of culture, classic, medieval, and modern as necessary to the progressive development of the human spirit" (23). O'Hara suggests that the irony of the Mona Lisa is the evolutionary *telos* of world history, the end result of modernity as a developmental process. But the irony of the La Gioconda may be more radical than this, resisting the Hegelian ideas of summation and development altogether: through the figure of the vampire, Lady Lisa is determined as outside of history—aesthetic vampirism might then be regarded as a symptom of the striving to abstract the idea of art from historical becoming.

The way that Pater introduces the figure of the Mona Lisa continually undermines any attempt to identify her with a historical process or spirit of development. The idea of the image as a historical synthesis is developed in the assertion that the thoughts of the world have been "etched and moulded there, in that which they have of power to refine and make expressive the outward form" (*Renaissance* 98), but it is important to register at this point that the space of the image, "*there,*" is straining toward its limits as a textual deposit: "that which they have of power to refine" suggests that there are limits to this power, that there is always an invisible remainder to the signifying process. The final sentences of the passage increasingly focus on the problematic status of the image and the inaccessibility of the Mona Lisa, both as a subject and as an idea, and Pater ends with a speculation on the conditions of interpretation, rather than a statement about the object: "Lady Lisa *might* stand as the embodiment of the old fancy, the symbol of the modern idea" (*Renaissance* 99, emphasis added). It is worth stressing the conditional here, which might be extended into a more radical uncertainty about the possibility of interpretation. The hermeneutic condition instated by this vampiric irony means that the conceptual content of the object is opaque, provoking a series of questions: how is the "old fancy" related to the "modern idea?" If the "old fancy" is equated with "the fancy of a perpetual life" (*Renaissance* 99), this might suggest that the desire which is invoked by the image is the desire for vampirism. If we are to interpret the "modern idea" as the vampire's ironic detachment from history and the image, then we might see this striving for Romantic irony as a refracted form of the "old fancy" for immortality. The uncertainty inherent in Pater's conceptual terms is exacerbated by the discourse of representation he uses; the aesthetic terms here are "embodiment" and "symbol," but they are used to introduce a spectral figure who is more alive as an abstract spirit than

in a body. The extent to which the ideas and fancies constellated around the Mona Lisa can be embodied, when Pater's *ekphrasis* is motivated and haunted by absence, poses more general questions about the condition of the artistic image as a conceptual vehicle. How can the modern object be said to embody the infinite possibilities of subjective spirit when it is limited by its immobile medium? What are the relative claims for symbolization and embodiment that Pater is mobilizing in his account of *La Gioconda*?

The contradiction at the heart of Pater's reading of *La Gioconda* is that if the "modern idea" is to be taken as the ironic detachment which abstracts the image of Lisa from history, then she is the symbol of precisely that principle which resists symbolization. Lisa is the figure or embodiment of the desire which cannot be figured and a symbol of the spirit which eludes symbolization. Like Baudelaire's "voracious irony" which is both "the knife and the wound it deals," this might be read in Paul De Man's terms as the production of "irony to the second power or 'irony of irony'" (De Man 218), a process which effectively stalls any capacity for reconciliation with the empirical world. De Man reads this kind of absolute irony as an instantaneous event, the negative suggestion of infinite potential revealed in a performative moment.[8] Yet in Pater's case the temporality of irony is quite different; when irony becomes vampiric it is as if the negative moment has been frozen in Lady Lisa's gaze. As Carolyn Williams suggests, "one cannot look at her face through the lens of Pater's prose without becoming, like her, immobile in the collapse of temporality" (121). The effect of this immobilising of consciousness is that the ironic distance of Lady Lisa appears to establish itself as an object. According to the anthropomorphic process, irony has achieved the status of the autonomous object, while at the same time being uncannily resistant to the sensuous material of the work of art. Adapting Goethe's idea that architecture is "petrified music" (267), we might say that *La Gioconda* is irony frozen into the solid state of painting, and this would suggest the more general relationship between irony and artistic autonomy which I have mobilized as a constitutive feature of nineteenth-century aestheticism. Conversely, we might see irony as the gaseous form of the art-object when, like the vampire in hiding, it assumes the form of a creeping mist. Irony is a mimetic desire for the autonomous object of art, and a striving for release from the body of representation.

This relationship between the condition of aesthetic subjectivity and the autonomous artwork is a consistent feature of Pater's work, and is central to the general account of the life of Leonardo da Vinci which precedes the evocation of *La Gioconda*. In the miniature *bildungsroman* typical of *The Renaissance*, Leonardo is identified from the outset within the terms of Romantic irony, as Pater notes "his high indifference, his intolerance of the common forms of things" (*Renaissance* 77). Just as Kierkegaard identifies the ironist with discontinuity and moods, Pater sees Leonardo's life as "one of sudden revolts" (*Renaissance* 77); the artist strives by negation, "for the

way to perfection is by a series of disgusts" (*Renaissance* 81). This oscillation between indifference and disgust appears to be an essential aspect of Leonardo's devotion to artistic perfection, and Pater goes on to distinguish his attitude to art in the terms of a modern conception of aesthetic autonomy, comparing Leonardo's "solitary culture of beauty" to those artists motivated by moral or political concerns:

> Other artists have been as careless of present or future applause, in self-forgetfulness, or because they set moral or political ends above the ends of art; but in him this solitary culture of beauty seems to have hung upon a kind of self-love, and a carelessness in the work of art of all but art itself.
>
> (*Renaissance* 92)

The devotion to "all but art itself" is described in terms of the Kantian definition of the idea of beauty as an "end in itself," as for Leonardo "the exquisite effect woven, counted as an end in itself—a perfect end." The terms for the fashioning of Leonardo's personality and his fashioning of the perfect object are interchangeable: the "high indifference" to which his self-fashioning aspires mimics the indifference of his most ideal object—the elusive and vampiric portrait.

This kind of transition between ironic self-fashioning and artistic autonomy is particularly relevant for the broader claims of aestheticism concerning the relationship between art and life. Pater's narratives of artistic life could be regarded as privileging the process of *bildung* or cultural development over the art object itself, yet this would be to neglect the constitutive role the autonomous art-object has in the process of aesthetic self-cultivation. The primary drive of many of Pater's artistic personalities appears to be a kind of self-undoing in which they come to mimic the object of art precisely for its Kantian qualities of autonomy and detachment. Pater is quite explicit about the negative tendency of this process, which he locates at the heart of the classical ideal. In "Winckelmann" he describes the "supreme, artistic view of life" as a process of negation: "with a kind of passionate coldness, such natures rejoice to be away from and past their former selves" (*Renaissance* 183). This aspiration to autonomy is associated with a striving toward death: "That high indifference to the outward, that impassivity, has already a touch of the corpse in it" (*Renaissance* 179), and in the essay on "Pico della Mirandola" the same indifference suggests the "chilling touch of the abstract and disembodied beauty Platonists profess to long for" (*Renaissance* 33). Although the Renaissance is interpreted as the rebirth of sensuous culture, in this essay and in the volume as a whole, Pico's works are "a glance into one of those ancient sepulchres" (*Renaissance* 31). As a personality striving for abstraction Pico himself is described as "one alive in the grave" (*Renaissance* 38), and Jeffrey Wallen has emphasized the way that this trope is intimately associated with both the vampire image in "Leonardo da Vinci"

and the suggestion Pater takes from Heine's "The Gods in Exile" that the god Apollo may have been sacrificed in the era of Christianity only to return as a vampire (1042–3). In Wallen's reading, Pater's vision of the Renaissance "is always also vampiric, displaced, and haunted by exile and death" (1045), and this negativity is implicit in the idea of Renaissance as the return of classical culture, where the Greek world reappears as a spectral ideal, haunting the present in a state of suspended manifestation.

It is clear that Pater remained haunted by this spectral and vampiric condition in much of the work he produced after *The Renaissance*. Laurel Brake has noted that the *Imaginary Portraits* frequently resemble vampire narratives, particularly those of "Carl of Rosenmold" and "Denys L'Auxerrois" (2002), and we might also include the deathly idealism of "Sebastian van Stork." It was only late in his career, however, that Pater would come to a direct theoretical treatment of these issues. Pater's most considered statement on the condition of irony and aesthetic vampirism was his essay on "Prosper Mérimée" (1890),[9] a highly significant late work, which performs a retrospective mediation on nineteenth-century aestheticism, clarifying the associations between aesthetic subjectivity, the autonomous art-object, and Romantic irony that were implicit in his earlier work.

Mérimée was famous as the author of stories such as "Carmen" and "Matteo Falcone," which Pater describes as "perhaps the cruelest story in the world" (*Miscellaneous Studies* 9). What Pater sees in Mérimée's stories is a combination of perfect self-containment, immaculate stylistic finish, and an inhuman detachment and violence. Once again he is drawn to a subject who is preoccupied with "the brief visit from the grave" (*Miscellaneous Studies* 22). Seeing the returning spectre as the condition of his art—"That ghosts should return [...] is but a sort of natural justice"—Pater finally reiterates the figure of the vampire to determine this uncanny return: Mérimée's chosen company are "half-material ghosts—a *vampire tribe*" (*Miscellaneous Studies* 22, emphasis added).[10] This undead condition appears "congruously with the mental constitution of the writer"—a peculiar compound of refinement and violence, and Pater identifies this "mental constitution" as essentially ironic. Mérimée is represented as a "master of irony," pathologically anxious to secure both his self-fashioning and his literary production as ends in themselves. This ironic mastery is fulfilled in the production of a mask: "himself carrying ever, as a mask, the conventional attire of the modern world—carrying it with an infinite, contemptuous grace, as if that, too, were a sufficient end in itself" (*Miscellaneous Studies* 5). Pater explicitly introduces the Kantian idea of art as an "end in itself" here, in order to describe a mode of aesthetic subjectivity that remains hidden, reflecting the ironic principle of the Mona Lisa's detachment from history and the general condition of artistic autonomy.

Pater's association of Mérimée's work with the condition of vampirism suggests the extent to which he was troubled by irony and aesthetic autonomy.

Irony is identified as the guiding principle and compulsion behind Mérimée's life and work, and Pater goes on to associate this compulsion with an incipient nihilism: "Almost everywhere he could detect the hollow ring of fundamental nothingness under the apparent surface of things. Irony surely, habitual irony, would be the proper complement thereto, on his part" (*Miscellaneous Studies* 4). This association of irony with the "sense of negation" (*Miscellaneous Studies* 3) reiterates Hegel's critique of irony as the destructive expression of philosophical subjectivism: in "Prosper Mérimée," Pater is more explicit than in any of his other critical essays in suggesting the limits of aestheticism and determining these limits according to the mutual inheritance of post-Kantian thought and French Romantic literature. His intellectual narrative here is nothing less than "the mental story of the nineteenth century" (*Miscellaneous Studies* 3). As its representative figure, Mérimée epitomizes "the *désillusionné*, who had found in Kant's negations the last word concerning an unseen world [...] and will demand, from what is to interest him at all, artificial stimulus" (*Miscellaneous Studies* 2). The various forms of artificial stimulus—including gambling, drugs, and the bullfight—are subsequently associated with "art exaggerated, in matter or form, as in Hugo or Baudelaire" (*Miscellaneous Studies* 3), and later with the quality of impersonality (*Miscellaneous Studies* 29), the "impeccably correct, cold-blooded" (*Miscellaneous Studies* 18) style he also associates with Flaubert (*Miscellaneous Studies* 28). Once again reflecting Hegel's critique, Pater establishes a qualitative ethical association between a mode of existence and an artistic style, with the result that aestheticism in general is apparently identified with the negative, de-humanizing principle of absolute irony. This produces a taste for violence which is associated with the faculty of taste itself: Mérimée's aestheticism embraces "the beauty of the fire-arms [...] a sort of fanatic joy in the perfect pistol-shot" (*Miscellaneous Studies* 18–19). What is extraordinary about this essay is Pater's ease in apparently determining this combination of spectrality and violence with a whole phase of French literature that is intimately associated with his own work and the development of aestheticism in Britain. In this respect, the essay on Mérimée might be regarded not only as a moment of self-criticism but as an expression of considerable anxiety about the work of his own disciples— a troubled meditation on the translation of aestheticism into decadence as an awakening of the inhuman. Pater tacitly invoked the Hegelian critique of irony at the moment when aestheticism was increasingly beginning to appear as the play of self-consciousness with its own refinements.

At the onset of the 1890's, the same year that Pater lectured on Mérimée, Wilde had already serialized *The Picture of Dorian Gray* and "The Critic as Artist." In the dialogue mode of "The Critic as Artist," he had found a suitable vehicle for his ironic consciousness, using masks to propose a theory of critical self-consciousness: "there is no fine art without self-consciousness, and self-consciousness and the critical spirit are one" (126-7). In his

previous aesthetic dialogue, "The Decay of Lying", Wilde had staged his most radical assertion of art's autonomy: "Art never expresses anything but itself. It has an independent life, just as Thought has, and develops purely on its own lines" (54). He was yet to achieve a mature theoretical statement of the relationship between the autonomous art object and the principle of ironic critical subjectivity, but the co-dependence of these principles was clearly demonstrated in his fictional work. *Dorian Gray* produces an effective metaphor for the ironic condition of aestheticism by combining the gothic conceit of the living artwork, familiar from Pater's "Leonardo da Vinci" and Poe's "The Oval Portrait," with the narcissistic narrative of Huysmans's *Against Nature*, where the critical self-consciousness of the aristocratic des Esseintes aspires to an absolute autonomy. As in Pater's essay on Mérimée, irony, artificial stimulus, and compulsive aestheticized violence are manifested in a vampiric personality. Camille Paglia has observed how Wilde's novel rehearses many of the classic tropes of vampirism—mesmeric influence, a hieratic aristocracy, and sexual possession (518–9). *Dorian Gray* is a tale of two vampires and an innocent Hegelian Hellenist, Basil Hallward, whose earnest ideals of the sensuous manifestation of artistic spirit are seen to fail as the vampiric ironists transform the culture of aestheticism. Henry Wotton, the hitherto largely inactive vampire and master of aristocratic irony, practices his "influence" for one last time on Dorian, who henceforth cultivates an ironic indifference to life which, as with Mérimée, develops into violence. Identified from the beginning with "the spirit that is Greek," Dorian is initially framed in the discourse of aesthetic humanism: "the harmony of body and soul," the "abstract sense of beauty" which can be materialized in the "visible presence" of the beautiful boy (10). These are largely Basil Hallward's ideals, but Wilde represents, both conceptually and historically, the passing of Basil's humanist version of aesthetic idealism into decadent irony.

This process of decadence is clearly situated in relation to Pater's work, and the vampiric image of *La Gioconda* is echoed throughout the novel, most obviously in the reanimated portrait, but also in the form of Huysmans's *Against Nature*. This "novel without a plot" inherently refuses the humanist ideals of development and *bildung*, effectively working as the vampire who stands in for Lord Henry in his absence, mediating the spirit of irony and raising it in the form of a sacred text. The effect on Dorian is to induce the condition of Pater's Lady Lisa, as the world appears to pass him by "to the delicate sound of flutes" (*Dorian* 125). This Paterian allusion is then consolidated in the description of the unnamed protagonist of the novel, Wilde's version of des Esseintes: "A certain young Parisian, who spent his life trying to realise in the nineteenth century all the passions and modes of thought that belonged to every century except his own, and to sum up, as it were, in himself the various moods through which the world-spirit had ever passed" (*Dorian* 125). Huysmans's protagonist is framed by Pater's negative dialectics

of the portrait. Like Lady Lisa, the young Parisian has stepped outside of dialectical development: his ambition to invoke the various historical experiences "for their mere artificiality" facilitates a reduction of history to a "dumb show," and this translation of the world into a general theatricality supports an essentially ironic condition. This is subsequently elucidated in Chapter 11, where Dorian completes his aesthetic education, fully embraces Lord Henry's cynicism, and masters the practice of dandyism in all its modes. At this point he arrives at the theory, which Wilde himself proposed in "The Critic as Artist," that "insincerity is merely a method by which we can multiply our personalities" (*Dorian* 142-3). This critique of the ego as "permanent, reliable, and of one essence" is subsequently translated into the gothic idea of the human as "a complex multiform creature that bore within itself strange legacies of thought and passion, and whose very flesh was tainted with the monstrous maladies of the dead" (*Dorian* 143). It is at this point that Wilde invokes Pater's conceit of "the soul with all its maladies," effectively situating the ironic condition of aesthetic vampirism as a direct legacy of Pater's work.

By repeatedly bringing Huysmans and Pater together here, Wilde begins to suggest that the condition of vampiric irony is equally integral to the foundational documents of British aestheticism and French decadence. This diagnosis is consolidated in the culminating scene of this central phase of the novel, when Dorian visits the haunted gallery of his ancestors, echoing the opening scene of *Against Nature*, where des Esseintes is introduced in his family gallery as the end of a degenerate aristocracy. As Dorian contemplates the demonic portraits, each figure mimics the vampiric condition of Lady Lisa: George Willoughby and Lady Elizabeth Devereux, his "sensual lips twisted with disdain" and his mother, whose eyes "seemed to follow him wherever he went" (*Dorian* 144). Dorian realizes two aspects of his ironic condition at this point; his position of ideal spectatorship and knowledge, and his peculiar mode of historical being at the end of history: "He felt he had known them all, those strange terrible figures that had passed across the stage of the world" (*Dorian* 144). Dorian can only conceive of himself historically insofar as his own present condition is repeated or rehearsed in the portraits of his ancestors, where the "the whole of history was merely the record of his own life." The condition of the Wildean dandy here performs a narcissistic translation of Pater's aesthetic historicism, in which the aesthete sees himself repeated in an endless series of ancestral portraits. Since each of the ancestors is undead, contained and reanimated by their portrait, this is not a genealogical relationship; uncanny repetition replaces development. Dorian finds his ancestry in a tribe of vampires, a genealogy outside of history.

This paradoxical relationship with an ahistorical residue repeated throughout history might be said to represent Dorian's temporal condition according to three essential modes of his experience: his ironic dandyism, his status as

an object of beauty in the Kantian sense, and his position as an aristocrat. All of these modes have an ambivalent position in modernity which is encapsulated by the idea of vampirism. The fictional vampire commonly figures a premodern social form—in Franco Moretti's famous reading of *Dracula*, the Count figures the feudal aristocracy before the advent of capitalist modernity, but he is also the vampire that Marx unveiled within capitalism, the monopoly capital which reinstates the relation of lordship. The resulting condition is that "Dracula is at once the final product of the bourgeois century and its negation" (Moretti 93). The same can be said about Dorian's dandyism, which he himself considers in terms of Baudelaire's ideas as "an attempt to assert the absolute modernity of beauty" (*Dorian* 129). The other side of Baudelaire's theory, which Dorian neglects, is that the dandy retroactively performs the position of an outmoded aristocracy (Baudelaire 1964). In the case of Dorian Gray, the "modern idea" of an ironic urban dandyism ultimately supports the "old fancy" of an aesthetic aristocracy. As Linda Dowling has argued in *The Vulgarization of Art*, Wilde's work staged an emerging tension between a democratic and liberal model of aestheticism and an aristocratic idea of the 'aesthetic critic', detached from the *sensus communis* in a fundamentally illiberal posture of aristocratic independence. The logic of Wilde's orchestration of the discourses of aestheticism in *Dorian Gray* has particularly dangerous suggestions about the status of British aestheticism as a humanist discourse, since it situates the condition of aesthetic negativity, irony, and vampirism as the legacy of Pater's work, threatening to undermine the ideals of aesthetic education and development that were equally central to Victorian aesthetic Hellenism. One of the most significant features of *Dorian Gray* is that Wilde chose *not* to focus his attention on the life and adventures of Basil Halward, which might have produced an artistic and philosophical *bildungsroman* in the mold of Pater's recently successful *Marius the Epicurean* (1885). For Wilde the twinned principles of ironic consciousness and absolute artistic autonomy increasingly undermined the idealist conception of historical and personal development: the humanist discourses of aestheticism were haunted by the ironic condition of frozen temporality and aristocratic distance.

If Pater himself had suggested his anxieties about the aristocratic irony of aestheticism in "Prosper Mérimée," he gave no suggestion of how it might be overcome. In his later review of the 1891 edition of *Dorian,* he continued to express the moral doubts to which he had given public voice in his lecture. Confronted with the continuous echo of his own ideas and the reanimation of his own vampire, Pater was forced to be more emphatic in distinguishing his own positive aestheticism from the inhuman negations embodied by Henry and Dorian. Criticizing the novel's espousal of a "dainty Epicurean theory" (Beckson 84), Pater implicitly takes issue with the negative dialectic instated by Henry and Dorian. Against the decadent aesthete's

ironic relation to history and morality he attempts to restore the ethical credibility of what he recognized as a distortion of his own theories:

> A true Epicureanism aims at a complete though harmonious development of man's entire organism. To lose the moral sense therefore, for instance, the sense of sin and righteousness, as Mr Wilde's heroes are bent on doing so speedily, is to lose, or lower, organization, to become less complex, to pass from a higher to a lower stage of development.
>
> (Beckson 84)

Against the condition of vampiric irony, Pater asserts a discourse of organic development, echoing his statement in the early essay "Winckelmann," that "the mind itself has a historical development" (*Renaissance* 167) ,and implicitly suggesting the example of his own *Marius the Epicurean*—a novel of spiritual education and development, albeit of a curiously spectral kind. Pater is clearly anxious to qualify his conception of development, and he does so according to the value of complexity. This intervention is both provocative and risky in relation to Wilde's novel, since Pater is in danger of demonstrating his affinities with Wilde's aristocratic ironists at the moment he seeks to disavow their cynicism. Complexity is in fact one of the recurrent terms of Lord Henry's philosophy: in a typically Paterian move he embraces the moment when "a complex personality took the place and assumed the offices of art" (*Dorian* 57), but the idea is morally compromised by his notion that "there are certain temperaments that marriage makes more complex" (*Dorian* 74), since in this case complexity facilitates the capacity for dissimulation. The immoralist form of complexity is also embodied in the "complex refrains and movements" (*Dorian* 126) of the "novel without a plot," and is subsequently reiterated in Dorian's assertion of the "complex multiform creature" who multiplies, rather than harmonizes his personality. Complexity, in this case, expresses the sophistication, irony, and subversive capacities for which Wilde is frequently celebrated—qualities which risk de-humanizing aestheticism and reducing it to a narcissistic play with spectacle. In the light of Wilde's decadent turn, Pater is forced to contest these qualities with his own notion of development: in order to rescue complexity from decadent vampirism, he reasserts the "modern idea" not as the negative dialectic of irony but as a dialectical development with a moral humanist *telos*. Pater appears to need this developmental and organic idea to achieve the re-humanization of art; his only way of combating decadence is to restore a humanist notion of *bildung* which is sanctioned by a wider cultural dialectic.

Considering the complexity of his engagement with aesthetic vampirism in "Prosper Mérimée," Pater's critique of *Dorian Gray* appears to be an anxiously defensive gesture. He could well be accused here of attempting to defensively slay the vampire that he himself had unleashed and even tacitly celebrated in the evocation of *La Gioconda*. What Pater's review demonstrates

is the difficulty of reconciling the humanist legacy of aestheticism – the idea that the aesthetic subject has a reciprocally productive relationship with the organic development of culture—with its equally central claim to a position of ironic detachment; the aesthete as cosmopolitan subject and independent faculty of judgment. The ideas of development and *bildung* were fundamental to the foundational discourses of Victorian aestheticism, but so was the vampiric detachment of the Mona Lisa and the eccentric and subjective appropriation of art that Pater and Wilde practiced. The idea of the "aesthetic critic," as it was promoted by Wilde in "The Critic as Artist," might be seen as a parasitic figure who demanded the liberties of critical consumption at the expense of artistic production and embodiment. Yet to a certain extent this spectral form of the idea of art was integral to the historical possibilities of aestheticism: the discourse of aesthetics intimating an art without substance, and, in the figure of the vampire, a disembodied subject existing only in the form of an apparition. The claims for the absolute detachment of the art-object and the aesthetic subject were in one sense motivated by the demands of an enlightenment liberalism which enshrined the freedom of individual subjectivity according to its capacity for artistic expression. The problem that haunted Pater, and which drove Wilde to his most extravagant gestures of independence, was that this enlightenment claim for autonomy could not be reconciled with a moral or social claim for art's re-humanizing capacities. As long as aestheticism had to determine art's independence as an absolute principle, the threat of vampirism always remained implicit. The dialectical optimism of aestheticism was haunted by the possibility that the primary force of art resided in the inhuman image; this haunting was both an intimation of the limits of art and the condition of its freedom.

Notes

1. For a clear statement of the idea of Romantic irony see *Friedrich Schlegel's Lucinde and the Fragments*, "Critical Fragments," 42 (148). The association between Romantic irony, Fichtean subjectivism and the Kantian idea of beauty is made explicit in "Athenaeum Fragments," 252 (198).
2. See the section on "Irony" in the Introduction to *Aesthetics*, I: 64–9.
3. As Kierkegaard would later admit, much of his critique here is dogmatically Hegelian. See *The Concept of Irony*, "Supplement: A Passage in my Dissertation"; "What a Hegelian Fool I was!" (453).
4. "Ne suis-je pas un faux accord / Dans la divine symphonie, / Grâce à la vorace Ironie / Qui me secoue et qui me mord?" (*The Flowers of Evil*, 156). The translations I have quoted are adapted from McGowan.
5. Regenia Gagnier has argued that both *Dracula* and Victorian Aestheticism articulate a series of anxieties about boundary breakdowns, including "self and Other, Britain and the world, men and women, organisms and machine, and 'Art' and life" (141). Gagnier's extraordinary interdisciplinary reading also links the idea of the autonomous artwork, vampire eroticism and Pater's evolutionary image of Lady Lisa.
6. It is well known that Ruskin's mode of the gothic was equally rooted in conservative feudal ideals. Linda Dowling (1996) takes this tension in the formulation

of the gothic as representative of the general problematic of aesthetic democracy in Pater and Wilde's work. For an equally expansive reading of the idea of the aesthetics and politics of the gothic, see Sondeep Kandola, *Gothic Britain*. Kandola traces the move from Ruskinian organicism to the haunted gothic of Pater and Vernon Lee, but one of the significant factors in her account is the persistence of organicist notions of race in the critical documents of cosmopolitan aestheticism, notably Wilde's "The Critic as Artist", which relies on a racially determined notion of the Celtic as the basis of critical consciousness.

7. First Published in the *Fortnightly Review*, November 1869, then reprinted in *Studies in the History of the Renaissance* (1873).
8. See "The Rhetoric of Temporality" in De Man. 187–228.
9. First delivered as a lecture in November 1890, then published in the *Fortnightly Review*, December 1890, and later reprinted in *Miscellaneous Studies* (1895).
10. Pater's identification of Mérimée's irony with Vampirism can be illuminated by Mathew Gibson's reading of Mérimée's own vampire texts, particularly *La Guzla*. Gibson describes how the text uses a series of distancing devices to frame a grotesque subject, producing a 'tension between alienation and sublimity' (Gibson 138). This might suggest a broader definition of the rhetorical and aesthetic functions of the vampire: in Pater's construction of Mérimée, an alienating and vampiric impersonality strains to achieve a violent form of sublimity.

Works Cited

Agacinski, Sylviane. *Aparté: Conceptions and Deaths of Søren Kierkegaard*. Trans. Kevin Newmark. Tallahassee: Florida State University Press, 1988.

Baudelaire, Charles. *The Flowers of Evil*. Trans. James McGowan. Oxford: Oxford University Press, 1993.

——. *The Painter of Modern Life & Other Essays*, ed. and trans. Jonathan Mayne. London, New York: Phaidon, 1964.

Beckson, Karl. *Oscar Wilde: The Critical Heritage*. London: Routledge, 1997.

Brake, Laurel. "The Entangling Dance: Pater after *Marius*, 1885–1891." *Walter Pater: Transparencies of Desire*. Brake, Williams, et al. University of North Carolina, Greensboro: ELT Press, 2002 (24–36).

De Man, Paul. *Blindness and Insight: Essays in the Rhetoric of Contemporary Criticism*. London: Methuen 1983.

Dowling, Linda. *The Vulgarization of Art: The Victorians and Aesthetic Democracy*. Charlottesville and London: University Press of Virginia, 1996.

Gagnier, Regenia, "Evolution and Information, or Eroticism and Everyday Life, in *Dracula* and Late Victorian Aestheticism", in Regina Barreca (ed.) *Sex and Death in Victorian Literature*. London: Macmillan, 1990.

Gibson, Mathew, *Dracula and the Eastern Question: British and French Vampire Narratives of the Nineteenth-Century Near East*. Houndsmills: Palgrave, 2006.

Goethe, Johann Wolfgang von. *Goethe's Literary Essays, a Selection in English*. Oxford: Oxford University Press, 1921.

Hegel, G.W.F. *Aesthetics: Lectures on Fine Art*. Trans. T.M. Knox, 2 vols. Oxford: Clarendon Press, 1975.

Kandola, Sondeep, *Gothic Britain: Nation, Race, Culture and Criticism, 1707–1907*. Manchester: Manchester U.P., 2008.

Kierkegaard, Søren. *The Concept of Irony, with continual reference to Socrates*, ed. and trans. Howard V. Hong and Edna H. Hong. Princeton, N.J.: Princeton University Press, 1989.

Moretti, Franco. *Signs Taken for Wonders: Essays in the Sociology of Literary Forms.* Trans. Susan Fischer, David Forgacs and David Miller. London: Verso, 2005.

Nordau, Max. *Degeneration.* Lincoln: University of Nebraska Press, 1993 [1895].

O'Hara, Daniel T. *The Romance of Interpretation: Visionary Criticism from Pater to de Man.* New York: Columbia University Press, 1985.

Ortega y Gasset, Jose. *The Dehumanisation of Art and Notes on the Novel.* Trans. Helene Weyl. Princeton, New Jersey: Princeton University Press, 1948.

Paglia, Camille. *Sexual Personae: Art and Decadence from Nefertiti to Emily Dickinson.* London: Penguin, 1992.

Pater, Walter. *Appreciations, with an Essay on Style.* London: Macmillan, 1889.

——. *Miscellaneous Studies: A Series of Essays,* ed. Charles L. Shadwell. London: Macmillan, 1895.

——. *The Renaissance: Studies in Art and Poetry,* ed. Donald Hill. Berkeley, Los Angeles, London: University of California Press, 1980.

——. "Winckelmann." *The Westminster Review,* January 1867, Volume 31, pp. 80–110.

Schlegel, Friedrich von. *Friedrich Schlegel's Lucinde and the Fragments,* trans. Peter Firchow. Minneapolis: University of Minnesota Press, 1971.

Wallen, Jeffrey. "Alive in the Grave: Walter Pater's *Renaissance.*" *ELH.* 66.4 (Winter 1999): 1033–51.

Wilde, Oscar. "The Critic as Artist," *Collected Edition: Intentions and the Soul of Man under Socialism,* ed. Robert Ross. London: Methuen, 1908 (97–224).

——. "The Decay of Lying," *Collected Edition: Intentions and the soul of Man under Socialism,* ed. Robert Ross. London: Methuen, 1908 (3–57).

——. *The Picture of Dorian Gray.* Oxford: Oxford University Press, 1994.

Williams, Carolyn. *Transfigured World: Walter Pater's Aesthetic Historicism.* Ithaca and London: Cornell University Press, 1989.

5

The De-Humanization of the Artistic Receptor: The George Circle's Rejection of Paterian Aestheticism

Yvonne Ivory

When the aesthetic movement is characterized as having a de-humanizing impulse, the argument is generally based on the premise that "art for art's sake" must be the opposite of "art for life's sake"; that if—to use Peter Bürger's phrase—aestheticism made *art* the content of art (239), the realm which was sacrificed in that operation was *life*. While this may be the case for much of the output that we label aestheticist, a number of foundational texts of the aesthetic movement in fact privilege the human experience of the aesthetic object, and champion a mode of engaged *reception* that transforms, and is transformed by, art. Walter Pater and Oscar Wilde put the artistic receptor at the center of their aesthetic economy, rendering moot the question of whether the art object itself is utilitarian or useless, socially engaged or oblivious to the world, humanized or de-humanized.[1] Regardless of the nature of the work of art, in Paterian aestheticism the role of the art critic is revitalized, his or her[2] work imbued with precisely the "human qualities, personality, [and] spirit" that Merriam-Webster associates with the humanizing impulse.[3]

This chapter argues that, from the perspective of reception, then, aestheticism had a (re-)humanizing tendency. I begin by tracing the notion of the subjective, engaged artistic receptor through works by Pater and Wilde, and then turn to the German poet Stefan George (1868–1933), arguing that his efforts to control his own reception amount to a rejection of aestheticism. For while George makes grand gestures toward the concept of individual aesthetic autonomy, his keenness on the prophet/disciple model of aesthetic education curbs aesthetic individualism in those around him. Rather than cultivating an atmosphere in which aesthetic reception is a productive and innovative phenomenon, he cultivates one in which the reproduction and reification of his own responses are the order of the day. By analyzing a key essay by one of George's followers, I show how emulation in the realm of artistic reception can empty aesthetic experience of its idiosyncratic elements and thus go, self-consciously, against the grain of Paterian aestheticism.

* * *

In Oscar Wilde's "The Portrait of Mr. W. H.," a short story positing Shakespeare's passion for the (fictional) child-actor Willie Hughes, the narrator pauses at one point to reflect on the role art plays in all of our lives:

> Art, even the art of fullest scope and widest vision, can never really show us the external world. All that it shows us is our own soul, the one world of which we have any real cognizance. ... Consciousness ... is quite inadequate to explain the contents of personality. It is Art, and Art only, that reveals us to ourselves. We sit at the play with the woman we love, or listen to the music in some Oxford garden, or stroll with our friend through the cool galleries of the Pope's house at Rome, and suddenly we become aware that we have passions of which we have never dreamed, thoughts that make us afraid, pleasures whose secret has been denied to us, sorrows that have been hidden from our tears. ... [Art] ... leaves us different.
>
> (*Complete Works,* 1194)

This passage can be read as a declaration of one of the main principles of aestheticism: art's greatest meaning lies not in its mimetic function, but in its ability to change the artistic receptor. Wilde's words echo those of his idol Walter Pater, for whom art should not be studied in order to "see the object as in itself it really is"—the classic Arnoldian formula[4]—but rather "to know one's own impression as it really is" (xxix). We must ask ourselves:

> What is this song or picture, this engaging personality presented in life or in a book, to *me*? What effect does it really produce on me? ... How is my nature modified by its presence, and under its influence? The answers to these questions are the original facts with which the aesthetic critic has to do; and ... one must realise such primary data for one's self, or not at all.
>
> (Pater xxix; emphasis in original)

These questions are aired in the preface to Pater's great manifesto of aestheticism, his *Studies in the History of the Renaissance*. Pater makes clear from the start that the "aesthetic critic" must bring his or her own personality to the task at hand, that it is only through the unique responses of the sensitive critic that we can appreciate beauty and genius:

> The aesthetic critic, then, regards all objects with which he has to do, all works of art and the fairer forms of nature and human life, as powers or forces producing pleasurable sensations, each of a more or less peculiar or unique kind. This influence he feels, and wishes to explain, by analysing and reducing it to its elements. ... What is important, then, is not that the critic should possess a correct abstract definition of beauty for the

intellect, but a certain kind of temperament, the power of being deeply moved by the presence of beautiful objects.

$$(xxx)^5$$

If the aesthetic critic is the one who must bring personality to the task of criticism, that personality is in turn enriched by the practice of criticism. In his infamous "Conclusion" to the Renaissance volume, Pater asserts that the act of critical thinking revitalizes us, for "speculative culture['s] ... service ... towards the human spirit, is to rouse, to *startle it to a life* of constant and eager observation" (152, emphasis added). Aesthetic criticism rouses the human spirit—breathes life into the human spirit—or, in the language of the present volume, aesthetic criticism re-humanizes; and the one who is re-humanized is the critic. Pater implies, moreover, that the critic plays an active role in artistic production, that the artistic receptor is potentially also the producer of new aesthetic works, such as the essays that precede the volume's conclusion.

Oscar Wilde would restate Pater's argument most emphatically in his dialogue "The Critic as Artist." Here the characters of Gilbert and Ernest debate the merits of art criticism, with Ernest claiming that "in the best days of art there were no art-critics" (346) and Gilbert countering (at length and persuasively) that critical thinking is and always has been a prerequisite for good art, for "without the critical faculty there is no artistic creation at all" (355). He goes on to claim that good criticism in and of itself constitutes "an art" (364); and, making explicit a point only implicit in Pater's *Renaissance* volume, asserts that "criticism of the highest level ... treats the work of art simply as a starting point for a new creation" (367). Like Pater, Gilbert emphasizes the importance of the critic's unique and strong personality: "self-consciousness and the critical spirit are one" (356), he argues, criticism "being the purest form of personal impression" (365). A period without great individuals must be a period without great art, for without individuals there can be no criticism, and without criticism there can be no art: "An age that has no criticism is either an age in which art ist immobile, hieratic, and confined to the reproduction of formal types, or an age that possesses no art at all" (356).

Wilde uses Pater's ideas about aesthetic criticism throughout his oeuvre; in essays, plays, and stories, Wilde often returns to the notion that aesthetic appreciation is best practiced by the autonomous individual, and is both transformative and creative. It is a notion that drives much of the plot of *The Picture of Dorian Gray*. Dorian is transformed, for instance, when watching the superlative performances of the actress Sibyl Vane. In Sibyl's hands, art does not imitate life, it produces life (here, it produces new impulses in Dorian; and indeed when her art begins to *imitate* her life—when she plays Juliet after having fallen in love with Dorian—she can no longer produce great art, either on stage or among her critics). Later, it is Dorian's reception

of a thinly veiled *A Rebours*[6] that enables him to continue the experiment of aestheticizing all aspects of his life. And finally, in a Wildean masterstroke, it is Dorian's portrait that burns most brightly with Pater's "gem-like flame" (152), constantly producing a new artwork based on its vicarious experience of Dorian's (aestheticized) crimes. In all three instances (theater, the novel, and the portrait), we see further evidence that aestheticism makes art the subject of art; and we also see that the *way* art is made the subject of art follows a particular pattern: production inspires appreciation which constitutes a new production, which inspires appreciation and so on, in an endless progression of art's transformative potential, one which implicates the reader in the continuation of the aesthetic process.

The notion that art appreciation can be generative, revitalizing, or creative is so common in late-nineteenth-century aestheticism that it might even be considered the movement's hallmark. It is certainly at the heart of what is perhaps the most famous lampoon of the aesthetic movement, George du Maurier's 1880 *Punch* cartoon, "The Six-Mark Tea-Pot." An "Aesthetic Bridegroom" (clearly modeled on Wilde) has handed his new bride (an Elizabeth Siddal look-alike) a piece of china, which he describes as "quite consummate." She admires the piece and declares that the couple must "live up to it!" The caricature is alluding to the (possibly apocryphal) tale that Wilde, as an Oxford undergraduate, once quipped that he was "finding it harder and harder every day to live up to [his] blue china" (Ellmann 45). The very notion of being inspired to "live up to" a piece of art that one has admired—to alter one's behavior in order to make it more "consummate"— is profoundly Paterian, and the caricature illustrates the extent to which the ideas expressed in his "Conclusion" had entered the public sphere by 1880. The *Punch* cartoon also speaks to the fact that there are strong—and well-recognized—threads in European aestheticism that would breathe personality and spirit into the artistic receptor. This, then, is the re-humanizing impulse of late-nineteenth-century aestheticism, an impulse that Talia Schaffer and Kathy Psomiades have characterized as "a belief in art's ability to ... allow the beholder to achieve transcendence" (3), an impulse that was inseparable from the popular concept of aestheticism in the late nineteenth century.

If we can look to Pater's *Renaissance* volume to get a sense of what aestheticism's humanizing impulse looks like, we might also look there to find a profile of what constitutes a de-humanizing aestheticist impulse. "Our failure is to form habits," warns Pater in his "Conclusion," adding that "what we have to do is to be for ever curiously testing new opinions ... never acquiescing in a facile orthodoxy, of Comte, or of Hegel, or of our own" (152). A "facile orthodoxy" or the development of habitual behavior, then, is what for Pater prevents us from "rous[ing the human spirit] to life"; it is the opposite of a (re-)humanizing aesthetic. Wilde, too, gestures in this direction when his character Gilbert claims that an age without criticism

must be an age in which art stagnates; or when he has Sibyl Vane fail as an actor when her art merely imitates her life. For Wilde as for Pater, art which merely emulates experience does not create experience: it is art emptied of personality, and, as such, it no longer merits the label aestheticist.

Of course, Pater's position in his "Conclusion" is a precarious one: how can he offer us a particular formula for encountering art and at the same time criticize any formulaic approach to art? At what point does burning "with a gem-like flame" become its own "facile orthodoxy?" This is the problem that the Austrian poet Hugo von Hofmannsthal would locate in Pater's oeuvre two decades after the appearance of *Studies in the History of the Renaissance*. In one of the first essays in German on the aesthetic movement—an 1894 essay on Pater—Hofmannsthal describes aestheticism as "our ... falling in love with an ideal, or at least an idealized life" (872). He is sympathetic with aestheticism as an approach to art—as a mode of criticism—but he questions the wisdom of anyone who would adopt a whole lifestyle based on aestheticist principles. In this vein, he criticizes as "sterile" Pater's *Marius the Epicurean*, arguing that the novel "shows the inadequacy of the aesthetic world view, when one builds a whole way of life upon it." *Marius* fails, for Hofmannsthal, because it is so "firmly and voluptuously attached" to a long-gone period, a "dead" period; as such, it misses the "great and inexpressible beauty of existence." Hofmannsthal is charging Pater with trying so hard to create a life based on aesthetic principles that he loses the spirit of it, reifying it instead of breathing into it the life that Pater himself saw as the great promise of aestheticism. This emulation or reification is nothing less than de-humanizing (it negates the "beauty of existence") for Hofmannsthal; and his critique of Pater's novel highlights the ease with which aestheticism's humanizing impulse can stagnate and fall into a de-humanizing mode.

Hofmannsthal's essay is interesting in the context of the present study for several reasons. It is one of the earliest instances of the reception of Paterian aestheticism in the German-speaking world; it is written by an author who, like Stefan George, is often characterized as one of the German language's few aesthetic poets; and, most significantly, it is published during a particularly turbulent period in the personal and professional relationship between George and Hofmannsthal.[7] Starting in 1892, Hofmannsthal had been courted by George to become a contributor to the latter's elitist aestheticist publication, *Blätter für die Kunst* ("Pages for Art").[8] Hofmannsthal had initially agreed to do so, and had submitted various items to the "art for art's sake"[9] publication, but had been frustrated by the inflexibility of its editor. He broke with the *Blätter* in 1894, when the editor informed him that there would be a notice in an upcoming issue announcing Hofmannsthal's withdrawal from the project (*Briefwechsel* 70–1). In a letter to his friend Leopold Andrian about the episode, Hofmannsthal complained bitterly that the group around George was "unbearable" (qtd in Norton, 161). It is during this period that Hofmannsthal turned his attention to Walter Pater, and

began to work on the problems of basing a whole way of life on the notion of "art for art's sake." The piece on Pater can thus be read as an indirect attack on the rigidity of George and his associates—the primary practitioners of a German *l'art pour l'art* in the 1890s.

Much of the work of Stefan George—particularly that produced in the 1890s—can easily be classified under the rubric of European aestheticism. George had been heavily influenced by the French symbolists as a young man, spending time among Mallarmé's circle in Paris, and translating Baudelaire's *Les fleurs du mal* into German. In the last decade of the nineteenth century he produced works that have variously been categorized as impressionist, decadent, symbolist, and of course aestheticist.[10] His aestheticist bent is perhaps most evident when we consider his dedication to aesthetic publishing: he favored limited-edition decorated books; he developed new styles of writing (handwriting and punctuation) and an elegant new typeface that he used in most of his publications; he collaborated for years with the *Jugendstil* illustrator and book designer Melchior Lechter; he expressed enthusiasm for William Morris's Kelmscott Press; and he urged authors like Hofmannsthal to bring out their works in beautiful, limited editions whenever possible (Norton 200). Most significantly, he created and directed the *Blätter für die Kunst*, a volume whose opening editorial made clear its aestheticist agenda:

The name of this publication already signals its *raison d'être*: to serve art, especially poetry and writing, setting to one side all matters political and social. It advocates the ART OF THE MIND based on new ways of feeling and new structures – an art for art – and as such it stands in contrast to that dissipated and inferior school that emerged from a false understanding of reality. And it cannot waste its time with those dreams about making the world a better place or bringing happiness to everyone that nowadays appear to be at the heart of everything new. Nice as such notions may be, they belong in a realm other than that of poetry.

(George I, emphasis in original)

Here we have the classic formulation of art for art's sake, the formulation with which the present chapter began: aestheticism as the movement which hives art off from life, which sees action as a realm that should have nothing to do with writing or art. It is not the aestheticism of Pater's *Renaissance*, which would have us look at all aspects of culture from the point of view of the aesthetic critic; rather it is the position Hofmannsthal attributes to Pater based on his reading of *Marius the Epicurean*, the position of an individual so obsessed with basing a whole way of life on the principle of art for art's sake that he misses the "great and inexpressible beauty of existence."

George was very much dedicated to the project of making of his own life a work of art, not only using his experiences as material for his poetry,

but carefully tending to his image, both metaphorically and literally. He demanded full control over the appearance of his works in print as well as over their availability in the marketplace. His early works appeared in very low print runs, he decided which bookstores would carry them, and he even tried to have a say in who would be allowed to purchase them. When he started up his periodical, he insisted that only a select few should have access to it, that it should be the magazine (as the introduction to the inaugural issue phrased it) of a "closed readership on the invitation of its members," explaining that "if we distribute these pages then it occurs in order to discover and recruit scattered, still unknown like-minded people" (qtd in Norton, 136–7). This need to control his own output and reception, and indeed the output and reception of the contributors to his journal, was mirrored by his tendency to manage the opinions of those around him, especially those select few who styled themselves his followers—members of what came to be known as the *George-Kreis* ("George circle"). Maintaining one's status within the circle generally meant sharing the tastes and opinions of the Master—being "like-minded" as the introduction to the *Blätter* had put it. Acolytes published poetry in the style of George, wrote letters using George's new punctuation, and used the arcane vocabulary and symbology of which George was so fond. The circle was a group defined by proximity to George and/or affiliation with the *Blätter*, and both of these opportunities were controlled by the Master, with the result that the circle became, I would argue, George's greatest sustained performance, his most enduring creation, his most ambitious work of art.

For those within it, the George circle constituted the kind of orthodoxy against which Pater expounds in his "Conclusion." Some of its members would vociferously deny that this was the case, arguing that such a reading of the group betrayed a fundamental misunderstanding of the master–disciple relationship. Friedrich Gundolf, one of George's closest friends and staunchest defenders, wrote in his 1909 essay "Gefolgschaft und Jüngertum" ("Allegiance and Discipleship") that

> the duty of disciples is not imitation. ... Their pride is that the master is unique. They should not *make* his images • but rather be his work • not put on and display his petrified traits and gestures • but rather absorb into their being his blood and his breath • his light and his warmth • his music and his motion and pass them on into the still and frozen world.
>
> (Qtd in Norton, 409)[11]

On the surface, this sounds like the language of Pater's "Conclusion," but the praxis of "[absorbing] into their being" the "blood and breath" of one individual and "[passing] them on into the ... world" is certainly not the praxis that Pater has in mind when he envisions the "forever [curious] testing [of] new opinions and courting [of] new impressions" that defines the

aestheticist mode. The Paterian impression does not merely pass through the vessel of the artistic receptor, it is in fact brought into being by the sensitive critic, and the process of constantly bringing different impressions into being is transformative. Moreover, there is not one single source of inspiration for the Paterian aesthetic critic, but the whole of existence is potentially stimulating:

> At first sight experience seems to bury us under a flood of external objects, pressing upon us with a sharp and importunate reality, calling us out of ourselves in a thousand forms of action. But when reflexion begins to play upon those objects they are dissipated under its influence; ... each object is loosed into a group of impressions—colour, odour, texture—in the mind of the observer.
>
> (151)

It is not only one person who inspires us, either, but potentially every person: "Not to discriminate every moment some passionate attitude in those about us, and in the very brilliancy of their gifts some tragic dividing of forces on their ways, is, on this short day of frost and sun, to sleep before evening" (152).

For Pater, it is only in "the individual mind" (151) that life can finally be comprehended and processed. Personality is the catalyst that drives aesthetic revitalization. But in "Allegiance and Discipleship," Gundolf rejects what he sees as this all-too-modern notion of individualism. At the center of his ideal society he places a unique individual who can lead the people, but individualism in others he sees as a stumbling block on the road to this utopia. Where individualism reigns, discipleship will be misunderstood, and a subservient posture ridiculed (Gundolf 107). He rejects the cultivation of "personalities" who "live out their lives to the fullest" (111), laments the fact that "eccentricity" has become a virtue, and wishes that self-interest had not become more important than the general interest (107).[12] He is particularly critical of people who pretend to be followers of a great leader out of a sense of fashion—those dilettantes who act like disciples as long as discipleship is not yet popular, then reject the posture once others begin to join the movement (108). For these individualistic pretenders he reserves the label "Geck," a word meaning "peacock" or "dandy" that was often used to describe aesthetes like Oscar Wilde.[13] The use of the word underscores the extent to which Gundolf's manifesto is an outright rejection of Paterian aestheticism. Where Pater sees the potential for transformation everywhere and in everyone, Gundolf sees it only in the adoption of an appropriate attitude toward a single leader; where Pater finds in individualism a key to unlocking the mysteries of the universe, Gundolf finds personalities the scourge of the modern era; and where Pater places transformative power in the hands of the aesthetic critic, Gundolf places it squarely at the feet of the outstanding leader.

It would be a misrepresentation of the circle around Stefan George to say that they were always only emulating the man they so admired. There were certainly initiatives undertaken by members of the group or by individuals affiliated with the group that speak to their creative autonomy. Many were poets and editors in their own right, though they generally hoped to please George with their work. Gundolf himself was a trained scholar whose main advisor was the groundbreaking historian Wilhelm Dilthey. With his popular monographs on Caesar, George, Goethe, and Shakespeare, Gundolf put into practice Dilthey's theory that history can best be told by focusing on the lives of the great men who understood and transformed their eras. Again, the similarity to Pater's profiles of famous men and women in *Studies in the History of the Renaissance*, *Imaginary Portraits*, and *Appreciations* is only superficial: Pater is interested in portraying the famous figure through the eyes of the sensitive critic; Gundolf is interested in portraying the history of the bygone era as it was crystallized in the famous figure. Pater brings his own personality to the project, Gundolf brackets his own personality in order to highlight that of his subject. Pater's work is unapologetically presentist, Gundolf's historicist. The differences underscore, again, the extent to which the George circle rejected Paterian aestheticism in the early years of the twentieth century.

Personally rejecting Paterian aestheticism does not guarantee that your work will not itself be subjected to Paterian-style criticism. A 1904 short story by Thomas Mann serves to highlight some of the ways in which aestheticism, in both its humanizing and de-humanizing modes, permeated the *George-Kreis* at the turn of the century. In "Beim Propheten" ("At the Prophet's"), Thomas Mann fictionalizes his experience of hearing a performance of Ludwig Derleth's *Proklamationen* (*Proclamations*). Derleth was close to George for a very brief period at around this time. His *Proclamations* called for a rebirth of the Christian tradition in Europe; and he read them privately to George before going on to perform them in public. In Mann's short story, a young novelist and a group of similarly curious bohemians and wealthy slummers climb up into the garret of the impoverished "prophet" Daniel, to which they have been invited for a reading of his proclamations. They gather around an altar arrayed with candles and images of such figures as Nietzsche, Savonarola, and Caesar, and wait in vain for the visionary to appear. Instead, one of his disciples shows up—he is come all the way from Switzerland to fill in for his absent master—and proceeds to read the words of the prophet. Our protagonist finds himself distracted by thoughts of his future mother-in-law (who is also in attendance) and cravings for a ham sandwich. Still, he leaves what should have been a disappointing performance in high spirits, entertained by the bizarreness of the occasion, and persuaded that he is a fashionable and successful young man. Five years before Gundolf would characterize such types

in his essay, Mann portrays precisely the kind of "Geck" that Gundolf despises, one who can be found at the fringes of a cultish group so long as it is fashionable. Not only is Mann's protagonist a dandy in Gundolf's sense, he is also a Paterian aesthetic critic, for his aesthetic experience revitalizes his future plans. Here is a short story, then, in which both impulses are represented: the emulation of the prophet by the disciple (a de-humanizing aestheticism) becomes a performance that is transformed into a new aesthetic object—the narrative itself—by the artistic observer (a Paterian re-humanizing aestheticism).

* * *

I am suggesting in this paper that we might differentiate between re-humanizing and de-humanizing aestheticism as follows: re-humanizing aestheticism is the phenomenon described in Pater's "Conclusion"—a practice that breathes life into art and in so doing creates new art (a generative process whose outcome is *unpredictable*); de-humanizing aestheticism is a practice that reifies art, that privileges repetition or emulation over improvisation or originality, and is the mode that the atmosphere around George generally encouraged (a generative process, too; but one whose outcome is *predictable*). In describing this difference, I by no means wish to suggest that one method was good and the other bad; or indeed that they are mutually exclusive. (One might, for instance, look at the fascination among aesthetes for the Catholic Church around the turn of the century, and productively discuss that institution's rituals in terms of repetition and dogmatism; and at the same time recognize the re-humanizing potential Catholicism could hold for some converts.[14]) Nor do I want to suggest that George was simply dogmatic, or that his own work was a model of de-humanized aestheticism. Rather, I would argue that he allowed (or tacitly encouraged) members of his circle to foster a kind of orthodoxy that effectively meant— *pace* Gundolf—that emulation was the order of the day. And that the realm of emulation, of orthodoxy, of repetition is the realm to which we can turn in order to expand our notion of what might constitute a de-humanized aestheticism. An aestheticism not separate from life, or devoid of humanity, but perhaps simply less heaving with the "quickened, multiplied consciousness" that for Pater is the mark of the sensitive aesthetic critic.

Notes

1. This is not to say that Pater and Wilde do not have strong opinions about the function of art in society. Wilde, for instance, in his American lecture on house decoration, speaks at length about the joy he experiences when he sees a utilitarian object that has been made to look aesthetically pleasing. But the point here

is that where the issue of *reception* is concerned, Paterian aestheticism demands certain qualities of the critic, and not necessarily of the work of art.

2. Pater's default aesthetic critic is male throughout *Studies in the History of the Renaissance*, yet a number of the contemporaries who put his theories into practice were women. Vernon Lee (Violet Paget) and Michael Field (the lesbian couple Katherine Bradley and Edith Cooper), for instance, were profoundly influenced by Pater's philosophy, and produced works (in Lee's case art historical essays and in Field's case ekphrastic poetry) that are very much in the spirit of Paterian criticism.

3. Merriam-Webster Online defines "to dehumanize" as "to deprive of human qualities, personality, or spirit." "Dehumanize," *Merriam-Webster Online*, 10 July 2006 http://www.m-w.com/dictionary/dehumanize.

4. Adam Phillips points out that the phrase originally appeared in Matthew Arnold's 1862 essay "On Translating Homer," and was repeated at the start of "The Function of Criticism at the Present Time," which appeared in 1864, nine years before Pater's *Studies* (Pater, *Studies* 159).

5. Sixteen years later, Pater is still making this point in his essay on "Style," where he argues that "all beauty" is "in the long run only ... expression, the finer accommodation of speech to that vision within" (*Appreciations* 10). In other words, beauty is always that which is mediated by the sensitive art critic.

6. J.-K. Huysmans's notorious novel of aestheticism and decadence appeared in 1884. For a synopsis of the novel's influence on *The Picture of Dorian Gray*, see Calloway 47–8.

7. For a discussion of the fraught personal relationship between the two writers, see Rieckmann's *Hugo von Hofmannsthal und Stefan George*. See also Norton, 98–107.

8. On the homoerotic element in the relationship between the two men, see Rieckmann, *Hugo von Hofmannsthal und Stefan George*. For a discussion of George's concept of love between men in general, see Keilson-Lauritz.

9. In the first issue of the periodical, the editor (nominally Carl August Klein, but in reality Stefan George) had described it as being dedicated to "eine kunst für die kunst" (George I; "an art for art").

10. For a discussion of how George's work has variously be categorized, see Rieckmann, "Introduction" 18; for a treatment of the difficulty of labeling George as simply an aesthete, see Todd.

11. Excerpts from Friedrich Wolters's account of the Georgian project, *Herrschaft und Dienst* (*Sovereignty and Service*) appeared in the same issue of *Blätter für die Kunst*. Wolters's is a more esoteric piece, but also expands on the notion of the inspirational leader and the natural attitude of service he inspires in those around him. For an excellent analysis of the master/disciple dynamics at work in the circle around George, see Winkler.

12. Gundolf's argument stands in stark contrast to other deployments of the discourse of individualism in turn-of-the-century Germany. Many gay rights advocates at the time were using the language of "personality" and of "living life out to the full" in their defenses of same-sex desire. The individualistic theories of Friedrich Nietzsche, Max Stirner, and Julius Langbehn were folded in to writings by homosexuals like John Henry Mackay, Adolf Brand, and many contributors to the gay-themed magazine *Der Eigene* in an effort to portray love between men as something other than criminal or pathological. The homosocial aspects of the circle notwithstanding, the *George-Kreis* downplayed the individualism of all its adherents except, of course, George himself.

13. In his 1905 essay on Wilde, for instance, Hofmannsthal uses this word to refer to the Irishman ("Melmoth" 41).

14. Edith Cooper and Katherine Bradley continued, for instance, to produce volumes of only occasionally dogmatic, and often quite blasphemous poetry after their conversion to Catholicism in 1905.

Works Cited

Bürger, Peter. "The Negation of the Autonomy of Art by the Avant-Garde." ed. Thomas Docherty. *Postmodernism: A Reader*. New York: Columbia University Press, 1993. 237–44.

Calloway, Stephen. "Wilde and the Dandyism of the Senses." *The Cambridge Companion to Oscar Wilde*. ed. Peter Raby. New York: Cambridge University Press, 1997. 34–54.

Derleth, Ludwig. *Proklamationen*. Leipzig: Insel Verlag, 1904.

du Maurier, George. "The Six-Mark Tea-Pot." Cartoon. *Punch* Oct. 31, 1880: 194. Feb. 19, 2007. http://www.nyu.edu/library/bobst/research/fales/exhibits/wilde/images/punch.jpg

Ellmann, Richard. *Oscar Wilde*. New York: Vintage Books, 1988.

[George, Stefan]. "Blätter für die Kunst." *Blätter für die Kunst* 1.1 (1892): 1–2.

Gundolf, Friedrich. *Cäsar: Geschichte seines Ruhms*. Berlin: Georg Bondi, 1924.

———. "Gefolgschaft und Jüngertum." *Blätter für die Kunst* 8 (1909): 106–12.

———. *George*. Berlin: Georg Bondi, 1920.

———. *Goethe*. Berlin: Georg Bondi, 1916.

———. *Shakespeare und der deutsche Geist*. Berlin: Georg Bondi, 1911.

Hofmannsthal, Hugo von. "Sebastian Melmoth." *Oscar Wilde im Spiegel des Jahrhunderts*. ed. Norbert Kohl. Frankfurt am Main: Insel Verlag, 2000. 39–43.

———. "Walter Pater." *Art in Theory 1815–1900*. ed. Charles Harrison, Paul Wood, and Jason Gaiger. Oxford: Blackwell, 1998. 871–72.

Hofmannsthal, Hugo von and Stefan George. *Briefwechsel zwischen George und Hofmannsthal*. ed. Robert Boehringer. Berlin: Georg Bondi, 1938.

Huysmans, Joris-Karl. *A Rebours*. Paris: Charpentier, 1884.

Keilson-Lauritz, Marita. "Stefan George's Concept of Love and the Gay Emancipation Movement." *A Companion to the Works of Stefan George*. ed. Jens Rieckmann. New York: Camden House, 2005. 207–29.

Langbehn, Julius. *Rembrandt als Erzieher*. Leipzig: Verlag von C. L. Hirschfeld, 1890.

Mann, Thomas. "Beim Propheten." *Gesammelte Werke*. Vol. 8. Frankfurt am Main: S. Fischer, 1974. 365–9.

Norton, Robert E. *Secret Germany: Stefan George and His Circle*. Ithaca: Cornell University Press, 2002.

Pater, Walter. *Appreciations. With an Essay on Style*. London: Macmillan and Co., 1889. Rpt Evanston, IL: Northwestern University Press, 1987.

———. *Imaginary Portraits*. 1887. ed. Bill Beckley. New York: Allworth Press, 1997.

———. *The Renaissance*. ed. Adam Philips. Oxford: Oxford University Press, 1986. Rpt of *Studies in the History of the Renaissance*. 1873.

Rieckmann, Jens, ed. *A Companion to the Works of Stefan George*. New York: Camden House, 2005.

Rieckmann, Jens. *Hugo von Hofmannsthal und Stefan George: Signifikanz einer 'Episode' aus der Jahrhundertwende*. Tubingen and Basel: Francke, 1997.

Schaffer, Talia and Kathy Alexis Psomiades. "Introduction." *Women and British Aestheticism*. ed. Talia Schaffer and Kathy Alexis Psomiades. Charlottesville: University Press of Virginia, 1999. 1–22.

Todd, Jeffrey D. "Stefan George and Two Types of Aestheticism." *A Companion to the Works of Stefan George*. ed. Jens Rieckmann. New York: Camden House, 2005. 127–43.

Wilde, Oscar. *Collins Complete Works of Oscar Wilde: Centenary Edition*. Intro. by Merlin Holland. New York: HarperCollins Publishers, 1999.

———. "The Critic As Artist." *The Artist As Critic: Critical Writings of Oscar Wilde*. ed. and introduction Richard Ellmann. 2nd edn, Chicago: University of Chicago Press, 1982. 340–408.

Winkler, Michael. "Master and Disciples: The George Circle." *A Companion to the Works of Stefan George*. ed. Jens Rieckmann. New York: Camden House, 2005. 145–59.

Wolters, Friedrich. "Herrschaft und Dienst." *Blätter für die Kunst* 8 (1909): 133–8.

6

Art for the Body's Sake: Nietzsche's Physical Aestheticism

Kael Ashbaugh

The body of Nietzsche's philosophy is highly artistic. He presents his thoughts in such varied forms as the autobiography, the polemical essay, faux biblical narratives, lyrical poetry, and aphorisms. Along with his persistent critique of conventional morality, this wide ranging artistic approach to the discourse of philosophy has led to a reading of Nietzsche as part practitioner and part ideological patron of art for art's sake.[1] Indeed, this assumption to one degree or another has reached such currency that, in contemporary philosophical debates about art and ethics Nietzsche is invoked alongside Wilde in defense of the view that the value of a work of art should not depend upon a perceived ethical content.[2]

Certainly we would be remiss if we did not acknowledge that there is much in Nietzsche's thought that serves the cause of art for art's sake. At the same time, the picture is a good deal more complex. In his late notebooks, for example, he makes several critical references to *l'art pour l'art*.[3] In one entry, he writes that the principle of art for art's sake is as "equally dangerous" as any other distant ideal for its own sake: "instead of recognizing in [art, beauty, truth, and goodness] the intention to enhance life, one has associated them with [...] a higher world that peeps through this one here and there" (Nietzsche *Late Notebooks*, 206). With this comment, Nietzsche appears to place himself among those who would criticize aestheticism for turning its back on life. The perception of some measure of ambivalence lends credence to the view of those who would argue counter to the aestheticist reading and in favor of a portrait of the philosopher as a naturalist.[4]

Yet, should we really suppose that Nietzsche's attention to nature is exclusive of his turn toward art?[5] Rather than consider Nietzsche's emphasis on the natural as wholly separate from his interest in aesthetic phenomena, the present chapter examines how the two overlap. While there may seem to be a conflict between the world of artifice and adornment so important to aestheticism and the philosopher's frequent recourse to placing human affairs within a natural world, I propose that the two come to intersect in a kind

of "art for the body's sake." In this way, Nietzsche redefines the relationship between art and life as a complementary one. Rather than working against aestheticism, his concern for life, defined in relation to the body, goes hand in hand with his view of art's importance. Previously, this conjunction between the aesthetic and the natural in Nietzsche's aestheticism has been mostly overlooked. Instead, criticism of Nietzsche's aestheticism has tended to focus on these two dimensions of the philosopher's thought as at odds with one another. I begin by briefly reviewing how this divide has mostly been sustained and propose that once the split between art and nature is overcome, it becomes possible to see how this physical aestheticism (the pursuit of an experience of art, measured in relation to the body) entails an initial process of de-humanization, but is rapidly followed by a new account of the sensually re-humanizing potential of art. I follow the refinement of that account of the re-humanizing poten-tial of art across three texts that I take to be key to Nietzsche's expression of an aestheticism of the body: "On Truth and Lying in a Non-Moral Sense," *The Genealogy of Morals*, and *The Gay Science*.[6] By looking at Nietzsche's attention to physical sensation in his account of the value of art, I examine how Nietzsche's distinctively physical aestheticism, his "art for the body's sake," resists making of art an occasion for metaphysical exercise that would distance the artist or the artistic receptor from the sensations of the human body. In this way, Nietzsche comes to privilege aesthetic experience in a way that makes it more difficult to claim that the primacy of art is at the expense of life.[7]

Before turning to consider Nietzsche's physical aestheticism, it is instruc-tive to briefly review how past criticism has alternately come to classify him as either an aestheticist or a naturalist, largely excluding the possibility for an intersection between the two. This comes through most explicitly on the side of naturalism in "Nietzsche and Aestheticism," where Brian Leiter bases his criticism of Alexander Nehamas's reading of Nietzsche's aestheti-cism partially on the proposition that if Nietzsche is a naturalist he cannot also be an aestheticist (Leiter 275–6, 278–9, 288–90). At the other end of the spectrum, two other critics attempt to dislodge the either/or dichotomy between aestheticism and naturalism with different results. Ruben Berrios's fusing of vitalism and aestheticism in "Nietzsche's Vitalistic Aestheticism" seems to hold the most promise in terms of reconciling Nietzsche's turn to nature with his aestheticism.[8] However, Berrios's focus is on examining how Nietzsche's vitalism relates to aestheticism in the course of laying out the case for an instinctual ethics. Thus the focus is less on the role of corporeal experience itself. To speak of vitality or life without the body, risks to some extent moving away from life understood in the immediacy of bodily experience. That distinction between vivification in general and the idea of the body as a place for certain kinds of experience, aesthetic and otherwise, is important in setting out what sort of life it is that Nietzsche believes art

may enhance. Even so, Berrios's melding of aestheticism with other aspects of Nietzsche's thought suggests a promising direction for future scholarship.

Alan Megill, on the other hand, takes a more characteristic approach to the overall aestheticism/naturalism divide in "Nietzsche as Aestheticist." He balances the two positions, but does so only by committing provisionally to the idea of Nietzsche as an aestheticist or as a naturalist at different moments. Megill attempts to balance his many views by arguing all of the following in rather rapid succession: (1) that Nietzsche can be seen as anti-aestheticist; (2) that he can be seen as aestheticist; and finally, (3) that there are better arguments for his being seen as a naturalist rather than as an aestheticist (Megill 216–7). Yet he fails to appreciate how such pluralism may be the product of the very complexity of Nietzsche's aestheticism and not an inherent inconsistency. Instead, for Megill, nature contributes to an incompatible way of talking about Nietzsche: "Nietzsche can probably be more convincingly portrayed as a 'naturalist' than as an aestheticist" (Megill 217). By seeking to classify his writings within one of these currents of thought, it is easy to forget that they may entail a mixture of many things, especially if Nietzsche has as his aims not the historically prevailing goals of naturalism or aestheticism, but rather his own reasons for associating himself with elements of each.

How, then, do elements of physical nature come to the foreground for Nietzsche in the midst of outlining a mode of relating to art? In the analysis of Nietzsche's physical aestheticism that follows, I concentrate on how the account of art that he initially provides in "On Truth and Lying in a Non-Moral Sense," is extended and revisited in two later works: *The Genealogy of Morals* and *The Gay Science.*[9] Spanning Nietzsche's lifetime, these works provide an unfolding portrait of the philosopher's view of the value of aesthetic experience: first in relation to cognition, then, in relation to morality and philosophical inquiry. In "On Truth and Lying in a Non-Moral Sense," Nietzsche introduces a primal physical account of art, whereby art's value dwells not in escaping the world so much as in stimulating sensation and resisting cognitive distance from the physical world. In *The Genealogy of Morals*, that cognitive distance is seen in the domain of morality, which attempts to provide an explanation of suffering that would appeal to the mind, only to end by punishing the body. It is in *The Gay Science*, though, that Nietzsche conceives of an aestheticized mode of philosophy in the playfulness of a *fröhliche wissenschaft* or *gaya scienza*. In this case, philosophy itself looks to art to reengage with the life of the body. The new art that Nietzsche introduces is "mocking, light, fleeting, divinely untroubled, divinely artificial art, an art for artists, only for artists" (*Gay Science*, 7–8). This art serves aesthetic embodiment, the artist, rather than an abstract ideal of art. Here too, Nietzsche furnishes his reader with a phrase that reflects the corporality of his own aestheticism. That is, his battle cry appears not to be "art for art's sake," but instead "art for artists." Thus, Nietzsche's aestheticism

ultimately challenges art for art's sake to give aesthetic experience a body: a point of view and a space for sensation rooted in the moment. Though this aestheticism of the body eventually provides a sensual re-humanization of aesthetic experience, the price of that re-humanization is an initial critical de-humanization: the human as heretofore understood will need to be seen as a problem. This becomes most clear when Nietzsche begins "On Truth and Lying in a Non-Moral Sense" with the following account of human deficiency:

> In some remote corner of the universe, flickering in the light of the countless solar systems into which it had been poured, there was once a planet on which clever animals invented cognition. It was the most arrogant and most mendacious minute in the "history of the world"; but a minute was all it was. After nature had drawn just a few more breaths the planet froze and the clever animals had to die. Someone could invent a fable like this and yet they would still not have given a satisfactory illustration of just how pitiful, how insubstantial and transitory, how purposeless and arbitrary the human intellect looks within nature.
>
> (141)

Nietzsche's criticism of the human intellect challenges the idea that the human should be positively defined in terms of cognition. Resituating human existence within nature, he portrays the human penchant for interpreting the world through cognitive constructs as harmful to the degree that it leads one to accept a habitual perception as that view of the world within which one should live. That such a perception may appear true enough, of course, is hardly an excuse to Nietzsche, who will propose that truth is lying according to accepted convention, with its origins in the same techniques as art: "What then, is truth? A mobile army of metaphors, metonymies, anthropomorphisms, in short a sum of human relations which have been subjected to poetic and rhetorical intensification, translation, and decoration" ("Truth," 146). While the poetic intensification and decoration of truth sounds exciting for a moment, Nietzsche argues that the nourishing side of art that resides in truth has been depleted. Once the metaphors "have been in use for a long time, [they] strike a people as firmly established, canonical, and binding; truths are illusions of which we have forgotten that they are illusions, metaphors which have become worn by frequent use and have lost all sensuous vigour" ("Truth," 146). The aesthetic value of such truth, then, is extremely diminished. The art of truth has lost its aesthetic value for the individual, for whom truth becomes an abstract inheritance, cut off from personal sensation and relegated to the realm of cognition. Caught in the realm of cognition, "[a]s creatures of *reason*, human beings now make their actions subject to the rule of abstractions; they no longer tolerate being swept away by sudden impressions and sensuous perceptions" ("Truth," 146). We can see

now that Nietzsche's critical portrait of the human is based on an aesthetic objection: as truth-seeking creatures, we increasingly remove ourselves from sensuous perception, treating the world around us as one of truth rather than one of art. A drive to truth evades the lived experience, which for Nietzsche is rooted in the perspectival sensations we derive in an aesthetic realm rather than those ideas we universalize in an abstract one.

Given the need to get away from the cognitive tendencies that prevail among humans, it is only appropriate that the aesthetic realm be depicted as closer to the experience of animals. We are told that "[e]verything which distinguishes human beings from animals depends on this ability to sublimate sensuous metaphors into a schema, in other words, to dissolve an image into a concept" ("Truth," 146). Clearly, it would be a little strange to think of animals as more artistic than humans, or as more fully experiencing sensuous metaphors. However, by saying that the human is human by virtue of this ability to sublimate, Nietzsche is able to deploy a primal basis for his denunciation of the human. This de-humanization is in preparation for a revaluation of the human in physical terms. Nietzsche proposes the presence of a natural human ability that he says we encounter when faced with art. Since he must distinguish this from the negative portrait of the human at the start of the essay, he now associates the world of metaphors with something that seems more basic to life: animal experience. This explains the surprising, albeit charming, idea of animal poets. Therefore, while Nietzsche at first appears to describe animals as akin to poets and artists, things end the other way around. The animal serves as a metaphor for that which was left out of the earlier portrayal of the cognitive human and which Nietzsche seeks to recuperate: an experience of bodily health and vitality. Put simply, Nietzsche tells us that we would be more alive as humans if we were sensual, rather than clever creatures.

In response to the cooling security of human cognition, Nietzsche introduces an aesthetic alternative: a drive to form metaphors ("Truth," 150). By encouraging a drive to form metaphors, which replaces the drive to truth in fashioning the world in which we live, Nietzsche gives an account of what he takes to be the revitalizing effect of art. The artistic drive to metaphor

> seeks out a channel and a new area for its activity and finds it in myth and in art generally. It constantly confuses the cells and the classifications of concepts by setting up new translations, metaphors, metonymies; it constantly manifests the desire to shape the given world of the waking human being in ways which are just as multiform, irregular, inconsequential, incoherent, charming and ever-new, as things are in the world of dream.
>
> ("Truth," 151)

He adds that an intellect liberated by seeing the world as art, as if in a dream but believing it to be as real as any waking world, is now able to demolish

the old cognitive framework. Freed by art, the intellect will use the logical scaffolding supporting traditional truths as "a plaything on which to perform its most reckless tricks." Once this framework or scaffolding has been smashed, jumbled, and reassembled, Nietzsche argues, it becomes apparent that "those makeshift aids of neediness" were not required since the intellect "is now guided, not by concepts but by intuitions" ("Truth," 152). In this exuberant account of the freeing power of art, Nietzsche approaches the aesthetic exultation of art for art's sake. The goal of an intellect freed from "neediness" and following intuitions, however, may be all too remote and ideal for a later Nietzsche.[10] Furthermore, in this early essay, the account of art increasingly looks like an identifiable practice of art that we might locate in *particular* forms of art that challenge our "drive to truth" and the habits of relating to art mimetically. We should ask, then, whether what Nietzsche describes as a fundamental property of art is better understood as a tentative proposition about certain types of art, or even about a mode of relating to art rather than a property of the thing itself. Surely not *all* art pours forth a "hot liquid stream from the power of the imagination" ("Truth," 148). After all, there are aspects of artistic experience that are also entangled with cognition and which might lead us to solidify and cool our experience of the world by appealing to known concepts, themes, or tropes. For these reasons, I propose that Nietzsche's account in "On Truth and Lying in a Non-Moral Sense" sets forth only a partial account of a vitalizing aesthetic practice. In the essay, Nietzsche describes how cognitive abstractions distance us from the perspectival world of sense stimulation, a natural world in which animals live while the human increasingly becomes one of the "clever" creatures, left to freeze in some remote corner of the universe. An alternative is eventually introduced, as he begins to describe a new human, a "human animal" with aesthetic aspirations. Yet his description tends to idealize the power of art.

How, then, does Nietzsche's view of art develop elsewhere? The exuberance that Nietzsche shows for aesthetic experience reappears, but now with significantly greater qualifications about the power pertaining to the world of art. In *The Gay Science* he turns to the idea of a style or mode of aestheticized philosophy, rather than pursuing an intrinsic ideal of art in which responses are taken as predeterminedly beneficial or detrimental. In order to understand the urgent context for that *gaya scienza* though, it is necessary to flash forward to a work published later, in which Nietzsche gives a full account of ascetic ideals. In *The Genealogy of Morals*, Nietzsche also sheds the blinders he held in the early essay, while now identifying a new physiological malaise: asceticism.[11] From the first sentence of the discussion concerning ascetic ideals, Nietzsche exposes the vulnerability of artists to asceticism: "What is the meaning of ascetic ideals?—In the case of artists they mean nothing or too many things" (*Genealogy*, 97). He repeats the statement in Section 5: "What then is the meaning of ascetic ideals? In the case of an

artist, as we see, nothing whatsoever! ... Or so many things it amounts to nothing whatsoever!" (*Genealogy*, 102). This realization signals a more tempered view of the power of art. Nietzsche shows the artist to be vulnerable to asceticism, whether the artist purposefully seeks purity from the world for art or merely stumbles into an ascetic valuation. Yet, that vulnerability rests on the artist's realization that asceticism may lend itself to supporting the artist's efforts for self-preservation. In what he calls "a brief formulation of the facts of the matter," Nietzsche writes, "*the ascetic ideal springs from the protective instinct of a degenerating life* which tries by all means to sustain itself and to fight for its existence" (*Genealogy*, 120). As such, the ascetic ideal signals the presence of a life struggle and, insofar as it remains a device for preserving life, it is no worse than a sore throat signaling that the body is fighting an infection. Nietzsche associates this nontoxic aspect of the ideal with an instinct to flee from a decaying life, and calls the ascetic priest "the incarnate desire to be different, to be in a different place" (*Genealogy*, 120).

For Nietzsche, it is not the instinct for change that damages life. When humans find themselves in pain or oppressed by unassimilated suffering, the instinct to be different or to be elsewhere (in time or place) quite rightly takes effect. Aesthetically, this experience could have given rise to poetry, myth, and metaphors that would have made the time of suffering worthwhile. Instead, ascetic priests, philosophers, and artists, after identifying suffering with sinfulness, commanded us to be different. In ascetic terms, life became "this" life and over and above it, a better life was projected. The illusion was delivered as a truth ultimately supported by the illusion of a benevolent and provident creator.

Thus, Nietzsche allows for the role of such an instinct in creativity and survival, but sees the ascetic priest as impeding the possibility of the body's survival by sacrificing the body itself for a spiritual "life." The ascetic priest transforms the desire to be different into a disgust of the body (*Genealogy*, 121). Nietzsche explains how the ascetic ideal became detrimental by becoming a moral imperative against this life:

> The idea at issue here is the *valuation* the ascetic priest places on our life: he juxtaposes it (along with what pertains to it: "nature," "world," the whole sphere of becoming and transitoriness) with a quite different mode of existence which it opposes and excludes, *unless* it turn against itself, *deny itself* [...] The ascetic treats life as a wrong road [...] or as a mistake that is put right by deeds—that we *ought* to put right.
>
> (*Genealogy*, 117)

Overcoming the effect of that imperative requires that one unleash the desire to be different (this time, different from the ascetic mode) and that requires a new valuation or what Nietzsche calls a "revaluation of all values" (*Genealogy*, 160). Nietzsche turns to art once more to awaken the value of

the physical, even though the occasion for that physical revitalization has changed: to overcome the toxic effects of the ascetic ideal. Now art allows one to challenge deadened artifacts, something which resembles the lifeless metaphors from which truth was said to be constructed in "On Truth and Lying in a Non-Moral Sense." Since the instinct to be in a different place was turned into a moral imperative, the instinct and the devices generated by that instinct for flight have been robbed of their life-promoting force. Now art, "in which precisely the lie is sanctified and the will to deception has a good conscience" (*Genealogy*, 153), works as a perspective from which to reverse the damage of the ideal because the artistic perspective allows us to ridicule the ideal and its seriousness. Some hint of the value of ridicule appeared in the earlier essay when Nietzsche wrote of an intellect freed by art using truth as "a plaything on which to perform its most reckless tricks" by jumbling and ironically reassembling it ("Truth," 152). However, the equation is modified in *The Genealogy of Morals*. Here it is not all art, but rather an *ironic* art that attains such freedom. Nietzsche identifies "the comedians of this ideal" (*Genealogy*, 160) as the real enemies of the ascetic ideal because they can awaken mistrust of the ideal among the people.[12] Nietzsche himself indulges in some mischievous humor too when he writes: "it is the awe-inspiring *catastrophe* of two thousand years of training in truthfulness that finally forbids itself *the lie involved in belief in God*" (*Genealogy*, 160).

Consider briefly what makes this moment near the ending of *The Genealogy of Morals* so mischievously ironic. The very seriousness with which the will to truth took its task—to question everything, particularly ourselves, relentlessly brought about the discovery that "God" and all the other artifacts made by the ascetic priest were just that, artifacts. That ironic jest brings self-consciousness, the downfall of the ascetic ideal, and the self-negation of the will to truth. In other words, a will to truth led us to discover the worn-out value of certain grand truths (i.e., God). Nietzsche's aestheticism, however, takes a different path. He situates art, the artist, and artistic reception in a sensuously re-humanized space where the desire to be different does not deteriorate into a relentless self-analysis designed to escape the world and fulfill ascetic imperatives.

The Genealogy of Morals touches on the question of the importance of the body in the context of the harm done by morality. That critique, however, largely takes place at a distance. It looks back to another age for its account of the positive value of the physical when it refers to how "knightly-aristocratic value judgments presupposed a powerful physicality, a flourishing, abundant, even overflowing health" (Nietzsche, *Genealogy*, 35). It does not elaborate on how this past health and physicality are to be of use more immediately in relation to aesthetic experience. In *The Genealogy of Morals*, Nietzsche presents the problem of asceticism that an aestheticism of the body will need to

confront, and he even intimates the beginnings of a solution by referring to the comedians of the ascetic ideal, but our picture of his physical aestheticism is not complete. We need to return to *The Gay Science*, to get a more direct account of how the art and the life of the body meet. It is here that Nietzsche delves most explicitly into a physical account of art, and most relentlessly leaves behind the purity of an ideal art suggested by "On Truth and Lying in a Non-Moral Sense."

While thematically linked to *The Genealogy of Morals* throughout most of Book Four and through the recapitulation of the critique of morals in Section 335, it is in the *The Gay Science* that Nietzsche solidifies his physical aestheticism by advocating a link between art and physics, and a break from metaphysics.[13] *The Gay Science* sets itself apart from *The Genealogy of Morals* by providing a more direct account of what is involved in turning to the physical and resisting the lure of metaphysical ideals. Philosophy itself looks to art to rectify the "*misunderstanding of the body*" and to "acquire a subtler eye" (*Gay Science*, 5). The artistic process becomes an experience of one's own embodiment through which we feel the "*attraction of imperfection*" drawing us into the physical world, admittedly through the enjoyment of an ironic illusion: "putting oneself on stage before oneself" (*Gay Science*, 79).

Crucial to our understanding of Nietzsche's fashioning of an aestheticism of the body is section 299, entitled "What one should learn from artists." In this section, Nietzsche faces imperfection squarely and without loss of gaiety and the spirit of dance that characterizes the whole work. While *The Genealogy of Morals* will deal with healing the harm done by ascetic ideals, it is in *The Gay Science* that Nietzsche explicitly links artistic creation to the work of physicians and to the body, particularly the perceiving body. He asks, "What means do we have for making things beautiful, attractive, and desirable when they are not? And in themselves, I think they never are!" (*Gay Science*, 169). The exclamation that accompanies the question parallels the warnings of *The Genealogy of Morals* concerning absolutes, "things in themselves," and other ascetic constructs (*Genealogy*, Sections 9, 12, 13, 17). The ugliness of metaphysical constructs seems to Nietzsche to be insurmountable. The beautification of something, the awakening of its desirability, cannot, then, be accomplished through idealization. Nietzsche suggests that we learn from physicians, "when for example they dilute something bitter or add wine and sugar to the mixing bowl" (*Gay Science*, 169). That is, with sugar added, we might be able to taste the appeal of the medicine. While it remains bitter, we only have a cognitive notion of its benefit. Thus, Nietzsche's physician makes an appeal to the momentary experience of the body rather than relying on the mind to provide a strictly reasoned framework for the value of medicine.

Nietzsche argues that we learn even more from artists: (1) we learn to look at things from very far away until they become blurry and the eye has to

reinvent them *"in order to see them at all,"* (2) we learn "to see things around a corner and as if they were cut out and extracted from their context," (3) we learn to place things so that each partially distorts the view one has of the others and allows only perspectival glimpses, (4) we learn to look at things "through coloured glass or in the light of the sunset," and (5) we learn "to give them a surface or a skin that is not fully transparent" (*Gay Science*, 299). By reinventing, distorting with glimpses, looking through filters and giving things a skin, artists show us how aesthetic experience can provide not only comedy but also a sensual appropriation of given truths. That appropriation is not located in a drive to truth, but in the sensory realm of illusion. What is valuable about the world of the artist is that it teaches us to have a body—a tangible vantage point from which to reshape the truth. Nietzsche quickly qualifies what might sound like a new faith in artists by adding: "all this we should learn from artists while otherwise being wiser than they. For usually in their case this delicate power stops where art ends and life begins; *we*, however want to be poets of our lives, starting with the smallest and most commonplace details" (*Gay Science*, 299).[14] This is significant because Nietzsche's warning responds to the problem of trading an imperfect life for an ideal art. The possibility that he posits here is a break from any aesthetic reverie that might have entered the early essay. Instead of taking us to a primal world, which might serve as yet another distant ideal, art understood in physical terms should now begin with what is most immediate, but it is readily missed in the pursuit of what may lie beyond the horizon of sensation: "the smallest and most commonplace." Instead of pursuing more remote ideals, art re-humanizes by focusing on the immediacy of what surrounds us: our life understood in the plainest of experiential terms.

This turn toward the quotidian is unintuitively sensual. It focuses on discrete and everyday sensations that surround the body. By seeing this as the place of art, in being poets of our everyday life, art becomes re-humanizing relative to the here and now of the smallest and most commonplace. The body serves as a means by which Nietzsche is able to situate aesthetic experience in the moment. As a result, we see that the life of concern to Nietzsche is not only physiological but also highly contingent on the individual's experience as defined not through shared myths but rather in the aesthetic fashioning and appropriation of individual circumstances. Life is "this" life, rather than another set apart beyond it. In this fashion, Nietzsche's aestheticism becomes ever more a means of remaining in the realm of the senses, even when what is sensed does not beckon for special treatment. The meeting of life and art is not the provenance of romantically inspiring moments. No. In *The Gay Science*, we begin to see a mutual saturation of one in the other: for an instant, art and life intersect irreducibly.

Notes

1. At the core of Alexander Nehamas's analysis of Nietzsche's aestheticism in *Nietzsche, Life as Literature* is his argument that art infuses content and form alike in his writings. The present chapter focuses on the aestheticist content of Nietzsche's writing; however, the form and its relation to what he says of art is no less intriguing.
2. See Richard A. Posner, "Against Ethical Criticism," 1; Posner, "Against Ethical Criticism: Part Two," 394 and 398.
3. See *Late Notebooks*, 206 and 256, respectively. The second instance is no kinder. Nietzsche writes that if we but remove Love (i.e., "that intestinal fever") from the romantic lover's new faith in the world we have "L'art pour l'art, perhaps: the virtuoso croaking of abandoned frogs despairing in their swamp" (*Late Notebooks*, 256). The idealistic belief and remoteness of said frogs are presumably a part of the problem. Linking this passage to the preceding mention of art for art's sake, one could say that the problem is not that the frogs value art, but that they value art at the expense of an awareness of or a delight in their immediate amphibian reality. In the passage, Nietzsche uses the physical world of nature to burst the bubble of metaphysical reverie. Thus, the lover's new faith in the world is but an "intestinal fever" and the achievements of *l'art pour l'art* are caricatured using an image from the natural world: frogs croaking in a remote corner. Fittingly, the image itself reframes *l'art pour l'art* within nature, even as the imagery of the frogs entails an explicitly literary allusion to another work of art. No doubt some readers will have gathered already that the comment is not solely a reference to nature, but also a stylistic flourish wherein Nietzsche links his thoughts on art for art's sake to a scene from Aristophanes's play. My view that nature and artistry intersect in Nietzsche's physical aestheticism takes a small clue here from the dual effect of Nietzsche's frogs.
4. See Brian Leiter's "Nietzsche and Aestheticism," and Maudemarie Clark and David Dudrick's "The Naturalisms of Beyond Good and Evil." While Leiter is explicit in denying the aestheticist reading, Clark and Dudrick leave the matter off the table. I discuss the case of Alan Megill's "Nietzsche as Aestheticist" at greater length later, but it too argues for Nietzsche's naturalism as an alternative to his aestheticism.
5. In referring to nature or the body, my goal is not to assess the broader explanatory value of Nietzsche's remarks about either. Rather, my aim is to examine how that which Nietzsche speaks of as natural and as belonging to the body is important to his conception of the power of art.
6. *The Genealogy of Morals* is published on a date subsequent to, but nonetheless roughly contemporaneous with, the revised and expanded edition of *The Gay Science*, which was published earlier that same year of 1887 (see "Chronology," *Gay Science*, xxiv). While the first edition of *The Gay Science* was published in 1882, before *The Genealogy of Morals*, we should not necessarily suppose that the development of Nietzsche's ideas runs in tandem with dates of publication. Bernard Williams is but one of numerous scholars to note the complexity of *The Gay Science's* publishing history in particular (i.e., that it spans the period from 1882 to 1887). Williams further suggests that this complex history "throws some light on the development of [Nietzsche's] thought," which unfolds in an ongoing dialogue with ideas he voices in *The Gay Science* (*Gay Science*, vii). So while we could speak of its publication as at various moments preceding, following or roughly overlapping with other works of this time period, the present study treats

The Gay Science instead as a *space* in which Nietzsche takes the opportunity to cultivate certain ideas about art and the body beyond the scope he gives to this topic in other works. While he addresses issues of importance to aestheticism and writes of the body in numerous other works, some published after *The Gay Science*, this text comes last in my own discussion because it is the place where Nietzsche's aestheticism of the body is given its fullest and most direct treatment.

7. I am referring to a specifically physiological understanding of life. Life as it is experienced with reference to the body is critical to how I read Nietzsche's aestheticism.

8. In a footnote, Berrios makes an interesting point in this regard. He proposes that a shift toward the body is in a certain sense inevitable within aesthetics. Berrios points out that the aesthetic has been construed by the German tradition to entail fundamentally sense perception, thereby returning one to the organs of sensation (Berrios 85). While I take it that this return is indeed characteristic of Nietzsche, I am less sure that this is, as Berrios puts it, "motivated by the concept of the 'aesthetic' itself." If the concept of the aesthetic is defined as the "science of sensory cognition," as Berrios suggests it should be, this need not lead one toward (i.e., "motivate") the kind of focus on the body that we find in Nietzsche. Indeed, if anything, it would seem to lead one away from the kind of conceptualization that Nietzsche fashions, and toward the view that art and aesthetic experience are to be undertaken in the service of the very cognition that distances one from sensual experience in the moment. So while I agree roughly that for Nietzsche it is the case that with "sensory perception the body reveals, in palpable form, its identity as a living body" (Berrios 85), I am not sure that the seeds of that critical turn toward the living body are sown already into the concept of the aesthetic.

9. See Note 6 above for a discussion of the publishing chronology of the last two works. My analysis groups the second two works together and partially contrasts them to different degrees with the first work. In this way, I distinguish between the early and the later Nietzsche's views on the relation between art and life. I have opted to discuss the last two later works in an order that I think provides the clearest portrait of Nietzsche's ideas about art and the body. To a certain extent we need *The Genealogy of Morals* to understand *The Gay Science*. Walter Kaufmann makes this very point when he writes: "the whole conception of the 'gay science,' should be recalled in connection with Nietzsche's inquiry concerning 'ascetic ideals' in the *Genealogy*. Science and scholarship, he argues there, involve variations of asceticism. But his solution does not consist in renouncing reason: he wants to develop a 'gay science'" (*Genealogy*, 196). Since the idea of gay science unfolds from a reflection on the harm of ascetic ideals, I turn first to the work that is published later but which provides an explanation of those ideals.

10. We should recall that this work predates his break with Wagner, and like *The Birth of Tragedy*, could be said to exhibit a somewhat uncritical assessment of the power of art. In the other works I discuss, this enthusiasm is tempered.

11. Here he also turns to art to find an antidote to the drive to truth as that drive finds expression in ascetic ideals. While the ascetic ideal is initially associated with priests, increasingly it is encountered in idealist philosophy and science to some degree. When truth is taken to exist in a perfect realm outside the imperfections of the body, a search for truth becomes hostile to the body, and metaphysics turns against the physical.

12. The satirical response to received ideals implies a re-humanization at the level of the artistic receptor.

13. The linking of physics and art is one of many mischievously peculiar pairings that Nietzsche makes. I discuss another such pairing from *The Gay Science* later, when Nietzsche links physicians and artists. In both the case of physics and that of physicians a playful association takes place and a decidedly unsensual discipline is seen giving lessons about the physical.
14. One may recall that "On Truth and Lying in a Non-Moral Sense" drew upon this idea as well. Nietzsche refers to the drive to metaphor as continually showing "the desire to shape the given world of the waking human being in ways which are just as multiform, irregular, inconsequential, incoherent, charming and ever-new" ("Truth," 151). The presence of the "inconsequential," as an element of that refashioning of truth, partially anticipates the poetics of the "commonplace" that we find later in *The Gay Science*.

Works Cited

Berrios, Ruben. "Nietzsche's Vitalistic Aestheticism." *Nietzsche Studien: Internationales Jahrbuch für die Nietzsche-Forschung* 32 (2003): 78–102.

Clark, Maudemarie and David Dudrick. "The Naturalisms of Beyond Good and Evil." *A Companion to Nietzsche.* Ed. Keith Ansell Pearson. Malden, MA: Blackwell Publishing, 2006. 148–67.

Leiter, Brian. "Nietzsche and Aestheticism." *Journal of the History of Philosophy* 30: 2 (1992: Apr.): 275–90.

Megill, Alan. "Nietzsche as Aestheticist." *Philosophy and Literature* 5 (1981): 204–25.

Nehamas, Alexander. *Nietzsche, Life as Literature.* Cambridge, MA: Harvard University Press, 1985.

Nietzsche, Friedrich. *The Gay Science.* Trans. Josefine Nauckoff and Adrian del Caro. New York: Cambridge University Press, 2001.

———. *The Genealogy of Morals.* Trans. Walter Kaufmann. New York: Random House, 1989.

———. "On Truth and Lying in a Non-Moral Sense." *The Birth of Tragedy and Other Writings.* Ed. Raymond Geuss. Trans. Ronald Speirs. New York: Cambridge University Press, 1999. 139–53.

———. *Writings from the Late Notebooks.* Trans. Kate Sturge. New York: Cambridge University Press, 2003.

Posner, Richard. "Against Ethical Criticism." *Philosophy and Literature* 21.1 (1997): 1–27.

———. "Against Ethical Criticism: Part Two." *Philosophy and Literature* 22.2 (1998): 394–4.

Part III Rereading the Aestheticist Strand of Twentieth-Century Literature

7

From "God of the Creation" to "Hangman God": Joyce's Reassessment of Aestheticism

Daniel M. Shea

Armed with hindsight, most critics see early hints of Stephen Dedalus's Icarian flight within *A Portrait of the Artist as a Young Man*, recognizing that the narrative's ironic treatment of the young Romantic poet is suggestive of his failure. This hindsight, of course, is constructed mostly upon knowledge of the more naturalistic, yet sympathetic tone of *Ulysses*, and the shift between the novels in terms of their respective treatments of the artist as a young man has signaled many changes for scholars. Whether it is a movement away from a Yeatsian-inflected romanticism or a very real disillusionment with the promise of flight to the Continent, there is general tacit agreement that Stephen has failed to escape Dublin's paralysis. However, within the critiques and studies of Joyce's chimerical artistic appropriations, there is one artistic foundation which has not been examined: the two versions of Stephen reflect an author whose vision of himself as the "God of the creation" is unsettled by a growing uncertainty regarding the consequences of aestheticism. As a theory, *l'art pour l'art* seemed to promise the young artist the kind of freedom created and experienced by countrymen W.B. Yeats and Oscar Wilde. Free from Ireland, though, and never one to follow in the footsteps of others, Joyce treats the budding aesthete Dedalus with a healthy dose of irony. Healthy, perhaps, for 1914, but between *A Portrait* and *Ulysses* lies cataclysmic change. Although a short two years have elapsed between the novels, the reader is given a markedly different portrait of the artist. The difference is not to be found in Stephen, though; the death of his mother is not the cause for his paralysis and depression, nor are we to look for anything else that may have occurred between 1902 and 1904. Instead, the temporal (1914–21) and spatial (Trieste–Zurich–Paris) trajectories of *Ulysses* reveal an awareness of the Great War and its effects on the peoples involved. Once a liberating artistic movement, art for art's sake betrays its unwitting participation in the pursuit of modern warfare that suggests a larger concern of the potentially de-humanizing effects of this artistic movement.

The presence of aestheticism in Joyce's writings has been examined by a small, yet insightful number of studies.[1] Questions of influence usually revolve around the issue of style, such as, for example, Richard Ellmann's contention that Joyce imitated Pater's style for his early essay on John Clarence Mangan. Beyond concerns of style, which actually becomes moot after "Oxen of the Sun," a few scholars have argued for a more tangible debt, a source of the epiphany in Pater's concept of the "privileged moment." In many ways, the epiphany, the spiritual manifestation within a sensible object, serves as the doorway into a Joycean *l'art pour l'art*. The usual starting point for how aestheticism exists in the Joycean imagination is Stephen's explanation to Lynch in *A Portrait of the Artist as a Young Man*. After defining what beauty is, Stephen continues to explain the nature of the artistic mode of existence:

> The esthetic image in the dramatic form is life purified in and repro-jected from the human imagination. The mystery of esthetic like that of material creation is accomplished. The artist, like the God of the creation, remains within or behind or beyond or above his handiwork, invisible, refined out of existence, indifferent, paring his fingernails.
>
> (*Portrait* 215)

Here, Dedalus crystallizes his controlling metaphor for the artist, the Flaubertian "God of the creation," the artist as an indifferent creator. Placed, therefore, in context of his repudiation of Catholicism, Stephen justifies his role as artist, appropriates the act of creation from the divinity, and names himself as the "priest of the eternal imagination, transforming the daily bread of experience into the radiant body of everliving life," outside of demands of nationalism, religion, and politics (*Portrait* 221). More than any other aspect of *l'art pour l'art*, this insistence that art exists in an autonomous realm, outside social or cultural demands is where aestheticism most clearly emerges from within Joyce's corpus.

Influence, however, is often confused with appropriation in Joycean criticism, and the reader must be wary of claiming a Paterian influence with an artist whose style of writing was to pick up what his foot struck (Ellmann 661n). Few artists entered Joyce's imagination without some correction or diminishment. While the fecundity and notoriety of Pater's legacy may have inspired an entire generation of writers including Yeats and Wilde, Joyce seemed to distrust aestheticism's totalizing claim as it pertained specifically to the Irish experience; *his* Irish experience, however urban, middle-class, and priest-ridden. For example, in a deflating juxtaposition typical of *A Portrait*, Lynch immediately follows Stephen's definition of art with a demand to know why Stephen "prat[es] about beauty and the imagination in this miserable Godforsaken country? No wonder the artist retired within or behind his handiwork after having perpetrated this country" (*Portrait* 215).

Lynch's response, though flippant, is crucial, for it is an early echo of the limitation of *l'art pour l'art* in its ability to deal specifically with the Ireland: its weather, history, politics, religion, or people.[2] Stephen's art risks becoming an empty stance, looking "like a fellow throwing a handful of peas into the air" for all of its significance or consequence (*Portrait* 252).

The search for influence, then, tends to rest where criticism begins, and previous examinations of the role of aestheticism overlook Joyce's implicit critique. His initial attitude, inspired by his love of Ibsen's social awareness, seems to be rather dismissive. As early as 1900, Joyce, in "Drama and Life," argues for an aesthetic of engagement for art. Although he rejects ethics as an artistic concern, he avoids aligning himself with the aestheticist movement, unlike many of his contemporaries. He contends that, concerning the aims of drama,

> [a] more insidious claim is the claim for beauty. As conceived by the claimants, beauty is as often anaemic spirituality as hardy animalism. Then, chiefly because beauty is to men an arbitrary quality and often lies no deeper than form, to pin drama to dealing with it, would be hazardous. Beauty is the swerga of the aesthete; but truth has a more ascertainable and more real dominion.
>
> (43)

Of course, this is young Joyce, signing letters with "Stephen Daedalus," the student capable of resting his argument upon a forceful claim of "truth" as the highest end of drama. Nonetheless, Joyce's statement is quite bold, for he refuses the traditional Keatsian equation of Beauty and Truth, a distinction he reiterates and expounds later in his Pola Notebook. This actually separates the pursuit of Truth from any consideration of Beauty at all, thus casting doubt upon the general worth of *l'art pour l'art* for the artist. Furthermore, Joyce feels justified in his accusation of aestheticism's vacillation between "anaemic spirituality" and "hardy animalism," for this is another artistic Scylla and Charybdis. Art is neither passive contemplation of a Beauty unconnected to the world, nor is it submersion into baser passions and sensations. However, Joyce is also not casting the issue in the familiar rhetorical dichotomy wherein he will plot a middle ground. The suggestion that art is found somewhere between the two or in a combination of the two is a complete misunderstanding of the purpose of art, Joyce argues. Art is not a mathematics in which adding spirituality to animalism will yield the desired and calculated result; the Truth of the human condition is not to be found in the fusion of two inhuman elements. As we shall see, Buck Mulligan, Joyce's aesthete, represents the artist who experiences only "ideas and sensations," and the unsettling intersection of mere "ideas and sensations" or of "spirituality" and "animalism" without Truth leads to the consequences of the Great War and the rise of fascism (*Ulysses* 1. 192–3).

Like the Theosophy of Yeats and Russell, then, *l'art pour l'art* is an esoteric otherworld of art; as such, removed from the realities of Dublin, it is inherently uncertain as to what it is. Far more than Pater, it is Ibsen's unrelenting social awareness that shapes Joyce's demand for art's engagement of life. The relationship between life and art, especially as defined by Wilde, is reversed: aestheticism sought to turn art into life; Joyce turned life into art. The difference may seem slight, but an aesthetically determined life has ominous repercussions.

Pater's revolutionary ideas on the nature of art in relation to society may have been useful in showing the young artist how to fly by the nets of nationality, language, and religion, but that may be the extent of his appropriation of the aesthetic movement. For, where *l'art pour l'art* was the theory, Oscar Wilde was the practice, and here Joyce's misgivings about aestheticism became outright rejection. Wilde, the Irishman who went to Oxford and became more English than the English, as it is often put, is a much more complicated figure in the novelist's imagination than Pater or Swinburne. Joyce enjoyed his countryman's writings enough to stage his plays and praised his *Salomé*, and the idea that Joyce, like the playwright of *The Importance of Being Earnest*, usurps the conqueror's language has inspired countless studies. Moreover, Joyce clearly sympathized with an artist hounded to death by the *petit bourgeois* culture, even though Wilde's homosexuality was the "logical and inescapable product of the Anglo-Saxon college and university system" ("Oscar Wilde" 204).

However, Wilde's deathbed conversion to Catholicism and his role as "court jester" to the English present a troubled relationship among politics, religion, and art as they exist within the matrix of *l'art pour l'art* ("Oscar Wilde" 202). Selling out to the English as Wilde had done, Joyce suggests, has long been part of the Irish comic tradition, from Sheridan to Shaw; he continues the practice in *Ulysses* by having Stephen asking Haines for money in exchange for a definition of Irish art cribbed from Wilde: the "cracked lookingglass of a servant" (*Ulysses* 1. 146). Irish art, a colonized tradition, is complicated both by its own hybrid nature and by its reception by the colonizer, the arbiter of aesthetic success. To be successful, in short, the artist needs to be accepted by the English, as indeed Wilde and The Celtic Twilight were.

These postcolonial musings are essentially academic in nature, though, and Joyce's attitude likely would have remained as it was in "Drama and Life" and in *A Portrait*, dismissive. More disturbing was Wilde's conversion to Catholicism, as it called into question the pose of the aesthete, the ability of *l'art pour l'art* to remain aloof. In 'Oscar Wilde: The Poet of 'Salomé,'' Joyce suggests that the aesthete's pose is as much a lack of spiritual dedication as it is an embrace of the "divinity of joy" (203). The continuation of the theological metaphor central to *A Portrait* allows Joyce to locate precisely the problem with *l'art pour l'art*: as it shapes a religion of art, it ignores the human

being's role in that religion. Wilde's conversion greatly complicates that sense of art-as-religion as it stands in direct contrast to Stephen's declaration that he was "not afraid to make a mistake, even a great mistake, a lifelong mistake and perhaps as long as eternity too" (*Portrait* 247). There would be no conversion for the artist who refuses to kneel at his dying mother's bedside, but that great refusal has consequences that Wilde could not face. Thus, what concerns Joyce is the spiritual emptiness of the aesthete's pose. The full implications of this stance, however, did not become clear until after the eventual publication of *A Portrait of the Artist as a Young Man*, and both the events and the aftermath of the Great War, the effects of which characterize Joyce's treatment of aestheticism in *Ulysses*.

In the end days of the war and in the *Nachkrieg* (Afterwar), many intellectuals and artists attempted to make sense of what had happened. To Walter Benjamin, the German-Jewish literary critic, these philosophical assessments formed the theoretical basis for fascism in general and National Socialism specifically. In his "Theories of German Fascism," he argues that the loss of the war was compensated by the development of the "stance of obstinate rigor" of the front line soldiers (317). Heroism, along with its accompanying ideals, glory, and beauty, was pushed into "ever more remote and nebulous spheres" in response to the unleashed technological forces which threatened to make them irrelevant (317). As Ansgar Hillach notes in his commentary on Benjamin's work, this "stance" made "possible the continuation, even the glorification, of the World War, which had become absurd in the actual battles" (102). This glorified, inhuman stance, Benjamin rightly observes, is the "uninhibited translation of the principles of *l'art pour l'art* to war itself" (314). Benjamin noted that the theory of war arising from the 1914–18 conflict and the theories of *l'art pour l'art* shared the same roots in the *haute bourgeoisie's* need to have a psychically safe art, one unable to reflect social reality. For all of its notoriety and transgression of bourgeois expectations, *l'art pour l'art* mimicked bourgeois complacency. Furthermore, the aesthete's drive for sensation and experience finds a similar expression in the soldier's commitment to the fight for its own sake, "the expression and correlate of inner experience" (Hillach 101). The increasingly recognizable de-humanizing effect of mechanized, mass warfare essentially shaped a "war for its own sake" response within the *Nachkrieg* generation. The continuation of the Great War was in large part made possible by the "aestheticization of politics," a transposition of human-directed affairs into a realm beyond human control which Benjamin considered to be the cornerstone of fascist/National Socialist politics. This aestheticized response was made necessary by the decline of bourgeois culture, effected by the mass technological nature of the war, the first whose means had outstripped its respective society's ability to control it. The fighting could only be carried out through the fetishization of the military uniform as the outward manifestation of the soldier's "stance" (317).

While other artists had similar reservations to *l'art pour l'art*—Bernard Shaw, for example, famously found *The Importance of Being Earnest* to be "sinister" and "hateful"—few examined it in terms of its political implications. Indeed, there was little reason to do so, for *l'art pour l'art* scarcely inspired the same activism as Shaw's socialism, and Joyce's early response was likewise framed in mere artistic (i.e. Ibsenian) terms. The stakes became much higher. Benjamin's seminal analysis of aesthetic politics, which clearly identifies the intersection of *l'art pour l'art* and the experience of the Great War in the rise of fascism, clarifies why Joyce's hesitation in his early work becomes outright condemnation in *Ulysses*: *l'art pour l'art* ultimately de-humanizes both art and what it attempted to represent. In essence, the fall of Oscar Wilde, engineered by the very bourgeois society that had helped shape him, was played out again in the massive theater of the Great War. By rendering history and politics aesthetic, bourgeois culture freed itself of any moral or ethical responsibilities, and thus enabled the de-humanizing trauma of the Great War. Joyce's critique is more than merely an aesthetic judgment of the worth of a particular school or movement; it is a visceral analysis by a colonized artist all too aware of the aesthetic trappings of power and its uses in dominating the masses.[3]

Ulysses, therefore, vividly renders Stephen's distance from the promises that the echoes of aestheticism had seemed to offer in *A Portrait*. To punctuate the concern with *l'art pour l'art*, *Ulysses* opens not with him, but with "[s]tately, plump Buck Mulligan," the Wilde-inspired and Swinburne-quoting medical student whose wish is to "Hellenize" Ireland (*Ulysses* 1. 1). While Mulligan clearly embodies his inspiration, Oliver St. John Gogarty, who, like Wilde before him, had attended Oxford and was once considered the "wittiest man in Ireland," Joyce had more than mere literary revenge in mind (Ellmann 117). The aesthete contextualized by colonized Ireland rather than England, Mulligan manifests Joyce's concern with the artistic, political, and human consequences of *l'art pour l'art*.

If one thinks back to Stephen's definition of art explained in *A Portrait*, it will be remembered that the young poet has no "terminology" to define "artistic conception, artistic gestation and artistic reproduction," a crippling limitation for any artist (*Portrait* 209). In *Ulysses*, though, Stephen has developed a fascinating theory on *Hamlet* and Shakespeare's ability to use his own life as the source of his art. Again, the reader is able to see a change from *A Portrait* to *Ulysses*: instead of encountering the "reality of experience" as a catalyst for art, the artist creates it, God-like, from himself. Though slight, the change from the artist as "god of the creation" to the artist as "father of his own grandfather" heralds Joyce's break with aestheticism as an artistic mode, though it does not come without its costs. The source of this art is, as Joyce explains in "Oscar Wilde," and more fully in "Scylla and Charybdis," a wounding of the self through betrayal, separation, and sin.

The context of this wounding, however, is precisely what aestheticism cannot engage, for this is not a Swinburne transgression in search of sensation, but a Miltonic *non serviam*. In Joyce's eyes, Wilde was not "tough-minded enough" to directly depict his own wound, his homosexuality; instead, "lies and epigrams" hide what Ibsen would have placed clearly on stage (Ellmann 233). However, Wilde at least had "Truth" to explore, both in his homosexuality and in his Irishness; he failed to express either. Without this "Truth," Joyce suggests, the artist is left as Mulligan. Listening to Stephen's theory on *Hamlet*, Mulligan constructs his own parodic theory of artistic creation: a masturbatory play: "*Everyman His Own Wife, or, A Honeymoon in the Hand*," a typically Joycean critique of an artistic movement whose end was sensation and enjoyment (*Ulysses* 9. 1171–3).[4]

Mulligan's art, as good satire should not, offers nothing other than sensation and a certain amount of aesthetic pleasure. The Irish *seanchai* could rhyme rats to death, and Jonathan Swift's satire was aimed squarely at human folly. Mulligan engages neither of these, choosing instead mere mockery against which Stephen mentally warns him: "*Was Du verlachst wirst Du noch dienen*" (What you mock you will one day serve) (*Ulysses* 9. 491; my translation). As with his reaction to Stephen's theory of artistic creation, Mulligan cannot create; he can only mock and echo. Thus, like Wilde's fate, Mulligan becomes a "court jester to the English." His "ballad of joking Jesus" is part of the act to impress the cultural imperialist by playing the witty Irishman, and, as Haines notes, "his gaiety takes the harm out of" his blasphemy (*Ulysses* 1. 606). However, as with his own form of artistic creation, this leads ultimately nowhere: it may be witty and clever, but it ignores Life. The fate of this "brood of mockers," like that of the heretics, is "the void" and "a worsting from those embattled angels of the church" (*Ulysses* 1. 657; 663).

Far from the liberation promised by aestheticism, without political or social awareness, *l'art pour l'art* is appropriated by the hegemonic powers for their own ends. Stephen is very aware of how easily the artistic diffuses within the political. As he tells Haines, he is the "servant of two masters [...] an English and an Italian. [...] And a third [...] there is who wants me for odd jobs": in other words, England, Rome, and the Irish Renaissance (*Ulysses* 1. 638; 641). Stephen continues his stance of *non serviam*, acknowledging the result as a "horrible example of free thought" (*Ulysses* 1. 625–6). The aesthete, on the other hand, pursues the Wildean artistic model, as Mulligan asks Stephen "[w]hy don't you play them as I do," clearly suggesting that to play up to the English, to become like them, is to find simultaneously artistic freedom and political statement in the style of *The Importance of Being Earnest* (*Ulysses* 1. 506). Similarly, Mulligan rebukes Stephen for failing to pray at his mother's deathbed: "Humour her till it's over" (*Ulysses* 1. 212). In another instance, Mulligan wonders why Stephen—reflecting an actual Joycean review—"[c]ouldn't [...] do the Yeats touch" when reviewing Lady Gregory's work for the *Daily Express* (*Ulysses* 9. 1160–61). Mulligan

capitulates whenever the situation calls for it; unpleasantness is thus avoided. Ultimately, Mulligan, as Stephen predicts, serves Haines as tour guide, as jester, and, literally, as servant when he helps the waitress "to unload her tray" laden with Haines's food (*Ulysses* 10. 1081). Politically speaking, Mulligan is clearly playing the "court jester" to the Englishman Haines, the Oxfordian who is in Ireland to experience the now-fashionable "Celtic Twilight." Military, political, and cultural imperialists, the English in *Ulysses* have reduced the Irish Renaissance and its aesthete cohort to souvenirs to be collected on a vacation from Oxford. Commonly seen as representing the forces of imperialism, Haines is the genial imperialist who has since forgone direct military control and exploitation, shunning any potential guilt by aestheticizing the political trajectories of the two countries. Haines removes human agency from the arena of imperialism and colonialism, explaining to Stephen in an oft-quoted phrase that "history is to blame" for England's treatment of Ireland (*Ulysses* 1. 649). England has settled into a far more comfortable role of benevolent father figure, reducing both Irish Home Rule and artistic independence to a well-worn axiom: "I should think that you are able to free yourself. You are your own master, it seems to me" (*Ulysses* 1. 636–7). Following this piece of subjective "self-actualization," though, is the movement away from independence: "I don't want to see my country fall into the hands of German jews either. That's our national problem, I'm afraid, just now," including Stephen apparently as a "Britisher" (*Ulysses* 1. 666–8). This is, according to Hillach's analysis of Benjamin, a typical manifestation of political action emerging from the Great War: politics becomes "goal-oriented action which remains metaphoric, since the constructed image of the enemy cannot replace the real goal of self-determined action. Action is removed to a level of representation, it becomes aestheticized" (104). Like the spiritual substance lacking in Wilde's "divinity of joy," both *l'art pour l'art* and aestheticization of politics erase any real consideration of the individual. Perhaps the best punctuation of this point is the "onelegged sailor" whom, in the "Wandering Rocks" chapter, the narrative interjects into Haines and Mulligan's tea shop conversation. He embodies exactly what Haines and "*England expect*" in terms of national problems and art's participation in them (*Ulysses* 10. 1064).

The final failure of *l'art pour l'art* emerges from its inability to aesthetically engage death, just as the *Nachkrieg* likewise turned away from doing so in favor of a war for its own sake. Joyce already knew that Wilde's response to his own impending death was "[to close] the book of his spirit's rebellion," a capitulation reminiscent of Mulligan ("Oscar Wilde" 203). When Stephen confronts him with a slight toward his deceased mother, Mulligan reveals an inability to respond to death in any humane fashion:

> And what is death […] your mother's or yours or my own? You only saw your mother die. I see them pop off every day in the Mater and Richmond and cut up into tripes in the dissectingroom. It's a beastly

thing and nothing else. It simply doesn't matter. [...] To me it's all a mockery and beastly. Her cerebral lobes are not functioning.

(Ulysses 1. 204–11)

While the argument may certainly be made that Mulligan's response is conditioned both by a sense of defensiveness and his medical education, death's relegation to something that "doesn't matter" is simply unacceptable to Joyce. If one considers the continued presence of the shade of Parnell in his fiction, of Michael Furey in "The Dead," not to mention the liveliness of Rudy Bloom, Rudolph Virag, and May Dedalus in *Ulysses*, death is certainly not "nothing" in Joycean fiction.

At this point, a movement from the problems of life to the metaphysics of death, the fuller examination of Joyce's controlling metaphors must be carried out. The failure of aestheticism may be realized in a political context, but Joyce suggests the inadequacy of Pater's movement through his change in artistic metaphor. In Stephen's oft-quoted speech, the artist is "the God of the creation," a divine identity affirmed time and again throughout *A Portrait*: Stephen is the "priest of the eternal imagination, transmuting the daily bread of experience into the radiant body of everliving life," and, therefore, poetry echoes the conception of Christ, as "[i]n the virgin womb of the imagination the word was made flesh. Gabriel the seraph had come to the virgin's chamber" (221; 217). This appropriation of religious metaphor, particularly as it suggests the Christian fusion of divine and human, as Moliterno observes, is very much in line with Pater's dialectic of sense and spirit (137).

However, this Romantic and aesthetic self-portrait of the artist as divinity has vanished by the writing of *Ulysses*, replaced with Stephen's vision of Shakespeare. This artist is only a reflection of the *dio boia*, the hangman god, the divinity which frustrates one's designs and probably caused Wilde's deathbed conversion to Catholicism (*Ulysses* 9. 1049). Whether as the thunder which frightens Stephen in "Oxen of the Sun," as the "shout in the street" defined in "Nestor" and manifested in "Circe," or as the Blakean "old Nobodaddy," the *dio boia* is the ineffability of reality, that which ultimately frustrates the artist (*Ulysses* 2. 386; 9. 787). This is a fundamental difference between the Joycean artist and the aesthete: where *l'art pour l'art* seeks to turn art into life, the author of *Ulysses* turns life into art. A slight difference perhaps, but it is, as Benjamin might observe, the same slight difference between the fascist aestheticization of politics and the socialist politicizing of art. Because life stands at the center of art, the cult of absolute beauty fails in a world whose "playwright [...] wrote the folio of [...] it badly" (*Ulysses* 9. 1047). Haines can easily say "I couldn't stomach that idea of a personal God," but Joyce and Stephen both realize that a casual agnostic is aesthetically insufficient precisely because the "personal" or the individual has no value in such a system (*Ulysses* 1. 623).

Most critics fail to comprehend Stephen's sense of Catholicism, relegating it to intellectual aesthetic, convenient symbol, or lingering guilt. It is likewise difficult to avoid Joyce's Catholicism when discussing his aesthetic, and in terms of the potentially de-humanizing effects of art for art's sake, there is certainly no need to do so on our part. The novelist clearly pursues his assessment in terms of the divinity.[5] Unlike Haines, neither Joyce nor Stephen is able to slough off the material of life to an impersonally conceived "nightmare" of history, or, by extension, to reimagine the deity as an impersonal force, liberating one from personal responsibility. God, as a cultic figure and as historical constant, like Stephen's aesthetic theory, *"remains* within or behind or beyond or above his handiwork," a continual reminder of the Creator [emphasis added]. In short, merely claiming to be an apostle of beauty or the priest of the eternal imagination does not remove the divinity from His position.

Simply put, Stephen has never recovered from the Father Arnall's hellfire sermon, a misunderstood event. While most critics read it as evidence of a dogmatic and oppressive Church, it actually shaped Stephen's concept of the artist positively. For one, it makes the stance of the aesthete impossible. Consider, for example, the difference Hell makes to Stephen's ability to "play" as Mulligan puts it: steeped in sin, yet prefect of the sodality of the Blessed Virgin Mary, Stephen notes that the "falsehood of his position did not pain him" (*Portrait* 104). It is only after the sermon, after he aesthetically experiences Hell that the empty stance of a Mulligan or of a Wilde becomes impossible. True art comes only out of the sense of sin and consequence, but this liberating understanding paradoxically paralyzes Stephen. Mulligan, playing the ubiquitous betrayer of the Irish artist, says that Stephen "can never be a poet" and will never know "[t]he joy of creation" (*Ulysses* 10. 1074–75). The difficulty? The Jesuits "drove his wits astray [...] by visions of hell" and he now fears "[e]ternal punishment" (*Ulysses* 10. 1072; 1076). Typical Mulligan mockery, but it is also true of Stephen's hesitation. Death, ugliness, and the potential of hell exist, and the attempt to aestheticize them—this does not mean to render them in art, but rather to turn them into artistic "stances," a trait shared by the proto-fascists Haines, Deasy, and the Citizen—ignores the truth of human suffering: the source of our dignity.[6] As early as *A Portrait*, Stephen recognizes the necessity of this suffering, as he says that he is not afraid to make an eternal mistake; the aesthete, on the other hand, is.

Like the heretics with whom he keeps company, Mulligan's mockery, though ultimately wrong, aids in shaping our understanding of Stephen's condition. Just as Arius, Sabellius, and the other heresiarchs helped to define Catholic dogma, Mulligan continues the Joycean religious contextualization by locating the source of Stephen's paralysis in his "visions of hell." Neither the Hellenic Mulligan nor the ancient Irish (respectively *l'art pour l'art* and the Irish Renaissance) have any concept of eternal

punishment, but the still-Catholic Stephen is unable to move past the sense of sin and consequence. It is the knowledge of Hell, though, that makes the difference, that creates the complete human being. One need only to look at Odysseus, that oft-forgotten figure in Joycean studies, to understand this. Even after having seen Hades and hearing Achilles, Odysseus rejects what would amount to divinity with Calypso, choosing instead a life of suffering with only death as the end. This is Joyce's Complete Man. The flimsy aesthetic "stance" in the face of life and death leads to its eventual rejection, based on the art and the fall of Oscar Wilde who had "deceived himself into believing that he was the bearer of good news of neo-paganism to an enslaved people" ("Oscar Wilde" 204). The "gift" of neo-pagan Hellenism was, to Joyce, a "European appendicitis," for it offered Beauty without Truth, a condition which, left untreated, could kill (Ellmann 103n). Benjamin, writing under National Socialism, clearly recognizes the implications:

> "*Fiat ars-pereat mundus*" says Fascism, and [...] expects war to supply the artistic gratification of a sense perception that has been changed by technology. This is evidently the consummation of '*l'art pour l'art.*' Mankind, which in Homer's time was an object of contemplation for the Olympian gods, now is one for itself. Its self-alienation has reached such a degree that it can experience its own destruction as an aesthetic pleasure of the first order.
>
> ("Work of Art" 242)

The pride of *l'art pour l'art* was that it was beyond the demands of morality, ethics, and social concern. However, its pursuit of beauty and sensation, naïve in its ignorance of mechanized mass production, merely contributed to the already de-humanizing effects of technology, effects made clear by the Great War. According to Benjamin, as mass technology became the *de facto* vehicle and structure for art, aestheticism found itself contemplating the kinds of sensations and experiences that could be found in such an arena: those arising from the new mass technological war.

The way to engage the realities of cultural and socio-economic reality, like those of imperialism and bourgeois hypocrisy, is not through disengagement. Aestheticism's attempt to rise above cultural decline inspires fascism's eventual attempt to burn away the dross through war. In the face of so many demands upon the purpose of art, Joyce refuses them all except one. He returns to art's original cultic center, a culturally defining essence which existed before the rise of the *bourgeoisie* and mass production. This is not to be confused with mere religion, though, for that path leads to dogmatism and institution. Walter Benjamin would agree with this assessment, for he too saw an original cultic or ritualistic role for art. The rise of the bourgeois culture, though, simultaneously created

[t]he secular cult of beauty, which developed during the Renaissance and prevail[ed] for three centuries, clearly [showing] the ritualistic basis in its decline and the first deep crisis which befell it. With the advent of the first truly revolutionary means of reproduction, photography, [...] art sensed the approaching crisis which has become evident a century later. At the time, art reacted with the doctrine of *l'art pour l'art*, that is, with a theology of art. This gave rise to what might be called a negative theology in the form of the idea of "pure art."

("Work of Art" 224)

Like the crisis of technology which shaped the *Nachkrieg* experience and, as Benjamin observes, the fascist class warrior, a crisis in art created aestheticism.

Joyce's final correction of *l'art pour l'art*, less harsh than his rather scathing conclusion that the pursuit of Absolute Beauty at best results in a Buck Mulligan self-gratification, is the appropriation of Pater's "privileged moment." While Pater may have been a source for the Joycean epiphany, it is shortsighted to ignore the continued religious terminology that Joyce uses, for the epiphany calls attention to the divine, specifically the *dio boia*. Whereas aestheticism was concerned with beauty and the aesthetic sensation, the epiphany, informed by its adherence to "things as they really are," forces the spectator and the reader to engage life directly: this is precisely Wilde's "cracked lookingglass." And, true to his Jesuit training, Joyce deliberately frames this artistic device within a tradition that directs our attention to the divine within the mundane, even the ugly, or, in other words, the realm of humanity. This was, after all, the original Epiphany, and any movement away from human beings *as they are* deviates from the Truth for which the young follower of Ibsen so passionately argued.

Joyce's early reservations on the emptiness of the aesthete position are ultimately justified by *l'art pour l'art*'s participation in the political morass surrounding and following the Great War. The young writer who fled provincial Ireland for the openness and the culture of the continent found there, particularly from 1914 and its aftermath, something far more dangerous than a repressive Catholicism and a nostalgic cultural revival. Aestheticism may have given Joyce the vision of the liberated artist, flying beyond the nets of nationality, language, and religion. It even inspired the vocabulary by which to define himself as a new kind of artist, the priest of the eternal imagination. To be an apostle of beauty, a priest of the eternal imagination is to gloss over "things as they are," and, in light of the political developments during and after the Great War, the artist was not prepared to play anyone's court jester, even as a satirist. The replacement of the cultic center of art with a subjective aesthetic experience, what Thomas Mann, in his *Doctor Faustus*, would call a "culture without the cult," will have terrible repercussions. The substitutions for a cultic divinity—cults of beauty, personality, or the *Volk*—eventually result in mass destruction, carried on

for its own sake, if not militarily, then culturally or ethnically. Through its "scrupulous meanness" and its "cracked lookingglass," *Ulysses* reminds us that, as unaesthetic as it may be, the true source and subjects of art are the dignity of the individual human being in a degrading world.

Notes

1. Cf. Jay B. Losey, "Pater's Epiphanies and Open Form" in *South Central Review*; Frank Moliterno, *The Dialectics of Sense and Spirit in Pater and Joyce*; Robert Scholes and Richard Kain, *The Workshop of Daedalus: James Joyce and the Raw Materials for "A Portrait of the Artist as a Young Man"*; Judith Ryan, *The Vanishing Subject: Early Psychology and Literary Modernism*.
2. Judith Ryan's *The Vanishing Subject* is an excellent examination of the issue of the material world through the divide between Stephen's and Pater's "metaphysics" and "physics," though without investigating the political and materialist consequences of this divide (148).
3. For more on the presence of the Great War in Joyce's writing, see Robert Spoo, "'Nestor' and the Nightmare: The Presence of the Great War in *Ulysses*," in *Twentieth Century Literature*.
4. Gerty MacDowell, whom Frank Moliterno sees as a "Paterian archetype" and "an intertextual blend of the sensual and spiritual" in the "Nausicaa" episode, effects a similar experience of sensation and (self-)enjoyment on Leopold Bloom (14).
5. Other scholars who recognize this Catholic element in the construction of Joyce's aesthetic include Robert Boyle, *James Joyce's Pauline Vision: A Catholic Exposition*; William Noon, *Joyce and Aquinas*; and Beryl Schlossman, *Joyce's Catholic Comedy of Language*.
6. Flannery O'Connor, another Catholic writer, once noted: "If there were no hell, we would be like the animals. No hell, no dignity" (231).

Works Cited

Benjamin, Walter. "Theories of German Fascism." *Selected Writings. Vol. 2: 1927–1934.* ed. Michael W. Jennings, Howard Eiland, and Gary Smith. Trans. Jerolf Wikoff. Cambridge, MA: The Belknap Press of Harvard University Press, 1999. 312–21.
——. "The Work of Art in the Age of Mechanical Reproduction." *Illuminations.* ed. Hannah Arendt. Trans. Harry Zohn. New York: Schocken, 1968. 217–51.
Boyle, Robert. *James Joyce's Pauline Vision: A Catholic Exposition.* Carbondale: Southern Illinois UP, 1978.
Ellmann, Richard. *James Joyce.* Oxford: Oxford UP, 1982.
Hillach, Ansgar. "The Aesthetics of Politics: Walter Benjamin's 'Theories of German Fascism.'" *New German Critique.* Trans. Jerolf Wikoff and Ulf Zimmermann. 17 (1979): 99–119.
Joyce, James. "Drama and Life." *The Critical Writings of James Joyce.* ed. Ellsworth Mason and Richard Ellmann. New York: Viking, 1959. 38–46.
——. 'Oscar Wilde: The Poet of 'Salomé.'' *The Critical Writings of James Joyce.* 201–5.
——. *A Portrait of the Artist as a Young Man.* New York: Viking, 1970.
——. *Ulysses.* New York: Random House, 1986.
Losey, Jay B. "Pater's Epiphanies and Open Form." *South Central Review.* 6.4 (1989): 30–50.

Moliterno, Frank. *The Dialectic of Sense and Spirit in Pater and Joyce*. Greensboro, North Carolina: Elt Press, 1998.

Noon, William. *Joyce and Aquinas*. New Haven, CT: Yale UP, 1957.

O'Connor, Flannery. *The Habit of Being: Letters*. ed. Sally Fitzgerald. New York: Farrar, Straus, Giroux, 1979.

Ryan, Judith. *The Vanishing Subject: Early Psychology and Literary Modernism*. Chicago: U of Chicago P, 1991.

Schlossman, Beryl. *Joyce's Catholic Comedy of Language*. Madison, WI: U of Wisconsin P, 1985.

Scholes, Robert, and Richard Kain. *The Workshop of Daedalus: James Joyce and the Raw Materials for "A Portrait of the Artist as a Young Man"*. Evanston: Northwestern UP, 1965.

Spoo, Robert. "'Nestor' and the Nightmare: The Presence of the Great War in *Ulysses*." *Twentieth Century Literature*. 32.2 (1986): 137–54.

8

The Aesthetic Anxiety: Avant-Garde Poetics, Autonomous Aesthetics, and the Idea of Politics

Robert Archambeau

If you are personally acquainted with any significant number of poets, you will perhaps not be surprised to find that the thesis of this essay is as follows: poets want to have their cake and eat it too. The particulars of the argument, though, go beyond the intuitive and the obvious, or so I hope. What I want to say is this: since the nineteenth century, poets have faced a dilemma. On the one hand, many poets have felt the allure of the radical freedoms of an entirely autonomous art, an art not in the heteronomous service of any religious function, ideological formation, moral system, cause, or institution, an art that exists for art's sake alone. On the other hand, poets have faced the anxieties that such autonomy seems, inevitably, to create: fears of losing their readerships, their social roles, and their political utility. Many poets of the twentieth century, especially those affiliated with avant-garde movements, have been haunted by such anxieties, and have sought to assuage them by claiming that a commitment to aesthetic autonomy can, in and of itself, be a form of political action. Such an identification does not bridge the chasm between a belief in autonomous art and a belief in the kind of heteronomous art that serves a cause. Rather, it denies the existence of such a gap, and asserts that the disinterested pursuit of art for its own sake is also, by its very nature, politically efficacious.

Positions of this kind are by their nature fraught with contradictions, and raise many a question. Can withdrawal from political engagement be anything other than quietism? What are the politics of audience, when the art speaks neither to the disempowered classes nor to a significant element of the power elite? Can a political art still be autonomous, or does it bend its craft to a political end? Indeed, the attempt to work through such questions has been the driving force behind many an avant-garde polemic. Despite the difficulty of maintaining the identity of aesthetic autonomy and political utility, though, this dream of the poets has endured for the better part of a century.

Two groups of poets who attempt to identify aesthetic autonomy with the political—the surrealists and the language poets—are of particular interest

because of the different forms of politics to which they link autonomous aesthetics. Starting in the 1920s, the surrealists, under the general guidance of André Breton, sought a link between the radical imaginative freedom of their movement and the project of Communist revolution. Later, beginning in the 1970s, the American language poets sought to identify aesthetic freedom with a kind of negative politics—a politics of critique and resistance, rather than one conducted with a specific revolutionary utopia in mind. Whatever the form of politics, though, the enduring nature of the poet's anxiety about reconciling aesthetic autonomy and political efficacy indicates that we may have reached a point in the history of poetics in which what I am calling the aesthetic anxiety (that is, the anxiety about the apparent political and social inutility of autonomous art) is not so much a passing crisis as it is a lasting condition of poetic production. Whether the solution to this anxiety proposed by the avant-garde poets can survive is, of course, another question, and one to which the answer, increasingly, seems to be "no."

To understand the aesthetic anxiety, we need to look briefly at certain conditions of the creation of aestheticism, which was born of a rejection of utility. Aestheticism, at least in part, grew out of the alienation from the powerful classes of those committed to imaginative expression. The alienation was palpable enough for the Goncourt brothers to note that the social world of the writer had become "curious when you compare it to the society life of littérateurs of the eighteenth century, from Diderot to Marmontel; today's bourgeois scarcely seeks out a man of letters except when he is inclined to play the role of mysterious creature, buffoon, or guide to the outside world" (Cassagne 342). Animosity ran in both directions between bourgeois and littérateur, but the fundamental conditions for this situation lay in the newly powerful bourgeoisie's rejection of literary means of expression. As Pierre Bourdieu has argued, to understand "the horror the figure of the bourgeois sometimes inspired" for literary people "we need to have some idea of the impact of the emergence of industrialists and businessmen of colossal fortunes. [...] they were self-made men, uncultured parvenus ready to make both the power of money and a vision of the world profoundly hostile to intellectual things triumph within the whole society" (48). The artistic and literary tastes of the bourgeoisie created a market dominated by heteronomous principles of aesthetics, an environment in which art and literature were to be judged not as art and literature *per se*, but as expressions of bourgeois religious, moral, and economic systems. The producer of imaginative works unwilling to reconcile himself to such systems was driven toward a self-authorizing position, in which artistic activity was made legitimate on the basis of artistic values alone. We sense this revulsion from the bourgeois world when Flaubert writes, in a letter of 1871, that everything in the bourgeois order is "false": "all this falseness [...] was applied especially in the manner of judging. They extolled an actress not as an actress, but as a good mother of a family. They asked art to be moral, philosophy to be clear, vice

to be decent, and science to be within range of the people" (200). The rejection of the bourgeois order here involves turning one's back on the powerful, who see everything in terms of utility and morality.

Aestheticism, of course, is not the only response to growing bourgeois hegemony in the nineteenth century. While realism and naturalism, with their strong social commitments and occasional careless artistry, are often seen as antithetical to aestheticism, there is another sense in which they are aestheticism's counterparts. The followers of Hugo and Zola share with the practitioners of art for art's sake an opposition to the bourgeoisie, its art and its institutions (Bourdieu 75). Baudelairian rejection of moralisms of all stripes notwithstanding, it is remarkable how often one finds, among those associated with aestheticism, a sense of anxiety about the lack of the realists' strong social engagement. There is a certain buried envy, among aesthetes, for the clear social purpose of a different kind of art. Indeed, those drawn to the aesthete's rejection of bourgeois hegemony often show signs of anxiety about their mode of rejection. Algernon Charles Swinburne, Arthur Symons, and W.B. Yeats all provide examples of these anxieties.

The literary trajectory of Algernon Charles Swinburne has often been described as a matter of rapid acceleration in the direction of aestheticism, followed by a sudden reversal with a turn toward writing in the service of - politics. While this is not entirely untrue of the broadest outlines of Swinburne's career, it would be more accurate to say that Swinburne constantly vacillates between aestheticism's autonomous art and a heteronomous writing in the service of politics. While his early period is dominated by aestheticism, it is haunted by the specter of the political.

Having been introduced to ideas of *l'art pour l'art* after meeting Dante Gabriel Rossetti while at Oxford in 1857, Swinburne tried to embrace the principles of his mentor and, through him, the work of Baudelaire and his school in France. His enthusiastic 1857 review of Baudelaire's *Flowers of Evil* (suppressed and republished in slightly different form in 1862) was meant to be his declaration of aestheticist principles, a proud waving of the banner of autonomous art. The essay certainly begins with an unambiguous declaration of the autonomy of art. "A poet's business," says Swinburne,

is presumably to write good verses, and by no means to redeem the age and remold society. No other form of art is so pestered with this impotent appetite for meddling in quite extraneous matters; but the mass of readers seem actually to think that a poem is the better for containing a moral lesson or assisting in a tangible and material good work. The courage and sense of a man who at such a time ventures to profess and act on the conviction that the art of poetry has absolutely nothing to do with didactic matter at all, are proof enough of the wise and serious manner in which he is likely to handle the materials of his art.

(*Works* XX, 432)

"Here is an aesthete rampant," the reader may well declare. By the end of the review, though, Swinburne is already hedging his bets. Responding to unnamed critics who have, he says, accused Baudelaire of immorality, Swinburne backs away from the idea that art need not serve morality, and tells us that, despite appearances, "there is not one poem of the *Fleurs du Mal* which has not a distinct and vivid background of morality to it." While "the moral side of the book is not thrust forward in the foolish and repulsive manner of a half-taught artist," Swinburne assures us that "those who will look for them may find moralities in plenty behind every poem of M. Baudelaire's" (*Works* XX, 436). When the review was brought to Baudelaire's attention, he wrote to the young Englishman, denying that he was a covert moralist: the tempering of art's autonomy was, it seems, more present in the mind of the anxious reviewer than in the poems under review (Lang 88).

Swinburne's commitment to autonomous aesthetics wavered time and again, and his correspondence reveals the reason. Explaining, in a letter of 1866, why he had stopped writing poetry for much of 1861 to work for the cause of Italian liberation, Swinburne claims "it is nice to have something to love and believe in" and "it was only Gabriel [D.G. Rossetti] and his followers in art (*l'art pour l'art*) who for a time frightened me from speaking out" (Lang 195). Autonomous art seemed devoid of the kind of meaningful causes to be found in political action and engaged writing. That this letter was written the same year that Swinburne's *Poems and Ballads*—widely considered "his *Flowers of Evil*" (Cassidy 49)—only underlines the ambivalent nature of Swinburne's aestheticism, fraught continually with anxieties about art's potential for moral and political commitments.

Perhaps the most fascinating passage in Swinburne's prose, for our purposes, comes in his study *William Blake* (published in 1868 but written by 1866). Here, his vacillation with regard to autonomous art momentarily leads him to a position very like that adopted by the avant-garde poets of the twentieth century: the identification of autonomous artistic praxis with moral or political efficacy. "The contingent result of having good art about you and living in a time of noble writing," Swinburne writes, "is this":

> that the spirit and mind of men then living will receive on some points a certain exaltation and insight caught from the influence of such colors of verse or painting; will become for one thing incapable of tolerating bad work [...] which of course implies and draws with it many other advantages of a sort you may call moral or spiritual. But if the artist does his work with an eye to such results or for the sake of bringing about such improvements, he will too probably fail even of them. Art for art's sake first of all, and afterwards we may suppose all the rest shall be added to her (or if not she need hardly be overmuch concerned); but from the man

who falls to artistic work with a moral purpose shall be taken away even that which he has [...]

(XVI 137–8)

Here, a commitment to autonomy is essential to any true artist, but that commitment will, without the conscious intention of the artist, lead to the "moral or spiritual" improvement of the world. The heteronomous writer, committing his pen to causes, will by contrast inevitably go awry. The position is not so much argued as it is asserted, and like many un-argued assertions, it can be understood as an idea clung to less for its verifiability than for the way it seems to eliminate contradictions too painful to confront. Had Swinburne been able to convince himself of the proposition, he would have been able to transcend his dichotomy of autonomous and heteronomous principles of art.

Within a year of finishing the Blake study, though, Swinburne received a letter from the Italian revolutionary leader Giussepe Mazzini, urging him to give up "songs of egotistical love" such as those found in *Poems and Ballads*, and write "a series of lyrics for the Crusade" in Italy (Lafourcade 149). Swinburne's response, the long poem "A Song of Italy," seemed to indicate a definitive turn away from *l'art pour l'art*. But even in this late phase, having publicly rejected aestheticism, one still finds Swinburne vacillating with regard to autonomous art. Looking back on a mixed review of Victor Hugo's *Les Miserables* he had written during his aestheticist phase, Swinburne wrote that he was, at the time, too much "under the morally identical influence of Gabriel Gautier and Théophile Rossetti [sic] not to regret [...] that a work of imagination should be colored or discolored by philanthropy, and shaped or distorted by a purpose" (Lang 207). The deliberate reversal of Gabriel Rossetti and Théophile Gautier's names asserts a kind of identity between English and French versions of *l'art pour l'art*, but what, exactly, is Swinburne's attitude to this multinational movement? Does the philanthropy of a heteronomous art like Hugo's color or discolor the writing? Does a purpose beyond art itself shape or distort the aesthetic? It is impossible to say. And in this impossibility we see Swinburne's continued anxiety of the aesthetic, an anxiety that runs through the length of his writing career.

A similar anxiety finds its way into a later poet of British aestheticism, Arthur Symons. His famous 1893 essay "The Decadent Movement in Literature," for example, treats the movement he describes, and with which he wishes to be affiliated, with deep ambivalence. Symons refers to Mallarmé quite positively as the "leader of the great emancipation" (141), and sees the freedoms proposed by Mallarmé as liberations from the heteronomous art of the moralizing bourgeoisie, for Mallarmé "has wished neither to be read nor to be understood by the bourgeois intelligence, and it is with some deliberateness of intention that he has made both issues impossible" (142). But even as he celebrates Mallarmé's commitment to

artistic autonomy, Symons expresses uneasiness about an art apparently cut off from morality, politics, and any efficacy in the world of action. It is the literature, he says, of a moment "too languid for the relief of action, too uncertain for any emphasis in opinion or conduct" (136). When Symons discusses the poetry of Mallarmé, his language is telling in that it consistently indicates a sense of the limitations of the aesthetic/ decadent project he describes. Mallarmé's latest poems, says Symons,

consist merely of a sequence of symbols, in which every word must be taken in a sense with which its ordinary significance has nothing to do. Mallarmé's contortion of the French language, so far as mere style is concerned, is curiously similar to a kind of deprivation which was undergone by the Latin language in its decadence. It is, indeed, in part a reversion to Latin phraseology, to the Latin construction, and it has made, of the clear and flowing French language, something irregular, unquiet, expressive, with sudden surprising felicities, with nervous starts and lapses, with new capacities for the exact noting of sensation. Alike to the ordinary and to the scholarly reader, it is painful, intolerable; a jargon, a massacre.

(142)

Even leaving aside the obvious reservations about "painful, intolerable" poetry, one is struck by the negative nature of Symons's description ("deprivation," "reversion," "nervous"). Most strikingly, Symons describes Mallarmé's project as "merely a sequence of symbols" as involving "mere style"—as if something of great substance was missing from the aesthete's work. While Symons is committed to the project of literary decadence, he is by no means an unanxious adherent of the movement.

Symons's ideas were influential on W.B. Yeats, a fellow member of the Rhymer's Club.[1] Many of Yeats's poems can be read as meditations on their own conditions of production, and reveal a consistent ambivalence with regard to the aesthetic movement's claims for autonomous aesthetics. "Fergus and the Druid," for example, like Symons's essay, poses a dialog between a figure of autonomous imagination (the druid) and a figure of worldly, political power (Fergus). Fergus initiates the conversation, remarking on the infinitely changing nature of the shape-shifting druid's existence. The druid then asks "What would you, king of the proud Red Branch kings?" (7), and Fergus replies that he feels trapped in his role as a figure of power, always feeling the crown upon his head. He laments the fixed nature of his own identity that leaves him unable to enjoy the freedoms of the druid's imaginative existence. But when Fergus tells the druid that he would "be no more a king, but learn the wisdom that is yours," (7) the druid replies in language reminiscent of Symons's claim that aestheticism was unhealthy: "Look on my thin grey hair and hollow cheeks / And on these hands that may not lift the sword, / This body trembling like a wind-blown reed." (7).

The druid, for all his freedom, is a figure of weakness, impotence, and, significantly, a figure of no help to those in need. Autonomous aesthetics, while free of the rigidities of political responsibility, hardly appears ideal. When Fergus, despite the druid's warnings, opens the "little bag of dreams" and partakes of the druid's powers, he finds his experience curiously empty. The visionary imaginative experience, cut off from the possibility of action, use, or productivity is beautiful, but nothing more. It leaves him, to recycle Symons's words about the decadent movement in literature, "too languid for the relief of action, too uncertain for any emphasis in opinion or conduct" (136). That the poem is drenched in the exotic and archaic imagery characteristic of the English decadent poets only serves to make more plain the source of Yeats's poem in his anxiously ambivalent response to the idea of autonomous art.

Other examples of the aesthetic anxiety are, of course, legion in the works of poets of the late nineteenth and very early twentieth centuries. Nor are the novelists of the period free of anxieties about autonomous art. The ambivalent fate of des Esseintes at the end of Huysmans's *Against Nature* and the horror of the aesthete's active, commercial doppelganger in Henry James's story "The Jolly Corner" provide just two of many examples of the period's anxieties. Along with their freedoms from bourgeois norms, the artists of aestheticism found new fears of irrelevance and irresponsibility. It is these anxieties that the avant-garde poets of the twentieth century sought to allay, often by asserting the identity of political and aesthetic freedoms.

Having inherited this anxiety-ridden autonomous aesthetic, successive generations of twentieth-century avant-garde poets would seek to assuage those anxieties while retaining the idea of artistic autonomy. Their means to this end would be systematically articulated versions of the idea that Swinburne had expressed in passing in his study of Blake: that autonomous artistic pursuits were, by virtue of their very autonomy, paths to moral or political utility.

Early twentieth-century avant-garde movements were, of course, tremendously varied in their goals and their means of expression, but, as a number of theorists have argued, the force uniting them was a general rejection of the limits of aestheticism. Peter Bürger, for example, tells us that with the avant-gardes of the 1920s "the social subsystem that is art enters the stage of self-criticism," a self-criticism based on a rejection of "the status of art in bourgeois society as defined by the concept of autonomy" (22). Avant-gardists of all stripes turned against the ideals of an aestheticism that, in their view, led not only to such positive things as artistic freedom, but also to "the other side of autonomy, art's lack of social impact" (22). Building on Bürger's analysis, Jochen Schulte-Sasse sees the project of the avant-garde movements of the 1920s as a matter of breaking free of social inutility:

Aestheticism's intensification of artistic autonomy and its effect on the foundation of a special realm of aesthetic experience permitted the

avant-garde to clearly recognize the social inconsequentiality of autonomous art and, as the logical consequence of this recognition, to attempt to lead art back into social praxis. [...] the turning point from Aestheticism to the avant-garde is determined by the extent to which art comprehended the mode in which it functioned in bourgeois society, its comprehension of its own social status. The historical avant-garde of the twenties was the first movement in art history that turned against the institution "art" and the mode in which autonomy functions.

(xiv)

Schulte-Sasse's final point is significant: it is not that avant-gardists rejected the idea of aesthetic autonomy, seeking to put their art at the service of various causes, campaigns, and institutions: theirs was not the path of agitprop or socialist realism. Rather, they sought a new way for aesthetic autonomy to function socially.

"Can one, in fact, claim to emancipate men when one has begun by betraying beauty and truth," asks Ferdinand Alquié in *The Philosophy of Surrealism* (66). Put another way, Alquié's question is this: can you have political revolution without aesthetic autonomy? The surrealists attempted to put to rest any anxieties about the political utility of autonomous art by asserting the identity of revolutionary politics and aesthetic freedom. The assertion of this identity was difficult to maintain, causing divisions within, and expulsions from, the surrealist movement. It was, moreover, treated with skepticism by the French Communist Party, and it raised unresolved questions about whether the kind of revolution envisioned by the surrealists could be connected with any specific political program. Such was its appeal, though, that it was embraced by some of the most vibrant artists and writers of Europe for decades.

When the Bureau of Surrealist Research issued its manifesto, the "Declaration of January 27, 1925," it set out to do three things: to distance itself from established ideas of literature that walled writing off from social praxis; to affirm the autonomy of aesthetic activity; and to assert the identity of that activity with revolution. "We have nothing to do with literature," asserts the first of the declaration's clauses, while the final clause tells us: "Surrealism is not a poetic form" (450). The need for distance from "literature" and the "poetic" was urgent because autonomous aesthetics had, it seemed to the signatories of the declaration (Breton, Louis Aragon, Paul Éluard, Antonin Artaud, Philippe Soupault, Benjamin Péret, and some twenty others), severed the vital links between art, on the one hand, and life and action, on the other. While the signatories rejected autonomous art's isolation, though, they affirmed its freedom from limits imposed by causes, institutions, and systems of morality, maintaining that their project would involve a "total liberation of the mind" (450). This liberation was to be connected to a larger project for, as they made clear, they were "determined to make a Revolution" (450).

Just what kind of revolution was entailed by the January 1925 "Declaration" was somewhat ambiguous at first, but it soon became clear that it was not to be limited to a revolution in style.[2] Indeed, by the time the third issue of *The Surrealist Revolution*—the journal associated with the Bureau of Surrealist Research—appeared in April of 1925, André Breton was asserting the inherent solidarity between surrealist revolution and the less radical (to his mind) revolutionary tendencies of the striking workers of France (Picon 73). This identification of aesthetic autonomy and a specifically leftist political revolution became a hardened position, and by March of 1928, with the eighth issue of *The Surrealist Revolution*, Breton, Péret, and Éluard united with the painter Pierre Unik in condemning Artaud for "seeing the Revolution as no more than a metamorphosis of the soul's inner conditions," a subjectivist and aestheticist "dead end," as far as Breton was concerned (Picon 77).

In "Legitimate Defense," also from the eighth issue of *The Surrealist Revolution*, Breton addresses French Communist Party criticism of the surrealist version of revolution. While Breton firmly asserts the identity of aesthetic autonomy and political revolution, we can already see the first small cracks begin to appear in what he hoped would be a seamless ideology. Breton tells us that the author of a Communist party broadside has been

accusing us of still vacillating between anarchy and Marxism and calling on us to decide one way or the other. Here, moreover, is the essential question he puts to us: 'Yes or no—is this desired revolution that of the mind *a priori* or that of the world of facts? Is it linked to Marxism, or to contemplative theories, to the purgation of the inner life?' This question is of a much more subtle turn than it appears to be, though its chief malignity seems to me to reside in the opposition of an interior reality to the world of facts, an entirely artificial opposition which collapses at once upon scrutiny. In the realm of facts, as we see it, no ambiguity is possible: all of us seek to shift power from the hands of the bourgeoisie to those of the proletariat. Meanwhile, it is nonetheless necessary that the experiments of the inner life continue, and do so, of course, without external or even Marxist control.

(56)

The erasure of any division between imaginative freedom and political revolution is necessary to retain the surrealist position, a position the Communists had already come to look on with distrust. And in Breton's "meanwhile" and "nonetheless"—terms indicative of a coincident, rather than a causal or essential relation—we see his own language begin to express doubts about the possibility of maintaining an essential link between autonomous aesthetics and political revolution. The faintest ghost of the aesthetic anxiety remains, buried deep within the edifice of Breton's polemic.

The difficulties in maintaining the idea of an identity between aesthetic autonomy and political revolution went much further than a subtextual disturbance of Breton's prose, though. Such difficulties came in three principle forms: Communist insistence on heteronomous art; the gravitation of some surrealists toward aesthetic concerns at the expense of politics; and a growing skepticism about whether surrealism could be compatible with specific political projects.

Although that most heteronomous of aesthetic theories, socialist realism, did not become state policy in the Soviet Union until 1932, surrealists, under pressure from French communists, had already felt pressure to put their art and writing directly at the service of the revolution. When, for example, Marcel Fourrier wrote in the seventh issue of *The Surrealist Revolution* that "once and for all, our business is to realize in full all that the working class represents, all that its revolution implies," he comes close to abandoning the aesthetic autonomy the surrealists had claimed in their "Declaration" (Picon 78). The value of autonomous art was always less clear to representatives of the French Communist Party than it was to the surrealists themselves. As André Thireon, a representative of the Party, puts it, "what could the Party have done with Max Ernst or André Breton to win over the miners of Lens?" (Haslam 161). Moreover, when Breton joined the Communist Party in 1927, he was shocked to find that the Party's idea of writing for the revolution did not involve any consideration of aesthetic autonomy: they asked him to work as a labor journalist, a task he refused on the grounds that it was a "dirty business" (Picon 79). "Surrealism," as Ferdinand Alquié put it, "found itself in the dilemma of having to choose between a social revolution that it wished to support but which discouraged freedom of expression, and a bourgeois society that it abhorred but which tolerated and even encouraged intellectual freedom" (59). While the majority of the surrealists upheld the identity of aesthetic autonomy and political revolution, their position was eccentric within communist circles. In 1930 the Kharkov Conference of the Association of Revolutionary Writers and Artists denounced Breton, and after 1932 stances such as his were considered heretical.

While the claims of heteronomy troubled surrealism from one side, the claims of an aestheticism without much direct concern for politics plagued it from another. As early as 1925 Louis Aragon had claimed that true surrealist work, work that addressed "the problems raised by the human condition," had "little to do with the miserable flicker of revolutionary activity which has appeared in the east in these last few years" (Picon 73). The 1933 folding of the journal *Surrealism in the Service of the Revolution*—the successor to *The Surrealist Revolution*, and a journal whose very name indicates the pressure the surrealists were under from the proponents of a heteronomous aesthetic—led to a further drift toward aesthetics at the expense of politics. When the journal closed, many of the surrealists migrated to Albert Skira's

new journal *Minotaure*. This was very much a journal of the art-world, with beautiful production values, exquisite illustrations, and an overt restriction on the expression of political views. If political figures on the left wanted revolution without aesthetic autonomy, art-world figures like Skira wanted aesthetic autonomy without political revolution. The idea of the identity of the two was under attack from all sides.

In addition to these difficulties, the surrealists faced charges from both inside and outside the movement to the effect that their emphasis on aesthetic autonomy was not compatible with any specific revolution, but was, rather, a matter of perpetual critique or purely negative politics. Such charges came from within the movement very early on, and we have evidence (though, lamentably, no transcriptions) of a vigorous debate on the issue. In 1925, Pierre Naville and others issued a statement in *The Surrealist Revolution* which declared that there had been a meeting of surrealists "to determine which of the two principles, surrealism or revolution, ought best to guide their activity." Having "failed to resolve this question," though, they came to agree that "for the moment, they see only one positive point" on which all could agree: "that the Spirit is an essentially irreducible principle which cannot be fixed either in life or beyond" (Naville 15). The "Spirit," in this view, could not be embodied and fulfilled in any Marxian–Hegelian utopia. If this art was to be revolutionary, some of its practitioners felt it could not be tied to any specific revolution.

Similar arguments about the nature of surrealist revolution came from outside the movement itself, with one notable example issuing from the pen of Herbert J. Muller in 1940. The surrealists, he says,

> proclaim that their art is an application of dialectical materialism, a necessary counterpart of political revolution. This is nonsense. Surrealism is a glorification of the irrational, the unconscious; Marx invested his faith in rational analysis for the sake of conscious control. The Surrealists may contribute their mite to the destruction of the old social order; they can contribute nothing to the building of a new order. If anything like the kind of society they want does emerge from the war, it will be only because of a mighty collective effort, disciplined and controlled by conscious intelligence, and in this task attitudes like theirs would be at best a nuisance.
>
> (44)

Surrealism cannot be at the service of any specific revolution, says Muller: an autonomous art's politics can only be critical or negative, and can have no constructive part to play in the creation of revolutionary social order.

Despite criticisms of this kind, Breton clung steadfastly to the idea of the unity of aesthetic autonomy and political revolution, issuing a major

restatement of the view in 1938's "Manifesto for an Independent Revolutionary Art," a document ostensibly coauthored with Diego Rivera, but actually written by Breton with the assistance of Léon Trotsky. Breton's primary thrust in the manifesto is to denigrate the heteronomous art emanating from the Soviet Union, and assert both the autonomy of art and its essential connection to revolution. The Soviet Union, he says, has "spread over the entire world a heavy twilight" and "in this twilight of filth and blood we see men disguised as intellectuals and artists who have turned servility into a stepping stone" (473). Heteronomous art such as socialist realism is inherently servile, for "art cannot [...] without demeaning itself, willingly submit to any outside directive" (474). Citing Marx himself as a believer in autonomous art—"The writer does not in any way look on his work as a *means*. It is an *end in itself*"—Breton argues for the necessary freedom of artistic production (474). Such artistic autonomy must, by its nature, be a matter of constructive political revolution, declares Breton, reaffirming his position of 1925: "True art, art that [...] strives to express the inner needs of man and of mankind as they are today—cannot be anything other than revolutionary: it must aspire to a complete and radical reconstruction of society, if only to free intellectual creation from the chains that bind it" (473). The circularity of the passage is remarkable, indicating the inherent instability of a position that refuses to prioritize either art or politics over the other. Free art, following only the inner direction of the artist, must strive for political reform, "if only to free intellectual creation from the chains that bind it." Art serves politics to serve art. The argument chases its own dialectical tail.

Did the surrealist assertion of the essential identity of aesthetic autonomy and political utility assuage the old anxieties about art's isolation? Given the constant controversy about the identification of aesthetics and politics both within and around the movement, given the widespread rejection of surrealism by the representatives of the revolutionary forces with whom the surrealists sought to affiliate themselves, and given the drifting away from politics toward more purely aesthetic concerns by some surrealists, we can at best call their solution to the aesthetic anxiety a problematic one. Such is the appeal of their kind of solution to the aesthetic anxiety, though, that more recent avant-garde movements have followed similar, if less tumultuous, paths to that of the surrealists.

Since the 1970s the language poets have attempted to soothe the aesthetic anxiety in a manner much like that of the surrealists before them. Embracing a radical critique of capitalism, they have also steadfastly maintained that theirs will be a poetry unbeholden to any limits on expression imposed by institutions, political parties, or audience expectations. They yearn for an art both autonomous and political, and, like the surrealists, resolve these contradictory yearnings by claiming that artistic autonomy is a path to the political.

Perhaps the most common version of the identification of autonomy and politics among language poets comes in the form of the assertion that a truly autonomous poetry will be unreadable by conventional means, and will therefore be uncommodifiable. Indeed, it will ideally resist incorporation into any part of the capitalist system (as product, as ideology, as entertainment property), and will constitute a kind of critique of that system. When the poet Abigail Child proclaims in capital letters that her poetry will consist of "UNITS OF UNMEANINGNESS INCORPORATED ANEW // VS. A COMMUNITY OF SLOGANEERS" (94) she makes an assertion of this kind. Against the practitioners of heteronomous writing (the sloganeers, apologists for the dominant social form), she holds up her own autonomous writing. In its very "unmeaningness" lies its politics: a refusal of commodification. Canadian language poet David Bromige makes much the same case for an autonomous political art when he says that "the profound vocation of the work of art in a commodity society: not to be a commodity, not to be consumed" (217).

Those who would claim that a truly political writing must put itself under certain restrictions, such as a simple language that can be understood by potentially revolutionary classes, face hostility from language poets. Charles Bernstein, the foremost polemicist among language poets, shows real frustration with this kind of criticism in a passage just a little reminiscent of Breton's refusal to act as a leftist journalist:

> I flip through this week's *Nation* (October 3, 1988) and notice a letter to the editor by their own small press critic. He suggests that the 'clarity' that the *New York Post* 'demands of its sports writers' is a model that poets who wish to be political should emulate. Is it just my pessimism that makes me feel that this reflects an ever deepening crisis in our culture— a contempt [...] for intellectual and spiritual articulations not completely assimilated into and determined by the dominant culture's discursive practices?
>
> ("The Value of *Sulfur*" 105)

We get a clear sense of the way language poets have identified autonomy with politics here. Bending to the demands of a readership would, in Bernstein's view, be a form of heteronomy, in that the poet who does this is governed by a market, not by the demands intrinsic to art.[3] But bending to the demands of a readership would also be a matter of assimilation to "the dominant culture's discursive practices." A refusal to conform stylistically is also a refusal to conform politically. The autonomous *is* the political to Bernstein.

Since this approach inevitably limits the reach of the writing to a relatively small number of readers, it often strikes the unsympathetic as counterintuitive. Just as André Thireon wondered "what could the Party have

done with Max Ernst or André Breton to win over the miners of Lens?," an American leftist might well wonder just what could be done with Abigail Child or Charles Bernstein to win over the displaced auto workers of Flint, Michigan. In more candid moments, some representatives of language poetry have expressed anxieties of these kinds. Susan M. Schultz, for example, states simply that "the questions of relevance, of audience, of efficacy, will always haunt us" (215).

Against such haunting doubts, how do language poets maintain a sense of the identity of aesthetic autonomy and political efficacy? For many, it begins with an elimination of the distinction between linguistic and material realities. Just as Breton, in "Legitimate Defense," denies the division between inner and outer worlds, the pioneering language poet Ron Silliman, in his seminal 1977 essay "Disappearance of the Word, Appearance of the World," denies the division between the linguistic and the material. Silliman begins his essay with a long quotation from linguist Edward Sapir:

> Human beings do not live in the objective world alone, nor alone in the world of social activity as ordinarily understood, but are very much at the mercy of the particular language which has become the medium of expression for their society. It is quite an illusion to imagine that one adjusts to reality essentially without the use of language and that language is merely an incidental means of solving specific problems of communication or reflection. The fact of the matter is that the 'real world' is to a large extent unconsciously built up on the language habits of the group.
>
> (123)

Endorsing Sapir's view that the real world is largely a matter of our accumulated language habits, Silliman finds himself in a position to turn linguistic activity into political activity. Asking himself whether the capitalist system has "a specific 'reality' which is passed through the language and thereby imposed on its speakers," Silliman replies in the affirmative.

But just what is this linguistic system of capitalism, and how is it to be challenged? For Silliman, capitalism seeks to make language invisible: the ideal capitalist text can be consumed with ease, and will present no language that draws attention to itself as language. "In its ultimate form," says Silliman, capitalism creates a linguistic situation in which "the consumer of a mass market novel [...] stares numbly at a 'blank' page (the page also of the speed-reader) while a story appears to unfold miraculously of its own free will before his or her eyes" (127). The language is transparent, unchallenging, and therefore pacifying. It gives no sense of itself as a created thing, and therefore implies it is a natural system, rather than the product of a particular ideological system. This, says Silliman, constitutes "an anesthetic transformation of a perceived tangibility of the word, with corresponding

increases in its descriptive and narrative capacities," and these provide the "preconditions for the invention of 'realism,' the optical illusion of reality in capitalist thought" (125). In Silliman's view, poetry has the possibility of breaking down the language system upon which capitalism depends. "The social function of the language arts, especially the poem," writes Silliman, "place them in an important position to carry the class struggle *for* consciousness to the level of consciousness" (131). The struggle, it is important to note, can be carried on without putting one's language in the service of mass movements. One need not follow the injunctions of *The Nation* to write with the simple clarity of sports journalists, still less need one follow the injunctions of some new Mazzini to write "lyrics for the Crusade." Acts of political resistance take the form of linguistic disjunction, the creation of the "unmeaningness" called for by Abigail Child. The satisfactions of such a belief are clear enough: one maintains total aesthetic autonomy, remaining above the dirty business of political journalism, and at the same time exorcizes the aesthetic anxiety.

It is far from clear, though, that Silliman is entirely successful in this exorcism. Toward the end of his essay we find a certain hedging of bets with regard to the efficacy of his brand of linguistic politics. After insisting on the political power of linguistic disruption, we find the following statement: "It is clear that one cannot change language (or consciousness) by fiat [...] First there must be a change in the mode and control of production and material life. [...] poetry can work to search out the preconditions of post-referential language within the existing social fact" (131). Linguistic disruption, it seems, will not change the world or bring about the revolution. Its role is in fact profoundly limited, and its political utility—the problem the essay set out to solve—turns out to be extremely, perhaps excruciatingly, limited: it can lay the groundwork for the kind of "post-referential" language that, presumably, will be used in poetry after a real, material revolution that changes the "mode and control of production." Silliman's essay was published twenty-eight years before Susan M. Schultz concluded that questions of efficacy will always haunt the language poets, but clearly her observation was as pertinent to the early years of the language movement as it was to be in the movement's twilight: Silliman's essay all but concedes the failure of its own thesis.

Like Silliman, Charles Bernstein insists on the identity of artistic autonomy and political action. He wants to write an autonomous poetry "that insists on running its own course, finding its own measures" ("State of the Art" 1), and champions poetry that (like the poetry of the aesthetic movement) "is political not primarily in its subject matter, or representation of political causes [...] but in the form and structure and style of the poems, and in the attitude toward language" ("The Value of *Sulfur*" 107). Since

Bernstein, like Silliman, accepts the notion that language systems define our relation to the world, he can maintain that linguistic convention "is a central means by which authority is made credible," and that "conventional writing—with and without oppositional content—participates in a legitimating process" for existing systems of power ("Comedy and the Poetics of Political Form" 220, 221–2). A poem that radically breaks with convention, presenting situations where "linguistic shards of histrionic inappropriateness pierce the momentary calm" (220) can, in this context, be political, because the war of linguistic convention against linguistic disruption pits "the authority of money versus aesthetic innovation" (220).

To his credit, Bernstein attempts to answer the question of just how the writing of linguistically radical poems would translate into radical political action. Bernstein makes the argument in a straightforward statement: "the poetic authority to challenge dominant social values, including conventional manners of communication, is a model for the individual political participation of each citizen" (219). Linguistic radicalism is to be an inspiration for political radicalism, a shattering of formal complacency that translates into a shattering of political complacency. For this argument to function, though, one still has to confront the question of readership, as a virtually unread poem would, in this model, have a negligible political impact. Unfortunately, though, Bernstein chooses to dismiss the question of audience altogether:

> Poets don't have to be read, any more than trees have to be sat under, to transform poisonous societal emissions into something that can be breathed. As a poet, you affect the public sphere with each reader, with the fact of the poem, and by exercising your prerogative to choose what collective forms you will legitimate. The political power of poetry is not measured in numbers: it instructs us to count differently.
>
> (236)

The analogy with forests hardly bears examination. To accept it would be to believe that an entire advertising campaign, or an enormous effort of political propaganda, could be undone simply by being understood and reworked in a poem. Nor does the assertion that the legitimation of one or another "collective form" in a poem constitutes "political power" hold up. Questions of audience remain. Who gives poets the authority to legitimate discourse? Is this a matter of speaking truth to the powerful, or to a few of the likeminded among the powerless? As to how we should "count differently," if we are not to count readers and those influenced by readers, Bernstein is silent.

Bernstein's contortions of reason are surprising, and one could be tempted to see in them an attempt to avoid confronting the aesthetic anxiety were it

not for the fact that at one point in the same essay he confronts that anxiety directly. "Don't get me wrong," he writes:

> I know it's almost a joke to speak of poetry and national affairs. Yet in *The Social Contract* Rousseau writes that since our conventions are provisional, the public may reconvene in order to withdraw authority from those conventions that no longer serve our purposes. Poetry is one of the few areas where this right of convening is exercised.
>
> (225)

It is a little poignant that Bernstein sees this last assertion as a sign of hope rather than of despair, a sign of poetry's political efficacy rather than its marginalization.

"It is hard," writes critic Geoff Ward, "not to see a discrepancy between the aims and the achievements of Language poetry" (13). One can get a sense of this discrepancy not only from a look at our contemporary political situation, but from a look at our poetic situation as well. Language poetry postulated an essential identity between stylistic and political concerns, but an examination of the situation of poetry reveals that such a connection was by no means essential or inevitable. The stylistic devices of language poetry have become increasingly widespread since the mid-1980s, but in the process they have become increasingly divorced from the political radicalism the early language poets thought their corollary. Ken Edwards, editor of the avant-garde journal *Reality Studios*, was the first to note this trend. Writing in 1990, he looked back on 1983 as the year when the stylist devices of language poetry started to be appropriated by poets who did not share their concerns with radical politics:

> By 1983 I had received, among the many eager unsolicited manuscripts arriving for *Reality Studios*, one from an American poet who enclosed some Surrealist-style poems with a note to the effect that if I didn't like them this person could send me some in a 'Language poetry style,' or 'like Charles Bernstein.' This told me two things: one, the language poets (and Bernstein in particular) had definitely arrived; two, the movement had reached its culminating point or point of failure (that is, when people start imitating its effects without understanding its bases) remarkably early. Since resistance to reification is a central driving force for these poets, such a development gives rise to decidedly mixed feelings.
>
> (58)

The market proves to be a powerful solvent dissolving the supposedly essential bond between style and politics the language poets thought they had found.

The critic Robert Baker concurs with the anecdotal evidence Edwards provides. Tracing the history of innovative poetic technique from the Romantics to the present day, Baker argues that techniques of the early twentieth century were picked up by poets in America after the Second World War; then, "from the mid-seventies on," he argues,

> Language Movement poets [...] radicalized these sorts of practices into a polemical art of the indeterminate and dispersive. In turn, and perhaps surprisingly, these practices have in recent years been loosely assimilated by many poets working in more traditional modes and only occasionally sharing the concerns—themselves extremely diverse—of these earlier modernist and avantgardist formations. Many contemporary poets, that is, appear to have adopted a similar distrust of inherited modes of narrative and thematic patterning [...] and a sort of programmatic disjunction [...] now appears to be taught in writing workshops around the country.
> (361–2)

The supposedly uncommodifiable style has become a commodity of sorts provided by graduate writing programs intent on selling the latest, most advanced model of poetry.

It is interesting to note that surrealists were never quite able to establish a solid link between revolutionary politics and surrealist practice, and that the language poets were unable to establish a definitive link between textual disruption and resistance to capitalism. But what is more significant is to note just how long the urge to have both autonomous art and political efficacy simultaneously has endured. If nothing else, this should tell us that the anxiety of the aesthetic has been a condition of poetry from the mid-nineteenth century on, and that it seems likely to be with us as long as the idea of autonomous art endures. Whether there is a future to the particular illusion of the avant-garde (that autonomous art is inherently politically radical and politically efficacious) is dubious: that idea has worked its way through at least two full cycles now. Its durability has been proven, but so have its profound limitations.

Notes

1. For a discussion of the mutual influence of Yeats and Symons, see Haskell M. Block, "Yeats, Symons and *The Symbolist Movement in Literature*," *Yeats Annual* 8 (1990): 9–18.
2. As Helena Lewis demonstrates in *Dada Turns Red: The Politics of Surrealism*, "revolution" for the surrealists "first meant the liberation of mind and spirit, but later came to include political and social revolution" (17).
3. Some might find Bernstein's insistence on poetry's autonomy with regard to market forces somewhat superfluous, given poetry's very limited potential for market success. As Pierre Bourdieu has demonstrated in *The Field of Cultural*

Production, when we look at the hierarchy of the literary marketplace "at the bottom is poetry which, with few exceptions (such as a few successes in verse drama), secures virtually zero profit" (46–7). Bourdieu also points out that "from the 1860s on [poetry] exists virtually in a closed circuit" isolated from the market (52). It is perhaps not coincidental that this situation coincides with the rise of autonomous aesthetics in poetry in the wake of Baudelaire.

Works Cited

Alquié, Ferdinand. *The Philosophy of Surrealism*. Ann Arbor: University of Michigan Press, 1965.

Baker, Robert. *The Extravagant: Crossings of Modern Poetry and Modern Philosophy*. South Bend: University of Notre Dame Press, 2005.

Bernstein, Charles. "Comedy and the Poetics of Political Form." *A Poetics*. Cambridge, Massachusetts: Harvard University Press, 1992: 218–28.

———. "State of the Art." *A Poetics*. Cambridge, Massachusetts: Harvard University Press, 1992: 1–8.

———. "The Value of *Sulfur*." *My Way: Speeches and Poems*. Chicago: University of Chicago Press, 1999: 104–7.

Block, Haskell M. "Yeats, Symons and *The Symbolist Movement in Literature*." *Yeats Annual* 8 (1990): 9–18.

Bourdieu, Pierre. *The Field of Cultural Production*, trans. Richard Nice. New York: Columbia University Press, 1993.

———. *The Rules of Art: Genesis and Structure of the Literary Field*, trans. Susan Emanuel. Stanford: Stanford University Press, 1996.

Breton, André. "Legitimate Defense." *What is Surrealism?: Selected Writings*, vol. 2, ed. Franklin Rosemont. New York: Pathfinder, 2000: 46–60.

Breton, André and Diego Rivera [Léon Trotsky]. "Manifesto for an Independent Revolutionary Art." *Manifesto: A Century of -Isms*, ed. Mary Ann Caws. Lincoln, Nebraska: University of Nebraska Press, 2001: 472–7.

Bromige, David. "My Poetry." *In the American Tree*, ed. Ron Silliman. Orono: National Poetry Foundation, 1984: 217.

Bureau of Surrealist Research. "Declaration of January 27, 1925." *Manifesto: A Century of -Isms*, ed. Mary Ann Caws. Lincoln, Nebraska: University of Nebraska Press, 2001: 450–1.

Bürger, Peter. *Theory of the Avant-Garde*. Trans. Michael Shaw. Minneapolis: University of Minnesota Press, 1984.

Cassagne, Albert. *La Théorie De L'Art Pour L'Art en France Chez les Derniers Romantiques et les Premiers Réalists*. Generva: Slatkine, 1979.

Cassidy, John A. *Algernon Charles Swinburne*. New York, Twayne, 1964.

Child, Abigail. "Cross Referencing the Units of Sight and Sound / Film and Language." *The L=A=N=G=U=A=G=E Book*, ed. Bruce Andrews and Charles Bernstein. Carbondale: University of Southern Illinois Press, 1984: 94–6.

Edwards, Ken. "Language, the Remake." *fragmente* 2 (1990): 58.

Flaubert, Gustave. Letter to George Sand, 29 April 1871. *The George Sand—Gustave Flaubert Letters*, trans. A.L. McKenzie. Chicago: Academy, 1979.

Haslam, Malcolm. *The Real World of the Surrealists*. New York: Galley, 1984.

Lafourcade, Georges. *Swinburne: A Literary Biography*. London: Russell and Russell, 1967.

Lang, Cecil Y., ed. *The Swinburne Letters*. New Haven: Yale, 1962.

Lewis, Helena. *Dada Turns Red: The Politics of Surrealism*. Edinburgh: University of Edinburgh Press, 1990.

Muller, Herbert J. "Surrealism: A Dissenting View." *Surrealism Pro and Con*, ed. Nicolas Calas, Herbert J. Muller, and Kenneth Burke. New York: Gotham, 1973: 44–64.

Naville, Pierre, ed. *La Revolution Surrealiste*. New York: Ayer, 1955.

Picon, Gaeton. *Surrealists and Surrealism, 1919–1939*. New York: Rizzoli, 1977.

Schulte-Sasse, Jochen. "Theory of Modernism versus Theory of the Avant-Garde." Foreword to Bürger, Peter. *Theory of the Avant-Garde*. Trans. Michael Shaw. Minneapolis: University of Minnesota Press, 1984: vii–xlvii.

Schultz, Susan M. *A Poetics of Impasse in Modern and Contemporary American Poetry*. Tuscaloosa: University of Alabama Press, 2005.

Silliman, Ron. "Disappearance of the Word, Appearance of the World." *The L=A=N=G=U=A=G=E Book*, ed. Bruce Andrews and Charles Bernstein. Carbondale: University of Southern Illinois Press, 1984: 121–32.

Swinburne, Algernon Charles. *The Complete Works of Algernon Charles Swinburne*, ed. Edmund Gosse and Thomas J. Wise. London: Heinemann, 1925.

Symons, Arthur. "The Decadent Movement in Literature." *Aesthetes and Decadents of the 1890s*, ed. Karl Beckson. Chicago: Academy, 1981.

Ward, Geoff. *Language Poetry and the American Avant-Garde*. Keele: British Association of American Studies, 1993.

Yeats, W.B. *Selected Poems*, ed. M.L. Rosenthal. New York: Scribner, 1996.

9

On the Cold War, American Aestheticism, the Nabokov Problem—and Me

Gene H. Bell-Villada

With the onset of the Cold War, aestheticist doctrine triumphed in high-culture circles in the United States. The triumph was a bit paradoxical. After all, the United States had previously been perceived—both here and abroad—as a land of Babbitts and cowboys, "of gum-chewing, Chevy-driving ... philistines" (Saunders 19). The shift has nonetheless been recognized and documented over the last two decades.

I employ "aestheticism" here not in the limited yet polemical nineteenth-century sense associated with Oscar Wilde, but in the general denotation set forth by Kelly Comfort in her Introduction to this volume: "the tendency to attach an unusually high value to the form of the artwork as opposed to its subject matter. Style is what matters; it alone determines the quality of a work of art." And so, in post-War US painting, music, and literature, the "tendency" gained general acceptance, consensus, and hegemony. It became all but normal.

In the visual arts, Abstract Expressionism took center stage as the most esteemed style, with critic Clement Greenberg as its chief spokesman (Guilbaut 94–8, 168–72). Realistic art was marginalized, to such an extent that, "in 1952, some fifty American artists, including Edward Hoper [and] Charles Burchfield ... attacked [the Museum of Modern Art], in what came to be known as the 'Reality Manifesto,'" for "coming to be more identified in the public eye with abstract and non-objective art" (Saunders 265).

In classical music a daunting and ever-more complex twelve-tone system (also known as "atonality" and "dodecaphony") won out as the most prestigious of idioms, notably in the universities. The founder of the method, Arnold Schoenberg, had actually taught at UCLA in 1936–45, where their music building was subsequently named after him. Yet another segment of American composers followed in the footsteps of Stravinsky's "neoclassical" phase (the Stravinsky of *Soldier's Tale* and the two symphonies) and, again in the hospitable setting of the campus and the conservatory, built on the legacy of this less forbidding branch of musical avant-gardism.

In the case of literature, the change was more complex. The novel, still a market-driven genre, saw a withdrawal from modernist experimentation and a corresponding return to traditional realism via Bellow, Malamud, and Updike—though now without the broad societal vision of the nineteenth-century European masters, and also without the social conscience of Steinbeck in *The Grapes of Wrath* or Mailer in *The Naked and the Dead*. The focus was more on the individual consciousness, on existential subjectivity (Dickstein 25–50)—a kind of "solipsist realism." The outstanding exception in this trend, as we shall see, was Nabokov.

It was in literary studies that the post-War aestheticist "turn" came through with special clarity. Between 1945 and the late 1960s, New Criticism became the dominant paradigm for examining poetry and fiction in the classroom and in academic journals. There is an irony in the triumph of the New Critics. In their original incarnations as Fugitives and Agrarians in the 1920s and '30s, these men of letters were ardent neo-feudal nostalgists who celebrated the antebellum South (yes, slavery and all). The group, however, also comprised practicing poets on the order of John Crowe Ransom, Robert Penn Warren, and Allen Tate, who—the common pattern with many poets since 1830—profoundly disliked an industrial capitalism that they viewed as inimical to their art and values.

By the 1940s, however, the Agrarian-New Critics had abandoned their retrograde social project, and they and their followers grew into the regnant literary voice on US campuses. Their hegemony is symbolized by the widespread use, during that era, of Brooks and Warren's *Understanding Poetry* (1940) in undergraduate courses, and Wellek and Warren's *Theory of Literature* (1949) in graduate seminars. Eventually, New Criticism's well-focused formalism would be complemented by the grand system of Northrop Frye's *Anatomy of Criticism* (1957), where the Canadian nonetheless still saw literature as being shaped by itself rather than by external factors (Frye 97).

The New Critics and their kin in some measure won by default. Nineteenth-century historicism—itself the product of bourgeois progressivism—was an exhausted model, and lacked the verbal tools for dealing with the more elaborate, hermetic products of modernism. In addition, the McCarthyite witch hunts had not only purged the academy of individual Marxists but had succeeded in exorcising all left-wing discourse from respectable debate. To apply "social" criteria to literature was considered suspect and would have endangered any young scholar's career. During the years of New Critical hegemony, form mattered most, while content and background counted for little.

The reasons for these discourses' victories were ultimately political and ideological. The Soviet's military victory over the Nazis, and the control they went on to exert over Central Europe as an unexpected result of that bloodletting, were to generate among ascendant US conservatives a backlash against anything deemed "socialistic" or "social." In the culture wars

that ensued, the general aestheticist position would function as a reverse mirror to the doctrines of the Soviets and of their allies on the Western Left. Where Soviet commissars rejected "formalism" and literary experimentation, American academics welcomed those very tendencies. Where the Soviets dismissed abstract art as "decadent," New York celebrated it. Where musical avant-gardism was dangerous in the USSR, the Ivy League campuses gave it free rein. And whereas Soviet aesthetics stressed content and background at the expense of form, American critics made form their sole criterion, relegating other concerns to the sidelines.[1] To put it in Ortega y Gasset's terms: while the Soviets wanted to see the garden outside, America's Cold War intellectuals preferred contemplating the windowpane in between.

These cultural shifts, whether or not autonomous, gained further strength and legitimation from arts policies consciously adopted in certain ruling circles. The financial élites of New York purposely set out to foster art forms and artists that were not "socially" minded or engaged. Jackson Pollock had actually studied with Mexican muralist (and avowed Communist) David Alfaro Siqueiros, while Adolph Gottlieb and other Abstract Expressionists had done time as Marxist activists. With the Cold War gearing up, they would put their leftist sins behind them. Nelson Rockefeller himself loved non-figurative art and reportedly had some 2500 abstract canvases, many of which served as perfect décor in the family's Chase Manhattan Bank buildings (Saunders 258).

In addition, the CIA, via international conferences, dummy foundations, and other means, actively (and covertly) encouraged aestheticism and avant-gardism in the arts. The agency funded music festivals that featured twelve-tone composers, and was supportive of abstract-painting exhibits. Through its front, the Congress for Cultural Freedom (CCF), it furnished the full budget for the influential British monthly *Encounter* and also partly supported well-respected little magazines such as *Hudson Review* and *Partisan Review*. The CCF, moreover, sponsored in 1952 an International Exposition on the arts in Paris, where Allen Tate, now reconstructed as a Cold-War liberal, delivered a lecture in which he made no mention of the alleged virtues of the old slave South, and defended the right to free speech instead. In yet another, somewhat bizarre instance, "the CIA ... commissioned a translation of Eliot's *Four Quartets* and then had copies air-dropped to Russia" (Saunders 248).

Within this broad picture the errant, thrice-uprooted Vladimir Nabokov would find a new home and a decent salaried job. In the process the émigré novelist evolved into a great American author and, subsequently, a highly vocal spokesman for an absolute "aestheticist" stance. Pre-*Lolita*, Nabokov was known, if at all, as an obscure if brilliant Russian word spinner, the fashioner of strangely clever narratives characterized by dazzling formal artifice as well as by a certain lack of human feeling—not to mention

touches of cruelty (e.g. *Laughter in the Dark*). *Lolita*, as we know, made Nabokov rich, allowing him to resign from his tenured Cornell professorship and move yet once more, settling permanently into the comfort of the Hotel Montreux-Palace in Switzerland, where he now wrote fiction full time.

Lolita is something of an artistic miracle. In the hands of a Naturalist author—a latter-day Zola or Dreiser, say—so sordid a subject would have generated a correspondingly sordid novel, with an implicit yet foreseeable moral to it. In Nabokov's atélier the tale becomes a wondrous artifact, a thing of self-reflexive, multifaceted beauties. The moralizing role is assigned to John Ray Jr., Ph.D., a psychologist who in his "Foreword" describes protagonist Humbert Humbert as "horrible ..., abject, a shining example of moral leprosy" and worse (5). All of which, in terms of everyday mores and ethics, is simply true. Yet nothing in *Lolita* is "simply." Dr. Ray's piece is of course a spoof on the invented experts' prefaces that, until the 1960s, would "present" pornographic novels to the reader—a formulaic way of imparting "redeeming social value" to such fare in legal prosecutors' eyes. The front matter also serves to inform us about Dolores Schiller/Lolita's death in childbirth and about the diverse destinies of the other characters—information usually reserved for a novel's final pages.

The first-person account that follows, the novel itself, is H.H.'s purported defense to be read before the jury, an apologia for his misdeeds sexual and homicidal. The book thus exists as a hall-of-mirrors-type montage of texts-within-texts. This distancing artifice is further compounded by Humbert's narrative voice and its key traits. First, he is very funny. His confession bristles with jokes, puns, conceits, alliterations, self-deprecating jabs, and amazingly succinct summaries. (About his parents' death: "picnic, lightning." About his first marriage bonds: "These burst" [10, 27].)

H.H., besides, is crazy. He himself admits it, and alludes to his previous stays in sanatoriums. He is hence ipso facto "unreliable," and we are inclined to judge him less as depraved than demented. The certifiable madness of a wrongdoer, by definition, puts him outside the realm of ordinary humanity and its laws. Furthermore, it must be emphasized, Humbert comes to *love* his Lolita to distraction—a sentiment he declares on numerous occasions, especially toward the end. About the only subject on which Humbert repeatedly waxes lyrical concerns either Lo or his love of Lo. Some of the paeans he pours out to her are truly gorgeous effusions of prose poetry, in the venerable tradition of love verse addressed to one's beloved. Finally, in his last visit to Lolita, now Mrs. Schiller, H.H. all but proposes, asking her to join him so that "we shall live happily ever after" (278). In an odd sort of way, such feelings potentially redeem Humbert in the reader's eyes, or at least make his motives more complex, his actions less than merely heinous or evil.

Humbert's transgressiveness, moreover, is somewhat mitigated by the character (in both senses of the word) of Dolly Haze herself. It is not H.H. who deflowers her: she has already had sexual relations with camp mate Charlie Holmes. Those relations, moreover, were hardly the awkward fumblings of a pair of novices, according to Humbert's report:

> All at once, with a burst of rough glee ..., she put her mouth to my ear ... and she laughed ..., and tried again, and gradually the odd sense of living in a brand new, mad new dream world, where everything was permissible, came over me as I realized what she was suggesting. I answered I did not know what game she and Charlie had played. "You mean you have never—?"—her features twisted into a stare of disgusted incredulity ... I took time out by nuzzling her a little. "Lay off, will you," she said, with a twangy whine, hastily removing her brown shoulder from my lips. (It was very curious the way she considered ... all caresses except kisses on the mouth or the stark act of love either "romantic slosh" or "abnormal".)
> "You mean," she persisted, now kneeling above me, "you never did it when you were a kid?"
> "Never," I answered quite truthfully.
> "Okay," said Lolita, "here is where we start."
> However, I shall not bore my learned readers with a detailed account of Lolita's presumption. Suffice it to say that not a trace of modesty did I perceive in this beautiful hardly formed young girl whom modern co-education, juvenile mores, the campfire racket and so forth had utterly and hopelessly depraved. She saw the stark act merely as part of a youngster's furtive world, unknown to adults. What adults did for purposes of recreation was no business of hers.

(133)

Later, a woman lodger at a hotel asks Humbert, "Whose cat has scratched poor you?" (164)—an indication that Lolita is rough in bed. Lolita is thus wiser about sex, and has had a far more active pubescence, than H.H. could even have imagined in his proper European adolescence or in his truncated idyll with Annabel Leigh. And of course there is Lolita's concurrent, secret amour with Clare Quilty, the intimate details of which remain elusive both to Humbert and ourselves.

In this regard, Nabokov's nymphet looks ahead to the promiscuous, somewhat anomic sexuality that would grow commonplace among certain sectors of American preadult life. Today's press has its share of reports about teens and even preteens who look upon sex as "no big deal." Although prophecy was the least of Nabokov's concerns as a novelist, his evolving portrait of Lolita has its uncannily prescient side.

During the few occasions on which Dolly Haze surfaces as a character in her own right, she proves to be a fairly typical suburban brat who is bored with school and rather prefers comic books. As H.H. pointedly notes:

Mentally, I found her to be a disgustingly conventional little girl. Sweet hot jazz, square dancing, gooey fudge sundaes, musicals, movie magazines and so forth—these were the obvious items in her list of beloved things ... If some café sign proclaimed Icecold Drinks, she was automatically stirred ... She it was to whom ads were dedicated: the ideal consumer ...

(148)

In addition, the relatively scarce samples of Lo's language that filter through Humbert's prose are the recognizably slangy yet limited patterns of American teen-speak. Hence, save for her magnetic sexual aura ("she radiated ... some special languorous glow which threw garage fellows, hotel pages, vacationists [etc.] into fits of concupiscence"—159), Lo comes across as an unremarkable young WASP-American, as relayed via the Old-World refinements of H.H.—himself a parody of the cultured European, for whom Lo's speech may well seem exotic. Lolita, then, while not necessarily a negative figure, is at least an ordinary one—except for the extraordinarily monstrous situation that she has had the misfortune to fall into.

In the way it is assembled, *Lolita* is a prime instance of the various kinds of aestheticism defined and surveyed by Kelly Comfort in her preface. First, there is the "windowpane" of Nabokov's verbal wizardry. During his American phase, the author took the Flaubertian search for the *mot juste* to heroic extremes, writing his novels on 3" by 5" cards, with one sentence per card, and not moving on to his next sentence until the one he was crafting was complete. The elaborate web of words and texts that constitutes *Lolita*— a totally "autonomous sphere" in which pedophilia, rather than a moral issue is but one element within a vast pattern—stands far removed from any "human" issues or concerns outside of and beyond it. (Pedophilia is "de-humanized," as it were.) The intricate dynamic between all-American teen Dolores and dandified European H.H. (with the latter's coruscating prose as medium) constitutes the main event. To merely label Humbert a "child molester" and Lolita his "victim" would be inappropriate, a violation of the specially constructed, rarefied world in which Nabokov's novel exists. (In fact I have yet to encounter such loaded terms systematically applied in any serious critical commentary on the book.) As Oscar Wilde might have declared in an updated preface to *Dorian Gray*, "There is no such thing as a moral or immoral book *about pedophilia*. Books are well-written or badly written, that is all." Or, "*Child molestation* and virtue are materials for art."

Lolita attained world fame, if often for the wrong reasons. (Many purchased copies probably went unread.) In time it became a prized item

in the so-called post-Modern canon. Scholars combed its complex texture for hidden meanings and allusions, and Alfred Appel Jr., a Princeton academic, gave its fans the highly useful *Annotated Lolita*. The most audible and omnipresent spokesman for the work and its broader purposes and contexts, though, was to be Nabokov himself.

In his famous "Afterword" to *Lolita*, Nabokov explains that his aim as a novelist is to bring about nothing more than "aesthetic bliss" (perhaps his best-known artistic dictum), a privileged state that places writer and reader above and apart from "topical trash." This at first may seem in line with T.W. Adorno's desire, cited by Kelly Comfort in her "Introduction", that art for art's sake can exist in "opposition to society" and furnish a critical voice "merely by existing." The trouble here is that Nabokov saw no critical function to his fictions whatsoever. Moreover, unlike Adorno, Nabokov was frankly fascinated by American vulgarianism, and soon became a very nationalistic, even jingoistic American, to the point of praising Senator Joe McCarthy and doggedly defending the Vietnam War. Behind his flag-waving posture there stands a complex ideological history, in which politics, aesthetics, and sheer nostalgia are all closely intertwined, and which now calls for examination.

In interviews, classroom lectures, prefaces to the translations of his Russian books, and even in a couple of earlier novels, Nabokov repeatedly affirmed a staunch "aestheticist" position. (Just a sample, from an interview with Alvin Toffler: "A work of art has no importance whatever for society ... I don't give a damn for the group, the community, the masses" [Nabokov *Strong Opinions* 33].) Such stated dogmas do not spring from nowhere. Nabokov, after all, first started out and then developed as an émigré Russian author. The scion of wealthy, cultured, displaced aristocrats, he had many a reason to despise Soviet rule and everything it stood for. Not least of all those reasons was the Stalinist doctrine of social usefulness in art, an official line that had historical roots in the theories of such nineteenth-century liberal critics as V. Belinsky, among others. In choosing the absolute aestheticist stance, Nabokov was, in a dialectical way, differentiating himself from an entire Russian legacy as well as repudiating its allies on the Western left.

Though Nabokov claimed an avowed and oft-reiterated dislike for what he termed "publicist" art, he was not above utilizing his narrative talents to convey ideas of his own. *The Gift* (1938), his bid at a major statement within Russian literature, has as its fourth chapter a biography of Chernyshevsky, the nineteenth-century writer-pamphleteer whose novel, *What Is to Be Done?*, was to serve as basis for Socialist–Realist doctrine. In Nabokov's interpolated essay, purportedly written by his protagonist—a budding poet and, not just incidentally, a Count—the entire philosophy of Chernyshevsky, including the latter's social view of art, is taken apart and found wanting, while Chernyshevsky is made to come across as a pathetic fool.

The Real Life of Sebastian Knight (1941), Nabokov's first novel in English, came out shortly after *The Gift* and can be read as a sort of sequel, an ideological companion, to the thicker Russian tome. Among its characters is a mediocre hack named (presumably with ironic intent) Goodman, who serves Nabokov as a whipping boy with which to mock historically minded literary critics, and who more or less inherits the role allotted to Chernyshevsky in the previous, polemical book. By contrast, the eponymous hero, whose surname "Knight" carries obvious implications of nobility, represents the aristocratic writer who stands at a superior, smirking distance from collective ills like mass hunger, joblessness, and world war. Sebastian Knight here corresponds to the young Count, poet, and aesthete who was Nabokov's positive figure in *The Gift*. The novel, significantly, was composed in the late 1930s, when hunger and war fever were widespread; at one point its nameless narrator blithely brushes off the anti-fascist popular front (along with anti-Semites) as "idle idiots" (258).

Then there is Nabokov the teacher. Not surprisingly, in his published lectures at Cornell, the novelist shuns all questions of intellectual, historical, or social background. He considers Dickens's "sociological side" to be "neither interesting nor important," and can treat *Bleak House* as a strictly formal structure while willfully ignoring such key Victorian aspects as the juridical machinery or the battles in defense of children's rights—what Professor Nabokov serenely ridicules as "child labor and all that" (*Lectures on Literature* 68, 65).

Nabokov's hates are an entire topic unto themselves; he became especially notorious for his impassioned loathing of literally hundreds of major authors—and I mean respected figures on the order of Cervantes, Balzac, Stendhal, Dostoevsky, Conrad, Faulkner, Lorca, Brecht, and Camus, to cite just a few. These wholesale dislikes are neither arbitrary nor capricious; they are of a piece with Nabokov's absolute aestheticism. First, in a kind of *anti*-socialist realism, a reverse Zhdanovism, he habitually rules out as inferior any art marked by social content—Balzac on the new French bourgeois, Conrad on British imperialism, Faulkner on the Deep South, even Picasso's *Guernica* (a protest painting and hence unacceptable as art).[2] And left-wing writers such as Brecht, it goes without saying, are a no-no.

Furthermore, as a stylistic and formal perfectionist, Nabokov rejects any novelist whose style and structure may be imperfect (Cervantes, Dostoevsky, Céline), yet whose rough-hewn, anguished humanity is essential to their uneven art. ("Human interest" for Nabokov was a term of derision—hence his disdain for Van Gogh.) Also out are novelists of "ideas"—Mann, Camus, Sartre, and any philosophically inclined author who aims to depict the role of spirit and intellect in human life.

In fact, the very word "thinker" in the Nabokov lexicon is a pejorative. His famous attacks on Freud, Marx, and others, however, consist of little more than name-calling and vicious, Soviet-style invective ("the Viennese quack"), with no counterarguments and no concrete references to those

thinkers' works. One eventually begins to wonder whether Nabokov has ever so much as read their writings. He actually admits to no knowledge of physics when he attacks "Einstein's slick formulae" (*Strong Opinion* 116), although his early biographer Andrew Field suggests that the Russian's disdain for the great scientist may well have been motivated by Nabokov's dislike of Einstein's left-wing politics (Field 199). Similarly, in his valedictory novel, *Look at the Harlequins!*, the author has his narrator take a swipe at a place called "Neochomsk" and "the about-nothing land of philosophic linguistics" (124–5). How much Nabokov knew about linguistics is a matter for investigation, but one can feel fairly sure that he would have had no truck with Noam Chomsky's politics.

Nabokov's brand of anti-intellectualism may be a matter of personal temperament. Among the most dazzling strengths of Nabokov as individual and as artist is his eye for detail, his ability to conjure up the look of things with vivid accuracy and high poesy. The virtue has its downside, though. John Burt Foster observes that the novelist's constitution is "radically empirical and individualizing," to the point where "he dismisses abstract of *all* kinds" (50). In some measure, then, Nabokov was making an asset out of a liability when attacking "thinkers." But I would take Foster's point a bit further and speculate that Nabokov appeared to suffer from some sort of metonymic disorder whereby he could see every detail yet could scarcely understand abstract thought, let alone produce it. About the only philosopher he seems to have much knowledge of is Bergson, and when he ventures into his own reflections on time, in *Ada* and elsewhere, the results come close to hifalutin, arrant nonsense.

Nabokov's position on aestheticism was as uncompromising and extreme as was that of the Soviets on Socialist Realism. The extent of his dogma, moreover, is very much a product and reflection of his time and place—a moment or "chronotope" worth recapitulating. Previously, during Nabokov's fifteen years in Berlin, he had stuck well within the isolated circle of émigré Russians, living on odd jobs and never learning German; and in his Russian novels the German milieu is for the most part a shadowy, abstract entity. By contrast, the America where he arrived in 1940 was a land whose language he knew intimately, and whose very best academic enclaves (Harvard, Wellesley, Cornell) would give him dignity, a livelihood, and a professional purpose. First in Boston and then in Ithaca NY he went on to share in the nation's post-War comfort and stability, with a decent salary and paid vacations that allowed for his far-flung butterfly-hunting trips. Those cross-country wanderings acquainted him with the vast landscapes, myriad small towns, and quirky motels that were still new even for Americans (many of whom had just purchased their first cars, too), and that would be reimagined in *Lolita*.

Meanwhile the decade's center-right political alignment and official anti-communism were just the ideological home Nabokov needed, and the manorially beautiful Ivy League campuses were perhaps the closest thing he

had found to his lost aristocratic utopia. In these settings, we have seen above, aestheticism emerged as the reigning US literary orthodoxy, and Nabokov could write fiction that was in accord with, and responded to, that shared conception. His brand of aestheticism, though, was not what Peter Bürger might see as the possible precondition for an oppositional avant-garde. Nabokov's American works and years take for granted the rightness of American ways and power, and virtually everything he wrote and said in this period was in implicit opposition to *Soviet* policies and to the "social" aesthetic anywhere on this Earth. In time, his dizzying fame provided him a broad podium for his outrageous pronunciamientos, which, as the golden 1950s consensus came apart, grew increasingly petulant and shrill.

On yet another note, Nabokov's hands-on experience of the American university gave him the raw material for a touching academic novel like *Pnin*. More importantly, his large-scale involvement with in-depth literary scholarship, through his four-volume translation of *Eugene Onegin*, provided him the template to fashion, in *Pale Fire*, a brand-new novelistic form. The very notion of starting with an invented poet's longish poem, and then following it with a fantastic narrative told entirely, via endnotes, by a deliriously insane narrator, boldly expands the story-telling arsenal and builds on the path-breaking work made two decades earlier in the Argentine fabulator Borges's essayistic short fiction. D.M. Thomas's *The White Hotel* and A.S. Byatt's *Possession*, with their own fictive poets, long verse excerpts, and textual interplay, are the artistic offspring of *Pale Fire*, as is *Widows* by Ariel Dorfman, who dreams up a Greek manuscript novel about the Nazi occupation as his means of subtly criticizing the Pinochet dictatorship in Chile.

There is still one more question I should like to address: namely, why does the author of this essay, Gene Bell-Villada, seem to have it in for Vladimir Nabokov? Much of what I say here I deal with in slightly different form in my volume *Art for Art's Sake and Literary Life*, the contents of which, I am aware, have ruffled some ardent Nabokovians' feathers. For instance David Andrews, a young Nabokov specialist at the University of Illinois, Chicago, takes me to task both in his fine book and in his *Nabokov Studies* article for "maligning" the Russian master in my opus, for my "treating him with the same immoderate scorn that Nabokov applied to his own *bêtes noires*" (Andrews "Varieties of Determinism" 2). So we are both guilty of the same sin, Nabokov and I.

Well, why? Here, dear reader, I must confess. I am a lapsed Nabokovophile. During my student days back in the late 1960s I was thoroughly hooked on Nabokov and infatuated with his prose style. I read *Lolita* three times and used to carry photocopies of some of its key pages in my shirt pocket for casual sampling while waiting at a bus stop or a café. I do not know how many times I must have savored the episode of Valeria and her lover the Tsarist taxi driver, who leaves a liquid souvenir of himself in Humbert's toilet. In addition, in practical terms I learned a lot about writing from Nabokov, who taught me to

avoid set formulas and clichés, and showed me just how difficult it is to move someone across a room on a page of prose.

Later, however, in the 1970s, I discovered the other Nabokov, the Nabokov of the interviews and prefaces, and found myself terribly disillusioned. In that other, more public incarnation, Nabokov the man came across as a great deal smaller than Nabokov the artist. I have never gotten over the trauma, the shock. Anatomizing Nabokov's hates has thus since served me as a kind of exorcism, something I have done off and on since 1975, when I published unfavorable reviews of *Strong Opinions* and of *Look at the Harlequins!* in a couple of liberal weeklies.

It bears noting that I am not alone in my youthful disillusionment. A colleague of mine at Williams College, Steven Fix, informs me of a similar experience. Steve Fix teaches an English course on Nabokov and Pynchon, in which highly sophisticated seniors read some of the Russian author's short stories, plus *Pnin*, *Lolita*, and *Pale Fire*. So they come to know Nabokov fairly well. Next, he has the class read *Strong Opinions*. And now, grievously disconcerted, the intelligent, sensitive twenty-somethings invariably ask Professor Fix, "How could so great an author also be the nasty little man of the interviews?," or words to that effect. This happens every time he teaches the course, incidentally. Well, if a survey were to be taken by the Gallup Poll or some other such organization, I am sure they would find more than a few Nabokov lovers who have similarly tempered or even lost their initial faith in the master.

I wish to end on a positive note. One of the reasons for the greatness of *Lolita*, I believe, is that it allowed Nabokov to transcend and sublate his obsessions, which at times have intruded into and marred his other work. Inasmuch as Humbert Humbert is crazy, his anti-Freudian asides make perfect sense within context. Battles over literary doctrine and reputation, moreover, are perfectly alien to *Lolita*, the novel and the character both, so there are precious few of the potshots that are more or less central to novels such as *The Gift*, *Pnin*, and especially *Ada*. And finally, *Lolita* has nothing to do with the self-enclosed world of Russian émigrés that limits the horizon of many of Nabokov's other narratives. Indeed, one of the most hilarious moments in the book is Humbert's running commentary on his rival Maximovich, the taxi driver whom he refers to as "Taxovich."

So *Lolita* the book still stands, along with *Pale Fire*, a few of the Russian works (notably *The Defense*), several wonderful short stories, and of course the incomparable prose style, which we can separate from the man. As Richard Rorty once observed, and as we all know, there have been plenty of past instances of great writers who were not necessarily nice guys, and Nabokov serves as a potent instance thereof. Still, most first-time readers of *Lolita* do not know and probably would not even find out about the existence of that disturbing volume *Strong Opinions*. And maybe that is all to the good.[3]

Notes

1. I deal with these shifts at greater length in my *Art for Art's Sake and Literary Life*, 251–6.
2. Interestingly enough, Nabokov would never see fit to praise Solzhenitsyn's novels or non-fiction works about Soviet evils, while at the same time, out of anti-Soviet solidarity, he never attacked his celebrated compatriot's frankly "social-realist" and publicist art, either. Biographer Brian Boyd points out that Nabokov "had grave reservations about Solzhenitsyn's artistic gifts" (570), and quotes Nabokov's private diary in which the novelist reflects on *The Gulag Archipelago*, "His style is a kind of juicy journalese, formless, wordy, and repetitious, but endowed with ... oratorical force" (648).
3. I am grateful to Zoran Kuzmanovich of Davidson College for allowing me the opportunity to air some of these ideas at his session of the Vladimir Nabokov Society, Modern Language Association conference, New York, 2002. My thanks also to Ron Morin for some helpful editorial suggestions.

Works Cited

Andrews, David. *Aestheticism, Nabokov and Lolita*. Lewiston: The Edwin Mellen Press, 1999.

——. "Varieties of Determinism: Nabokov among Rorty, Freud, and Sartre." *Nabokov Studies* 6 (2000/2001): 1–33.

Bell-Villada, Gene H. *Art for Art's Sake and Literary Life: How Politics and Markets Helped Shape the Ideology and Culture of Aestheticism, 1790–1990*. Lincoln: University of Nebraska Press, 1996.

Boyd, Brian. *Vladimir Nabokov: The American Years, 1940–1977*. Princeton: Princeton University Press, 1991.

Dickstein, Morris. *Gates of Eden: American Culture in the Sixties*. Second edition. Cambridge: Harvard University Press, 1997.

Field, Andrew. *Nabokov: His Life in Part*. New York: Viking, 1977.

Foster, John Burt. *Nabokov's Art of Memory and European Modernism*. Princeton: Princeton University Press, 1993.

Frye, Northrop. *Anatomy of Criticism: Four Essays*. New York: Atheneum, 1968.

Guilbaut, Serge. *How New York Stole the Idea of Modern Art: Abstract Expressionism, Freedom, and the Cold War*. Trans. Arthur Goldhammer. Chicago: University of Chicago Press, 1983.

Nabokov, Vladimir. *The Annotated* Lolita. Edited with preface, introduction, and notes by Alfred Appel, Jr. Revised and updated edition. New York: Random House, 1991.

——. *Lectures on Literature*. Edited by Fredson Bowers. Introduction by John Updike. New York: Harcourt Brace Jovanovich, 1980.

——. *Look at the Harlequins!*. New York: McGraw-Hill, 1974.

——. *The Real Life of Sebastian Knight*. London: Penguin Books, 1964.

——. *Strong Opinions*. New York: McGraw-Hill, 1973.

Saunders, Frances Stonor. *The Cultural Cold War: The CIA and the World of Arts and Letters*. New York: The New Press, 1999.

Part IV Reassessing Aestheticism in Twentieth-Century Theory

10
Beauty be Damned: On Why Adorno Valorizes Carrion, Stench, and Putrefaction

Charles B. Sumner

The fundamental premise of this essay is that re-humanization involves interrogation of the notion of the human in connection with a critique of de-humanizing modes of production, be they cultural, industrial, political, etc. Neither *l'art pour l'art* ideology nor the aesthetic practices it motivates undertakes this critical interrogation. Consequently, *l'art pour l'art* ideology re-humanizes neither art, nor the artist, nor the artistic receptor. After considering the shortcomings of *l'art pour l'art*, I will try to show that Adorno's theory of the relationship between art and society in fact undertakes this critical interrogation, stressing the need for a humane social order and the role art might play in its creation. I will therefore argue that he advocates aesthetic practices which initiate a process of re-humanization. Specifically, I will focus on how Adorno envisions the ability of ugliness, in contrast to beauty, to meet "the objective need for a change in consciousness that might ultimately lead to a change of reality" (*Aesthetic Theory* 345).

The doctrine of art for art's sake emerged in nineteenth-century Paris in reaction to an increasingly instrumental and rationalized social milieu and in response to the growing influence of Kantian aesthetics.[1] I will consider the social genesis of this doctrine later and focus for now on its primary philosophical influence, namely the Kantian concept of disinterested contemplation. According to Kant, judgments of taste which assert the beauty of an object are impure if conditioned by interest in its real existence or if directed by a determinate concept. In order for a judgment to be pure, or in order to represent "free beauty," the viewer, reader, or listener must simply reflect the form of the given object.

> In the estimate of a free beauty (according to mere form) we have the pure judgment of taste. No concept is here presupposed of any end for which the manifold should serve the given Object, and which the latter, therefore, should represent—an incumbrance which would only restrict

the freedom of the imagination that, as it were, is at play in the contemplation of the outward form.

(Kant 72–3)

Freedom from interest in the ends of the object means that aesthetic judgments refer only to the indeterminate accord of the imagination and understanding, faculties possessed by every human being. Consequently, aesthetic judgments are universally valid: "the judgment of taste, with its antecedent consciousness of detachment from all interest, must involve a claim to validity for all men" (Kant 51). Whereas the self-referential quality of aesthetic judgment guarantees its universal validity, circumscription within the human psyche presupposes the human without questioning what it is. And indeed if this question were raised, it would vitiate aesthetic judgment because the introduction of a concept—be it that of the human or otherwise—destroys the disinterested condition which makes judgment possible. Insofar as *l'art pour l'art* ideology is a derivative of Kantian disinterestedness, we have here a first indication of why it must be rejected as a means for mediating the notion of the human.

Of course, Kantian aesthetics deal primarily with artistic reception, and one might argue that the *production* of an autonomous art exemplifies an equally autonomous artistic will that could inspire a desire and push for freedom in other areas of life. In this way, so the argument might go, art plays an indirect role in the constitution of the human condition. Indeed, this argument becomes all the more plausible when we consider the sociohistorical circumstances through which the doctrine of art for art's sake first emerged. As Rose Frances Egan explains, "the passing of literary patrons and the rise and development of the publishing business tended to change, in literary circles at least [...], the center of interest [...] from the artistocracy who gave patronage, to the democracy who must buy the printed books in large numbers" (27). This democratic shift meant that early nineteenth-century writers were largely at the mercy of market forces and were therefore increasingly subservient to the political interests which commanded these forces: "the rise of great political parties there [England] made it possible for struggling authors to maintain themselves by propaganda. Literature in all three countries, England, Germany and France was becoming more and more subservient to political and social influences" (Egan 27). In short, writers found themselves working for "the public" and the political apparatus which aimed to govern it.

However, Egan goes on to say that "there was a contrary influence at work among the finer spirits, which tended to obscure [political] differences and to make for unity in a larger whole than men had yet conceived" (27–8). These "finer spirits" are those artists who refused to allow politico-economic interests to determine their aesthetic production. They subjugated the importance of objective moments of content which could directly express

these interests and instead emphasized art's formal dimension. Restricting the influence of these interests limited the artist's chances for material success, a fact which underscores the exercise of an autonomous artistic will in the name of an equally autonomous art. Under these conditions, the end or purpose of art is the simple production of beauty. Théophile Gautier, one of the first celebrated practitioners of art for art's sake, puts it thus:

> What end does this book serve? – It serves by being beautiful. – Isn't that enough? [...] In general, as soon as a thing becomes useful, it ceases to be beautiful. [...] Art is liberty, luxury, efflorescence, the soul blooming in idleness. – Painting, sculpture, and music serve absolutely nothing. [...] There is and there always will be some artist souls for whom the paintings of Ingres and Delacroix, the water-colors of Boulanger and Decamps, will seem more useful than railroads and steamships.
>
> (4–5)

Gautier's comment that watercolors and paintings are more useful for some than railroads and steamships contradicts his previous assertion that the beautiful cannot be useful. We might try to reconcile his remarks by summoning the Kantian postulate of purposiveness without purpose, a predicate of disinterested contemplation, but this reconciliation works only when considering artistic reception, not production. Instead, the subtext of Gautier's remarks is that the relations of fine artistic production must be clearly distinguished from those of industrial, political, and indeed mass cultural production. Gautier fails to see, however, that the latter affect the former in a *negative* fashion. For example, if Gautier had not found something objectionable about modern processes of industry, politics, and mass culture, and the forms of sociality impacted by these processes, he would not have fled into the realm of an emphatically formal art. This negative determination negates the possibility of both aesthetic autonomy and a "free," i.e. unconditioned, will which creates an autonomous aesthetic sphere. Consequently, we must also reject the idea that the exercise of a free artistic will can inspire the exercise of free will in other areas of life. Again, this point applies even to artistic reception; for, as Adorno asserts: "The thing disinterestedly contemplated pleases because it once claimed the utmost interest and thus precluded contemplation" (*Minima Moralia* 224). The disinterested quality of both production and reception is the residue of a latent, or hidden, interest, and is therefore a socially mediated condition.

Still, one might object that the creation of an aesthetic sphere in opposition to other modes of production implies an element of free choice in spite of that sphere's negative conditioning. Very well, but let us consider what aesthetic autonomy really looks like when mediated through this opposition. In aesthetic judgment, for instance, we might say that free will is demonstrated in the suppression of socio-historical interests. Kant provides vivid

examples of such suppression. Consider, for example, his illustration of disinterested contemplation:

> If anyone asks me whether I consider that the palace I see before me is beautiful, I may, perhaps, reply that I do not care for things of that sort that are merely to be gaped at. [...] I may even go a step further and inveigh with the vigour of a *Rousseau* against the vanity of the great who spend the sweat of the people on such superfluous things. [...] All this may be admitted and approved; only it is not the point now at issue. All one wants to know is whether the mere representation of the object is to my liking, no matter how indifferent I may be to the real existence of the object of this representation. It is quite plain that in order to say that the object *is beautiful*, and to show that I have taste, everything turns on the meaning which I can give to this representation, and not on any factor which makes me dependent on the real existence of the object.
>
> (43)

According to this example, we must suppress any thought of the sweat shed by laborers in building the palace and say simply whether its form is beautiful. If we cannot exercise our will in order to accomplish this suppression, we have no taste. Thus the judgment of taste *demands* indifference to socio-historical concerns, and this demand reduces art to a mere plaything.[2] Worse still, the *demand* for indifference to the plight of the underclass in Kant's seminal example is inhumane. Given that inhumanity is a recurring historical feature and indeed necessity of human civilization, the cult of beauty which privileges such indifference leaves humanity essentially unaltered.

Moreover, judgments of taste produce "false consciousness" because in them the demand to suppress historical antitheses is itself suppressed, notwithstanding Kant's assertion that judgments of taste possess "an antecedent consciousness of detachment from all interest" (51). Were the suppression of historical antitheses not an unconscious operation, we would knowingly attach an interest to the condition of disinterestedness and thereby eradicate it. Fin de siècle decadence squarely faces this point, as Adorno explains:

> Critics confronted bourgeois society not only economically but morally with its own norms. This left the ruling stratum, in so far as it was unwilling to lapse into apologetic and impotent lying like the court poets and the novelist upholders of the state, with no other defense than to reject the very principle by which society was judged, its own morality ... The uprising against bourgeois good was an uprising against "goodness."
>
> (*Minima Moralia* 93–4)

Decadence is a mature manifestation of *l'art pour l'art* because it displays a conscious awareness of its own amorality, thereby purging the false consciousness

of its predecessors. However, this maturity vexes decadent art with an ambivalent self-relation: it demands that the artist criticize the unconscious pretension to aesthetic amorality, a very moral gesture, while simultaneously embracing the inhumanity which lies beneath this pretension. This embrace gives the lie to amorality, uncovering its immoral foundation. The following lines from Richard Le Gallienne's poem, "The Décadent to His Soul," illustrate this dynamic:

> Sin is no sin when virtue is forgot.
> It is so good in sin to keep in sight
> The white hills whence we fell, to measure by—
> To say I was so high, so white, so pure,
> And am so low, so blood-stained and so base;
> I revel here amid the sweet sweet mire
> And yonder are the hills of morning flowers;
> So high, so low; so lost and with me yet;
> To stretch the octave 'twixt the dream and deed,
> Ah, that's the thrill!

(95)

The first line articulates the dialectical bond between morality and immorality, and the second and third lines criticize the moral impulse of this articulation: the sight of the "white hills" is good only for emphasizing the depth of my fall, not for helping me to "rise" again. Thus the critical impulse of this poem is not intended to move the bourgeoisie to adherence of its own moral codes. Rather, the remainder of this strophe dramatizes the revelry won by openly rejecting them. Adorno emphasizes the social conflicts which subtend decadent revelry, interpreting the latter as a tragic gesture: "In beauty the frail future offers its sacrifice to the Moloch of the present: because, in the latter's realm, there can be no good, it makes itself bad, in order in its defeat to convict the judge. Beauty's protestation against good is the bourgeois, secularized form of the delusion of the tragic hero" (*Minima Moralia* 95). Thus the contradiction of decadent aestheticism is best described as an embrace of the immorality against which it protests via recognition of its dialectical bond to morality. This embrace negates the possibility for any positive change to issue from the protest. Consequently, decadent art neutralizes its own critical potential: it cannot humanize the inhumane social conditions over which it seems to wring its hands.

So far we have seen that aesthetic practices motivated by *l'art pour l'art* ideology bring neither the artist nor the artistic receptor to reflect on the notion of the human. Indeed the very logic of the phrase *l'art pour l'art* suggests that any practices to which it refers would be decidedly indifferent to this notion.

From one point of view, this indifference is negligible. If particular art works, artists, and artistic receptors do not care about social influence—and the question of the human is a distinctly social question—then they do not have to. Live and let live. However, the essays in this collection are supposed to consider whether art for art's sake can be viewed as an attempt to re-humanize art, the artist, or the artistic receptor. Obviously, the possibility of re-humanization presupposes a prior de-humanization. And if we agree that de-humanization is a given fact of modern life, then indifference toward the notion of the human is pernicious.

In working out his theory on the relationship between art and society, Adorno takes de-humanization as a social fact, and he sees beauty as an affirmative consolation for the de-humanization registered by socio-political interest and suppressed in judgments of taste. Accordingly, he emphasizes the potential for aesthetic dissonance and ugliness to reject this consolation and to heighten sociopolitical interest. This heightened interest might then actually move us to confront particular forms of de-humanization and thereby effect positive change. In order to better understand this possibility, we should more thoroughly explore Adorno's theory of the art–society relationship.

Adorno implicitly takes his point of departure from Marx's ideas regarding the capitalist manufacture of gratuitous human need. According to Marx, capitalism's "true norm" is excess and intemperance. The latter are subjectively manifested when "the extension of products and needs falls into *contriving* and ever-*calculating* subservience to inhuman, refined, unnatural and *imaginary* appetites" (Marx 116). That is, we intuitively imagine that forces of industrial production advance in response to preexisting need, but here Marx argues that certain producers actually manufacture needs, and that this manufacture is motivated solely by the desire for personal profit. These needs are therefore gratuitous. As industry develops, the fulfillment of gratuitous need tends to overwhelm daily life, diverting attention away from genuine self-fulfillment and into an imaginatively and spiritually impoverished consumerism. This impoverished form of consumption is dialectical: the human subject is consumed through his own act of consumption. The rich are consumed by capital itself, or the relentless desire to produce need in order to pile up more and more capital; and the poor consume themselves through the labor they expend in order to fulfill these needs. For if, as Marx argues, labor is stored-up capital, then the expenditure of labor by the poor is the price they pay for the misery of work; they consume this misery and lose themselves in this consumption.

It follows that both rich and poor are dominated by the exchange principle, or more precisely the exchange of the self for dead, alien capital, which is antithetical to the self. Self-alienation is a form of de-humanization, and the domination by exchange which precipitates self-alienation is therefore a source of de-humanization.

Adorno takes up the idea of gratuitous, self-alienating need and applies it most extensively to the culture industry, the products of which are in his view not only an example of such need but also a means for its further propagation. He argues that culture industry executives speculate on the conscious and unconscious state of the masses in order to develop an advertising scheme which is disseminated via the modern media apparatus. This ubiquitous media machine deifies the power of production, and the individual feels impotent in the shadow of its omnipotence. However, this sense of impotence is overcome by identifying with the production deity, or with its "inescapable product" (Adorno, "On the Fetish Character in Music" 48). Identification is achieved through consumption, a secular, capitalistic version of the Eucharist. This new consumerist Communion generates an ecstasy similar to that produced by more traditional religion, as Adorno explains: "Mimesis explains the enigmatically empty ecstasy of the fans in mass culture. Ecstasy is the motor of imitation. [...] Under the force of immense pressure the identity of the personality gives way, and since this identity itself already originates in pressure, this is felt as a liberation" ("The Schema of Mass Culture" 95). The ecstasy of consumption eradicates critical consciousness, and this eradication reifies consciousness, so that the individual mimes or approximates the condition of the dumb, reified commodity. In turn, the reification of consciousness liquidates subjectivity, and this liquidation feels like liberation because subjectivity no longer has to be protected from the production deity: "If you can't beat 'em, join 'em."

This cliché points to a complication in Adorno's neat schema of mass culture. The forces of production have indeed *beaten* the individual power of consciousness, or subjectivity. And whereas liquidation of the latter is consciously felt as liberation, this liquidation also produces anger and fear which are suppressed and relegated to the subconscious.

> It is no coincidence that [man] is still capable of barbarous outbursts because of suppressed rancour about his fate, about his deeply-felt lack of freedom. The fact that he welcomes the trash of the culture industry— half aware that it is trash—is another aspect of the same state of affairs, the seeming harmlessness of which is probably restricted to the surface.
> (Adorno, "Culture and Administration" 126)

The suppression of critical consciousness has definite social consequences. Once the individual deifies the power of production, he conforms to and thus perpetuates the social order compelled by this power. The ratio of the latter—mechanical rationality and cold efficiency, mere quantum ideals— displaces the importance of categories like human dignity and various other qualitative ideals. The social coldness produced by this shift is a precondition for some of the twentieth century's greatest horrors such as the holocaust and the enslavement of political dissidents in the Soviet Gulag. These

"barbarous outbursts" demonstrate the ire of repressed nature, or of the anger and fear generated by repressed subjectivity. Thus these outbursts suggest that individual subjectivity is actually worth more than the false liberation for which it is exchanged, and one of the problems faced by critical theory is how to balance this inequity.

According to Adorno, art plays an immediate role in opposing this imbalance. For example, he argues that art must challenge the united front of corporate trusts and modern technology, which, in part through the dissemination of mass culture, palms off the destruction of subjectivity as a form of liberation.

Progress and barbarism are today so matted together in mass culture that only barbaric asceticism towards the latter, and towards progress in technical means, could restore an unbarbaric condition. No work of art, no thought, has a chance of survival, unless it bear within it repudiation of false riches and high-class production, of color films and television, millionaire's magazines and Toscanini. The older media, not designed for mass-production, take on a new timeliness: that of exemption and of improvisation. They alone could outflank the united front of trusts and technology.

(*Minima Moralia* 50)

Initially, the claim that art can beat back the destructive influence of a union between business and technological "progress" seems merely utopian. However, if aesthetic experience is conceived as a process which transpires through interaction between the artwork and its receptor, and if this interaction is necessarily situated in the receptor's consciousness, then it is possible that art could restore the critical capacity of its receptor. With this newly acquired capacity, the artistic receptor might be able to see the gratuitous nature of certain needs manufactured by capitalist production, and thereby reclaim the subjectivity which has been sacrificed to these needs: "Works of art affront prevailing needs by throwing light on the familiar, thus meeting the objective need for a change in consciousness that might ultimately lead to a change of reality. Art cannot achieve the much desired impact by adapting to existing need, for this would deprive human beings precisely of what art has to offer" (Adorno, *Aesthetic Theory* 345). Insofar as art can affront prevailing (gratuitous) needs, it has the potential to counteract their de-humanizing effects. But despite Adorno's belief in art's ability to oppose the de-humanizing processes propagated by mass culture and the corporate and technological interests which drive it, he splits with orthodox Marxists in his rejection of socialist realism. In opposition to the realists, he asserts that "the unresolved antagonisms of reality reappear in art in the guise of immanent problems of artistic form. This, and not the deliberate injection of objective moments or social content, defines art's relation to

society" (*Aesthetic Theory* 8). We should be careful when interpreting comments like this one. Here Adorno emphasizes that *l'art pour l'art*'s fundamental impulse to harmonize form for the sake of beauty must be rejected, and that antagonistic social relations must be formally sublimated in order to produce aesthetic dissonance. But just because social antagonisms are formally mediated does not mean that they are eliminated as recognizable, objective moments of content. It simply means that these moments cannot be "deliberately injected"; that is, they cannot appear without having been touched by and altered through formal dissonance.

"Formal dissonance" is a somewhat vague term; and we are often content to let it remain vague, to think simply that we know it when we feel, see, or hear it. But we can learn more about Adorno's thinking on dissonance by turning to his discussion of the artwork's spirit. The formal mediation of content generates the artwork's spirit. Put differently, the primary function of form is to set certain objective moments in opposition to one another, and this opposition generates the dissonance which Adorno defines as spirit: "The tension between the elements of the work of art is spiritual, issuing in a process that renders the work of art itself spiritual" (*Aesthetic Theory* 130). As spirit, artworks exceed their existing qualities, and their essence shines through their material appearance. This "appearing essence"—a revelation of the practical activity sedimented in materiality and consequently of the specific social relations embedded in the artwork's formal construction—exposes the normally hidden oppression immanent to bourgeois order.

In short, spiritualization in art is not some linear progress. Its criterion of success is the ability of art to incorporate into its formal language those phenomena that bourgeois society outlaws, revealing in them a natural other, the suppression of which is truly evil. The recurrent indignation about modern art being so ugly is anti-spiritual, despite its [the indignation's] evocation of high-falutin ideals.

(*Aesthetic Theory* 137)

After being touched by the artwork's spirit, our vision of reality changes. Now we can see those aspects of reality which have been repressed, and these include, among other things, the falsity of certain needs to which we give the better part of our life. But as with most aspects of Adorno's philosophy, this new vision of reality is dialectical. It must not only identify current social antagonisms and the need for their reconciliation, it must also turn inward and reflect on its own reflections, thereby grasping the repressive tendencies immanent to various approaches we might take toward reconciliation: "Correctly understood—and speaking from the perspective of possible freedom—true consciousness refers to the most progressive consciousness, which is one that is aware of contradictions within the horizon of possible reconciliation" (*Aesthetic Theory* 274). This self-reflection sharpens

the previously dormant critical faculty and initiates a challenge to the value of capitalistic production, thereby inducing man to think beyond the limited possibilities provided by this mode of production. Thinking beyond these possibilities initiates entry into the spiritual realm and overturns the subordination of spiritual value by exchange value, thereby inaugurating the individual's re-humanization.

Adorno's theory of the link between art and society is well-meaning but the conclusions to which it leads us are beset by certain logical difficulties: if we are supposed to apprise ourselves of the "contradictions within the horizon of possible freedom," are we not destined to accept the inevitability of such contradictions? After all, if we *do not* see them within our vision of possible freedom, then we cannot lay claim to "progressive consciousness." Practically speaking, does not the inevitability of contradiction within the horizon of freedom mean that the category of repression will always play in our understanding of the world? And if this is the case, what is the difference between any moral advances I might try to make and the status quo, the repressions of which initially move me to challenge it? This contradiction within Adorno's own theory has not gone unnoticed by his commentators, and indeed has split them into opposing camps: some see it as productive of a self-perpetuating cycle of criticism, the necessity of which borders on a moral imperative;[3] still others see this theoretical contradiction as an excuse for immoral resignation, or a policy of nonaction from the standpoint of real social intervention.[4] Rather than dwell on this debate, I want to explore those moments when Adorno seems to leap outside the limits of dialectical logic in order to reconcile this tension within his own theory. As we shall see, this reconciliation can only be achieved aesthetically.

According to Adorno, traditional moral philosophy is erroneous in its recourse to the notion of a will directed by pure consciousness. The philosophical construction of an autonomous will—i.e. a will independent of external influence—follows the paradigm of the industrial division of labor because it splits the individual into various functions for the sake of internal order and efficiency. The valorization of mental order and efficiency subordinates the importance of empirical experience without which there would be no will to begin with. The empirical moment must be returned to its place of prominence in moral philosophy lest the coldness of reason render us unfeeling toward real suffering. In short, moral philosophy must now be conceived as a materialist philosophy.

> If I say to you that the true basis of morality is to be found in bodily feeling, in identification with unbearable pain, I am showing you from a different side something that I earlier tried to indicate in a far more abstract form. It is that morality, that which can be called moral, i.e. the demand for right living, lives on in openly materialist motifs. The metaphysical principle of the injunction "Thou shalt not inflict pain" ... can find its

justification only in the recourse to material reality, to corporeal, physical reality, and not to its opposite pole, the pure idea. Metaphysics, I say, has slipped into material existence.

(Adorno, *Metaphysics* 441)

There are two precipitating factors driving the urgency of the metaphysical slip into materiality. First, totalitarian movements in the first half of the century co-opted metaphysics, so that, as Adorno puts it, "ideals have, to an almost inconceivable degree, become a screen for vileness" (*Metaphysics* 447). Consequently, any attempt to strike at these movements with traditional metaphysics or idealist philosophy recruits the very ratio which props them up. Second, the emphasis on reason mitigates our sensitivity to the expression of suffering, and this mitigation facilitates an overvaluation of technology that "finally leads to the point where one who cleverly devises a train system that brings the victims to Auscwitz as quickly and smoothly as possible forgets about what happens to them there" (Adorno, "Education after Auschwitz" 29).

In order to revitalize our sensitivity to suffering, Adorno advocates direct confrontation with it. Recasting metaphysics as a materialist thought system is supposed to facilitate this direct contact and is synonymous with the leap outside of dialectics: "As soon as one attempts to provide a logical foundation for a proposition such as that one should not torture, one becomes embroiled in a bad infinity, and probably would even get the worst of the logical argument, whereas the truth of this proposition is precisely what falls outside such a dialectic" (*Metaphysics* 440). Locating the truth of a moral injunction outside the realm of dialectics seems to suggest that philosophy is simply unequipped to handle moral problems, but according to Adorno, philosophy actively evades them. Or, more precisely, philosophy represses them: "It is almost as if philosophy—and most of the great, deep, constructive philosophy—obeyed a single impulse: to get away from the place of carrion, stench, and putrefaction" (*Metaphysics* 441). Now if progressive consciousness demands first of all recognition of present repression – the result of which is carrion, stench, and putrefaction—then a thought system which conceals its own repressive tendencies would not do. However, by virtue of its semblance character art can produce the illusion of convergence between experiences of consciousness and entities accessible to the senses; and this illusion grants a more immediate sense of contact with the phenomena of carrion, stench, and putrefaction than does traditional philosophical speculation. Consequently, we must turn to art to gain a truly moral or modern metaphysical perspective. This fact helps to explain Adorno's insistence in *Metaphysics* that Beckett has produced the only relevant metaphysical reflections since the end of World War II (442).

The moral urgency of Adorno's aesthetics is the primary reason for his rejection of beauty. Returning to Kant's illustration of aesthetic taste, reflection on

the beautiful form of the palace cannot admit concern for hardship endured in its construction. Adorno also employs the palace motif; only he uses it to illustrate the moral culpability of not mediating its formal reflection with concern for the suffering endured in its construction:

> It might be said that culture itself stinks—which Brecht once formulated in a truly magnificent and inspired statement that humanity up to now had built itself an immense palace of dogshit. I believe that culture's squalid and guilty suppression of nature—a suppression that is itself a wrongly and blindly natural tendency of human beings—is the reason why people refuse to admit that dark sphere.
>
> (*Metaphysics* 442)

Earlier we saw that aesthetic judgment represses its initial repression of sociopolitical interest, and here we see Adorno advocating an art which recalls this second repression, pulling the contents of the first up to the surface along with it. Here then we get some insight into Adorno's thought on artistic content, which is usually subordinate to speculations on form. Art must present the material motifs of carrion, stench, and putrefaction, the underside of social privilege attached to the appreciation of beauty. The presentation and recognition of these ugly features of reality is the first step toward their amelioration, and the will on which moral philosophy traditionally rests is manifested in the imaginative impulse toward amelioration. In this imaginative movement of the will, materialist moral philosophy converges with social practice: "The physical moment tells our knowledge that suffering ought not to be, that things should be different. 'Woe speaks: "Go."'" Hence the convergence of specific materialism with criticism, with social change in practice" (Adorno, *Negative Dialectics* 203). We should note in passing that these remarks suggest Adorno considers criticism to be a form of social praxis, a point I will return to shortly.

But, one might ask, what is the difference between an art that employs motifs which represent "carrion, stench, and putrefaction" and socialist realism, which tends to employ similar motifs? And why does Adorno put such emphasis on art's formal dimension when these disenchanting motifs seem to be doing so much of the work? Recall first that aesthetic spirit, which we now see takes the form of commitment to criticize and reform sociohistorical antagonisms, is generated through formal dissonance, and this dissonance is achieved by setting objective moments of content in tension with one another. The reciprocal influence of these moments clarifies critical problems within particular artworks, but these problems seem initially irreconcilable precisely because of the formally mediated oppositions which generate them. Nonetheless we constantly return to the problems in attempts at reconciliation, compelled as we are by the sense of commitment transmitted through aesthetic spirit. Each new critical return intensifies the

commitment which originally compels it, and the cycle repeats itself with increasing intensity. Thus the critical problems generated by the artwork are always before us. This constant awareness, which would be impossible without formal dissonance, is a desideratum of aesthetic engagement: "By failing to be aware at every moment of what threatens and what has happened, one also contributes to it; one resists too little; and it can be repeated and resinstated at any moment" (Adorno, *Metaphysics* 437). An example may help to illustrate this abstract dynamic, and we will take this example from Adorno's own reading of the technological problematic in Samuel Beckett's *Endgame*. Adorno assumes that *Endgame* is set just after World War II ("Trying to Understand Endgame" 323). Given this assumption, we extrapolate his belief that the World War II is a result of complete world socialization, or the achievement of "pure identity": "*Endgame* occupies the nadir of what philosophy's construction of the subject-object confiscated at its zenith: pure identity becomes the identity of annihilation, identity of the subject and object in the state of complete annihilation" ("Trying to Understand Endgame" 329). By pure identity Adorno means that man has made himself the measure of all things, and thus colonized everything—and everyone— external or Other to himself. Man remakes his Other according to his own preconceived design. Paradoxically, this Other is not only external nature, but also internal nature, or the need for genuine self-fulfillment and sensual gratification. Similarly, Hamm demands to be placed in the center of the enclosed room, and this desire for centrality symbolizes the aggressive narcissism that drives natural domination.

> HAMM: I'm more or less in the center?
> CLOV: I'd say so.
> HAMM: You'd say so! Put me right in the center!
> CLOV: I'll go and get the tape.
>
> (Beckett 26–7)

Adorno links Hamm's desire to set himself up in the center—the position from which man makes himself the measure—with his responsibility for the "tellurian catastrophe" that has destroyed the outside world, thereby killing its inhabitants.

> HAMM: That old doctor, he's dead naturally?
> CLOV: He wasn't old.
> HAMM: But he'd dead?
> CLOV: *You ask me* that?
>
> (Beckett 24–5)

These exchanges suggest that whereas the drive for pure identity is meant to advance human freedom, a critical position outside this drive is needed to

ensure that the means to freedom are not fetishized as ends in themselves. With this sort of fetishization, the drive to "freedom" becomes a form of bondage. Or worse, fetishization of technological means destroys the human ends to which they ought to be put—consider the atomic bomb and Auschwitz.

Although Adorno is reasonably clear about *Endgame*'s technological problematic, or the critical constellation it directs toward the overvaluation of technology, he offers no clear solution. For if, as Adorno suggests, pure identity in the form of technology causes *Endgame*'s catastrophe, then our hands are tied when fixing it. How else could we fix it than by a more thorough subjugation of nature, which caused the problem to begin with? Put differently, new technologies must restrain the destructive potential of old ones and clean up their messes, but history suggests that these new, more advanced technologies will create even greater messes than their predecessors. Thus Adorno states that "the drama's freedom is only the impotent, pathetic reflex of futile resolutions" ("Trying to Understand Endgame" 336).

The critic will himself repeat these "pathetic reflexes" as long as he tries to resolve the problem in terms employed by the play. Hope lies in the possibility of rejecting these terms and generating new ones. For example, we might eventually draw a distinction between instrumental understanding, which aligns itself with technological interests, and a more substantive or value-oriented understanding, which guides and directs its instrumental counterpart.[5] The subordination of instrumental understanding by its value-oriented variant might lead us away from historical miseries and into a new social order, but it is doubtful that we would have split the sense of understanding had we not initially failed to resolve *Endgame*'s technological problematic. Yet even this new form of understanding must be constantly mediated by the memory of past failures lest we begin to fetishize it as well. Thus we must be ever aware of the de-humanizing effects of fetishization while also trying to move beyond them.

Let us return for a moment to the competing moral evaluations of Adorno's stance toward real social practice. One group characterizes his theoretical orientation as essentially noninterventionist, in a sense repeating the "sin" of aesthetic judgment in its penchant for contemplation, the only difference being that Adorno's contemplative stance is interested, or critical, rather than disinterested. Consequently, this group ultimately views Adorno as an advocate for immoral resignation in the face of real suffering. The other group views Adorno's theoretical orientation as essentially moral insofar as he demands perpetual criticism of the status quo. We have seen, however, that he tried to reconcile these opposing views via the demand that art squarely face social oppression. Art can produce the illusion of convergence between experiences of consciousness and entities accessible to the senses; and this illusion grants a more immediate sense of contact with disenchanting material motifs than traditional philosophical speculation. This

sense of immediacy compels identification with the suffering expressed through these motifs, and this identification moves us to recognize and undo the antagonisms which cause suffering. Adorno believed that the recognition of repression which precedes this act of undoing is an enlivening of the artistic receptor's will and therefore a form of social praxis. This belief implicitly rejects the division between mental and physical labor. Each reader must decide for him or herself whether this rejection is legitimate; but the fact remains that Adorno was at least intuitively aware of the possible contradiction immanent to his own theory, and by espousing a material metaphysics he pushes his thought toward reconciliation.

In the lectures on metaphysics, Adorno relates a conversation with Adler on the subject of Beckett's work. He says that Adler "revealed an extremely violent affect against that writer, giving vent to the comment: 'If Beckett had been in a concentration camp he probably would not write these despairing things; he'd write things that gave people courage'" (*Metaphysics* 448). Adorno's difference from Adler is very simple: the gift of courage diverts attention from those things which inspire the need for courage in the first place; it wishes them away. Invoking the central theme of this essay collection, we might say that turning attention away from the dark side of reality is de-humanizing precisely because it allows de-humanizing social processes freedom from critical scrutiny. On the other hand, the willingness to engage these processes is the first step toward re-humanization, or toward a material praxis which can really challenge them: "Art renounces happiness for the sake of happiness, thus enabling desire to survive in art" (Adorno, *Aesthetic Theory* 18). To repeat, Adler says Beckett should give people courage; Adorno would say Beckett does give courage—the courage to feel bad enough to move and make a difference.

Notes

1. For more on the genesis of *l'art pour l'art* ideology and its relation to Kant's *Critique of Judgment*, see John Wilcox, "The Beginnings of *l'Art pour l'Art*."
2. "In the last analysis the postulate of disinterestedness debases all art, turning it into a pleasant or useful plaything" (Adorno, *Aesthetic Theory* 18).
3. See, for example, Michael Hirsch's "Utopia of Nonidentity."
4. The student protestors in Germany in the 1960s took this view and publicly criticized Adorno. Indeed, it is often asserted that the strain Adorno endured vis-à-vis the protestors precipitated his fatal heart attack in 1969.
5. As Martin Jay argues in *Adorno*:

> Drawing on the idealist distinction between *Vernunft* and *Verstand*, Horkheimer and Marcuse in particular had emphasized the 'eclipse' of the former in the modern world in favor of the latter. Whereas *Vernunft* meant a substantive rationality in which the antinomies of thought and existence were reconciled, *Verstand* accepted them as inevitable realities in an unchangeable world. Related to this reduction of rationality to *Verstand* was its instrumentalization, the confinement

of reason to the choice of means rather than ends, or in Max Weber's celebrated
terms, the hegemony of purposive over value rationality.

(72)

Works Cited

Adorno, T.W. *Aesthetic Theory.* ed. Gretel Adorno and Rolf Tiedemann. Trans.
C. Lenhardt. London: Routledge & Kegan Paul, 1984.
——. "Culture and Administration." *The Culture Industry.* ed. J.M. Bernstein. London:
Routledge, 2004.
——. "Education after Auschwitz." *Can One Live after Auschwitz?* ed. Rolf Tiedemann.
Stanford: Stanford UP, 2003.
——. *Metaphysics: Concepts and Problems. Can One Live after Auschwitz?*
——. *Minima Moralia.* Trans. E.F.N. Jephcott. London: Verso, 2005.
——. *Negative Dialectics.* Trans. E.B. Ashton. New York: Continuum, 1997.
——. "On the Fetish Character in Music and the Regression of Listening." *The Culture
Industry.* London: Routledge, 2004.
——. "The Schema of Mass Culture." *The Culture Industry.* London: Routledge, 2004.
——. "Trying to Understand *Endgame.*" *The Adorno Reader.* ed. Brian O'Connor. Trans.
Michael J. Jones. Oxford: Blackwell, 2000.
Beckett, Samuel. *Endgame: A Play in One Act.* New York: Grove Press, 1958.
Egan, Rose Frances. "The Genesis of the Theory of 'Art for Art's Sake' in Germany and
England." *Smith College Studies in Modern Languages* 4 (1921): 1–61.
Gautier, Théophile. *Poésies Complètes.* Paris, 1889.
Hirsch, Michael. "Utopia of Nonidentity." *Adorno: The Possibility of the Impossible.*
Frankfurt: Lukas & Sternberg, 2003.
Jay, Martin. *Adorno.* Cambridge: Harvard UP, 1984.
Kant, Immanuel. *The Critique of Judgement.* Trans. James Creed Meredith. Oxford: Oxford
UP, 1961.
Le Gallienne, Richard. *English Poems.* "The Décadent to His Soul." London: John Lane,
1895.
Marx, Karl. *Economic and Philosophic Manuscripts of 1844.* Moscow: Foreign Languages
Publishing House, 1961.
Wilcox, John. "The Beginnings of *l'Art pour l'Art.*" *The Journal of Aesthetics and Art
Criticism* 11 (June 1953): 360–77.

11
"This temptation to be undone ..."
Sontag, Barthes, and the Uses of Style

Sarah Garland

> *This temptation to be undone by the otherness in what we read*
> *is one of reading's attractions. The temptation is both intensi-*
> *fied and distanced through criticism: one cannot, in effect, cul-*
> *tivate the temptation without also increasing the distance ...*
> —Cary Nelson, "Soliciting Self-Knowledge:
> The Rhetoric of Susan Sontag's Criticism"

The value of uselessness

The branches and offshoots of nineteenth-century aestheticism are so tan-
gled with the idiosyncrasies of other ages and strategies that it would be dif-
ficult to plot a straight path through without clumsily hacking. However, it
is possible to pull at a few important tendrils that make it through to the
twentieth century. I do not have space here to consider each twist, disap-
pearance and reemergence of the ideas clustered as "art for art's sake" and
will, in the main, be concentrating on a particular, late sixties moment.
Nevertheless, I would like to argue that some of the most important and
controversial critical subtexts of twentieth-century art and literature might
be seen as hybrid variants of ideas that bloomed forth in exaggerated form
in nineteenth-century aestheticist doctrine.

As Monroe Beardsley points out (from a thoroughly partisan position) the
nineteenth-century aestheticism manifest in Gautier, Pater, and Wilde made
familiar a Kantian conception of art as unique and autonomous, as a valued
sphere outside of industrial consideration. From this perspective the aes-
thete's domain might be thought of as the negative spaces between the marks
of modernity, a tradition of protest and resistance that throws the dominant
culture into relief. It is not quite avant-garde because by and large it is a way
of talking about art rather than producing it, but aestheticist strategies often
work with the avant-garde, on the edges of artistic production, attempting
to find and interpellate a receptive audience for these dangerous objects.
The nineteenth-century aesthetes' refusals and revaluations might be thought

of as strategies for mediating between a late-romantic vision of the artist as an isolated but nonetheless privileged seer, and a newly modern producer of the exquisite—in an economy where there is only so much demand for exquisite objects, and still less for those with little or no practical value. In *Dead Artists, Live Theories, and Other Cultural Problems*, Stanley Aronowitz calls art for art's sake "the slogan of the protesting artist whose autonomous space becomes even narrower," and Gene Bell-Villada, in *Art For Art's Sake and Literary Life*, connects it to the rise of the mass market, where those writers with slower, more meticulous working habits could no longer compete, and so "unmarketability was transformed into an aesthetic, spiritual, even moral asset" (62, 50). The particularities of surface and form that made Mallarmé's poetry or Picasso's painting so different were held up as their value, and this kind of highly freighted separatism, Beardsley argues, goes on to feed into the formalist aesthetics of Clive Bell and Roger Fry in the early twentieth century, and also, by implication, into Beardsley's own part in the New Criticism, and into the kind of Greenbergian aesthetics that were so influential in the era of abstract expressionism.

In its meditation on the medium's mechanisms, beauties, and ambiguities, the New Criticism might be thought of as aesthetic criticism, even as it attempts to keep affect away from the compromises of the body. The idea that the work should not only be worth something on its own, but be readable out of context suggests something like a paradox of transcendent materialism, the idea in Woolf's *Waves* or Eliot's *Wasteland* that ideally structure should be enough to change things, that the bewitching otherness of art can offer an alternative to the chaos of modern life. Even here though, style is something of a heroic failure. The grand gestures toward form never quite work out; what we retain from modernism is a much more fragile form of aestheticism and the sense of a few moments that might bring the kind of brightness that Walter Pater had hoped for before the shattering First World War.

Another of aestheticism's stronger branches stretched in the other direction, into the heart of consumer culture. The Epicurean idea (again in Pater, but also in Wilde) that there could be an art to life and to identity travels through the Bloomsbury group, certainly, but also appears in *art nouveau* and *art deco* styles. The hope that there could be a bliss of surface and function, that utility is not always ascetic, lodged its way in the Arts and Crafts movement and has remained there ever since. Despite its usefulness, to a certain extent the suspicion of public philistinism still remains. There have always been *cognoscenti* in the field of design as there have been in the field of the fine arts, but in the artisanal tradition there are moments like the Bauhaus where the democratic and utopian vision is the stronger. The apportion of unequal value between the arts and crafts movements and fine art is one that the camper aesthetes repeatedly subvert, but the gesture still depends on a well-established hierarchy. Pater's plea that what he calls "the mode of handling" should become an end in itself, holds good, he argues

in "*all* things that partake in any degree of artistic qualities:" "of the furniture of our houses, and of dress, for instance, of life itself, of gesture and speech, and the details of daily intercourse," for "the wise, being susceptible of a suavity and charm, caught from the way in which they are done," this "gives them a worth in themselves" and "a mysterious grace and attractiveness" (Pater 131). Beardsley and the formalists, while part of the canonising search for value and valued readers, turned this upside down and proletarianized themselves, so to speak, by taking on the workman-like vocabulary of well-wrought urns and craft ("the poet or painter does his duty in cultivating that [aesthetic] emotion just as surely as the doctor or lawyer does by his activities," (Beardsley 290). By the mid-sixties, when Sontag and Barthes are writing, the political antagonism between those that have access to man-made material pleasure and those that do not is so explosive that, as I will argue later, materialism comes to seem absolutely antithetical to radicalism in art, even as formal innovation moved toward the emphasis of materials and artifice.

Perhaps the most tangled of these tendrils is, paradoxically, that variant which has sought to isolate itself most fully, that is, the version of the aesthete's stance that makes a show of refusing the social commitments of the political, economic, and utilitarian. There is a sense here too that extreme aestheticism is an ideal and a discourse rather than a production strategy, that as the producers of these privileged and often problematically referential objects were more and more pressed to explain their status, they were less inclined to be tractable about it—virtuosity should be its own reward perhaps. Wilde is an obvious case, as is Whistler's *The Gentle Art of Making Enemies*, but Poe might also be seen to give us a red herring in "The Philosophy of Composition." The *transition* group's damning the plain reader also comes out of this tradition, as does Baudelaire's "épater le bourgeois" and Joyce's angry 1936 riposte to his brother: "For God's sake, don't talk politics! The only thing that interests me is style" (Joyce qtd in Bell-Villada 180). Critically, it is as if the formalists take the artist at their word rather than at their deed. The artists' evasive strategies are translated into a way of reading with its own protocols, connoisseurs, and virtuosos, despite the fact that very little of this stylised art was actually asocial. As Wendy Steiner points out throughout *The Scandal of Pleasure*, since the valorisation of formalist readings in the modernist and postmodernist critical traditions, isolationist strategies have usually been brought out as a faux-conservative defence of risky art, a way of arguing that a contested work like Rushdie's or Mapplethorpe's (her examples) should be allowed a place in civilized society because their status as book or photograph means we have no business judging them in the same way as we would judge action in the real world. The problems with this refusal to account are as obvious as its temporary advantages—in cutting the text off from the world the formalist critic refuses the part of the art that *is* concerned with resemblance. Even very

abstracted pieces or works make their impact through their denials, distances, and comparison with the real.

Seriousness and the sense of an ending

Susan Sontag's sixties work partakes of a fair amount of this isolationism, but like the work of her aestheticist predecessors, *Against Interpretation* is better read as a social refusal than theory in a vacuum.[1] In "Thirty Years After ..." (1996), Sontag expresses her surprise that nobody had noticed that her antagonistic stance in *Against Interpretation* has a history. "As I saw it," she writes, "I was merely extending to some new material the aesthete's point of view I had embraced, as a young student of philosophy and literature, in the writings of Nietzsche, Pater, Wilde, Ortega (the Ortega of "The Dehumanization of Art"), and James Joyce" (*Where the Stress Falls* 270). As Liam Kennedy explains, many of the essays in *Against Interpretation* were "very deliberately staged provocations": specific critiques of the moral utilitarianism of the New York intellectuals and their Marxist and Freudian reading strategies (17, 21–2). The theories of Pater and Wilde are mischievously dripped into the ears of an urban American discourse accustomed to moral earnestness, and into the political pages of *Commentary* and *Partisan Review*. Even as she has clearly learnt her style and bought some of her courage from the precedents of Trilling et al., the essays give off a feeling of restlessness, and a sense that social utility cannot quite account for the allure of *Last Year at Marienbad*, or John Cage's work, or Artaud's or, Beckett's, and a frustration that the responsibilities of the mimetic tradition are still too dominant and too predictable.

In that same retrospective essay, Sontag characterised herself then as "a pugnacious aesthete and a barely closeted moralist," and both in *Against Interpretation* and in *Styles of Radical Will* we see her thinking through the possibility of a relationship between these two positions (*Where the Stress Falls* 270). The two "pioneering forces of modern sensibility" she argues for in "Notes on Camp"—"Jewish moral seriousness and homosexual aestheticism and irony"—give us her alternating identities (and perhaps her target audiences), but they also give us two postures that define themselves against each other until her later work on photography, where she moves into a more obviously mimetic but much more personal voice (*Against Interpretation* 290). Sontag herself maintains that her Wildean moments of the doctrine of uselessness in *Against Interpretation* were a polemical move, designed to revivify reading practices, and that "... it would be imbecilic simply to defend beauty or to contend that there is something called beauty which exists absolutely apart from any kind of historical coloring or ethical mandate," and that "no one believed that, least of all Oscar Wilde, Baudelaire, Valéry, or Barthes" (Poague 190), but her worry about a collision between aesthetics and morality is evident as late as *The Volcano Lover*.

Sontag's sixties essays are particularly useful then because she reinvestigates aestheticism's function as mediator between art and life, but also because she is so well sunk into the discourses of her own time. Sontag brings together a collection of warring influences—as well as continental philosophy, phenomenology and existentialism in particular; she cites Lionel Trilling's essays as an early influence, but also the New Criticism, and she was trained under the rhetorician Kenneth Burke (Poague 223, 275). In her journals (only recently excerpted in *The New York Times*), however, she repeatedly returns to the romantic line of Nietzsche, D.H. Lawrence and her contemporary, Norman Mailer. Indeed, these generic splits, more evident in encyclopaedias than in any of these writer's actual essays, dramatise the personal tensions at the heart of the twentieth-century version of *l'art pour l'art*. Post-Depression, post-Holocaust, and in the middle of the Cold War there is not an easily available vocabulary which will both politicise aesthetics and retain the writer's individuality, or subtlety. There is a sense that she is finding herself having to choose. More recently, Angela McRobbie has suggested that Sontag's problem with finding an idiom is also gendered that in "high or late European modernism [...] there was no critical space for women unless they demonstrably transcended gender" (79). In terms of my arguments here, Sontag's move into a supposedly transcendent language of art, value and the canon is part of this pragmatic attempt to speak. Sontag maintains in several interviews that these essays were part of a process whereby she translates her self into a stance and a set of objects, and in "Pilgrimage" (1987), she writes of how "seething with the desire to express," she focuses "feeling away from myself onto something I admired or felt indignant about" (qtd in Kennedy 5). Interestingly, by the time she is interviewed in 1984 this modernist persona has failed her: "the essays are extremely personal and yet operate on a strategy by which the first person is renounced. Eventually this formula becomes impossible and I'm finding now that I can't write them anymore ..." (Poague 208).

As with the nineteenth- and early twentieth-century variants, in mid-century criticism a concentration on the medium was also a central signifier of what it meant to be serious about one's vocation. Often this comes in the form of a triumphant avant-gardism that relies upon an eschatological and mystical vocabulary, and recaps a late-romantic description of textual force. What Steiner describes as the birth of aestheticism in the *fin de siecle* "sense of living at the end of an age, of making do with diminished possibilities" is a sentiment absolutely echoed in sixties rhetoric, as is the association she makes with religious energies released by the late nineteenth-century "death of the gods." A good aesthete would be wary of this Christianised teleology where art operates as a kind of cathexis for religious feeling—the mobility of desire and value in aestheticism suggests that god may, in many cases, have been an alibi for the power of the fetish—but this history of adoration and sensation does offer a rationale for the number of times the aesthetic tradition

meets the religious one. As Bell-Villada points out, the idea that an aesthetic bias creates "a religion of art" is a truism; Wilde and Pater were lapsed believers (Bell-Villada 92), and, for the purposes of this comparison it seems significant that Sontag and Barthes were both very well read in the mystical tradition, and had both taught the history of religion.

The mid-century aesthetic idiom resurrects the kinds of paganised rapture we find in Pater's "Conclusion," and puts it in the service of a more obviously nihilistic rhetoric of end times.[2] The cultural discourses of silence and exhaustion, of a formal "sense of an ending," commingle with a sixties concern about radical overhauls of interiority, with hopes that speech or drugs or sex or poetry or art can absolutely alter how the self exists in the world. What I find interesting here is how the sixties subgenre that writes about "silence" and "exhaustion" intersects with the wider social upheavals of the time. In one sense, it is those with voices and established genres that write about these genres' "used-upness": ludic postmodernism plays itself off a death of the gods that is absolutely aestheticist in tone. However, multiethnic, feminist and queer writers were also feeling a politicised frustration with bourgeois authority and bourgeois realism.[3] In critical writing, particularly in the hyperbolic tones of Ihab Hassan and Norman Mailer, this moment of cultural violence has the result of injecting huge surges of energy into heavily overdetermined moments of aesthesis, whether artistic, religious, sexual or linguistic, and into voices that recall Nietzsche's fiery declamations. Sontag is no exception; throughout her texts, as her interviewers often point out, there are recurrent moments where art is the prompt for a moment of concentration where the self becomes soluble. "Contemplation," she says in "The Aesthetics of Silence," "entails self-forgetfulness on the part of the spectator: an object worthy of contemplation is one which, in effect, annihilates the perceiving subject" (*Styles of Radical Will* 16).

Returned to an American romantic tradition we can see the repetition of moments like Emerson's ecstasy in *Nature* ("I am nothing. I see all"), but, in opposition to the Emersonian model, Sontag's trans-Atlantic version focuses these moments on artefacts heavy with the history of material culture and civilisation, even as she shares the transcendentalists' longing for a kind of consciousness that is not reflexive. As Cary Nelson notes with such nuance in "Soliciting Self-Knowledge," two essays as far apart in subject matter as "The Pornographic Imagination" and "Trip to Hanoi," share very similar moments where Sontag reads her subjects as yearning to "transcend the personal," and "to satisfy the appetite for exalted self-transcending modes of concentration and experience" (*Styles of Radical Will* 70; Nelson 719). Nevertheless, this aesthetic of transcendence is still settled in a relatively stable self. It represents a desire to know and examine the other, but also as a desire to use the material to stretch experience into the ecstatic.

Concealing the artist and revealing art

In keeping with this ambiguous relationship with the personal, another way of approaching the history of aestheticist criticism might be to read it as the history of a textual tease, a tradition where the artist or writer tries to replace the sense of themselves as originators, hidden behind the text, by a sense of themselves consumed by the text, dissolved and replaced by language.[4] This rebellion depends upon a cultural background where the default reading method is humanist and postitivist, and, as Seán Burke suggests in his critique of Barthes's anti-authorialism, it may be the case that the practice of what a formalist would refer to as naïve interpretation was never as fully and as firmly entrenched as these writers would have you believe. Certainly, an imagined *bête noire* of bad reading is as necessary to Sontag's argument as "Art"—the beautiful damsel threatened by such rough handling. However, the inviolability of the text is only one part of this (infamously) persistent concern about invasive interpretation; reading Sontag and Barthes's own texts in the rhetorical tradition of Pater and Wilde also suggests that the critic's own honour might be at stake.

When Wilde pronounces in his notorious preface to *The Picture of Dorian Gray* that "all art is at once surface and symbol," that "those who go beneath the surface do so at their peril" and "those who read the symbol do so at their peril" (5), his eminently quotable bravura tends to obscure the original function of the Preface as a defence against moral censure of the book, against critical muckraking, and against rogue interpretation. When she discusses Roland Barthes's version of aestheticism in a later piece called "Writing Itself," Sontag argues that this kind of emptying out of meaning is what links Barthes's anti-authoritarian stances with that of art for art's sake. What Barthes in *Camera Lucida* describes as his "desperate resistance to any reductive system" (8), leads to a position where there must always be a way to empty out value and reassign it, or as Sontag puts it:

> All of Barthes' intellectual moves have the effect of voiding work of its "content", the tragic of its finality. That is the sense in which his work is genuinely subversive, liberating—playful. It is outlaw discourse in the great aesthete tradition, which often assumes the liberty of rejecting the "substance" of discourse in order better to appreciate its "form": outlaw discourse turned respectable, as it were, with the help of various theories known as varieties of formalism.
>
> (*A Roland Barthes Reader* xxx)

As Stanley Aronowitz points out, there is a danger that this emphasis makes Barthes more conservative than he actually was—Barthes's scientific preoccupations, his "relentless efforts to find a model through which the cultural

process could be understood" and his "profound interest in everyday life" contrast sharply, Aronowitz argues, with Sontag's obsession with writing in and for itself (98). Nevertheless, Barthes's type of antifoundationalist reasoning might be thought of as one of late romanticism's snakiest and most important offshoots. Its evasiveness forms a crucial part of the secrets of *l'affaire* De Man, as well as the problematic legacy of the Nietzschean tradition in general, but, it has also formed the core of a large part of a more constructive one. It is certainly part of the camp tradition; once Wilde's reader is trained in this kind of contrary thinking, any denial the writer makes is likely to be read as the final stage in reassigning value. His dictum that "to reveal art and conceal the artist is art's aim" (5) prepares the way for the book that reveals the artist, in his own choices, fantasies, fears, and tastes. And, although her polemic against colonising and moralising interpretation is absolutely sincere, *Against Interpretation* also gains part of its impact from an ingenious counter-intuitivism that is similar to Wilde's—the texts Sontag asks us not to restructure with our interpretations are precisely those whose sheer complexity and opacity seems to *ask* one to interpret.

Barthes goes on to resell the advantages of this vanishing act most notoriously in "The Death of the Author." The essay is, like Sontag's "Against Interpretation," primarily a polemic against invasive and reductive reading, but scanned for traces of the writer's motivation one sees a similar aesthetic of dissolution as in Sontag's texts—the writer here "slips away," "identity is lost," "only language acts, 'performs', and not 'me'" (*Image, Music, Text* 142–3). Asserting the primacy of the medium rather than the author offers the tantalizing prospect of ventriloquism, of a voice that can speak without fear of recuperation or shame, even as the frame of disavowal does not really obscure what is within. From a writer's point of view, the erasure with a trace in "The Death of the Author" is, as Barthes knows, having your cake and eating it, or, to switch metaphors, like shouting "objection" in court after a dangerous piece of argument: the argument continues to ring in the ears of the jury, it is just rendered inadmissible and taken off the record. In *Roland Barthes* he writes wistfully of "earlier times" where scholars "sometimes discreetly followed a proposition with the corrective word '*incertum*,'" where, in the event of "a clear-cut piece whose *embarrassment* was always certain, it would be enough to announce this piece on each occasion [...] in order to be cleared of having written it" (105). The mischief in this position is profound, and reminiscent of Pater's thoughts about "how much fun it would be to be ordained and not believe a single word you're saying" (Bell-Villada 75). As with other subversions, this constitutes complicity to a certain extent, but perhaps it is the only move available in a post-structuralist system where one needs to write to attempt change, but where writing, like all forms of authority, is suspect.

There is also something in Barthes's certainty of embarrassment that might precipitate an aestheticist outlook. From a radical point of view a guaranteed "embarrassment" of the text is politically necessary, but it still is

not a pleasant position for the writer—writing becomes shameful, even as the interrogation of authority is felt as a liberating and ethical act. For Barthes as a writer there is a discomfort in this double position, ("sometimes acute," "mounting some evenings, after writing the whole day, to a kind of fear") because even though "the aim of his discourse is not truth," "this discourse is assertive" (*Roland Barthes* 48). Barthes's disavowal goes far enough to shift him to the third person, and his uneasy sense of self-composition remains in the self-cancelling and self-fracturing and self-compounding names on the book's jacket.

Barthes's materialism might be thought of as a way of rendering this linguistic shame more slight. In "The Death of the Author" the text is given to the reader as an *object trouvée*, as a dissonant and plural "tissue of quotations" drawn from "innumerable centres of culture," and writing is emphatically posited as an act of "prerequisite impersonality" (*Image, Music, Text* 143, 146). The self-assured prose of "The Death of the Author" does not read like an abdication from personality (or even seem in the least bit embarrassed about its supposedly posthumous liveliness) because Barthes's aestheticist view of language as authorial erasure produces an incredibly distinctive critical voice. By "de-humanizing" himself (in Ortega y Gasset's terms) Barthes becomes an even more vital textual presence. As with Stephen Dedalus's artist-god, this return to the fetish of words gives us an author refined out of existence, impersonalizing himself, who nevertheless remains "within or behind or beyond or above" because language is as impersonal as it is idiosyncratic. Barthes's disappearance *behind* his text actually constitutes an appearance *in* the text.

Sontag's rhetoric transposes this into a particularly intense register because a concentrated relationship with the other of "art" is so vital to her writing. Whereas Barthes finds his ideal particulars in the nineteenth-century realists' art of inventory (in *Pleasure of the Text* he writes about a fleeting fixation on the word "*horodeictic*" because it is "unexpected, succulent in its newness, an incongruous apparition that glistens, is distracting" [42]) for Sontag the stylised and impenetrable surfaces of the twentieth-century avant-garde offer themselves as pristinely aloof. This is why the stances in *Against Interpretation* and *Styles of Radical Will* work so well with regard to pop art and minimalism; in this early work especially she seeks out objects like John Cage's or Robbe-Grillet's, or Artaud's, which come close to Beckett's aestheticist dream of an art "too proud for the farce of giving and receiving," and repel the viewer's desires as much as they invite them. There is a need for the text to be constituted as absolutely other, absolutely unreadable, so that the act of criticism has an element of flight, but there is also an act of appropriation and reading the self through its desires.

Nelson goes on to translate this dialectic between language as personal and as fascinatingly alien into the ambiguous, intermediary stance of criticism. For Nelson, Sontag acts as exemplary negotiator between the text as other

and outside, and the text as brought into the writer's monologue. Because Sontag's mode of knowing is primarily *aesthesis*, that is, things perceptible through the senses, there is a sense that consciousness is either consuming, or being consumed, or coming to terms with something that it cannot consume. Sontag says in an interview from 1981 that her subject is "consciousness as a form of acquisition" and its "counter-projects of disburdenment and silence—the temptations of silence" (Poague 181). This sensualist position has the Barthesian political advantage that it is relatively non-didactic, but it also seems to precipitate a kind of crisis, an uncertainty about place and history and value that is very isolating, as well as potentially imperial. Ontological lack of foundation can be valuable in an environment where dogma is the norm, but it does leave an existential discomfort that comes through in Sontag's later work on melancholy. Sontag's solution is Nietzschean, what she calls her "working illusion" of being self-created (Poague 136), but again, as late as *The Volcano Lover* there is a pervading sense of unease at the prospect of the self as collection or archive, no matter how the objects glitter. Because the self as written plots its contours through a shifting relationship with objects, the tension between concentration and dispersion of the self that, I would argue, is at the centre of the aestheticist outlook, forms a recurrent moment in her essays and her fiction. Both Barthes's and Sontag's careers show this doubleness at work—Barthes starts and ends his with intense meditations on the form of the writer's journal, on autobiography and the language of the personal, but his sense of language being borrowed, social, and constituted somewhere else is acute. Similarly, Sontag's most formalist and "inhuman" pieces appear bracketed with piece after piece on writers and their journals. Apocalyptism seems partly to drive a sense of dissolution, to reveal the material and the aesthetic as a place where consciousness is undone, but also to be part of the recomposition.

The aestheticist concern with objects and lists plays this out most obviously—a list is a form of immanence, but also a decision not to appear, it shows the process whereby the writer is displaced into their choices about something else. A text as "a tissue of quotations" might be seen as a highly crafted list, with all the ambiguities that follow—by refusing to fix hierarchies the post-structuralist position displaces dogma and allows in pluralism, but it also contains something of the museum's imperialist history of appropriating, isolating, and displacing objects. Seeing a text as a list of curios isn't too far from a late Victorian plunderer's mentality, unless the reader takes the time to study the provenance of these quotations. The accusations of plagiarism levelled against *In America* illustrates the slippage well—she maintains she was quoting, the accusers saw it as stealing. Similarly, Barthes's collections are wonderful if one shares his textual fetishism: "*I like*: salad, cinnamon, cheese, pimento, marzipan, the smell of new-cut hay [...] peonies, lavender, champagne, loosely held political convictions, Glenn

Gould, too-cold beer, flat pillows, toast, Havana cigars, Handel, slow walks, pears, white peaches, cherries, colors, watches, all kinds of writing pens ..." (*Roland Barthes* 116). However, a list is not a life, it is a proxy that we can only read back so far. As far as self-revelation goes, a list is only the record of consumption, only a part of a person's actions. For rhetoric though, the noun has an indispensable precision and authority, and the writer's voice not only borrows the speed of reference from this signifier, in the aestheticist tradition there is a sense that it tries to take on some of its opacity as self-protection.

Camp and aesthetic virtues

That Pater, Wilde, Barthes, and Sontag all intersect in their articulation of what has been fairly recently "revealed" to be a queer subject position makes their defiant display of self-construction all the more personally necessary, and all the more brave.[5] Sontag puts it quite succinctly in her journal: "Dec. 24 [1959]. My desire to write is connected with my homosexuality. I need the identity as a weapon, to match the weapon that society has against me. It doesn't justify my homosexuality. But it would give me—I feel—a license. [...] Being queer makes me feel more vulnerable." Barthes too connects his writing with a sense of outsideness:

> [H]e has always belonged to some minority, to some margin—of society, of language, of desire, of profession, and even of religion (it was not a matter in indifference to be a Protestant in a class of Catholic children); in no way a severe situation, but one which somewhat marks the whole of social existence: who does not feel how *natural* it is, in France to be Catholic, married and properly accredited with the right degrees?
>
> (*Roland Barthes* 131)

This undermining of the natural is absolutely what is at stake in aestheticism; it has always intersected with an ambiguously mimetic tradition in the arts; the whole, ragged, formalist line shares a common refusal to treat language as instrumental, or merely representative. Ortega y Gasset calls stylisation "dehumanization" because he reads "natural" (i.e. mimetic), as "human," but read as an action, that is, as a set of assertions and a way of thinking through an individual's response to objects, concepts, situations, and relationships, artifice is a necessary form of consciousness. There is a sense that (as William Burroughs wrote in a letter to Allen Ginsberg) this kind of use of "human" as an adjective is regrettable, because it suggests that there is a way of being human below this threshold of value. It is precisely this connection between a conservative "naturalness" and the received prejudices about human value that aestheticism attempts to dismantle.

Aestheticism reveals the workings of this moral economy by exposing us to a shift in the value of objects, and reflecting this newly subjectivised

outlook back from art, into life. In the Author's Preface to *The Renaissance*, Pater's standards of judgment make explicit this substitution of values: "the landscape," he writes, "the engaging personality in life or in a book, *La Gioconda*, the hills of Carrara, Pico of Mirandola, are valuable for their virtues, as we say, in speaking of a herb, a wine, a gem" (Pater 28). The vocabulary of tourism, epicurism and richness crops out, as it will do throughout this tradition, but more importantly, in the space of a sentence virtue becomes a matter of gourmandise and its objects. In disassembling value and reassembling it again from the perspective of personal pleasure, Pater also allows in a subversive voice. Kenneth Clarke tells Pater's later readers that "in writing about his period at all Pater was on dangerous ground, for ever since the early Romantic movement the Renaissance had been associated with every conceivable vice" (Clarke qtd in Pater 24), and that in his lecture of 1892 on Raphael, Pater praised the Baglionis for perpetrating "crime for its own sake, a whole octave of fantastic crime," "under brilliant fashions," and "with a certain immaculate grace and discretion" (Clarke qtd in Pater 24). This is clearly Decadent, but still, in 1961 Clarke is being fairly discreet about the fact that part of this aura of vice also emanates from the Italian Renaissance's passionate paeans to homosexuality. In his unqualified appraisal of this "Greek way" as beautiful, Pater (most obviously in the essay where he attempts to inhabit the consciousness of the art historian, Winckelmann) defies the Pauline split and posits ancient vices as modern liberty. The act of appreciating the "virtues"—that is, the distinctive beauties—of what is, more often than not, a naked lad, replaces the kind of virtue that involves steering clear of prohibited objects of desire.

To borrow Sedgwick's terms, there is also a sense in which aestheticism in the personages of Pater, Clarke and, I would argue, Sontag, can be described as a closeted discourse. After complaints, Pater's Conclusion was withdrawn from the second edition, because Pater conceded that his instructions might "mislead some of those young men into whose hands it might fall" (Pater 24). When it was reinstated the phrases that relativised religion had been altered, but there is also a case for reading the heresies here as alibis for a wider moralistic, and specifically, homophobic judgment. The open secret of "the Greek way," of Winckelmann's murder by a male prostitute, of Michelangelo's *David*, and then Pater's urging of these young men "to grasp at any exquisite passion," "any stirring of the senses, strange dyes, strange colours, and curious odours, or the work of the artist's hands, or the face of one's friend" (223), is surely a clearer message, if one is already familiar with this vocabulary of "strangeness."

Wilde, like Pater, was virtuoso at returning a quality of attention to surfaces, and bringing these shiningly resonant surfaces into a discourse that deliberately and perversely refuses to legitimise their interpretation. Like Pater, Wilde substitutes the "virtues" of a gem, a personality, a cigar, a wine, a beautiful boy, for moral virtue, but Wilde's impertinence (repeated later in

camp's reassignment of value into flawed and staged objects) is that he asks us to watch while he makes the switch, and then either to assent or to be scandalised.[6] In *The Renaissance* Pater asserted the value of appearances in the context of a discourse where the objects were created to be appreciated. His attention to appearance is seemly until it escapes its discipline and pauses to suggest that a great picture is as much or as little as "an accidental play of sunlight and shadow for a few minutes on the wall or floor," or worse still, starts seducing its way into young men's lives (Pater 24). Wilde, and the tradition following on from him that Sontag describes as "camp," deliberately antagonises these standards of disciplinary decorum, and then defies us to make pure morality stick to such a hybrid argument.

The way Sontag and Barthes's aestheticism allows the scaffolding of self to ghost the work of art, but, importantly, not to be naturalised from it, can then be read as a version of camp, even as the tone of their work deviates from camp's signature hauteur and humour. A queered subject position might give rise to the preoccupations with authorship as exposure, masquerade and self-effacement that are evident in *Against Interpretation* and "The Death of the Author." From this point of view the aesthetic of consumption in Barthes's most famous essay, where the text is "a tissue of quotations from innumerable centres of culture" becomes the formation of a self as text, concrete in its taste and preferences but eluding definition.

Self-composition

The name that remains attached to the work after its author's dispersion into language is also important. This isn't the humble quest for absolute anonymity as much as a yearning for a public, writerly self that is as impervious as an object, a self where the author is felt to exist *in* a text or image—*because of* that text or image—but is, at the final assessment, unrecuperable. To paraphrase Nelson, the temptation to be undone by the otherness of what one reads is potent, but there is also what appears in Sontag's journals from the fifties and sixties as something almost like a temptation to objecthood, a strengthening that occurs as she strenuously imagines herself into "that persona, the writer." In these entries she internalises an outside reader, telling herself things she presumably already knows ("A freshly typed manuscript, the moment it's completed, begins to stink. It's a dead body—it must be buried—embalmed, in print. I rush out to mail the mss. the moment it's finished, even if it's 4 a.m"), collates herself in lists of paintings, painters, films, philosophers, and writes, she maintains, to strengthen a puny ego, an overcautious "I." "I cannot write until I find my ego," she says, "to write is to spend oneself, to gamble oneself. But up to now I have not even liked the sound of my own name. To write, I must love my name." This sense of self-creation seems especially strong when Sontag writes about herself as "a writer," referring to "the writer" with a male pronoun: "I lust to

write. [...] The only kind of writer I could be is the kind who exposes himself [...]. The writer is in love with himself ... and makes his books out of that meeting and that violence" ("On Self"). A mainly male canon and a sense of femininity as masquerade might suggest why this gendered imagining comes as no surprise, but the concentrated effort to create oneself also suggests a trouble with legitimacy that writers with fewer secrets might still share.

This strenuous sense of self-creation is not specific to subaltern groups, however, there is something in Sontag's sense of "justification" that also shows through in the work of her contemporaries, as well as in the longer history of women's writing. Musing on her friend, Jasper Johns, she makes a casual equation between Johns's charismatic poise and his authority which is revealing: "Jap's authority, his elegance. He is never flustered, apologetic, guilty, ashamed. Perfect certitude. So, if he picks his nose or eats in the Automat, he's being elegant" ("On Self"). Practiced aesthetic discipline of gesture, of style and surface seems somehow to mimic authority in both senses of the word, even if it is sometimes threatened by the body's appetites, or by a faint sense of excess and absurdity. Similarly, in "Notes on Camp" Sontag reads Genet through Sartre as using elegance to construct a kind of display that is both self-protective and self-displaying: "Elegance is the quality of conduct which transforms the greatest amount of being into appearing" (*Against Interpretation* 288). Translated into textuality this might give the qualities of theatricalised elegance evident in Mary McCarthy and Joan Didion's prose, as well as in Sontag's. The staginess of their writing plays off, for example, Norman Mailer's, or Kurt Vonnegut's or Richard Brautigan's studied casualness, while it displays in its style the sense of intrinsic worth Didion writes about in "On Self Respect," where "all the small disciplines" add up to a habit of mind, "a certain toughness, a kind of moral nerve" (Didion 127, 125). Part of what is so interesting here is the refusal of the romantic tradition of art as spontaneous expression, even as the materials of art are sensualised and tuned for immediacy. In terms of Picasso's famous dictum, art is the lie that tells the truth, and self-composition means composition in both senses of the word. When describing a cure for crying Didion wryly observes that "it is difficult in the extreme to continue fancying oneself Cathy in *Wuthering Heights* with one's head in a Food Fair bag" (127), but equally, there is a sense that at the time these women were writing it was neither safe, nor honourable, to give into one's Cathyish impulses.

Obviously, there is a point where this can become brittleness, but it does seem entirely understandable that a woman intellectual carving out her place in the pre-Stonewall, pre-feminist New York scene should be entuned to a mode of existence that Sontag in "Notes on Camp" refers to as "Being-as-Playing-a Role" (*Against Interpretation* 280). The notion of textuality as performance permeates both camp and constructivist feminist positions. For

Sontag as a woman writer, the quest for legitimacy was necessarily a defiance, and the fact of her sleeping with other women only squared the sum. The whiff of implied imposture in Jonathan Miller's comment (printed on the front cover of my edition of *A Susan Sontag Reader*) that Sontag is "probably the most intelligent woman in America," or Norman Podhoretz's snipes in *Making It*, suggest that she was indeed read as a being playing a role.[7] The shades of a performative aesthetic that Terry Castle reads in Sontag's prose and her personae are, in strategy, deadly serious. Her "adamantine hardness" (Castle 20) and casual imperiousness are a version of Richard Dyer's post-Stonewall assertion that "it's being so camp as keeps us going."[8] Castle's "Sontag" is worth quoting at length because it is one of the few that reads camp back into Sontag's persona as well as her work. It includes the sense that Sontag knows the rules and displays their play:

> Among other things, Sontag was a great comic character [...] The carefully cultivated moral seriousness—strenuousness might be a better word—co-existed with a fantastical, Mrs Jellyby-like absurdity. Sontag's complicated and charismatic sexuality was part of this comic side of her life. The high-mindedness, the high-handedness, commingled with a love of gossip, drollery and seductive acting out—and, when she was in a benign and unthreatened mood, a fair amount of ironic self-knowledge. [...] Among the susceptible, she never lost her sexual majesty. She was quite fabulously butch—perhaps the Butchest One of All. She knew it and basked in it, like a big lady she-cat in the sun.
>
> (Castle 20)

This sense of authority in a carefully controlled pose (or prose) is one of the better things to come out of the Nietzschean will to style. In both its camp and straightened versions the veneer of the aesthete's persona is, like the veneer of their texts, a piece of bold self-composition, a set of choreographed and repeated gestures that in their sheer obviousness suggest to a watching audience that the self is authored.[9] For the Regency dandy this had an aristocratic dimension: the liberty to disdain naturalness suggested superior will as well as leisure time and disposable income. As Ellen Moers explains so well:

> The dandy's achievement is simply to be himself. In his terms, however, this phrase does not mean to relax, to sprawl, or (in an expression quintessentially anti-dandy) to unbutton; it means to tighten, to control, to attain perfection in all the accessories of life, to resist whatever may be suitable for the vulgar but is improper for the dandy. To the dandy the self is not an animal, but a gentleman. Instinctual reactions, passions, and enthusiasms are animal, and thus abominable.
>
> (18)

In its twentieth-century variant the aesthete's control of their persona remains tight, but it now works in tandem with the post-romantic *dishabille* of the ardent admirer. The "temptation to be undone" is rigorously policed: only the most exquisite objects are worth unbuttoning the self for, and, even then, this passion appears to the reader as almost rebarbative, as a glazed presentation-cabinet of objects, texts, and curiosities. These objects of composition (in prose or in dress) are not assimilated into the natural, instead, linguistic and personal style makes continually visible the way identity is assembled (in Judith Butler's words) "through a stylized repetition of acts" (140). In working with language and art as "found objects," Barthes and Sontag both end up with a conception of authorship that mirrors the dandy's self-composition; for them, an author, like a dandy, is "a person who plays the part of himself" (Feldman 2).

Conclusion

The aestheticist tradition styles the strangely anonymous materials of art and language into a persona; its elegance is to retain something of the unreadable otherness of the object as defence against the ravages of interpretation. This constructivist aesthetic is also how Sontag, in "Writing Itself," can read Barthes as an aesthete, even though his writings have never placed themselves outside of a political reading and the negotiation of power. By reading his subjectivity as a mandarin taste that would rather not involve itself in didacticism—"Confidently assertive, it nevertheless insists that its assertions are no more than provisional," for "to do otherwise would be ... bad taste" (*Barthes Reader* x)—she gives a good sense of the way he argues his way out of dogmatic stasis and unites him with those in the aestheticist tradition that have also concentrated on shifting power and value away from the already legitimate. Even, she says, "the Saussurean theory— that language *is* form (rather than substance)—is wonderfully congruent with a taste for elegant, that is, reticent discourse," because "for reality to exist *as* signs conforms to a maximum idea of decorum: all meaning is deferred, indirect, elegant" (xxiv, xxv).

By asserting the provisionality of interpretation—its status as a personal aesthetic act rather than an absolute and definitional one—the aesthete's hope is that writing becomes something more than the duplication of prejudices. Individual prerogative and the individuality of reading are asserted among a plurality of tastes and sensations, and in an environment where value can be mobilised and found again in a new, or old, or kitsch, or taboo object. The intricate idiosyncrasies of each natural, created or critical thing and the differences between encounters are, from a Barthesian (and a Nabokovian) viewpoint, their value. The work of art is distinct and valuable because it is fundamentally other to the receptor, meaning is not consumed as much as produced. As Wolfgang Iser argues a few years later, the reality of

the reading process produces a state *different* to our normal one, and in this respect the aesthete's bliss can be seen as eminently sociable.[10] Aestheticism is not the sickly child of solipsism, it is a way of experiencing everything else. Sontag's pieces against interpretation foreshadow this effacement of self in their sixties apocalyptism, Barthes's late work is a more subtle *jouissance* of the text, but both share an acute respect for the otherness of the work, a humanising and intimate de-centring of the self which produces, as part of writing like a reader, theatrical writing postures which are exhilaratingly sincere and stridently individual. Far from being a de-humanized, aestheticism here offers a complex knot of human concerns. It offers an interrogation of the values and responsibilities of subjectivity, the place of desire, objects, and appearances in the most intimate levels of consciousness, and a nexus of dilemmas about class, power, taste, and interpretation.

Notes

1. It is telling that Sontag feels the need to revisit Leni Reifenstahl's work again in the seventies (see "Fascinating Fascism," *Styles of Radical Will*). Her early refusal to discuss political content in the same breath as aesthetic content cannot account for the dangerous allure of *The Triumph of the Will*, or the aesthetics of authoritarianism.
2. This eschatological wave, where aesthesis swells into apocalyptism, appears to have crashed around 1967. Ihab Hassan's "The Literature of Silence" came first, in the January edition of *Encounter,* very shortly after the *New York Times,* in 1966, had accused the journal of receiving financial aid from the CIA's anti-communist program; this was followed by John Barth's "The Literature of Exhaustion" in *The Atlantic,* which in *The Friday Book* introduces with accounts of the campus rebellions and the shadow of Vietnam. Later on that year an English translation of Barthes's "The Death of the Author" appears with Sontag's "The Aesthetics of Silence" in the "minimalist edition" of the cutting-edge magazine *Aspen,* extending this radical political panorama into radical formalist aesthetics. The "minimalism issue" came in the wake of a pop art issue edited by Andy Warhol and another issue edited by Marshall McLuhan. Frank Kermode's *Sense of an Ending* was also published in 1967.
3. This re-entry of an engaged criticism in the form of identity politics was eventually to wrench American criticism away from formalist concerns into a more socialised mode, but, as Bell-Villada and Steiner both argue, the European version of formalism that became deconstruction retains many of the aestheticist tropes.
4. The place of this dissolution in formalist history is well articulated by Colin Lyas, who points out the similarity of the idea of "the death of the author," to Derrida's assertion that the work is "cut off from any father," and Beardsley's and Wimsatt's insistence that texts are "cut off from the author at birth" (136). This, I would suggest is the end of a tendril that grows out of Wilde and Nietzsche's admonitions against symbolic fixity and the author's constancy.
5. I use the metaphors of revelation guardedly. As Eve Kosofsky Sedgwick argues in *Epistemology of the Closet,* the whole point of the theatricality of all this is to create an open secret, readable by a sympathetic audience.
6. The vertiginous ontology here provides a way in for deconstruction (which Steiner, Burke, and Bell-Villada all place as a later part of the aestheticist tradition),

but what I am most interested in here are the uses of this pose. After Judith Butler's studies in *Gender Trouble*, many of queer theory's most radical and necessary structures have been built upon this anti-foundational notion of gender as performance, but the idea of the text as performance can be followed back as far as the ancient conception of rhetoric. The existence of speechwriters and quotations reminds us that the rhetorical gesture is detachable, it exists within a set of rules and an instance of communication far more than it does within the paradigm of intellectual property, and yet, performing that gesture fixes it in a moment and a speaker. This removal of inherent and natural authority (and of the Author as God) is taken by Barthes as an always-available tactic, as something which enables a writer or reader to assert provisionality. It is this deliberately foundationless stance that allows Barthes to articulate a position beyond Sontag's and refuse the split between art and politics that has formed aestheticism's most attractive and most troubling structure. A rhetoricised discourse has a similar effect to an aestheticised one; it draws the viewer's attention to the stylized structures and rules of the game, even as they partially persuade. Camp provisionalises gender as rhetoric provisionalises speech—the act and the gesture are genuine, but their origin can only be traced as far back as a set of codes.

7. What is specifically in the background of Podhoretz's jibes are the accusations that Sontag is not the *real* and only legitimate dark lady of American letters. This dubious and singular role was bestowed on Mary McCarthy, who, in her turn, had to labour to escape comparison with her husband, Edmund Wilson.

8. Dyer's 1979 essay is reprinted in *Camp: Queer Aesthetics and the Performing Subject* (Edinburgh: Edinburgh University Press, 1999).

9. For the link between camp, aestheticism, and the dandy, see collections and studies including Cleto's *Camp: Queer Aesthetics and the Performing Subject*. Edinburgh: Edinburgh University Press, 1999; Moe Meyer, ed., *The Politics and Poetics of Camp*. New York: Routledge, 1994; Pamela Robertson, *Guilty Pleasures: Feminist Camp from Mae West to Madonna*. London: Tauris, 1996; and Rhonda K Garelick. *Rising Star: Dandyism, Gender, and Performance in the Fin de Siècle*. Princeton, NJ: Princeton UP, 1998.

10. See, for example, Iser's "The Reading Process: A Phenomenological Approach", rpt in *Modern Criticism and Theory: A Reader*. Ed. David Lodge. London: Longman, 1988. 211–28.

Works Cited

Aronowitz, Stanley. *Dead Artists, Live Theories, and Other Cultural Problems*. New York: Routledge, 1994.

Barthes, Roland. *A Roland Barthes Reader*. ed. and Introduction by Susan Sontag. London: Vintage, 2000.

——. *Roland Barthes*. Trans. Richard Howard. London: Macmillan, 1977.

——. "The Death of the Author". *Image Music Text*. Trans. Stephen Heath. London: Fontana, 1977.

——. *The Pleasure of The Text*. Trans. Richard Miller. New York: Hill and Wang, 1975.

Beardsley, Monroe C. *Aesthetics: From Classical Greece to the Present*. London, MacMillan, 1966.

Bell-Villada, Gene H. *Art For Art's Sake and Literary Life: How Politics and Markets Helped Shape the Ideology and Culture of Aestheticism*. Lincoln: University of Nebraska Press, 1996.

Burke, Seán. *The Death and Return of the Author: Criticism and Subjectivity in Barthes, Foucault and Derrida.* 2nd edn, Edinburgh: Edinburgh University Press, 2004.

Butler, Judith. *Gender Trouble: Feminism and the Subversion of Identity.* New York: Routledge. 1990.

Castle, Terry. "Desperately Seeking Susan". *London Review of Books,* 27: 6, 17th March 2005. 17–20.

Didion, Joan. *Slouching Towards Bethlehem.* London: Flamingo, 2001.

Feldman, Jessica R. *Gender on the Divide: The Dandy in Modernist Literature.* Ithaca: Cornell University Press, 1993.

Kennedy, Liam. *Susan Sontag: Mind as Passion.* Manchester: Manchester University Press, 1995.

Kosofsky Sedgwick, Eve. *Epistemology of the Closet.* Berkeley: University of California Press, 1990.

Lyas, Colin. *Aesthetics.* London: UCL Press, 1997.

McRobbie, Angela. *Postmodernism and Popular Culture.* New York: Routledge, 1994.

Moers, Ellen. *The Dandy: Brummell to Beerbohm.* Lincoln: University of Nebraska Press, 1978.

Nelson, Cary. "Soliciting Self-Knowledge: The Rhetoric of Susan Sontag's Criticism." *Critical Inquiry 7.* Summer 1980. 707–26.

Ortega y Gasset, José. *The Dehumanization of Art and Other Essays in Art, Culture, and Literature.* Trans. Helen Weyl. Princeton: Princeton University Press, 1968.

Pater, Walter. *The Renaissance: Studies in Art and Poetry.* Introduction and Notes by Kenneth Clark. London: Fontana, 1961.

Poague, Leland, ed. *Conversations with Susan Sontag.* Jackson: University Press of Mississippi, 1995.

Sontag, Susan. *A Susan Sontag Reader.* Introduction by Elizabeth Hardwick. London: Penguin, 1983.

——. *Against Interpretation.* 1966; London: Vintage, 2001.

——. "On Self". *New York Times,* 10th September 2006.

——. *Styles of Radical Will.* London: Secker and Warburg, 1969.

——. "Thirty Years Later ..." [1996]. *Where the Stress Falls.* 268–73.

——. "Writing Itself: On Roland Barthes". [1982] in *A Roland Barthes Reader,* vii–xxv.

——. *Where the Stress Falls.* London: Jonathan Cape, 2002.

Steiner, Wendy. *The Scandal of Pleasure: Art in an Age of Fundamentalism.* Chicago: University of Chicago Press, 1995.

Wilde, Oscar. *The Picture of Dorian Gray.* Ware: Wordsworth, 1992.

12

Art for Heart's Sake: The Aesthetic Existences of Kierkegaard, Pater, and Iser

Ben De Bruyn

After decades of relative neglect inspired by modernist and Marxist tendencies alike, recent decades have witnessed a resurgence in critical interest with regard to both the aestheticist movement and the phenomenon of the aesthetic as such. As Nicholas Shrimpton has pointed out in "The Old Aestheticism and the New," critics gradually returned to aesthetes such as Walter Pater in the 1960s, ultimately leading to a widespread re-examination of their core texts in terms of recent critical movements such as deconstruction, new historicism, and gender studies in the 1980s and 90s. This literary–historical research, Shrimpton suggests, helped create the conditions under which the "new aestheticism" of the last decade or so could arise. Rejecting the conception of the aesthetic as a straightforward epistemological or ideological smokescreen, recent publications have attempted to recast the aesthetic in more appreciative "deconstructive," "Marxist," and "ethical" terms (Shrimpton 10).

As "[t]his anxious search for a theory which is simultaneously 'aesthetic' and [...] socially purposeful is edging back [...] to the Aesthetic Movement" (13), Shrimpton joins the advocates of the new aestheticism, who are "reasserting the importance for modern critical practice of concepts associated with the creed of Art for Art's Sake" (1). Despite their emphasis on beautiful works of art, the aesthetes did not want to exclude moral considerations altogether, he notes, nor did they fail to realize that ordinary phenomena can be appreciated in an aesthetic fashion or that the aesthetic is a markedly fluid concept. The possibility of a fruitful interchange between the old and new aestheticism notwithstanding, Shrimpton is critical of those who want to establish an unbroken continuity between the late nineteenth and the early twenty-first century: "[t]he opportunistic use of 'Aestheticism' as a chronological catch-all [ultimately entails that] the term 'Aesthetic' has been stretched so thin that it is [in] danger of collapsing" (7).

Both the possibilities and pitfalls of an interchange between old and new reflections on the aesthetic might be elucidated by discussing the often-overlooked dialogue between Walter Pater and Wolfgang Iser. This

twentieth-century German critic keeps returning to the English aesthete in his attempt to articulate a "theory of aesthetic response" (Iser *Act of Reading*, x). Even though his conception of the aesthetic has grown out of a discussion of Pater's work, Iser is nonetheless critical of aestheticist views on the relation between art and life. More specifically, Iser draws upon a superficial reading of Søren Kierkegaard's *Either/Or* to argue that Pater's emphasis on art in *The Renaissance* remains trapped in the morally problematic "aesthetic stage." In what follows, I will first discuss Kierkegaard and Pater to underscore that Iser's reading of both thinkers is ultimately unconvincing. Rather than opposing the beautiful and the moral, their work implies that aesthetic criteria can be mapped onto ethical ones in both de- and re-humanizing ways. The true point of my argument, however, is not simply that Iser misrepresents Kierkegaard and Pater, but that this skewed representation reveals an aspect of his theory that connects him to Pater's nineteenth-century aestheticism. Some important nuances notwithstanding, Iser's literary anthropology ultimately offers a modern articulation of the re-humanizing aesthetic existence.

Kierkegaard, aesthete/moralist

In one of his most famous pseudonymous publications, *Either/Or* of 1843, Søren Kierkegaard (1813–55) offers the writings of two narrators who hold a different "life-view," a different "conception of the meaning of life and of its purpose" (Kierkegaard *Either/Or II*, 179). Although the differences between the "esthetic" and "ethical view of life" (Kierkegaard *Either/Or I*, 13) provide the blueprint for Iser's interpretation of Pater, the straightforward opposition between the immoral narrator of the first and the un-aesthetic narrator of the second volume is ultimately undermined by Kierkegaard's own text. Rather than rejecting the aesthetic altogether, the second narrator replaces an aesthetic life of immediacy or possibilities with a truly beautiful, ethical life of harmony. *Either/Or* thus introduces two conceptions of the aesthetic existence that will return in my discussions of Pater and Iser, namely a life of indifferent possibilities on the one hand and of conscientious harmony on the other.[1]

Before comparing these two life-views, it is necessary to recall Kierkegaard's view of the self and the stages of existence. Throughout his writings, the Danish philosopher distinguishes three life-views: the aesthetic, the ethical, and the religious mode of existence. Seeing that Kierkegaard's writings attempt to edify their readers, Mark C. Taylor points out, the views or stages are best seen "as both phases of the development of the individual self and as ideal personality types" (75–6). Although in an ideal situation the preceding stages are incorporated, though demoted, in the next phase, the development of the self can be arrested at a specific stage. Kierkegaard therefore presents his readers with "ideal personality

types" or emblematic incarnations of specific stages in order to prod them out of their possibly arrested development and help them recommence their spiritual progress. The religious stage crowns the self's development, Taylor continues, as it establishes an "equilibrium" (126) among the components of the self and the correlative tenses of existential time:

> The past refers to the self's actuality, or to that which the self has become through sufferings and actions. The future is correlative with the possibility of the person. It is that which one can yet become, or that toward which one moves. The present is associated with the activity of the spirit [or will], or with the engagement of freedom in the effort to actualize [or choose] one's possibilities.
>
> (Taylor 123)

In a phrase that anticipates Iser's views, Taylor concludes that, for Kierkegaard, "[h]uman reality is a 'being between' possibility and actuality" (46).[2] Even though self and time are only harmoniously united in the stage of Christianity, *Either/Or* is mostly concerned with the time and self of the preceding aesthetic and ethical stages.

Mainly focusing on the essay about the sensuous in Mozart's *Don Giovanni* and the cunning strategies of Johannes in "The Seducer's Diary," Taylor contends that the writings of the first volume's "A"-narrator present two ways of living aesthetically: the "sensual immediacy and [...] theoretical reflection" (128) associated with, respectively, "Don Juan and Faust" (167). In their different ways, both poles are characterized by a disharmonious relationship between the components of the self as well as the various tenses of existential time. Both show a quietist lack of decision, first of all, and that leads to a fragmented self:

> While [Don Juan's] immediacy stresses the self's actuality to the exclusion of possibility, [Faust's] reflection stresses the self's possibility to the exclusion of actuality. In both cases, there is a failure of the self to exercise freedom in decision. The result of such a form of existence is that the self becomes 'multifarious' either as an array of conflicting sensual desires, or as a collection of incompatible possibilities.
>
> (Taylor 183–4)

Seeing that the present moment of pleasure invariably passes, and the past memories or future ideals of reflection are either irrevocably absent or but partially realizable, moreover, the tenses of time are not harmonized and "time becomes the enemy of aesthetic experience" (Taylor 183).

It is no coincidence, Taylor rightly notes, that the second volume's "B"-narrator is "William [the] *judge*" (Kierkegaard *Either/Or I*, 7, emphasis added), as it is preoccupied with the two levels of decision that define the

"ethical view of life" (13) and that seem to harmonize self as well as time. First of all, the ethical self has to choose itself. Although its actuality is determined by its "ontological dependence upon God, and the impact of the environment" (Taylor 188), the self has to recognize and appropriate itself in its concrete, determined being by reverting both desirable and less desirable determinants into possibilities and then consciously choosing all of them. Secondly, the self can then choose those possibilities that are compatible with its now properly understood actuality and with the "universal laws of moral obligation" (197). These ethical decisions ultimately solve the problem of the fragmented aesthetic self, as the conscientious decision-maker of the ethical stage resolves the tug-of-war between Don Juan's conflicting desires and Faust's contradictory possibilities:

> By committing oneself to ethical ideals, one assumes the obligation of remaining loyal to those goals throughout temporal duration. With this decision, the self gains a certain continuity. Some possibilities are excluded, and others are opened. Furthermore, one becomes the master over one's inclinations, for desires are controlled in light of the goal for which one strives.
>
> (Taylor 207)

Not only the components of the self, but also the tenses of time are united in the ethical stage, as "[i]n the moment of decision (the present), the self's actuality (the past) and the self's possibilities (the future) are joined" (Taylor 215). Although the dependence on God and awareness of sin ultimately undermine the self's equilibrium, these nuances will not be discussed here, as the religious stage ultimately falls outside the scope of both *Either/Or* and this chapter.

Even though it is a helpful corrective to anachronistic readings, the idea that, for Kierkegaard "as for the originators of the discourse, aesthetics refers not in the first place to art but to the whole lived dimension of sensory experience" (Eagleton 173) might explain why critics such as Taylor and Eagleton do not discuss the artistic dimension of *Either/Or* in detail. It is nonetheless clear that both life-views are articulated in writings about or referring to art. The two poles of the aesthetic existence, for instance, are compared to music and literature. The eulogy on Mozart's *Don Giovanni*, first of all, notes that "the sensuous" exists in a rapid "succession of instants" and remains on the level of "immediacy" (Kierkegaard *Either/Or I*, 56–7). It can thus neither be seen nor read, but only heard: "[t]he only medium that can present [the sensuous] is music" (57). As aesthetics is concerned with beauty, secondly, "The Seducer's Diary" claims that it should only study "belles lettres and the fair sex" (428), both of which are associated with a sense of infinite, uncommitted possibility. In contrast to his immediate counterpart, the reflective aesthete does not aspire after the transparent medium of music, but after literature,

the fact that "a book has the remarkable characteristic that it can be interpreted as one pleases" (374).

Even though the views of both narrators on art and morality initially underscore the opposition between their life-views, furthermore, they ultimately threaten to subvert it. At first sight, the A-narrator seems to advocate an "art for art's sake" that rejects any obtrusive moralizing. His discussion of Eugène Scribe's *The First Love*, for instance, clearly rejects an edifying reading of the play in favor of a comic one. If it were moralizing by aiming at the main character's "improvement," *The First Love* would be changed "from a masterpiece to a theatrical triviality" (255). Thankfully, however, it is not "moralizing," but "witty" (258). Upon closer analysis, however, it appears that the immoral Johannes of "The Seducer's Diary" still has "a certain respect for the ethical" (367). Although it may be seen "only in artistic portrayal, not in actuality," the seducer concedes that at least part of the family unit celebrated by B in the second volume has an aesthetic appeal, as the picture of a mother and child is "the loveliest that human life has to display" (435). On top of that, Taylor fails to note that the writings of the first volume already undermine the aesthetic view. In its contemplation of suicide and the meaninglessness of life, the opening "Diapsalmata" testify to the *ennui* engendered by the ideal of infinite possibilities, as living a "poet-existence" (36) means "to have to *suffer* through all possible moods, to be required to have experiences of all kinds" (31, emphasis added). Seeing that A is perhaps "not [...] the author but only the editor" (8) of "The Seducer's Diary," finally, the first narrator should perhaps not be seen as the defender, but as the accuser of the aesthetic existence, as this editor claims the seducer will ultimately face a "terrible" (308) deadlock.

In response to A's apparent view of beauty, the judge of the second volume emphasizes the difference between what is beautiful as such and what can be presented in a beautiful manner. Disregarding the issue of having to evaluate the play "esthetically" (Kierkegaard *Either/Or II*, 300), the judge criticizes Scribe's *The First Love* for its celebration of an "immoral" (23) love of transitory sensations. Even though the alternative, a truly historical love, is actually "the summit of the esthetic" (137), it cannot be artistically represented, as "an esthetic representation always requires a concentration in [...] the infinitely rich moment" (133). The only way this different, moral type of beauty can be articulated, William concludes, is by living it: "[e]verything I am talking about here certainly can be portrayed esthetically, but not in poetic reproduction, but only by living it, by realizing it in the life of actuality" (137). The judge renounces art, in other words, because the form of artistic beauty is incommensurate with the form of existential beauty. Rather than deriving our standards of living from the immoral form of works of art, then, we should derive artistic criteria from the truly beautiful form of the ethical existence.

Even though he rejects the aesthetic life of the first volume as de-humanizing, it is thus not surprising that Judge William describes his re-humanizing ethical ideals in remarkably aesthetic terms. The "amazingly unstable attitude" (111) of the aesthetic life is clearly seen as de-humanizing, as its submission to determinism entails "a development just like that of a plant" (225) and its theory that "[l]ife is a masquerade" (159) leads to an "eccentric" (230) and "fragmented" existence that ultimately condemns A to be "a defective specimen of a human being" (327). The ethical existence, conversely, ultimately "makes a human being greater than the angels" (176), as its continuous "teleology within himself" (275) leads to a "centralized" (230) personality characterized by "harmony" and "dignity" (176), "memory" and "continuity" (230).

As Terry Eagleton has astutely noted, even though William "elevates the ethical above the aesthetic, [...] his ethics are modelled on the very aesthetic notions they seek to transcend" (181–2). The judge's definition of the beautiful life, for instance, explicitly appropriates A's definition of autonomous art:

> I shall take the liberty of picking up the definition you usually give: The beautiful is that which has its teleology within itself. [...] When you define the beautiful as that which has its teleology within itself and give as examples a girl, or nature, or a work of art, I can come to no other judgement than that [this] is an illusion. [...] [In contrast, the ethical] individual has his teleology within himself, [...] his self is then the goal toward which he strives.
>
> (Kierkegaard *Either/Or II*, 272–4)

The judge thus replaces the idea of autonomous art with that of the autonomous individual; whereas art can never simply be for art's sake, the ethical life is truly lived for that life's sake. The continued reference to art suggests, however, that aesthetic autonomy ultimately remains a model for ethical autonomy. What is at stake in the rise of aesthetics, Eagleton claims in a more general context, is "nothing less than the production of an entirely new kind of human subject—one which, like the work of art itself, discovers the law in the depths of its own free identity, rather than in some oppressive external power" (19). The ethical existence, in other words, remains indebted to the aesthetic phase.

Despite his interesting suggestions, Eagleton fails to note a much more specific artistic metaphor, namely the description of the ethical ideal of marriage in the musical terms of its adversary, sensuous love. Music, it seems, does not only represent fleeting possibilities, but also enduring harmony:

> How much more *richness of modulation* there is in the marital 'mine' than in the erotic. It *resonates* not only in the eternity of the seductive moment

[but] in the eternity of eternity. What power there is in the marital 'mine,' for will, decision, intention, have *a far deeper tone* [...]. Listen to and admire this *harmonious unison* of different spheres [characterizing marriage].

(Kierkegaard *Either/Or II*, 58–60, Emphasis added)

In a similar fashion to Pater and Iser, as we shall see, the judge condemns the de-humanizing effects of the aesthetic existence, but later celebrates the ethical alternative in markedly aesthetic terms. This aesthetic residue can also be seen on the level of Kierkegaard's authorial strategy. As several alternatives ultimately lead to a similar regret, the reflective A-narrator advocates quietist indifference, contemplating possibilities rather than synthesizing them: "the true eternity does not lie behind either/or but before it" (Kierkegaard *Either/Or I*, 39). The judge retorts, however, that an existence of indecision is simply impossible: "if a person could continually keep himself on the spear tip of the moment of choice, if he could stop being a human being, [...] there could be no question of a choice at all. [...] The Either/Or I have advanced is, therefore, [...] between choosing and not choosing" (Kierkegaard *Either/Or II*, 163, 177). Although *Either/Or* concludes with a religious sermon, the book's fictitious editor hints at an aesthetic authorial strategy; its title

will release [the reader] from every final question—whether A actually was persuaded and repented, whether B was victorious, or whether perhaps B finally came around to A's thinking. In this respect, these papers come to no conclusion. [There is thus] no final decision in the particular personalities.

(Kierkegaard *Either/Or I*, 13–4)[3]

In sum, Kierkegaard offers a developmental narrative from a sensuous and uncommitted aesthetic existence to a continuous and harmonious ethical life. The contrast between both views, however, is not clear-cut, as the ethical alternative is described in aesthetic terms. The beautiful existence, it seems, is de-humanizing when it takes its cue from musical immediacy or imaginary possibilities and re-humanizing when it aspires after the autotelic and harmonious qualities of art.

Pater, studies in the art of living

As we shall see, Iser ultimately draws upon Kierkegaard's insights to interpret the aestheticist oeuvre of Walter Pater (1839–94). This is not inapposite, as the tension between an artistic and moral ideal of life returns in his work, especially in the relation between the supposedly "aesthetic" *Studies in the History of the Renaissance* of 1873 and the supposedly "ethical" *Marius the Epicurean* of 1885. Three years after publishing *Marius*, after all, a new edition

of *The Renaissance* appeared in which Pater reinstated the controversial "Conclusion" he had excised in the second edition. Although he initially omitted it "as I conceived it might possibly mislead some of those young men into whose hands it might fall," the fuller treatment in *Marius the Epicurean* of "the thoughts suggested by it" (Pater *Renaissance*, 233) apparently addressed the problem. It is hardly surprising, therefore, that early critics postulated "a transition on Pater's part from an early 'aesthetic' to a later moral standpoint" (Tucker).[4] As the idea of "a smooth and untroubled 'progression' from the one to the other" does not properly appreciate the nature and extent of "Pater's 'confusion between ethics and aesthetics'" (Tucker), however, this developmental narrative might be as problematic as that of *Either/Or*. A closer look at the ethical program of *The Renaissance* as well as the aesthetic residue of *Marius*, in fact, suggests continuity rather than progression.

Several critics have pointed out the moral subtext of *The Renaissance*. As Paul Tucker has recently argued, the moral concerns of *Marius* were already part of Pater's first work: "the ethical crisis of the 1880s was not extrinsic but rather fully intrinsic to the positions adopted by Pater in the writings of the 1860s and 1870s." Tucker himself claims that *The Renaissance* stages both a conservative and a revolutionary resistance against the inflexible rules of Victorian morality. Apart from Pater's more traditional defense of "a morality of 'sympathy'" (Tucker), the "Conclusion" seems to defend an ethical relativism that ends up overemphasizing the sensuous:

> The theory or idea or system which requires of us the sacrifice of any part of this experience, in consideration of some interest into which we cannot enter [...] has no real claim upon us. [...] our one chance lies in expanding [the limited] interval [of our lives], in getting as many pulsations as possible into the given time.
>
> (Pater *Renaissance*, 237–8)

This view is consonant with Kierkegaard's aesthetic existence, as this "ethic of 'passion'" calculates "the value and significance of art [...] on the basis of its subjective yield as a pre-eminent record and source of heightened sensation" (Tucker).

A purely aesthetic reading of *The Renaissance*, however, is ultimately not convincing. Its critical vignettes do indeed emphasize the resurgence of the sensuous after—and, in part, during—the Middle Ages, but all of these passages consistently refer not only to "the senses," but also to "the imagination" and "the understanding" (Pater *Renaissance*, 184). In describing the most beautiful work of Hellenic art, Pater does not celebrate its sensuality, but its "purity of life, with its blending and interpenetration of *intellectual, spiritual, and physical elements, still folded together*, pregnant with the possibilities of a whole world closed within it" (218, emphasis added). It is thus not surprising

that he rejects a story with the "faint air of overwrought delicacy, almost of wantonness" (20) in favor of another in which the moral and religious orthodoxy are not entirely contrasted with the life of the senses: "[i]n the story of *Aucassin and Nicolette* [...] the note of defiance, of the opposition of one system to another, is sometimes harsh. Let me conclude then with a morsel from *Amis and Amile*, in which the harmony of human interests is still entire" (27). Even though it is true that some of Pater's more programmatic formulations imply an over-emphasis on the sensuous, numerous passages from *The Renaissance* clearly defend a harmonious life.

In an attempt to articulate the work's ethical undertones, Franklin E. Court claims that *The Renaissance* propagates an ethical as well as an artistic conception of virtue.[5] In line with Kierkegaard's "ethical" life-view, to be virtuous is to live a consistent life aimed at fulfilling one's own potential: "[a] virtuous man is one who knows 'who he is,' who realizes what he does best, and then does it as completely and as intensely as possible" (Court 552). As Pater points out in the "Preface," furthermore, a work of art should also realize its individual potential in a consistent fashion:

> the function of the aesthetic critic is to distinguish [...] the virtue by which a picture, a landscape, a fair personality in life or in a book, produces [a] special impression of beauty or pleasure [...] that is the *virtue*, the active principle in Wordsworth's poetry; and then the function of the critic of Wordsworth is [...] to mark the degree in which it penetrates his verse.
>
> (Pater *Renaissance*, ix, xi)

Court therefore concludes that a hedonistic reading ultimately fails to appreciate the ethical nature of Pater's project: "the moral aim for Pater is the realization and employment to its fullest of the particular 'virtue' that gives to every person as well as to every classic work of art a unique, specific potential for excellence" (563). Whereas Tucker implies that Pater is in part a Kierkegaardian aesthete, Court thus suggests that he is a Kierkegaardian moralist.

Although it should indeed be emphasized, the ethical agenda of *The Renaissance* is more complex than Court claims. Whereas he emphasizes the importance of realizing a specific virtue, the idea of personal unity is nuanced by Pater's emphasis on the duality and completeness of the beautiful life.[6] It is true that he admires a life that is consistently dedicated to "one motive" (Pater *Renaissance*, 185), but Pater nonetheless rejects the idea of a straightforward personal unity: "if [man] was to be saved from the *ennui* which [...] attaches itself [even to] the realisation of the perfect life, it was necessary that a conflict should come, [and that] the spirit chafed by it beat out at last only a larger and profounder music" (222). The ideal of a

harmonious life and work, in other words, does not entail a rigid unity, but a reconciliation of contradictory tendencies. The emphasis on a specific virtue is considerably attenuated, moreover, by the ideal of a complete existence: "[Winckelmann's] feverish nursing of the one motive of his life is a contrast to Goethe's various energy. [...] the aim of our culture should be to attain not only as intense but as complete a life as possible" (185, 188).

The ethical ideal of harmony and completeness has an artistic counterpart in that form of art that offers "the *Allgemeinheit* and *Heiterkeit*, the completeness and serenity" (228) typical of Greek culture. The artist willing to deal with the complexity of modern life, Pater concludes, should turn to the flexible medium of "poetry" and should re-humanize life by offering a "sense of freedom" (230, 231) that effectively parries the de-humanizing relativism and determinism of the "Conclusion." Rather than defending a purely aesthetic or ethical life, in other words, *The Renaissance* argues for a life and art that combines the consistency and harmony of the Kierkegaardian moralist with the complete range of possibilities of its aesthetic counterpart.

After discussing the moral dimension of the supposedly hedonist study on *The Renaissance*, it is necessary to turn to the ethical and aesthetic dimensions of the supposedly moralist *Bildungsroman Marius*. Even though certain passages seem to reformulate the relativist "Conclusion" in more conventional moral and religious terms, the ideal of a complete and harmonious life returns unchanged in *Marius*. In a similar fashion to the second volume of *Either/Or*, furthermore, the ethical phase of Pater's apparent development clearly betrays aesthetic overtones.

At first sight, *Marius the Epicurean* moves away from the relativist hedonism of *The Renaissance*. The "Conclusion" to the latter work famously claims that "modern thought" (Pater *Renaissance*, 233) dissipates our sense of material and spiritual identity. "Like the elements of which we are composed," Pater observes with regard to our physical life, "the action of these [natural] forces [operating inside us] extends beyond us: it rusts iron and ripens corn" (234). Similarly, our psychological life boils down to "a tremulous wisp constantly re-forming itself on the stream, to a single sharp impression, with a sense in it [...] of such moments gone by" (236). In Marius's experience of late antiquity, this dissolution of world and self does not lead to the apparently hedonist views of *The Renaissance*, but to a religious epiphany that ultimately solves the problem of fleeting experiences registered in the "Conclusion":

[A]ctually his very self [...] was yet determined by a far-reaching system of material forces external to it [...]. And might not the intellectual frame also [...] be a moment only [...] in an intellectual or spiritual system external to it, diffused through all time and place [...]. How had he longed [...] that

there were indeed one to whose boundless power of memory he could commit his own most fortunate moments [...]. To-day [...] he seemed to have apprehended that in which the experiences he valued most might find [...] an abiding-place.

(Pater *Marius II*, 68–71)[7]

As this vision seems to be consecrated in the early Christian services attended by Marius, Iser's suggestion that the "ethical" and even religious overtones of the novel rebuke the "aesthetic" views of Pater's earlier work is hardly surprising.

Such a reading is ultimately unconvincing, however, as *Marius* describes the ideal life in terms reminiscent of *The Renaissance*. Court argues that Marius is a successful example of Pater's virtuous individual: "Marius' life is virtuous [...] because he recognizes the task before him—an eager and constant pursuit of truth ever devoid of any definite hope of realization" (Court 554). The passage invoked by Court does not underscore the success of Marius's life, however, but its failure. He has not lived up to his specific virtue at all: "His own temper, his early theoretic scheme of things, *would have* pushed him on to movement and adventure. Actually, as circumstances had determined, all its movement had been inward; movement of observation only" (Pater *Marius II*, 208–9, emphasis added). Even though the narrator underscores Marius's consistent nature—he is one "who was certainly to be something of a poet from first to last" (Pater *Marius I*, 126)—, his one-sided development ultimately leads to failure, as it is inconsistent with the harmonious and complete existence propagated by *The Renaissance* as well as *Marius*. The consistent reference to the harmonious unity of "his sympathy, his intelligence, his senses" (Pater *Marius I*, 152), for instance, returns.[8] The novel suggests, furthermore, that a Schillerian "'aesthetic' education" (147) will help achieve an existential completion; Marius searches "[n]ot pleasure, but fulness [sic] of life, and 'insight' as conducting to that fulness—energy, variety, and choice of experience, including noble pain and sorrow even" (151–2).

The supposedly moralistic *Marius* does not only recall *The Renaissance's* ethical program, however, but also its aesthetic dimension. Offering a fairly exhaustive overview of the artistic metaphors that are frequently applied to real-life situations in the novel, Clyde de L. Ryals rightly observes that "[t]o Marius the world is the stage for a drama in which he has a part but of which he is chiefly a spectator [...] his aestheticized existence progresses from romance to romance and picture to picture" (Ryals 161–2). This aestheticizing tendency is strikingly illustrated by Marius's description of the church ceremony he attends:

But again with what a novelty of *poetic* accent; what a genuine expansion of *heart*; what profound intimations for the *intellect* [...]. And the proper action of the rite itself, *like a half-opened book* [...]. The entire

office [...] with its interchange of lessons, hymns, prayer, silence, was itself *like a single piece of highly composite, dramatic music*; [...] the entire [ceremony] seemed to express *a single leading motive*. [...].

(Pater *Marius II*, 132–5, Emphasis added)

Not only is the church ceremony likened to various forms of art, it also has a specific virtue or leading motive and appeals in its harmonious composition to all the faculties of the human mind. As it offers a sense of "hope" (131) and represents "the whole company of mankind" (190), the divine service ultimately becomes "like the play of Hamlet or Faust" (128), offering an unrivalled sense of the *Allgemeinheit* and *Heiterkeit* needed in the face of modernity.

Despite this return of the aesthetic dimension, the idea that Marius indiscriminately aestheticizes events neglects a part of the novel that explains Marius's ambiguous attitude toward Christianity, something that keeps puzzling critics. Despite being buried as such by the people who treat him in his final days, Pater's protagonist does not think of himself as a Christian martyr. Ryals, therefore, argues that Marius both is and is not religious: "Which interpretation then is correct, the narrator's or the Christians'? The answer is both" (Ryals 170). This aesthetic reading fails to discuss the reason for Marius's refusal of martyrdom, however. Importantly, his conception of a martyr originates in the reading of "the Epistle of the Churches of Lyons and Vienne adapted from Eusebius" (Ryals 172), a letter that emphatically aestheticizes and eulogizes torture:

[T]he governor led forth the Martyrs *as a show*. [...] [Her tormentors admired] that [the martyr] still breathed after her whole body was torn asunder. [...] much joy was in our virgin mother, the Church; for, by means of these [tales of martyrdom], such as were fallen away retraced their steps [...]. After these things their martyrdom was parted into divers [sic] manners. *Plaiting as it were one crown of many colours and every sort of flowers*, they offered it to God.

(Pater *Marius II*, 191–4, Emphasis added)

The church, it seems, is sincerely grateful for this beautiful crown of pain and execution. Marius, however, is not.

As a previous passage on the cruel slaughter of animals in the amphitheatre already suggested, neither an aesthetic nor an indifferent perception of cruelty is reconcilable with Marius's ideal of a harmonious life. In contrast to his deceased friend Flavian, who would have enjoyed the spectacle with "a light heart [and] an appetite for every detail of the entertainment" (Pater *Marius I*, 235), Marius rejects the possibly edifying aspects of "the novel-reading of that age," as it is ultimately nothing more than a "great slaughter-house" (239–40). In a different, but equally problematic response, Marcus Aurelius shows no

sign of emotion whatsoever. This "stoical indifference" (Pater *Marius II*, 55), Marius claims, testifies to the fact that "[t]he philosophic emperor was a despiser of the body" (53) and is ultimately "akin to the sin of *Desidia* or Inactivity," to "a complacent acquiescence [and] a tolerance of evil" (51). Unsurprisingly, then, Marius notes that "[t]o him, in truth, a death such as the recent death of those saintly brothers, seemed no glorious end. In his case, at least, the Martyrdom [...] would be but a common execution: from the drops of his blood there would spring no miraculous, *poetic* flowers" (214, Emphasis added).

Apart from the fact that Marius is simply "not a Christian" (212), he thus refuses martyrdom because it implies either an amoral aestheticism or an immoral asceticism. It might be objected, of course, that Aurelius's quietism is contrasted with Cornelius's Christianity and that the episode of the martyrs begins with a celebration of its "strange new heroism" (191). The narrator's opposition between two forms of Christianity, however, clearly reveals his preferences; "[t]he ideal of asceticism" which entails "a sacrifice [...] of one part of human nature to another" should be replaced with "the ideal of culture" which implies "a harmonious development of all the parts of human nature, in just proportion to each other" (121). Furthermore, this celebration of a harmonious, "regenerate type of humanity" (110) is explicitly linked to the period defended in Pater's earlier work; the true early church is "'humanistic,' in an earlier, and unimpeachable *Renaissance*" (125). In a similar fashion to the two volumes of *Either/Or*, Pater does not simply evolve from the aesthetic position of *The Renaissance* to the ethical point of view of *Marius*. In contrast to Kierkegaard, however, Pater does not oppose aesthetic possibilities and ethical consistency, but aims to re-humanize man with a program that advocates both completion and harmony.

Iser, the implied aesthete

Seeing that Pater's impressionistic criticism is frequently hailed as a predecessor of modern "reader-response criticism,"[9] it is not surprising that Wolfgang Iser (1926–2007) turns to Pater's work to articulate his own ideas on "aesthetic response" (Iser *Act of Reading*, x). Mostly known for his seminal work on *The Implied Reader* and *The Act of Reading*, the recently deceased German critic has also published extensively on Pater's aestheticism. Despite contrasting him unfavorably with T.S. Eliot in an earlier article,[10] Iser wrote a *Habilitationsschrift* on Pater that was published in 1960 and was later translated in English as *Walter Pater. The Aesthetic Moment*. Before focusing on this early monograph, it should be noted that Iser has returned to the English writer several times, invariably underlining the continuing relevance of his aestheticist project.

Iser's influential account of *The Act of Reading*, for instance, distinguishes between centripetal, coherence-creating and centrifugal, coherence-destroying

tendencies in the reading process. Although *The Aesthetic Moment* points out its ambiguous value in the earlier text,[11] his term for the latter phenomenon is "alien associations" (Iser *Act of Reading*, 126), a phrase drawn directly from Pater's essay on "Style." The figure of Pater returns once more when Iser rejects colonizing readings in favor of exploratory ones in *The Range of Interpretation*. He maintains that Pater has "an unprecedented presence one hundred years after his death" (Iser *Range of Interpretation*, 184), as he has anticipated the problem of "the anatomy of interpretation" (198) and as the "Paterian essay" (193) offers a methodological example for the open-ended theorizing of the "operational models" (Iser *How to Do Theory*, 167) preferred by Iser.

His most important work on Pater, however, remains the early study on *The Aesthetic Moment*. As Winfried Fluck has pointed out, studying the English author helped Iser to articulate the conception of the aesthetic he was later to describe in his famous work on *The Act of Reading*. In contrast to the object-centered approaches of the New Criticism, Pater offers "a model for the description of the aesthetic mode" (Fluck 181) as he conceptualizes the aesthetic "not as a quality of the object but as an attitude to be taken toward an object" and as "an intermediate realm 'in-between'" (180). Fluck thus seems to agree that the study on Pater can be seen as "a somewhat impressionistic prophecy of Iser's influential phenomenological aesthetics of reading" (O'Hara 529): "[f]or any reader who is aware of the centrality of the idea of the 'in-between' for Iser's theory of reading and of fiction, it must be striking to realize the extent to which this idea [is] already present in the book on Pater" (Fluck 181). Even though Fluck offers some interesting suggestions in this respect, I will discuss the overlap between Iser's description of Pater and of the reading process in a more systematic fashion.

The notion of the aesthetic is crucial to Iser's project. In *The Act of Reading*—the subtitle of which is, after all, *A Theory of Aesthetic Response*—he notes that the apprehension of a literary work

> is not a passive process of acceptance, but a productive response. [...] The ability to perceive oneself during the process of participation is an essential quality of the aesthetic experience; the observer finds himself in a strange, halfway position: he is involved, and he watches himself being involved. However, this position is not entirely nonpragmatic, for it can only come about when existing codes are transcended or invalidated.
>
> (Iser *Act of Reading*, 133–4)

As it invalidates existing codes in order to bring the *"unfamiliar"* (50) and unknown to the fore, aesthetic value is seen as a relative phenomenon that always realizes itself in opposition to the dominant "world-pictures" (70) or thought systems of its time: "aesthetic value [is] an empty principle, realizing itself by organizing outside realities in such a way that the reader could build up a world no longer exclusively determined by the data of the world

familiar to him" (179). Heavily influenced by Theodor W. Adorno in this respect, Iser thus maintains that truly aesthetic experiences sprout from the dismantling of existing and the generation of new worldviews.[12] As it welds known and unknown worldviews together, the fictional text stages a "coherent deformation" (81) of the views referred to, and is later characterized as "the simultaneity of the mutually exclusive" (Iser *Fictive and Imaginary*, 51).

In an article aimed at making "a 'plea' for the aesthetic" (Iser "Aesthetic and Imaginary," 201), Iser further specifies the nature of "the aesthetic as an in-between state" (211) by focusing on the interplay between the conscious and the imaginary in "acts of ideation" (206) or mental images. *The Act of Reading*, of course, had already argued that reading is characterized by a process of impeded image-building that undermines the text's perspicuous development:

> In fictional texts [...] the suspension of *good continuation* resulting in a clash of images prevents us from moulding the knowledge offered [...] into a definitive form, and so prevents the process of 'degrading' this knowledge from coming to an end, as the reader is continually forced to abandon one image and to form another.
>
> (Iser *Act of Reading*, 188)

Iser has suggested, moreover, a link between these mental images and the bodily nature of the aesthetic in its contemporary incarnation: "[t]his may be one reason why the aesthetic has gained prominence in the present. The body has inherited the once all-encompassing significance of the mind. Such a transition has favored perception, or what Kant called 'inner intuition', over cognition" (Iser "Resurgence of Aesthetic," 11–2). Aesthetic experiences, in other words, lead to "a continual stimulation of the [senses], thus making them yield hitherto unforeseeable possibilities of visualizing and ideating" (8). A final aspect of the aesthetic is the oscillation between the self's habitual and new dispositions, a re-humanizing movement that occurs most clearly in reading: "[a]lthough self-fashioning is not in itself aesthetic, the aesthetic manifested in the back-and-forth movement is instrumental in enabling the shifting profiles of the self to emerge" (Iser "Aesthetic and Imaginary," 210). The aesthetic, in other words, is a subjective, relative, counter-ideological, and exploratory phenomenon that manifests itself in the mental images of the body and the self-transformation of the reader.

It is hardly surprising that several of these ideas were already present in the study on *The Aesthetic Moment*, as it explicitly aims for "a definition of the aesthetic whose validity will extend beyond Pater" (Iser *Walter Pater*, 5). The aesthetic, first of all, is a highly concrete, relative principle. Emphasizing the revolutionary references to an "element of change in art" (Pater *Renaissance*, 199), Iser claims that Pater rejects the idea of "[b]eauty as

harmony" (Iser *Walter Pater*, 63) and sees "beauty as something relative" (62–3), something that "will vary from one observer to the next" (64). Although we have seen that the ideal of harmony is still alive and well in Pater's work, neglecting this dimension allows Iser to cast the aesthete as a predecessor of his own reflections on a modern(ist) art that effectively subverts the classical criterion of "harmony" (Iser *Act of Reading*, 12). Rather than focusing on the old, moreover, the truly aesthetic work explores the unknown and what Kierkegaard would term the "interesting" (Iser *Walter Pater*, 40):

> Freed from the binding force of [traditional] conventions, art can give access to territories hitherto concealed by them, and so [...] the new means freedom from the old and also the uncovering of the extraordinary in what has so far been taken for granted. [...] Mimetic art seeks to grasp the significance of the given, whereas autonomous art seeks out the new, whose essence is otherness.
>
> (33, 35)

In Pater's conception of autonomous art, then, "the aesthetic [is] comprehensible only in terms of contradiction to the norms of the age" (38). This leads to an interaction between the old and the new thought system that Iser describes in terms that are familiar to readers of *The Act of Reading* and *The Fictive and the Imaginary*. The work of art, he claims, ultimately leads to a "reciprocal derangement of [...] two worlds" (124), "a telescoping of incompatibles" (39).

Anticipating his own emphasis on the clash of mental images, Iser focuses on a particular feature of Pater's style, namely the use of a "montage of images" that "gives free rein to the triumphant observer's imagination" (45). Pater's description of the shield of Achilles in a text on Greek sculpture, for instance,

> engenders new images and so endows the impression with an ever-changing, almost exploratory quality—intended to suggest more than can be said [...]. Pater's image is meant to take shape in the recipient's imagination, which is guided to conceive the moon in terms totally alien to common expectations so that it may be experienced in its otherness. [...] Nor does [his style] ever seek to capture a particular hidden meaning, but remains a kind of in-between world, to be felt, not interpreted.
>
> (58–60)

Pater's suggestive style thus conjures up an experience that cannot be pinned down intellectually. In line with the bodily nature of the aesthetic noted above, it is the heart that matters in reading, not the head. The "intermediary" position of the aesthetic does not only refer to the implicit

nature of meaning, but also to the "in-between world" of "periods of tran-
sition [which] invalidated existing norms without replacing them with
others" (81)—such as the Renaissance and Marius's late antiquity—and
anticipates Iser's interest in operational theories by referring to Pater's
generic "in-between quality" (3). Seeing that the aesthetic is characterized
as "a state between either/or positions, never identical with any of them,
but, instead, always moving between them" (Fluck 181), this early articu-
lation of the aesthetic also seems to anticipate Iser's concern with the self-
transformation of the reader. His reading of Pater thus also stresses the
relative, counter-ideological, exploratory, bodily/imaginary, and transfor-
mational qualities of the aesthetic.

Even though Iser explicitly connects his own project with that of Pater,
he is critical of both autonomous art in general and Pater's view of the aes-
thetic in particular. In an article on the "Changing Functions of
Literature," Iser claims that the problem of "the nineteenth-century aes-
thetic tradition" (200) is that it tries to distance itself from reality and to
establish a universal aesthetic norm. This escapist and universalist pro-
gram leads to the ideal of "the humanistic education beloved of the nine-
teenth century" (205) that effectively "drives out the threat of the real
world and offers the constant ennobling of man to help him on the path
to his own humanization" (205). But art can ultimately neither distance
nor ennoble. The flight from reality in the works of writers such as Walter
Pater ultimately "serves very real needs and shows very real practical pur-
poses" (203) and unwittingly helps to underscore the relativity of taste.
The atrocities of the twentieth century, moreover, have convincingly
demonstrated that "literature failed to bring the human being to full
fruition" (208). The current climate underscores the inability of literature
to further our spiritual growth. After all, literature is under increasing
pressure from other media, is no longer a tool for social recognition, and
"[h]umanization through culture has been proved by history—especially
in Germany—to be an illusion" (207). The aestheticist tradition, it would
seem, is an obsolete relic of a naïve nineteenth century.

In describing his own alternative, however, Iser seems to return to certain
aestheticist ideas. Pointing out that "any talk of the practical use of litera-
ture is a thing of the past" (Iser "Changing Functions," 208) ultimately
mirrors the attempt of autonomous art to rise "above any practical use"
(201). In direct contradiction to the purported absence of practical utility,
furthermore, a later essay by Iser concedes that literature still plays a role
in social recognition.[13] The idea that literature can re-humanize man by
revealing "the vast number of ways in which human faculties can be used
to open up the world in which we live" (209), finally, is reminiscent of the
nineteenth-century claim that art should be seen as "the realm of freedom
in which [lies] man's only chance to ennoble himself" (Iser "Changing

Functions," 204). Despite his earlier claims, it should come as no surprise, then, that another essay by Iser is programmatically titled "The Resurgence of the Aesthetic". Of course, this reemergence of the aesthetic should not be conceived as a return to "a self-centered quietism" (Iser "Resurgence of the Aesthetic," 1), but as a turn toward an emphatically political, counter-ideological conception of art: "[i]nstead of freezing open-endedness, as with all the brands of ideology now on the wane, the possibilities issuing from the modeling operation of the aesthetic articulate open-endedness by a multiplicity of patterns" (Iser "Resurgence of the Aesthetic," 13–4). Even though he remains critical of a conception of the aesthetic that separates art and life, in other words, Iser's emphasis on the sociocritical function of the contemporary aesthetic remains indebted to the ennobling view of art that fuelled nineteenth-century aestheticism.

This tension between a negative, amoral and a positive, ethical conception of the aesthetic is also at stake in Iser's more specific dispute with Pater. Although *The Aesthetic Moment* implies that his conception of the aesthetic is in part consonant with that of Iser, it also underscores an important difference between both critics. The problem, in short, is Pater's supposedly Kierkegaardian view of the aesthetic existence. As "Pater's work can be read almost as a blueprint for the aesthetic existence," Iser's foreword points out, his study has "borrowed the necessary heuristics from Kierkegaard, especially his *Either/Or*" (Iser *Walter Pater*, viii).[14] Initially advocating a Kierkegaardian aesthetic existence in the "Conclusion" to *The Renaissance*, Iser claims, Pater's fiction shows that he was nonetheless acutely aware of the limitations of the aesthetic existence. *Marius*, according to Iser, is an "existential test" (141) of this view of life and critically depicts the aesthete as a helpless "intermediate being" (132).

As the following summary of his interpretation indicates, Iser clearly alludes to Kierkegaardian ideas:

> Marius now finds himself confronted with the problem of whether to leave the aesthetic sphere of the moment for the ethical sphere of continuity. [...] The life of moments will yield the profit of pleasure and the loss of potential ideals; the life of a realised ideal will attain moral coherence, thus liberating it from its contingent temporality. Since Marius's ideals remain undefined, [...] there can be no question of him taking a decision [...] and so he remains trapped amid his crises of longing and anxiety.
>
> (144)

The young Roman is unable to reach any decision regarding actual conduct and thus leads a reflective existence that entails "aesthetic quietism" (36). Although Marius explicitly rejects the passive stoicism of Aurelius, Iser

contends that Pater has highlighted the de-humanizing effects of a quietistic aesthetic life and has thus offered "a substantial contribution to human self-understanding" (169):

> The aesthete lives in contradiction to reality [and thus] breaks up existing, solidified forms of life. But he can go no further than this negative contradiction, being unable to devise new forms and ideals. [...] this reification of an in-between state rejects all legitimation and comfort, and these are essential if a life in opposition to reality is to be bearable and sustainable.
>
> (168–9)

Iser thus accepts the view of the aesthetic arrived at by studying Pater, but rejects the latter's attempt to translate it into an existential model, ultimately agreeing with Kierkegaard's ostensive critique of the aesthetic existence. Fluck uncritically concurs: "Iser [...] cannot accept Pater's extension of the aesthetic sphere to an aesthetic existence because it robs the aesthetic of its very potential for distance" (Fluck 182–3).

In the light of the preceding discussions of Kierkegaard and Pater, Iser's reading of both authors is clearly rather one-sided. As was already suggested by the articles on the functions of literature and the resurgence of the aesthetic, furthermore, Iser's literary anthropology returns to certain ideas of the aestheticist tradition. His view of man in *The Fictive and the Imaginary*, for instance, is strikingly similar to that of Kierkegaard's reflective aesthete. In Iser's words, "human beings are the 'plenum' of their possibilities" (Iser *Fictive and Imaginary*, 235); we are all "actors" playing an unlimited number of "roles" (82). In a similar fashion to Pater, moreover, literary anthropology holds that aesthetic experiences help us to cope with life and death. Human beings are confronted with all sorts of ungraspable phenomena. First of all, humans "are but do not 'have' themselves" (296); we live our own life, but are unable to have a detached perception of ourselves. On top of that, neither "the beginning and the end" (297) of life, nor its "evidential experiences" (299) such as loving another person are definitively graspable in cognitive terms. The "staging" (235) of events and roles in literary representations helps human beings to deal with these existential enigmas, Iser holds, as these texts offer an inexhaustible range of unknown lives and interesting experiences while signalling their fictional and hence limited status.

The idea that literature constantly offers "alternatives" (300) to our actual existence by exploring the space between roles and worldviews, birth and death, is akin to Pater's suggestion that we should expand the "interval" of our lives by relishing in all sorts of artistic experiences and thus "getting as many pulsations as possible into the given time" (Pater *Renaissance*, 238). Whereas *The Aesthetic Moment* implied that such a view is ultimately de-humanizing, Iser's anthropology concedes that aesthetic

possibilities allow us to adopt different roles and thus to re-humanize our limited dispositions. In this respect, Iser's reaction to the collection of artistic masterpieces Pater calls "the House Beautiful" is revealing: "it adumbrates an infinity hidden in human finiteness, allowing man to experience his own unlimited possibilities" (Iser *Walter Pater*, 82). In a similar fashion to Kierkegaard and Pater, then, Iser suggests a structural affinity between his ethical and aesthetic ideals; the endless "possibilities" (Iser *Fictive and Imaginary*, 297) of the self, it seems, have an artistic parallel in the "infinite possibilities" (280) generated by the play-movements of literary texts.

Of course, Fluck would object that Iser does not extrapolate this definition of the aesthetic to the domain of real-life ethics. According to this view, Iser entertains a "weak" rather than a "strong" aestheticism, to use the distinction referred to in the introduction to this volume. Art and life, in other words, are strictly separated and self-enclosed spheres rather than partly overlapping domains that constantly interact with one another. Admittedly, there are passages in Iser's work that hint at such a view. As the following quotation implies, Iser seems to hold that it is impossible to step out of our habitual dispositions in real life: "staging allows us—*at least in our fantasy*—to lead an ecstatic life by stepping out of what we are caught up in, in order to open up for ourselves what we are otherwise barred from" (303, emphasis added). As the article on the changing functions of literature already implied, however, Iser is critical of a conception of art that completely divorces it from reality. *The Act of Reading* maintains, moreover, that the ecstatic consciousness attained in reading has a real impact on our actual self: "[our original] consciousness will clearly not remain unaffected by the [reading] process, as the incorporation of the new [experience] requires a re-formation of the old [consciousness]" (Iser *Act of Reading*, 159). The staging of new experiences and roles, in other words, continually remolds and re-humanizes the artistic receptor without aspiring after an illusory "completion" (Iser *Fictive and Imaginary*, 299). On top of that, the plethora of possibilities that Iser terms "the aesthetic" is operative on a social as well as an individual level. As his discussion of the relationship between aesthetics and politics makes clear, the aesthetic does not necessarily entail the stifling indecision typical of the Kierkegaardian aesthete, but can also lead to a highly productive and ethical perspective:

> Politics [...] is decision-based and partisan, whereas the aesthetic is a cascade of possibilities, unbounded in range. [...] politics has to weigh and ponder procedures and alternatives before decisions are made, and this is the door through which possibilities creep in. Possibilizing may either paralyze decision-making, or suppress partisan bias in favor of acknowledging plurality.
>
> (Iser "Resurgence of Aesthetic," 14)

Although his view of man and art is similar to the one he attributes to Pater, Iser does not propose that we should retreat to an ivory tower or should capriciously change ourselves in real life, but that the oscillation between selves in the reading process or between points of view in political decision-making makes us enduringly aware of the human ability to both adapt to and open up the situation at hand.

Art for heart's sake

As the preceding discussion has shown, the three critics under consideration all claim that art offers both a de- and re-humanizing model for everyday living. Kierkegaard ostensibly maintains that an aesthetic existence of immediacy or possibilities leads to inauthenticity and should be corrected by an ethical existence that is as harmonious and autotelic as a work of art. Pater is aware of the stifling consequences of a life of indiscriminate experiences and therefore advocates a life that contains traces of both the aesthetic and ethical stage, as its emphasis on harmony and completion stresses both continuity and possibilities. Iser, finally, claims that Pater's aesthetic existence leads to immoral inactivity, but nevertheless holds that the infinite possibilities of textual play are intimately connected to what it means to be human. Seeing that it focuses on the counter-ideological effect of fictional play on the self, furthermore, Iser's oeuvre might prove an interesting starting point to unite the "deconstructive," "Marxist," and "ethical" (Shrimpton 10) versions of the "new aestheticism."

On top of that, Iser's use of both Kierkegaard and Pater reveals the difficult and yet fruitful nature of a dialogue between nineteenth- and twentieth-century attempts at theorizing an aesthetic existence. Even though Iser emphasizes the similarities between his own project and that of Pater, there are conspicuous differences between these "old" and "new" aestheticisms. Whereas Kierkegaard and Pater emphasize the harmonious nature of good art and good living, Iser underlines the infinite quality of art and existence without aiming for harmony or completion. Despite criticizing Pater, on the other hand, Iser's emphasis on the limitless possibilities of man and art can clearly be traced back to Kierkegaard and Pater. The similarities between the old aestheticism of Pater and the new aestheticism of Iser do not corroborate the frequent accusation that Iser's theory entails "apolitical idealism" (Armstrong 211), however. As the preceding analysis has shown, both critics offer a definition of the aesthetic that has clear ethical and political implications. Albeit in different ways, these three critics weld the aesthetic to the ethical and the human. Rather than propagating an uncommitted "art for art's sake," then, they argue for a re-humanizing "art for heart's sake."

Notes

1. In his study on *Aestheticism*, Leon Chai describes the relation between art and life in aestheticism as follows: "[i]n life [...] we experience form only when our impressions come together in some arrangement expressive of a higher harmony or consistency. [...] This harmony would [...] transform life into a work of art" (86). As I will argue, however, an adequate discussion of Kierkegaard's, Pater's, and Iser's aestheticism requires a comparison between the emphasis on harmony on the one hand and the emphasis on possibilities on the other.

2. Taylor points out that Kierkegaard's view of man is indebted to Georg W.F. Hegel: "[f]or Kierkegaard, as for Hegel, the self is the dynamic process by which potentialities are actualized" (115). A similar observation might be made about Pater and even Iser. As far as the latter is concerned, James M. Harding has identified certain parallels between Hegel and Iser's project; he argues that the "progressive unfolding of receptivity is the sublation of the reader, who discovers him- or herself through the determinate forms of responses to a text, then negates these determinate responses as distinct (concretized) moments, and finally, in the act of this self-negation, transcends previous boundaries of response by gaining in self-consciousness" (41). Though it is clearly a crucial intertext of the three thinkers discussed in this chapter, I will not pursue this Hegelian background in more detail here.

3. Note also that the book's conclusion ironically suggests that A might have started seducing B's wife. In any case, William's defense of the married life ends with a dissonant note caused by A. William notes that "[r]ecently I have often spoken about you with my wife. She is really very fond of you" (Kierkegaard *Either/Or II*, 324). He emphasizes that he is not "jealous" (324) but nevertheless tells A that his behavior has led to a "conflict [that] is your fault" (326).

4. My references to Tucker's article do not contain page numbers, as it is part of an e-book on "Pater in the 1990s."

5. Another way of conceiving its ethical dimension is to discuss the homosexual subtext of *The Renaissance*. In this respect, Jonathan Loesberg contends that "as far as society's antagonism or the possibility of misleading young men was concerned, Pater's criticism of religious dogma and his concern for building a philosophy upon sensations and particularly aesthetic sensations were more homosexual than were his more explicitly homoerotic passages" (186).

6. Loesberg has also noted the importance of duality and completion to *The Renaissance*. He points out that, according to Pater, "[a]rtworks [...] take form from contrasts and, moreover, produce them as aesthetic impressions on the part of the spectator. These contrasts constitute artistic value" (42). Furthermore, he refers to "Pater's inclusive aesthetics and his inclusive ethics" (Loesberg 17). Although my discussion is indebted to his argument, Loesberg focuses more on the epistemological than the ethical dimension of *The Renaissance* and tends, in a similar fashion to Iser, to overemphasize the revolutionary dimension of Pater's project.

7. This vague religious sentiment is ultimately connected to one of the ethical doctrines noted by Tucker, namely the "power of sympathy": "those who have much of [this power], have something to hold by, even in the dissolution of a world, or in [the] dissolution of self" (Pater *Marius II*, 183).

8. Clyde de L. Ryals has also underlined the importance of harmony to *Marius*, referring to the passage in which Marius distinguishes "a continuance, if not of their material or spiritual elements, yet of orderly intelligible relationships, like the

harmony of musical notes" (Pater *Marius I*, 131) in the Heraclitean flux. Ryals wrongly opposes this sense of harmony, however, to the "philosophy of *carpe diem*" (158) purportedly defended in *The Renaissance*.

9. F.C. McGrath, for instance, notes that "in his emphasis on the effects of works of art on the observer, we can consider Pater as one of the earliest advocates of modern reader-response theory" (35).

10. See the article on "Walter Pater und T.S. Eliot. Der Übergang zur Modernität," in which Iser contrasts Pater's "late-romantic [...] position" (Iser 1959: 394, my translation) with T.S. Eliot's "genuine modernity" (393).

11. Even though they fulfill a crucial role in Iser's model, "alien associations" are not univocally positive in Pater's text: "For the decorative 'is rarely content to die to thought precisely at the right moment, but will inevitably linger awhile, stirring a long "brainwave" behind it of perhaps quite alien associations.' Pater's openness to words 'rich in "second intention"' [...] make[s] [his search for] the *mot juste* a real problem" (Iser 1987: 52).

12. Winfried Fluck points out that "Iser refers to Adorno's aesthetics in his own definition of negativity and thereby points to a common interest in the negating potential of literature that, in view of the complete collapse of a once cherished cultural tradition, linked a wide range of intellectual projects in postwar Germany" (Fluck 186). For an in-depth discussion of Adorno's relation to the aestheticist tradition, see Charles B. Sumner's chapter in the current volume.

13. See the discussion of John Guillory's *Cultural Capital* in *Why Literature Matters. Theories and Functions of Literature*. Eds. Rüdiger Ahrens and Laurenz Volkmann. Heidelberg: Winter, 1996, pp. 13–22.

14. In fact, Iser had asked the following rhetorical question in an earlier review of a study on *Aestheticism and Oscar Wilde*: "was it not Kierkegaard who illuminated the problem of aestheticism once and for all?" (216). His Kierkegaardian analysis in *The Aesthetic Moment*, in other words, can be extrapolated to the entire aestheticist movement.

Works Cited

Armstrong, Paul B. "The Politics of Play: The Social Implications of Iser's Aesthetic Theory". *New Literary History* 31.1 (2000): 211–23.

Chai, Leon. *Aestheticism. The Religion of Art in Post-Romantic Literature*. New York: Columbia University Press, 1990.

Court, Franklin E. "Virtue Sought 'As a Hunter his Sustenance': Pater's 'Amoral Aesthetic'". *ELH* 40.4 (1973): 549–63.

Eagleton, Terry. *The Ideology of the Aesthetic*. Oxford: Blackwell, 1991.

Fluck, Winfried. "The Search for Distance: Negation and Negativity in Wolfgang Iser's Literary Theory". *New Literary History* 31.1 (2000): 175–210.

Harding, James M. "Given Movement: Determinate Response, Textual Givens, and Hegelian Moments in Wolfgang Iser's Reception Theory" (review). *Diacritics* 23.1 (1993): 40–52.

Iser, Wolfgang. "Aatos Ojala. *Aestheticism and Oscar Wilde*" (review). *Review of English Studies* 7 (1956): 215–16.

———. "Walter Pater und T.S. Eliot. Der Übergang zur Modernität. *Germanisch-Romanische Monatsschrift* 9 (1959): 391–408.

———. *The Act of Reading. A Theory of Aesthetic Response*. London: Routledge & Kegan Paul, 1978.

———. *Walter Pater. The Aesthetic Moment*. Cambridge: Cambridge University Press, 1987.

——. "Changing Functions of Literature". *Prospecting. From Reader Response to Literary Anthropology*. Baltimore: Johns Hopkins University Press, 1989, pp. 197–214.

——. "The Aesthetic and the Imaginary". *The States of "Theory". History, Art, and Critical Discourse*. Ed. David Carroll. New York: Columbia University Press, 1990, pp. 201–20.

——. *The Fictive and the Imaginary. Charting Literary Anthropology*. Baltimore: Johns Hopkins University Press, 1993.

——. *The Range of Interpretation*. New York: Columbia University Press, 2000.

——. "The Resurgence of the Aesthetic". *Comparative Critical Studies* 1.1–2 (2004): 1–15.

——. *How to Do Theory*. Oxford: Blackwell, 2006.

Kierkegaard, Søren. *Either/Or*. Eds. Howard V. Hong and Edna H. Hong. 2 vols. Princeton: Princeton University Press, 1987.

Loesberg, Jonathan. *Aestheticism and Deconstruction. Pater, Derrida, and de Man*. Princeton: Princeton University Press, 1991.

McGrath, Francis Charles. *The Sensible Spirit. Walter Pater and the Modernist Paradigm*. Tampa: University Presses of Florida, 1986.

O'Hara, Dan. "Walter Pater. The Aesthetic Moment" (review). *The Journal of Aesthetics and Art Criticism* 46.4 (1988): 528–9.

Pater, Walter. *The Renaissance. Studies in Art and Poetry*. Oxford: Blackwell, 1973.

——. *Marius the Epicurean. His Sensations and Ideas*. 2 vols. Oxford: Blackwell, 1973.

Ryals, Clyde de L. "The Concept of Becoming in *Marius the Epicurean*". *Nineteenth-Century Literature* 43.2 (1988): 157–74.

Shrimpton, Nicholas. "The Old Aestheticism and the New". *Literature Compass* 2.1 (2005): 1–16.

Taylor, Mark C. *Kierkegaard's Pseudonymous Authorship. A Study of Time and the Self*. Princeton: Princeton University Press, 1975.

Tucker, Paul. "Pater as a 'Moralist'". *Pater in the 1990s*. Eds. Laurel Brake and Ian Small. 4 October 2007. <http://www.uncg.edu/eng/elt/pater/pater_chap9.pdf>.

Index

abstract expressionism, 159, 161, 190
Adler, H.G., 187
Adorno, Theodor, 9–11, 14, 19n9, 165,
 173–88, 222, 230n12
 Aesthetic Theory, 10, 173, 180, 181,
 187, 187n2
 "Culture and Administration," 179
 "Education after Auschwitz," 183
 "Letters to Walter Benjamin," 10
 Metaphysics, 182–3, 185, 187
 Minima Moralia, 175, 176, 177, 180
 Negative Dialectics, 184
 "On the Fetish Character of Music,"
 179
 "The Schema of Mass Culture," 179
 "Trying to Understand Endgame,"
 185–6
aesthete, 3, 4, 8, 15, 16, 62, 63, 65, 67,
 71, 73, 74, 90, 91, 93, 106n10, 128,
 129, 130, 131, 132, 133, 134, 136,
 141, 144, 189, 191, 192, 193, 203,
 204, 205, 208, 223
aesthetic anxiety, 139–56
aesthetic critic, *see impressionistic critic*
aesthetic disssolution, 15–16
aesthetic existence, *see aesthete*
aesthetically saturated readings, 42, 47–59
aestheticism, 1–20, 26, 34, 36, 43, 44,
 46, 64, 67, 79, 80, 81, 82, 85, 86,
 87, 88, 89, 90, 91, 92, 93, 96, 97,
 99, 100, 101, 109, 112, 114, 116,
 125, 126, 127, 128, 129, 131, 132,
 133, 134, 135, 136, 139, 140, 141,
 142, 143, 144, 145, 146, 148, 153,
 159, 161, 164, 166, 167, 168, 173,
 174, 176, 177, 181, 190, 191, 192,
 193, 199, 201, 204, 205, 206n6,
 206n9, 208, 212, 227, 229n1
 art v. life in aestheticism, 1, 3, 5, 6, 8,
 16, 27, 42, 44, 46, 47, 52, 63, 66,
 67, 71, 72, 80, 86, 96, 98, 101,
 105–6n1, 110, 118, 120n9, 128,
 133, 146, 174, 193, 200, 209,
 224, 227, 229n1

contemplative aestheticism,
 see aestheticism, as view of life
 definition of aestheticism, 2
 genealogy of aestheticism, 2, 17–18n2,
 140–41, 173, 187n1,
 189–91, 208
 new aestheticism, 2, 17–18n2,
 208, 228
 physical aestheticism, *see Nietzsche, art
 for the body's sake*
 rejection of bourgeois culture,
 hegemony, values, 140, 141, 145
 studies of aestheticism, 16–17n1
 as view of art, 2–3, 101
 as view of life, 2–3, 62, 63, 67, 71,
 74n6, 99, 101
 weak v. strong, 11, 19n10, 227
aestheticization of politics, 129, 130,
 131, 132, 133
Agacinski, Sylviane, 81
Ainsworth, Maryan Wynn, 60n1
Alighieri, Dante, 46, 56, 60nn11, 12,
 13, 61n14
 The Inferno, 56, 60nn11, 12
 The Paradiso, 56, 60n13
 The Purgatorio, 56, 60n13
Alquié, Ferdinand, 146, 148
 The Philosophy of Surrealism, 146
Andrews, David, 168
Andrian, Leopold, 100
Appel, Alfred Jr., 165
Aragon, Louis, 146, 148
Aristophanes, 119n3
Armstrong, Paul B., 228
Arnold, Matthew, 97, 106n4
Aronowitz, Stanley, 190, 195–6
Artaud, Antonin, 146, 147, 192, 197
art for art's sake, *see aestheticism*
art for heart's sake, 223, 228
art for money's sake, 5, 9, 19n7
artificiality, 42, 51, 52, 59
artistic critic, *see impressionistic critic, see
 also Pater and Wilde*
Arts and Crafts Movement, 82, 190

232

Made in the USA
Las Vegas, NV
06 October 2021

31859522R00142